OFFICE OF THE MAYOR

CITY OF CHICAGO

RICHARD M. DALEY
MAYOR

W E L C O M E

As Mayor and on behalf of the City of Chicago, I am pleased to introduce *Art for the People* by Heather Becker.

Chicago's schools are home to a wealth of artistic treasures. Scores of murals created prior to and as part of the Works Progress Administration document a pivotal period in our nation's history. They reflect a time of great change and accomplishment, as well as an optimism towards a better future.

Art for the People is a valuable guide for students, teachers, historians, and the general public. It will serve not only as an educational tool, but as a snapshot of Chicago history.

Sincerely,

Richard M Daley

Mayor

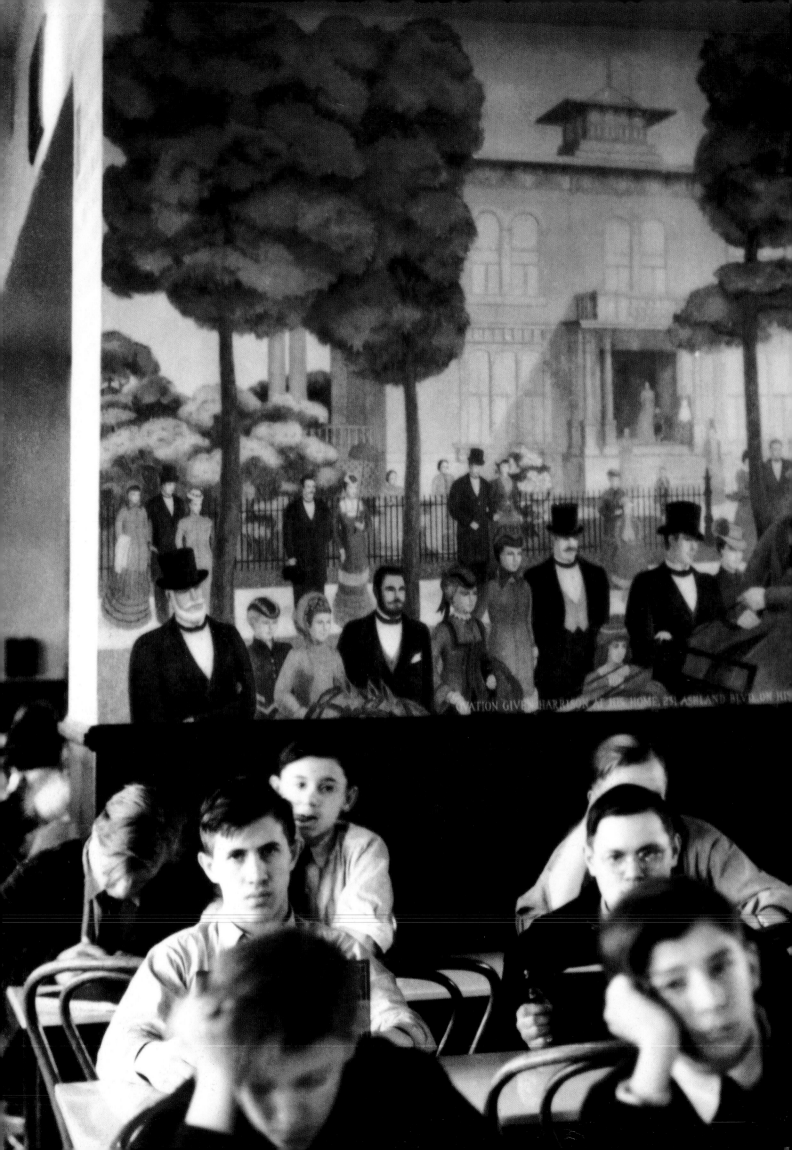

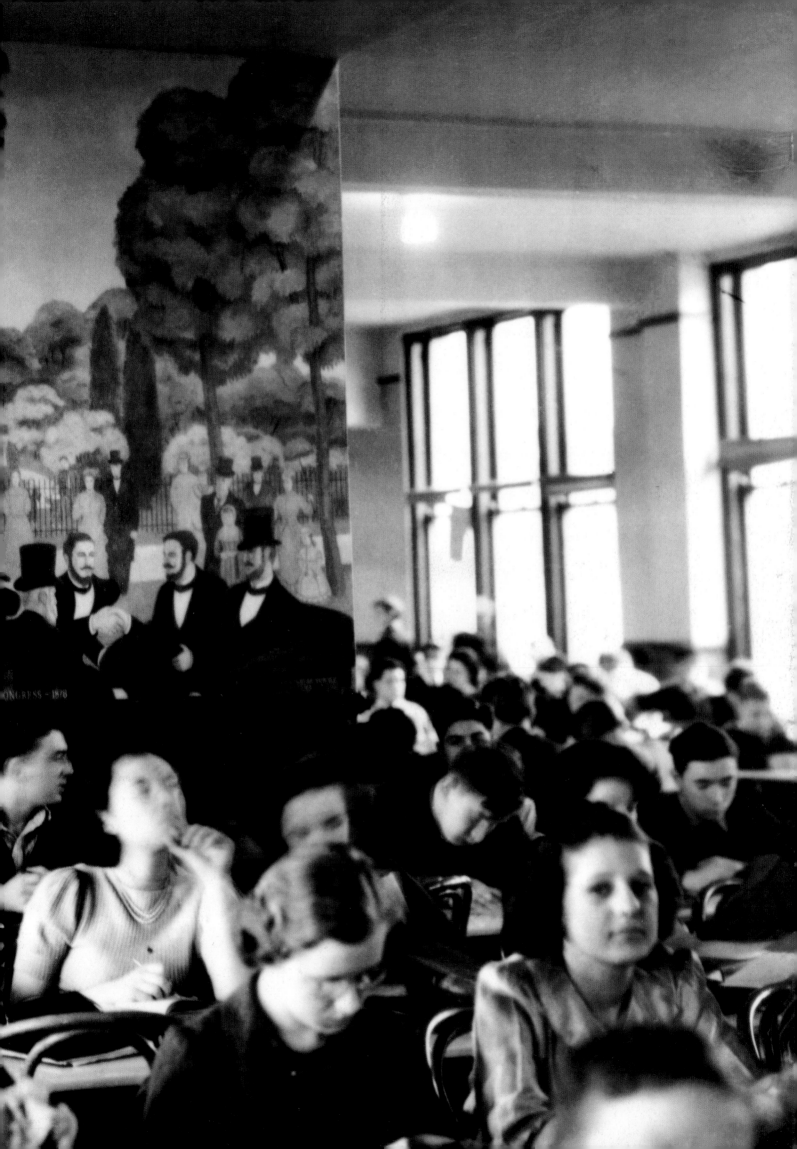

BY HEATHER BECKER
Principal Photography by Peter J. Schulz

Art for the People

The Rediscovery and Preservation of Progressive- and WPA-Era
Murals in the Chicago Public Schools, 1904–1943

CHRONICLE BOOKS

SAN FRANCISCO

This book is dedicated to Ben Reyes and all past, present, and future students of the Chicago Public Schools.

Page 235 constitutes a continuation of the copyright page.

Library of Congress Cataloging-in-Publication Data available.

ISBN: 0-8118-3579-0 [PB]
 0-8118-3640-1 [HC]

Manufactured in China

Photographs © copyright Heather Becker and the Chicago Conservation
Center except as otherwise noted.

Designed by The Grillo Group, Chicago
Typeset in Cooper Oldstyle, Futura, and Scala

The typeface Cagliostro Actuality is based on excerpts from pages 38–46
from *American Alphabets* by Paul Hollister. Reprinted by permission of
HarperCollins Publishers Inc.

Distributed in Canada by Raincoast Books
9050 Shaughnessy Street
Vancouver, British Columbia V6P 6E5

10 9 8 7 6 5 4 3 2 1

Chronicle Books LLC
85 Second Street
San Francisco, California 94105

www.chroniclebooks.com

Page iv: *History of Chicago: Great Chicago Fire of 1871,* Lucile Ward, 1940,
oil on canvas, Sawyer Elementary School.

Above: *Pioneers and Indians,* Datus E. Myers, 1910, oil on canvas, at Linné
Elementary School with students.

Table of Contents

Part I: Chicago Discovers Its Museum of Walls

Part II: Progressive Era Murals: 1904 to 1933

Part III: WPA Federal Art Project Murals: 1933 to 1943

Foreword

by Gery J. Chico, Former President, Chicago Board of Education

I am pleased to provide you with the first ever Chicago Public Schools mural reference guide, *Art for the People*. This book provides an overview of the hundreds of beautiful and historically significant murals in our public schools.

Under the leadership of President Franklin D. Roosevelt, the Works Progress Administration (WPA) commissioned artists across the country to paint murals depicting American life before and during the Depression. Hundreds of these murals were painted in our schools, but for decades most of them went unknown because they were hidden under layers of paint and dirt. After extensive efforts to inventory, recover, and conserve these murals, we discovered that the Chicago Public Schools has the largest remaining collection from the Progressive and New Deal eras in the country and that our conservation/preservation project is the only one of its kind in the nation.

Besides being aesthetically appealing, we are tremendously excited about the educational opportunities these murals present. The murals serve as extensions of the classroom and resources for teachers and students.

I encourage everyone who reads this guide to visit the murals and experience them yourself.

Incidents in the Life of Luther Burbank, *Andrene Kauffman 1937, oil on canvas, Burbank Elementary School.*

Preface

by Robert W. Eskridge, Women's Board Endowed Executive Director, Department of Museum
Education, The Art Institute of Chicago

In hallways, libraries, auditoriums, and cafeterias of nearly seventy Chicago Public Schools, a considerable number of murals can be found that were painted from the turn of the century to World War II, from the time these schools were founded or dating from the years of the distress during the Great Depression. In most cases, artists of local and national renown painted the murals. The subject matter of the murals was carefully chosen to educate, inspire, and edify students by placing before them images that directly concerned their curriculum, especially American history, literature, social studies, and geography. Over time, under the weight of changing social conditions in Chicago, an understanding of the initial motivation for creating these murals was lost, and they fell into serious neglect. In some cases, the very spaces chosen to display the murals had been transformed into inaccessible storage areas or offices. Other murals were simply left to gather dust or even completely painted over, obliterating their presence in the school.

Since 1995 the Art Institute of Chicago's Department of Museum Education has worked with faculty, students, and administrators in a considerable number of these schools to reclaim this significant artistic legacy for the classroom curriculum. The Art Institute of Chicago has been proud to assist the schools in this educational endeavor in a program called *Chicago: The City in Art,* funded by the Polk Brothers Foundation.

This program enlists the Art Institute's staff, collections, and teaching resources to raise the consciousness of students to the presence throughout their city, in schools and other public sites, of the eloquent artistic legacy that intersects with Chicago's history, affording students the opportunity to feel rooted in a past of whose vitality they can be proud. The program has been conducted during the process of conserving the murals by the Chicago Conservation Center. The results are a revelation for faculty and students, who can now see these murals as the artists intended them to be seen. In 1998 the Chicago Conservation Center received the Richard H. Driehaus Landmark Preservation Council of Illinois President's Award for Restoration and Education in recognition of this achievement. Only when the murals have been preserved have the possibilities of curriculum enrichment been revealed.

Heather Becker's *Art for the People* illuminates with utmost precision, imagination, and clarity of purpose the compelling art that has inspired the work of teachers and students in these schools in reclaiming this significant artistic legacy for the classroom curriculum. This book will further raise the esteem of students, faculty, and parents for these historic murals and add momentum to the spirited renaissance now under way in the Chicago Public Schools.

Dr. Margaret Nowosielska and Christopher Woitulwics, of the Chicago Conservation Center, preserving the mural attributed to Roberta Elvis, Characters from Children's Literature, 1937, oil on canvas, Bateman Elementary School.

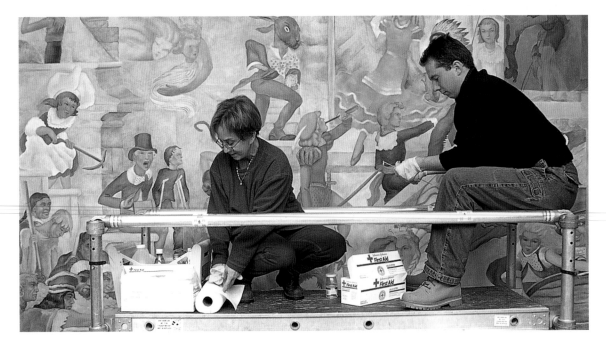

Introduction: Art for the People

by Heather Becker

Overview

This is a story of a rediscovered mural collection, and the unique series of events that followed. When this story began in 1994, many of the murals in the Chicago Public Schools were severely damaged and hidden beneath decades of dirt and deterioration. Others were covered by layers of paint, torn off walls, and put in storage rooms. A small group of people realized that preservation and education programs were needed to make others aware of the mural collection's cultural legacy. This book describes how these treasures were reintroduced to the public eye: how a small art project survived many obstacles and today flourishes as a citywide preservation project, complete with complementary educational programs. The extensive research, preservation, and education efforts related to the Chicago Public Schools' mural collection are the first of their kind in the nation. This book demonstrates how the various projects were established in the hope they will become models for similar programs across the country.

Nearly 440 murals produced between 1904 and 1943 still exist in the Chicago Public Schools. Together these works comprise one of the largest mural collections remaining in the country. This book is a historical guide to these murals housed in classrooms, hallways, libraries, and auditoriums. The book also serves as a catalog of the murals. Essays by artists, historians, New Deal scholars, teachers, principals, students, and city representatives place the murals in historical context. One goal of the text is to document and celebrate the unprecedented effort by the American government during the 1930s to bring art to the people. Chicago's mural collection serves as a reminder of art's undeniable ability to act as a powerful record of a people, place, and time.

Historical Timeline

Mural painting is a social medium when created for the public eye. It has long been associated with the expression of a community's history, ideology, and beliefs. Many cultures used wall paintings or murals as an esoteric or a social art form, from Paleolithic to Aboriginal, Egyptian, Asian, or the ancient art of the Americas, to classical, medieval, and Renaissance European cultures.

This historical guide is concerned with murals that divide about evenly between two historic periods: the Progressive Era (1904–33) and the New Deal era (1933–43). By the early 1900s, academic mural painting was flourishing in the United States, and reflected many of the Progressive movement's themes. As interpreted by President Theodore Roosevelt, Progressive movement concerns included reining in big business; developing policies favorable to the poor, to workers, and to women; emphasizing our country's international involvement; and conserving the natural environment.

Many of the murals from this period in the Chicago Public Schools refer to these issues, which were taken up again by President Franklin D. Roosevelt in the 1930s, after having been vigorously opposed during the 1920s. Roosevelt's New Deal, coming to power in 1933 after four years of a devastating economic Depression—and echoing Theodore Roosevelt's Square Deal—reinstated Progressive Era priorities and added to them. One of the additions was a series of art programs dedicated to indigent artists, starting with the Public Works of Art Project (1933–34) and continuing with the famous WPA Federal Art Project (1935–43), which sponsored a wide range of art activities including painting murals in public institutions such as the Chicago Public Schools.

With U.S. involvement in World War II and the subsequent dismantling of New Deal art programs in 1943, the mural movement in the U.S. lost momentum. Until recently, murals created during the Progressive and New Deal eras were often criticized, ignored, or forgotten, whitewashed, destroyed, or stolen. Yet their artistic, social, and political relevance endures.

Historical Context

Many young mural artists who began their careers depicting various Progressive Era themes in the 1920s became influenced by the dynamic Mexican muralists by the time mural production was at its height in America during the 1930s. During the early 1920s Mexico's president Alvaro Obregon had begun a nationalist cultural program. As part of the program, the Mexican Ministry of Education and other government entities commissioned artists to create public murals. The most prominent Mexican muralists were

Diego Rivera, José Clemente Orozco, and David Alfaro Siqueiros, who later received private commissions in the U.S. The program in Mexico became a model for the U.S. government's New Deal efforts starting in 1933. The careers, styles, and techniques of the Mexican muralists were inspirational sources for the New Deal muralists.

One of Chicago's most prominent muralists, Mitchell Siporin, was profoundly influenced by the work of the Mexican artists. He wrote,

Contemporary artists everywhere have witnessed the amazing spectacle of the modern renaissance of mural painting in Mexico, and they have been deeply moved by its profound artistry and meaning. Through the lessons of our Mexican teachers, we have been made aware of the scope and fullness of the 'soul' of our environment. We have been made aware of the application of modernism toward a socially moving epic art of our times and place. We have discovered for ourselves a richer feeling in the fabric of the history of our place.[1]

Like the Mexican muralists, Siporin and many other artists who created murals during the 1930s and 1940s for the Chicago Public Schools would focus on local, regional, and national themes and explore the region's and the nation's early peoples and progressive leaders.

When the stock market crash of 1929 paralyzed the country, artists were already suffering due to a shrinking art market. As the economy spiraled downward into the Great Depression (1929–43), so did the spirit of the American people; as unemployment soared, bank failures increased, and the loss of homes and farms forced people to wander the country seeking work. When President Franklin Delano Roosevelt came into office in 1933, he inherited a devastated economy and fifteen million unemployed, nearly a quarter of the labor force in America.[2]

In his inaugural address Roosevelt said his goal was to foster optimism and restore the broken spirits of the people, and he spoke his famous admonition, "The only thing we have to fear is fear itself." In the first hundred days of his administration the president acted vigorously on his plans for "a New Deal for the forgotten man" by initiating sweeping legislation. The severity and duration of the Depression mandated direct relief on a massive scale. One of the first priorities of the New Deal was to provide relief to the unemployed.

In addition to establishing a host of alphabet soup programs—such as the Civilian Conservation Corps (CCC), the National Recovery Administration (NRA), and the Civil Works Administration (CWA)—addressing work relief, banking, housing, and industry,

New Deal administrators formed the first federally sponsored work relief program for artists, the Public Works of Art Project (PWAP). American artists learned of the Mexicans muralists and began to see themselves as workers struggling against social inequities like other laborers. In 1933 Roosevelt received a letter from a former classmate, prominent artist George Biddle, who wrote,

There is a matter which I have long considered and which some day might interest your administration. The Mexican artists have produced the greatest national school of mural painting since the Italian Renaissance. Diego Rivera . . . tells me that it was only possible because (President) Obregon allowed Mexican artists to work at plumber's wages in order to express on the walls of the government buildings the social ideals of the Mexican revolution. The younger artists of America are conscious, as they have never been of the social revolution that our country and civilization are going through; and they would be very eager to express these ideals in a permanent art form if they were given the government's cooperation. They would be contributing to and expressing in living monuments the social ideals that you are struggling to achieve. And I am convinced that our mural art with a little impetus can soon result, for the first time in our history, in a vital national expression.[3]

Searching for the roots of national expression became a formula for identifying and creating a revitalized American culture during the Depression. Essayist Van Wyck Brooks (1886–1963) has described the era's push as a search for "a usable past."[4] This concept also became a goal of the New Deal art programs, especially in mural making.[5] In addition to the nationalist art then supported, the New Deal programs prompted debate about the roles of art and artists in a democratic society. For the first time in American history, the government supported a national program for the arts. A successful pilot program from 1933 to 1934, the PWAP, led the way for the more comprehensive WPA/FAP programs between 1935 and 1943. Unlike anything before or since, these government programs helped foster a wide appreciation of the arts throughout America. Public murals brought to the people art in a clear visual language that portrayed events in their own lives or from their own history. Such work also helped Americans to realize that artists were not isolated and mysterious individuals. In fundamental ways artists demonstrated they were just like other Americans, deserving of work, personal security, and pride. On the PWAP and WPA/FAP, artists were given a chance to further their careers instead of abandoning them, and in the process, many gained national recognition for their abilities.

Diego Rivera, portrait by Peter A. Juley & Son Collection (early 1930s).

In addition to addressing the professional concerns of the American artist, New Deal intellectuals instituted remedies for numerous social concerns made urgent by the Great Depression, often in the face of intense criticism from politicians and the public. Debates from the period continue today. While during the 1930s many supported state intervention into various areas of American society and business, in contemporary politics much of the public's belief in government's ability to solve social problems is weakening. The question of the merits of and need for government funding for the arts is often at the forefront of such debates. The New Deal art programs of the 1930s are evidence that government patronage of the arts leads to valuable cultural and societal growth, a fact that would seem to validate efforts for future government arts patronage.

Purpose

This book documents the sequence of events starting in 1994 that led to the largest mural preservation program of its kind in the country. Flora Doody, a teacher at Lane Technical High School, was concerned about a deteriorating mural in her building. She contacted my colleague Barry Bauman, the Chicago Conservation Center's director and painting conservator. Arriving at Lane Tech, Bauman was surprised to discover what is now thought to be one of the largest early-twentieth-century mural collections in an American school.

The discovery of this forgotten public art collection inspired me, as the Chicago Conservation Center's vice president, to research and inventory all of the Progressive Era and WPA/FAP murals in the Chicago Public Schools. Bauman and I jointly launched the

research project as a self-funded entity of the Chicago Conservation Center. The murals are scattered throughout sixty-eight of Chicago's six hundred schools. As the research proceeded, more and more people became interested in learning about the Chicago Public Schools' collection, long decayed and shrouded in mystery. With the support of the City of Chicago Board of Education, we determined the results of the research should be developed into a publication. After years of interviewing school employees, testing walls for hidden works, searching hallways, auditoriums, storage rooms, and libraries, our documentation work is now complete and ready to be presented to the public.

Murals in each location vary widely in content, style, and subject. They are unique to each school and community, having been conceptually defined by artists and school representatives. The Chicago Public School collection includes what is considered to be the first mural completed in an abstract style in Chicago. (See Rudolph Weisenborn, Nettelhorst Elementary School.) Numerous murals present interpretations of the historic events in Chicago such as the 1871 Chicago Fire, the 1893 World's Columbian Exposition, and the 1933 Century of Progress Exposition. History scenes include indigenous people as well as Columbus, explorers, and settlers; others depict national and state personalities such as Abraham Lincoln, George Washington, and Father Marquette. Scenes depicting steel mills, factories, farmers, or serene portrayals of the American landscape are prevalent as well.

In tandem with the research project launched in 1994, an effort began to preserve the murals and determine ways to use them as educational resources.

History of Chicago:
Great Chicago Fire 1871,
artist unknown, 1940,
Cecil A. Partee Academic
Preparatory High School.

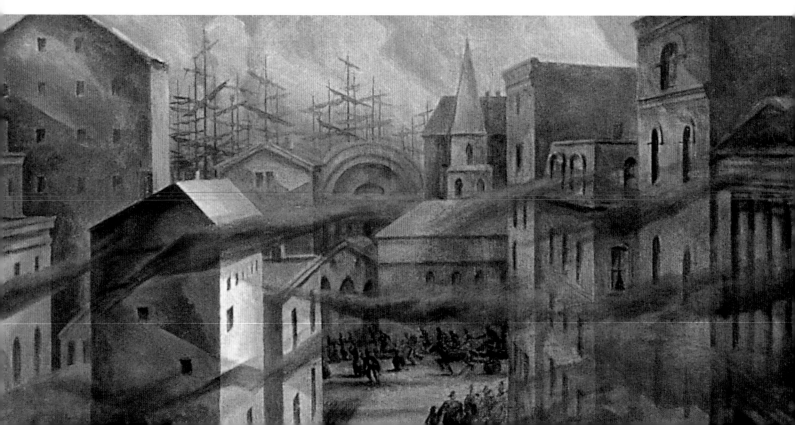

AS A STRUCTURE APPEARS WHEN COMPLETED SO MUST IT
FIRST HAVE EXISTED IN THE MIND OF THE BUILDER

The Lucy Flower Career Academy High School mural, painted over in 1941, was chosen as a pilot preservation project. This was exemplary for several reasons. Edward Millman, one of the primary Chicago muralists, had painted the six mural panels, comprising one of the city's few remaining *true* frescoes. The mural, depicting important American women, was painted in a social realist style and was rich with historical significance.

The Millman mural offered the most complex preservation challenge yet faced by Chicago Conservation Center staff: the removal of two layers of oil-base paint resting on top of water-based fresco. The preservation of this site in 1996 helped create an awareness of the collection and garner support for the continuation of the Mural Preservation Project. Through this ongoing project, Chicago has established itself as a leader and innovator in the arena of preservation and arts education.

Some may criticize the collection's "inconsistent" artistic merit, stylistic radicalism or conservatism, political agendas, absence of depictions of ethnic and racial groups, or stereotyping of these groups. Yet such concerns remind the viewer of art's complex role as a historic record and generator of new meaning for various audiences at various moments in history.

An important program of the WPA/FAP was arts education, a pursuit the Chicago Public School Mural Preservation Project seeks to continue today. As the research and preservation programs have begun at each mural location, a transformation has taken place, not only with the restored works but also with school children and communities. Students, teachers, and parents have expressed great interest in learning more about the murals.

The first formal initiative developed in response to this interest is *Chicago: The City in Art,* an educational program developed by the Art Institute of Chicago and the Chicago Public Schools, funded by the Polk Brothers Foundation. The program, based on concepts Flora Doody initiated at Lane Technical High School, has helped teachers establish course curriculum based on the murals. It has afforded students a unique opportunity to understand the historic legacy of their murals and to learn simple and advanced concepts in subjects such as the language arts, history, and science. We hope this project, and similar curriculum concepts being developed by the Chicago Public Schools, will become a model for similar education programs in America.

Audrey McMahon, the director of the New York WPA/FAP, writing in *Parnassus* (a magazine of the College Art Association) in 1936, summarized the legacy of New Deal art making:

> Three years of government patronage of the visual arts have proved several facts: that the individuality of the artist is not lost in a group effort; that the artist is deeply benefited by increased and broadened opportunity; that without this opportunity there seems to be little immediate hope for his survival; that the public gains educationally and materially from his efforts; that thousands of administrators of public buildings recognize the value of murals, easel paintings and other forms of art expression . . . that underprivileged children may be constructively influenced through art education; that there has been born a thirst for knowledge in the public and that of this thirst for knowledge may come a great culture.[6]

The resilience and idealism of the American people prior to and during the Great Depression is echoed in the tremendous efforts of the many people who have supported the rediscovery and preservation of the Chicago Public School Mural Collection. An American mural tradition has survived thanks to these preservation efforts. Its influence on the public can now continue as a dynamic force in Chicago's cultural history. The recent research, preservation, and education programs have invigorated the phrase "art for the people," used by New Deal arts administrators, by making the Chicago Public School Mural Collection once again available for the American public to enjoy.

Man the Builder; Man the Maker *or* Great Figures—Creative Figures (image 7), James E. McBurney, 1931, oil on canvas, Tilden Technical High School.

Art for the Public by Chicago Artists, *bulletin, an exhibition held at the Art Institute of Chicago in 1938.*

The Mural: An Art Form for the People

by Francis V. O'Connor, Ph.D.

This is a book about murals, and these general notes are meant to explain what murals are as works of art and as social statements. Of the art forms that constitute the visual arts, only three—murals, fine prints, and posters—are readily available to the public. Prints and posters are created in multiple copies available to more than one owner; murals are created, with rare exceptions, on public walls or in the public rooms of private institutions and residences. Whether located in a state capitol, church, commercial office building, hospital, railroad station, airport, boardroom, or dining room—or, as in this book's subject, public schools—they are designed to communicate. Of all the art forms, the methods of mural painting employed to effect such communication are the most elaborate, and understanding them helps us to interpret their meaning and success.

What I Learned about Murals from Siqueiros

Let me begin with a story. In 1969 I met the Mexican muralist David Alfaro Siqueiros when he was completing his now famous Polyforum Siqueiros in Mexico City on the site of the Hotel de México. Siqueiros greeted his "Americano" guest warmly, pointed to his extravagantly canted murals leaning out from the oval perimeter of the Polyforum, and led me up a precarious rope ladder into the womb of his self-proclaimed "last masterpiece." All the while he was confiding with delighted chuckles that the businessmen who were scrambling up behind us were angry about his spending so much of their money, that he and they were all going to be on TV to raise money, and that I was extra-lucky because the TV lights would give me a good view of his "Sistine Chapel."

Indeed they did. Spread before me was a vast room about the size of a football field whose walls curved up on all sides. It was a perfect elliptical ovoid covered with an enormous, partly sculptured mural of the "March of Humanity" that embodied every device, conceit, and cliché of Siqueiros's visual rhetoric. An international squad of young apprentices—as I would

discover later, the future leaders of the Community Mural Movement throughout the Americas—were working from suspended scaffolds painting 60-foot-high brushstrokes!

Siqueiros explained the overall subject matter, showed me the complex steelwork that knitted the angled exterior walls to the interior egg, explained how visitors would move through the painted environment, and asked if I had any questions. Overawed and utterly baffled, I asked if he could sum up his conception of a mural. He reared up to his full height, slapped his thigh with loud thwacks, and roared a lesson about wall painting I did not then comprehend: "Murals are to be seen with the legs."

With that, he excused himself and hurried to the TV cameras around which clustered his worried patrons. I watched him on a monitor, mugging and projecting like an elderly Cantinflas and talking vividly through the lens to the Mexican people—with a splendid long view of his stupefying masterpiece behind him.

With experience, I learned from Siqueiros that environmental and political factors are intrinsic to defining the art form. This means that murals create environments through which people move and thus must be conceived in three, not two, dimensions. Second, all muralists have to be politicians, since they must marshal the economic and political forces of their community to get the opportunity to express themselves.

Defining a Mural

A mural is any pictorial or abstract composition, usually, but not necessarily, large in scale and intended to be permanent, which has been executed on or for a specific interior or exterior wall, or situated on a ceiling or in an exterior or natural context, which defines, in visual terms, the purpose of its environment. Put in other words: Murals are images on walls that portray with deliberate intent the ideology of what goes on within or before those walls.

Facing page: **Children's Subjects: Art**, *Grace Spongberg, 1940, oil on canvas, Bennett Elementary School.*

Modernist art critics and historians of visual culture have tended to avoid discussing murals, since they appear to be art-by-committee rather than pure personal expression. As a result, modernist-influenced critics rarely nurtured strong muralists, the criticism lacking the requisite comprehensiveness of vision and forgetting the atelier tradition behind the great murals of Europe. Wall painting has also been ignored because of several practical reasons—such as the logistics of going to out-of-the-way sites, modernist architecture that was not much given to building walls, the vandalism of time and ignorance, and the nature of the art market, which finds it awkward to sell art permanently attached to buildings. And then there is the fact that strong muralists must overcome specific matters easel painters seldom encounter. These are the nature of walls, the concept of decoration, the problem of mural scale, the orientation of walls to the cardinal points of the compass, the various formal strategies muralists use to create mural environments, and the relationship between the muralist's art and the patron's ideology.

The Nature of Walls

Walls protect space by excluding what is outside. They create interiors—and insiders. Walls isolate what is inside from what is outside, making the inside environment exclusive—special. Doors and windows make the outside accessible; murals make the inside meaningful in terms of function. Looking outside identifies passing events; looking into and across the symbolic apertures of a mural environment explains ones interior location.

The first murals were on windowless walls: in caves or on cliffs. These were either utterly inside, or so utterly outside that they defined exterior precincts exclusive to insiders—as early Native American rock paintings did since prehistory and community murals do today. The first murals seem to have been the work of shamans and in that sense were in a place for initiates, rather than the public.

For most of recorded history, murals have been inside special, but not necessarily exclusive, places, giving meaning to their function by means of images. American murals are no exception—although early on there were few special places in which to paint them. Today, curiously, many vital American murals are outside again, on urban cliffs, making outcasts feel themselves insiders by means of images. In contrast, most recent interior murals tend to be wall-size easel paintings by individuals so interiorized that they can define nothing about their environments.

Walls pose any number of problems for the muralist, not the least of which is maintaining the integrity of the walls' surface despite their architectural articulation, or else violating the wall in ways compatible with both environment and imagery. Walls are vertical. They are, in a sense, surrogates and extensions of our body's self-protecting elements: skin, clothing, armor.

Walls can be terrifying. Several muralists have told me this. The terror of walls is that of awe: the same overwhelmingness of sheer physicality that those who enter caves in search of geology—or cave paintings—describe in the utter pressure of the earth, the knowledge of its weight, the awareness of one's vulnerability, the loss of a sense of scale. To stand a child in a corner is to perpetrate more than just humiliation through conspicuous isolation. It is also to impose sensory deprivation, denying a sense of scale and thus of relationship to a person's situation. The wall

can become finality. To break its plane is a healthy instinct, and murals can break it with images that open up what otherwise would be closed to inspection—and introspection.

All these factors are compounded by the reality that most walls apt for murals are public walls, which adds the factor of politics, prevailing taste, communal expectations, and the public's usual inexperience with the world of visual images. Only a strong artist can handle a wall.

The Spirit of Chicago (apse), The History of Writing (4 spandrels), and 20 historical portraits, by Gustave Adolph Brand and Schurz students from 1937–39, fill the walls of the Schurz High School library, some of which are represented in this room detail.

Decoration

We have been taught that decoration and art are not the same, but when dealing with the mural as an art form it is clear that decoration takes on a richer meaning than just fancying things up. "Decoration" finds its origins in the same Latin root complex from which we derive such words as "decency," "dignity," and "decorum," and thus refers to the rightness, fittingness, or aptness of a mural in its environment. A muralist is often responsible for carefully matching the colors and forms of the pictorial and decorative elements—the latter architecturally framing the former. But it is better today, when the term has been shot down by modernist critics (as when "interior decoration" is opposed to "fine art," or when high abstract art is damned as "just decoration"—which it often is), to reserve the idea of decoration for those historical periods when its full range of meanings still inhered in its usage. New Deal muralists, for instance, did not often have to deal with the overall decorative ensemble of the rooms they painted in.

The psychosocial implications of decoration cannot be ignored. In general, sumptuosity of decoration is found in those eras when the elite needed compensation for sensing itself a minority. (Earlier it simply identified who was boss—like Louis XIV at Versailles—and was recognized as such.) A quick comparison of our two greatest mural movements—the Academic, serving with cautious traditionalism a class of parvenu, turn-of-the-century industrialists, and the New Deal's democratically simple, undecorated walls, as in the schools discussed in this book—makes the point. But the bottom line is how well a mural relates to the human scale of the environment.

The Varieties of Scale

First, we must make a clear distinction between bigness and scale. Bigness means large size; scale, the ratio of size to its surroundings. The norm of that relationship has always been, of necessity, the size of the human body. Architecture and its embellishments have always accommodated that rather standard stature: about 6 feet tall with a reach about equal to the height. When the social implications of scale are ignored, the human factor is diminished.

There are five ways in which wall painting attempts to achieve the three-way balance between the size of a wall, the size of a mural, and the size of a human.

Pictorial Scale could just as well be called "easel-painting" scale, since the principle of relational balance is achieved entirely within the image-structure of the work, which, in itself, is most often smaller than a

Historical Scenes: Father Marquette Preaching to Native Americans, *Lauros Monroe Phoenix,* and Native Americans Watching a Dance, *Dudley Craft Watson,* both 1906, oil on canvas, *Wendell Phillips High School Academy.*

human. The idea of the easel painting as a "window" into its own spatial logic, in which the various figural, landscape, and/or architectural details exist in their own depicted relationships, is operative here.

This rather obvious aspect of scale is mentioned because many Early American overmantels are, for all practical purposes, easel paintings set in a wall and architecturally framed by some of its elements. These quite intimate works in equally intimate, domestic rooms have their own reasons for being. They also introduce into American art its historic tension between this contained, self-referential scale and that which operates in the wider, participatory space of a more public environment.

Transactional Scale refers to that set of kinesthetic and optical relationships congruent with a human's height, the reach of the arms, and the scope of the eyes. In general, this means a rectangle roughly 8 feet high by 12 to 18 feet wide. This is a size favored by most artists for a large picture because of its one-to-one relation to the viewer. Transactional Scale is, then, that set of relationships between the work and the viewer that best suits the establishment of some sort of interaction between the two—whether it is a reactive participation in the depiction of a great historic drama or the kinesthetic re-creation of an artist's painterly gestures.

Works of Transactional Scale are found most often today in large studio works like Jackson Pollock's big paintings, created outside an architectural context and conceived to establish their own environment before them in a display area. They are ambivalent as murals, depending on their creator's intention, the permanence of their installation, and their relationship to the architecture. True murals always exploit the drama of Transactional Scale, while employing Architectural Scale to mediate their much larger size.

The average size of five of the largest turn-of-the-century Academic murals comes to about 23 by 63

Pictorial Scale.

Transactional Scale.

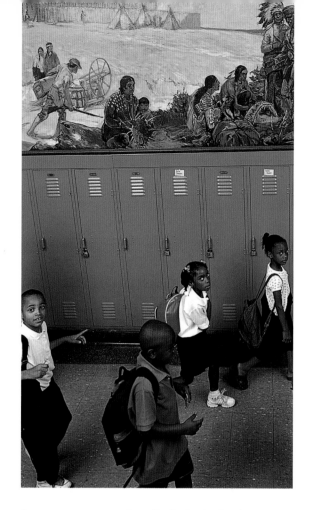

DuSable Trading with
Indians at Fort Dearborn,
*William Edouard Scott,
c. 1920s, oil on canvas,
Shoop Academy of Math,
Science and Technology
Elementary School.*

Architectural Scale.

Technological Scale.

Transcendent Scale.

feet, or 1,500 square feet. Similarly, the five largest WPA/FAP murals average about 1,400 square feet. All these works are far beyond Transactional Scale. They depend on their architectural contexts to relate them to human scale—to break up their overall surfaces into human-size doors, windows, and, as is most frequent, thematically related panels isolated or separated by architectural or decorative elements—as in many of the schools discussed here. Thus the architectural context of the mural determines and mediates the scale of the mural, contains it, edits it, and makes it humanly imperceptible while maintaining a superhuman monumentality. Architecture mediates the scale between viewer and mural, despite a disproportionate difference in the size of both. It is when this subtle decorum is abandoned, and the viewer is left to face the size without the context, that the situation becomes, literally, indecorous.

If the ambition of Architectural Scale is to balance the elements of an environment, as humanly and monumentally as possible, the ambition of Technological Scale is to do whatever is possible because it can be done, to make sure the viewer does not miss the feat, and forget relational ecology! In general, works displaying the characteristics of this scale are to be found in contexts of International Style architecture ranging from the antiseptic vacancies of museums and commercial galleries to the lobbies and corridors of public and private buildings. Since the ceilings are

invariably low, the length of these works is sometimes exaggerated to absurd extremes—sometimes nearing 200 feet. They can be experienced only in transit. As such, they embody all the inconveniences of modern life while attempting to ameliorate them. They are simply "big" pictures.

Finally, Transcendent Scale defines the special qualities of those works of art to be found in natural contexts, where the vastness of nature provides its own environment and transcends any human measurement of scale. The prehistoric rock art of Native Americans is the mural art most pertinent here—and certain multistoried works of community muralists.

Whatever the scale involved, the walls of a mural environment create a universe within or before themselves that relates to the larger universe beyond, and how those walls are oriented to the world is as important as how they relate to each other and to their human beholders.

The Orientation of Walls and Directional Symbolism

The coherence of a mural environment can be judged by how the muralist has handled the problem of directional orientation. As with architects, muralists are instinctively sensitive to the exposure of a room to light, but they are also sensitive to the directional symbolism and integrate that symbolism into their design whenever possible.

Directional symbolism can take two forms. The first is to relate a mural to things immediately outside the walls it is painted on—a river, for instance, or some neighboring landmark. This situational directionality is often combined, however, with the second and more profound symbology, that of the implications of the compass directions. Eastern walls are often treated differently from northern walls. The visual phenomena accompanying each of the compass directions contributes to their symbolism. In optical terms, compass symbolism is rooted in permutations of observed dimensionality, reflectivity, and contrast. Consider a stand of trees.

Dawn first reveals the trees in silhouette against its growing light from the east. Then the sun models their trunks, and they become two-dimensional, rather than one-dimensional. They are reborn from silhouettes to substantial things.

Day peaks at the south, everything comes alive in its dimensionality and begins to reflect light—sometimes glaringly—into the eye. It warms the day, lets us see what we are doing, and prompts every plant to follow its course.

At dusk in the west, the process is reversed. The

trees slowly lose their dimensionality, becoming silhouettes against the slowly darkening sky until they fuse with the dark or are seen as shadows against the stars or moonlight. This progression from light to dark—the most emphatic opposition we know—prompts associations of all the other dichotomies: life and death, love and hate, peace and war, good and bad.

Dark is the realm of night, invaded by the presence of lights that blanch the world of its color and most of its dimensionality. All that is mysterious, spooky, ambiguous, interiorized, and terrifying can easily be associated with the dark north. It is at night that what we know is there in that stand of trees, and what we imagine there is most exaggerated.

These simple realities have been imprinted in the human race ever since our first ancestors observed in awe and puzzlement the lights in the sky, their effect on the things of the earth, and their effect on those observing them. In turn, they have been specifically re-imprinted on the individual in the course of life's experience.

Dawn is the birth of light, day its fullness, dusk its demise, and dark its absence. We associate in consequence east with rebirth, south with nurturing, west with oppositions, and north with mystery and inner doings. And we associate agricultural and religious symbolism with the directions.

For our purposes here, it is enough to extrapolate this concept of an environment as imaging the external world to the heuristic approach to the mural program as a similarly emblematic environment, and to the dynamics of the artistic forms in the creation of such surroundings.

The Formal Strategies of Wall Painting

While successful solutions to the orientation of pictorial elements at a site, and to the problem of their scale, are perhaps the most important iconic and formal problems confronting the muralist, the public nature of a big wall poses others in the selection and arrangement of subjects over large areas. Optical problems result from the eye's ability to take in only so much of a wall at a time. They are also partly a function of how a wall is divided architecturally, and how its sightlines function from the entrance and other vantage points within the environment. In any event, temporal factors built into an environment that determine the sequence in which a work is seen—"with the legs," as Siqueiros said—can have a profound influence on the spatial solutions available to the muralist and on how subject matter is arranged.

That arrangement in space can take three general forms: Small walls, or large walls divided into discrete areas, tend to form what can be called presentational spaces in which single events or figures are encapsulated. Big, unarticulated walls, by contrast, prompt the telling of stories in a grand sweep of vision over time, and thus become narrative spaces. Finally, few murals present a purely "realistic" view of the world because muralists are trying to express multiple ideas in order to define the purpose of the space in which they are painting. To do so, they must communicate with a certain conceptual legibility. This almost always requires an abstract space that transcends depictions of natural space and time. Many of the school murals demonstrate these three spatial arrangements.

The Muralist, the Patron, and the Environment

Finally, every mural is more or less a compromise between the muralist, the patron, and the mural's architectural and communal environment. The contrasting temperaments of artists and patrons are thus determinants of the form and content of murals. Murals force artists to face social reality in the form of the patron. Some periods of history make this easier to do than others, but all require the artist to accommodate the ideals of the community. As this book reveals, working under government patronage during the 1930s was not easy.

Creating a mural is an integrative process, which involves the artist in nature both literally, in terms of compass directions, and figuratively, in terms of imaging a new idea of the world. What murals communicate in their effort to define the function of the space in which they are painted is part of an educational purpose intrinsic to the art form.

Murals in schools augment their educational purpose as well as create pleasing environments. Indeed, they fail in that function if left to decay, since young people tend to wonder how much they themselves are valued if their learning environment is left in disarray. So the preservation effort described in this book is equal in value to the murals saved and is, in itself, an important educational achievement.

Chicago Disco
Its Museum of

vers

Walls

The Mural Research Project: Discoveries of a Forgotten Public Art Collection

by Heather Becker

Between 1904 and 1943 artists painted murals in public buildings throughout Chicago. Many were created for post offices, government buildings, colleges, hospitals, libraries, and other public spaces. The great majority of murals were painted for Chicago Public Schools. Approximately 440 murals have been rediscovered in school hallways, auditoriums, classrooms, and libraries. The process of finding and bringing this lost collection to public awareness has been a rewarding experience for all involved. It has served to integrate the interests and efforts of teachers, historians, city officials, conservators, communities, and students.

The degree of art awareness prevalent in American society during the Depression years was considerable, yet the momentum that brought about this consciousness waned with the end of federal art patronage in 1943. As a consequence, at least fifty Chicago Public School murals were painted over, thrown away, stolen, destroyed, or left to deteriorate during the decades following World War II. Fortunately, over the years, teachers, principals, engineers, and local historians such as Barbara Bernstein and George Mavigliano recognized the significance of these and other Illinois murals.[1] Growing attention beginning in the 1970s helped prevent the murals from becoming completely lost to history. These efforts offered a foundation of information during the inception of the research and preservation project. Our story begins in 1994 with an insightful woman, Flora Doody, a special-education teacher at Lane Technical High School. She had the wisdom to investigate the unknown art in her surroundings.—H.B.

If Walls Could Talk

By Flora Doody

When I walked into Lane Technical High School in 1984, the walls talked to me. Above the heads of the high-energy teenagers, mural after mural lined the walls like railroad tracks, leading me to the office of my new position. In spite of needing serious cleaning, they were grand, quite striking, and bold, each one telling a story, yet totally invisible to the rush of students below. No one was looking up, except me. I imprinted that remarkable visual experience in my mind and thought that if I survived this new position, I would find out about all these murals.

My purpose in going to Lane Tech was to start a Resource Program for students with disabilities, and my program had only two students. Knowing that all the other classroom teachers would have at least 150 students, I didn't think I should point out the fact that the murals needed professional restoration work. Ten years later I knew that the time had come to do something about the murals.

Every teacher truly wants to inspire her students with lessons and special projects that will enhance the quality of their lives. Innovative ideas can be precarious. The project may be a disaster, a flop! Gratefully, there are other visions that do work, often better than expected. I began the Mural Preservation Project at Lane Technical High School in 1994 with the support of my principal, David A. Schlichting, and ten student leaders from the National Honor Society and the Student Council. The events that followed are quite curious and astonishing.

My contacts with the cast of players reached back to 1979, when I worked for a brief time in the Department of Museum Education at the Art Institute of Chicago

Facing page: **Processional, Henry George Brandt, 1913, oil on canvas, Lane Technical High School.**

as part of Superintendent Dr. Joseph Hannon's Access to Excellence programs. Two Chicago Public School teachers were based in area museums to help organize three-day, hands-on projects for student visits. Not really knowing anyone in the department and needing to make many photocopies of my lesson plans, I introduced myself to the gentleman who I thought ran the copy room. This individual turned out to be Barry Bauman, who led me to believe that he

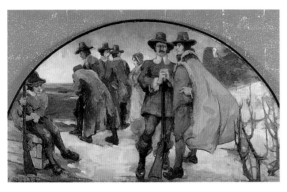

Before and after conservation: Pilgrims, *Janet Laura Scott, 1911, oil on canvas, Tilton Elementary School. The three murals in this series were painted over with several layers of oil base paint. These layers were removed using a scalpel and conservation solvents.*

History of Chicago: Father Marquette, attributed to Ralph Henricksen, 1940, oil on canvas, Partee Academic Preparatory High School. This mural shows severe paint loss.

was indeed in charge of the room. However, when I took my first tour of the many departments behind the scenes of the museum, I found Barry meticulously cleaning a painting. Behind him, casually leaning on a wall waiting to be cared for was the famous painting of Bertha Palmer by Anders Zorn, which originally hung in the Women's Building at the Columbian Exposition of 1893. He obviously did not run the copy room; he worked in the conservation department of the museum. Mr. Bauman is a talented man with a curious sense of humor! In 1980 the Chicago Board of Education was in financial turmoil and these special museum programs eventually closed.

I never imagined that my short stay at the Art Institute of Chicago would impact my life in such a dramatic way sixteen years later. My concern for our murals became quite serious when one of the murals was actually ripping out of its frame. Mr. Schlichting and I happened to be standing in front of this painting and he asked if I knew anyone who could help repair it. He had asked building maintenance for some suggestions and they told him that they could nail the canvas to the wall to keep it from falling. Fortunately,

he did not allow them to do that. I told him that I did have a friend who was the director of the Chicago Conservation Center. Barry Bauman, who had left the museum to start his own company, agreed to come to Lane Tech to see our art, but I knew that he thought that this was going to be some cute student work on the walls of our school. He reacted the way I did when I first walked into Lane Tech, and two hours later he said that we would develop a plan for repairs and treatment of our collection. —F.D.

The Formation of the Mural Research Project

After Barry Bauman's initial visit to Lane Tech in July 1994 and the subsequent preservation program, the Chicago Conservation Center decided to investigate early-twentieth-century murals in other Chicago Public Schools. We began by calling city representatives, historians, and architects for information on murals in Chicago schools. Over the next month details were gathered, mostly outdated, but the information confirmed that a large mural collection had originally existed in the Chicago Public Schools.

Based on the initial findings and concern for the status of the several hundred Chicago Public School murals, the Chicago Conservation Center took the initiative to establish and fund a comprehensive Mural Research Project in August 1994. The project was designed to verify, document, and photograph each Chicago Public School mural as well as others throughout Chicago from the Progressive and New Deal eras. Status reports were written on each mural detailing location, date, subject matter, style, artist, medium, and condition. The history of each school was also documented.

I directed the research project with assistants from the Chicago Conservation Center. The Center is a for-profit national resource facility for the research and preservation of damaged works of art. The research project had an obvious correlation with our preservation objectives as a conservation laboratory. When we began in 1994, many believed the years of neglect the murals suffered could never be reversed. During the research it was established that modern conservation technology could save a majority of the damaged murals, including those that had been painted over.

On-Location Research

In the beginning stages, I contacted John Vinci, a renowned Chicago architect. Vinci was knowledgeable and interested in the subject of Chicago murals and

intrigued by our inquiry. He suggested I contact Mary Gray, a local art historian, who was also investigating Chicago murals. Mary and I met and decided to continue our research together. Over the next six years we assisted with each other's projects.

By September 1994, using previous sources on Chicago murals, I had compiled a comprehensive list of murals believed to exist in the Chicago Public Schools and other public buildings.[2] The lists were cross-referenced with information from city representatives, the National Archives and Records Administration, and the General Services Administration, which is the federal agency responsible for the care of art in federal buildings nationwide. Mary and I then began the daunting task of searching each school's storage rooms, hallways, libraries, cafeterias, and auditoriums for hidden murals.

The Board of Education's map of all the Chicago Public Schools, approximately six hundred, was broken down geographically into six regions. Based on the record of original mural locations, we highlighted the schools with murals in each of the six regions. We would schedule a day for on-location research, visiting four to five schools in one region. On-location appointments often began with a brief conversation with the principal. Many school administrators were not aware of the presence of any murals and often were convinced that our visit would be futile. We explained the common locations of the murals and asked if we could search the school. Some schools were unaware of the murals because they had been

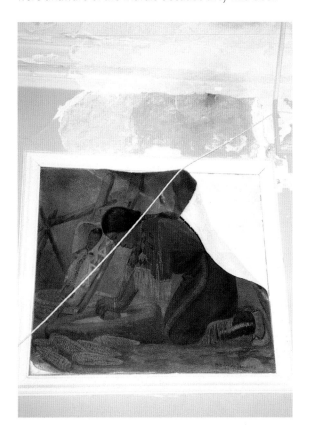

dismantled, placed in storage, or painted over. We sometimes removed small areas of overpaint with consent from the school, resulting in the discovery of a few murals that had been whitewashed. Many of the murals were found simply resting under decades of dirt, grime, yellowed varnish, and air pollution.

During one of our first days making on-location visits to the schools, we found five significant murals. The first was a politically controversial mural that

Harvesting of Grain: Spring and Fall, *Florian Durzynski, 1939, oil on canvas, Harvard Elementary School. This is a detail of a severely water-damaged mural due to a leaking roof. When varnish gets wet, it oxidizes and turns white. This type of damage makes the image appear irreversibly damaged, although the paint layer is intact underneath.*

had been whitewashed and hidden under layers of paint. The second was an elaborate series on the history of writing. The third depicted rural and industrial America. The fourth was a rare abstract mural with scenes of Chicago. The fifth school housed two enormous murals detailing the lives of the musicians Stephen Foster and Frederic Chopin. Other days were not so inspiring. Sometimes after hours of searching we found only bare environments. Yet through this manner of inquiry, the breadth of the collection was increasingly understood.

In several instances it was difficult to locate a school because its name or location had changed decades earlier. In some cases old buildings had been destroyed and new buildings built in their place. In other cases a wing of the school was original, and the rest new construction. Our work occasionally bordered on the forensic.

Mary and I visited hundreds of schools and public buildings throughout Chicago. Essential to our understanding of the murals were conversations with students, stories from teachers and engineers, and research on the history of the schools. We found 437 murals from the early twentieth century. Originally over 100 locations housed over 450 murals. Most of the 68 remaining locations house only one or two murals, while a few have dozens of examples. Tilden High School has 67 murals, Lane Technical High School has 66, Wentworth Elementary School has 34, and Schurz High School has 25.

Our research began during a transitional time for the City of Chicago Board of Education. Little attention was focused on art programs during this

Historical Scenes, *untitled (image 26), James Edwin McBurney, 1926–28, oil on canvas, Wentworth Elementary School. This mural separated from the wall due to severe deterioration of the wall from water damage.*

period. The buildings were in need of fundamental repairs and basic necessities like roofs, books, and computers were a priority.

In response to the various needs of the public schools, Mayor Richard M. Daley inaugurated an aggressive Capital Improvement Plan to renovate, reform, and beautify the entire school system in 1995.[3] Over the next few years we watched a revival occur in the Chicago Public Schools. Millions of dollars went into building renovations, additions, and upgrades. New management, programming, and testing agendas were put in place, and various school needs were addressed with vigor. As these changes took place, improved attitudes among teachers and students became apparent.

Now, with great pride, the school system is said to be undergoing a renaissance. Mayor Daley, Ben Reyes, Gery Chico, Tim Martin, in addition to principals, teachers, and students are a few of the many responsible for the turn of events. These efforts are currently being continued and expanded by Arne Duncan (Chief Executive Officer, Chicago Public Schools), Michael Scott (President, Board of Education), and many others. The goals of the Capital Improvement Plan directly related to the preservation and education endeavors of the mural project. The two programs have powerfully assisted one another in their efforts to reform and enrich learning environments for Chicago's children.

Unveiling the First Hidden Signature
At Lane Technical High School in 1994, Flora Doody found herself swept into a restoration drive she might never have envisioned. Following Barry Bauman's

original visit to Lane Tech in July of that year, he presented the school with a sixty-six-object preservation program. Flora decided to focus on fund-raising to preserve three of the earliest objects in the collection painted by graduates of the School of the Art Institute of Chicago. One, as discussed, was falling out of its frame and separating from the wall.

In August 1994 three Progressive Era murals were dismantled and transported to the Chicago Conservation Center for treatment. Barry began treatment by testing the three 18-foot murals using binocular magnification, organic solvents, and cotton swabs.

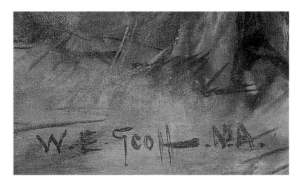

The first mural tested was *Steel Mill*, painted in 1909 by Margaret Hittle; the second was *Construction Site*, painted the same year by Gordon Stevenson; the third was an anonymous *Commerce* (or *Dock Scene*) of 1909, later attributed to William Edouard Scott.

When Barry began cleaning the third painting, Scott's original signature revealed itself under the microscope. Barry knew of Scott's work, having conserved several of his paintings for the DuSable Museum of African American Art in Chicago. Scott was an African American graduate of the Art Institute of Chicago and one of the pioneer mural painters in Chicago.

Example, William Edouard Scott signature.

Barry Bauman and Heather Becker in front of the oldest mural in the collection. King Arthur Meeteth Ye Lady Gweneviere, Norman P. Hall, 1904, oil on canvas, Wentworth Elementary School.

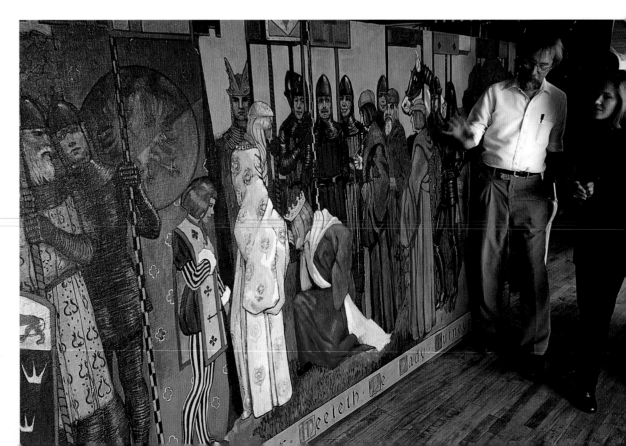

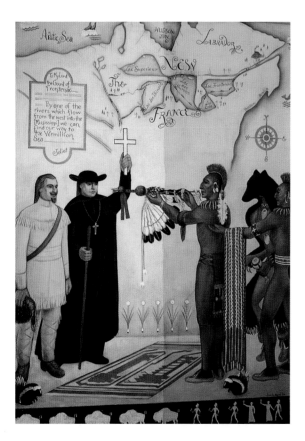

Few of his murals have survived. After the signature was revealed, the Terra Museum of American Art requested the painting for inclusion in the exhibition *A Shared Heritage: Four African American Artists*, in 1996. The painting is now reinstalled in the second-floor corridor at Lane Tech High School. The Center has since preserved other murals by Scott at Shoop Elementary School, Davis Square Field House, and most recently one of his largest projects at the old Wabash YMCA building on Chicago's South Side.

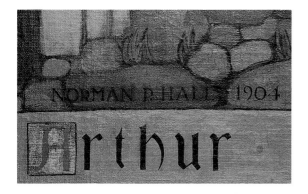

The First Fund-raising and Art Education Initiatives

Flora Doody's eventual goal was to use the Lane Tech murals as an educational resource by bringing the art collection into class curricula. As described following, Flora helped Lane Tech teachers create unique class activities, helped develop student docent tours, and initiated fund-raising efforts to support the conservation of the school murals.—H.B.

New Class Curriculum

By Flora Doody

In 1995 I wrote a State Chapter One proposal for presentation to our local school council. It included cross-curriculum lesson plans for art, history, and English classes to study our oldest murals (1909), the amount of money needed to repair the mural that had ripped out of its frame, and a culminating daylong festival, sharing student projects and activities with the classes involved.

During the planning stages of my proposal, I asked the Department of Museum Education at the Art Institute of Chicago to help me develop a field trip to the museum to view artwork from the same time period in American art. I had participated in many teacher programs over the years given by the department and had a good working relationship with Robert Eskridge, then associate director. Mr. Eskridge met with me and several other Lane teachers committed to this project. He was very supportive and felt that he could expand on my original idea in the form of a grant with funding from benefactors to the Art Institute of Chicago. A grant proposal was presented to the Polk Brothers Foundation and the Metropolitan Life Foundation for consideration. In 1996–97, these two foundations initiated the program *Chicago: The City in Art*, which continues today, funded by the Polk Brothers Foundation for the third year.

The projects and curriculum guide developed for *Chicago: The City in Art* at Lane Tech acts as a model for all the additional schools participating in this grant. A simple lesson plan about Chicago history evolved into a major curriculum guide, with support from the Art Institute of Chicago. A plan that incorporated a school walking tour for three classes to view the historic artworks housed at Lane Tech became a school project that reached out into the city of Chicago. A desire to prevent one mural painting from ripping out of its frame resulted in numerous works of art being reborn.

The hundreds of students who have been a part of this magical lesson plan have provided me with the most exciting time of my life as a teacher. Our murals are a wonderful educational resource. They offer endless opportunities for our students that go far beyond the classroom. Watching our students develop leadership skills, exhibit school pride, and reach out into the community to share their experiences make for a perfect day for this teacher. We have truly celebrated the rich heritage of Lane Technical High School.—F.D.

History of Chicago: Father Marquette, Lucile Ward, 1940, oil on canvas, Sawyer Elementary School. This image shows a cleaning line down the center of the mural, unveiling the original palette on the left.

Detail, Norman Hall signature, 1904, Wentworth Elementary School.

Lucy Flower Career Academy High School. A detail of a CCC conservator using cotton swabs and organic solvents to reveal the calcimine layer and the oil-based layer painted over the original fresco.

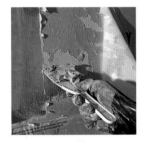

Lucy Flower Career Academy High School. A detail of the conservation paste used during cleaning to remove the overlying layers of calcimine and oil-based paint.

Outstanding American Women, Edward Millman, 1938–40, fresco, at Lucy Flower Career Academy High School. This is a view of the school foyer, showing the white-washed mural.

Chicago: The City in Art Project

The *Chicago: The City in Art* project initiated by the Art Institute of Chicago in 1995 expanded to include eleven Chicago Public Schools. The Art Institute developed this program to integrate the arts into Chicago classrooms. Participating children learned about their murals through music, art, theater, science, history, writing, and computer projects. This program has broadened students' awareness of American culture and helped foster school pride. It also has allowed the students to use their imagination and artistic abilities in ways that relate to their community history. A comprehensive overview of the program appears in Chapter 10.

The Pilot Mural Preservation Project at Lucy Flower Career Academy High School

While Lane Tech teachers and students developed a new relationship with their murals in 1994, another project began at Lucy Flower Career Academy High School. This was the Pilot Mural Preservation Project. The school housed a mural in its foyer room from 1940 that was whitewashed and hidden for nearly sixty years. It was one of a few true frescoes (water-based paint applied directly to wet plaster) created in the schools and had been painted by the prominent WPA/FAP artist Edward Millman. The six panels, spanning 54 feet, detail contributions of influential American women.

Newspaper articles from the early 1940s refer to an all-male committee from the Board of Education describing the mural as "depressing and misery laden" in addition to "subversive."[4] The articles mentioned that the school had requested lighting for the foyer because the room was too dark. So the school board sent a representative to investigate. In 1941 it was decided to paint over the "dark" mural.

The Art Institute of Chicago
Department of Museum Education

**Chicago:
The City in Art**
A Curriculum Guide for Teachers

This was only a year after Millman and his fresco plasterers had completed their work, which was begun in 1938. Millman was furious that his historic mural had been taken away from its public audience. The mural conformed to the style of social realism, addressing powerful issues of the time: child labor, the abolition of slavery, the women's suffrage movement, philanthropy, the inception of the Red Cross, labor unions, and pacifism in America. It was painted over because of the social issues it raised, not its dark palette.

Since 1985 the principal of the school had been trying to have the mural preserved. For these reasons we decided to use the Lucy Flower Career Academy High School mural as our Pilot Mural Preservation Project. Dorothy Williams, the principal at Lucy Flower, made a plea in a 1991 *Chicago Sun-Times* article asking the

Chicago: The City in Art, A Curriculum Guide for Teachers. Chicago: The Art Institute of Chicago, 2000.

Unveiling Our Historic and Controversial Mural, Hidden for Nearly Sixty Years

by Dorothy Williams

Knowing there was a Federal Art Project mural hidden under paint in the foyer of Lucy Flower Career Academy High School, I felt Flower students, staff, and community were being deprived of viewing a great work of art. I also felt the restoration of the mural would enhance our appreciation of art and our American history, even if some of the scenes were controversial. The mural was all but forgotten until 1985, when I decided to try and get the mural restored.

The unique mural depicted the lives and accomplishments of American women, both black and white, during the nineteenth and twentieth centuries. The gifted artist Edward Millman completed the 54-foot-wide fresco mural in 1940. It was felt that the mural would be a legacy for future generations to know the work of Lucy Flower and other outstanding American women. In November 1990 I contacted Patrick J. McDonald, curator for the Millman Collection, and photographs were obtained from his archives. All my attempts to generate interest in preservation of the mural went unanswered by the city. It was not until the Chicago Conservation Center became involved that movement toward preservation began. Early in 1995

Barry R. Bauman, director and painting conservator for the Chicago Conservation Center, conducted an on-location examination. In 1996, through the writing and coordinating efforts of Heather Becker, funding was finally secured. The Chicago Conservation Center began the laborious task of lifting off the whitewash, flake by flake. Seminars, presentations, and laboratory visits were offered to students during the preservation process.

With funding by the City of Chicago Board of Education, Chicago's Field Foundation, and New York's Bay Foundation, the restoration was completed by the Chicago Conservation Center by the end of 1996. The mural unveiling was held on Sunday, May 18, 1997. Over two hundred people were in attendance, including representatives from our funding agencies. A breathtaking, gloriously dramatic, tasteful, colorful, compassionate, and moving tribute to American women was revealed. Flower students now have the opportunity to study the mural; they now feel their school is special because of the outstanding work of art before them. Visitors come from near and far to visit our mural. This preservation project has truly enhanced our appreciation of art!

Outstanding American Women, *Edward Millman, 1938–40, fresco, Lucy Flower Career Academy High School, during and after cleaning.*

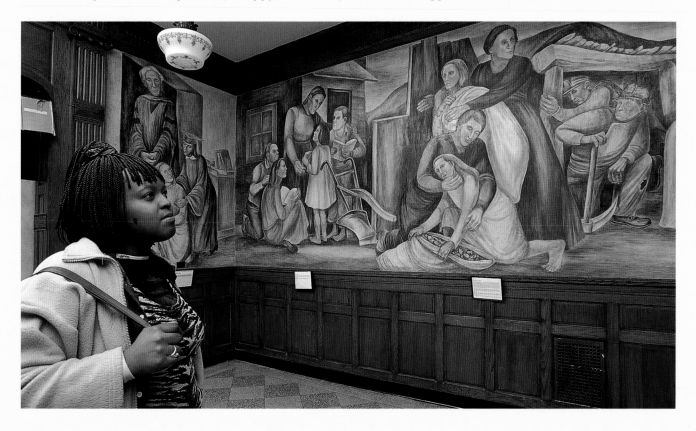

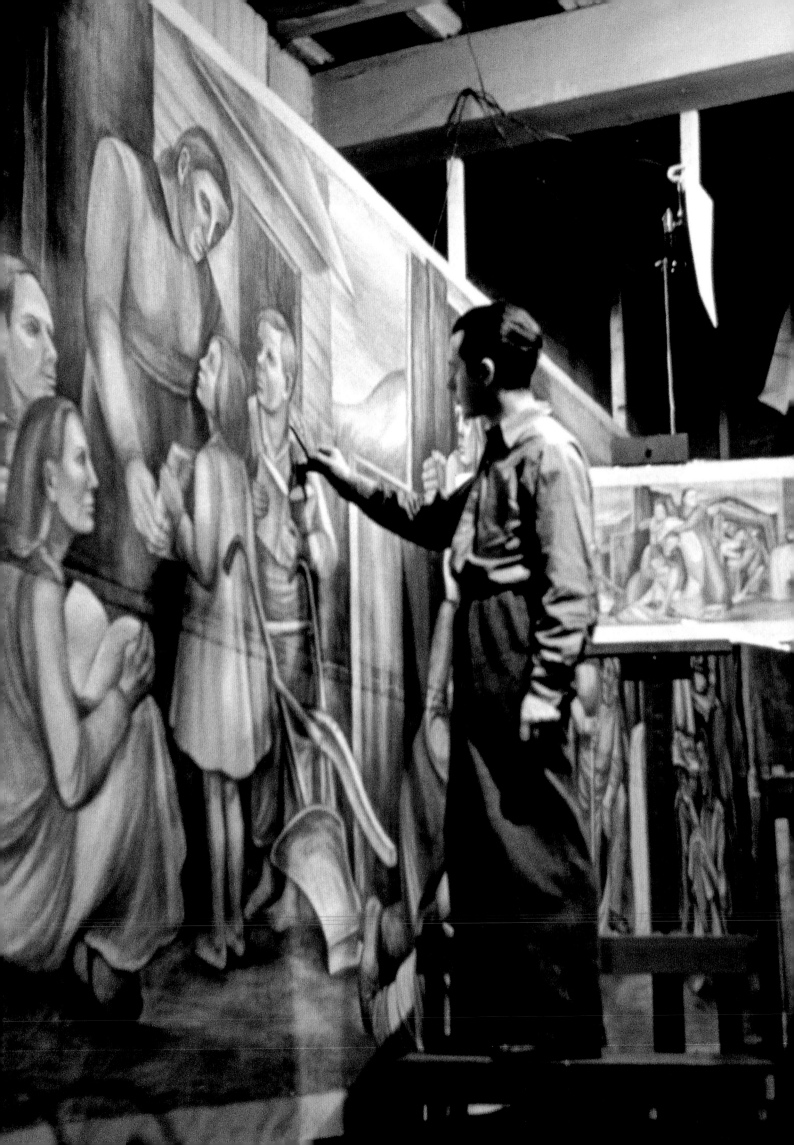

art community to help the school raise funds to have the mural cleaned and unveiled.[5] She received little response. People told her it would not be possible to salvage the water-based frescoes lying under layers of oil-base paint. The Board of Education was not aware of the whitewashed murals and was preoccupied with the overwhelming physical and educational needs of Chicago's schools. But when the Capital Improvement Plan started renovating Lucy Flower in 1995, the door for preservation of the murals opened.

In January 1995 Ms. Williams and I discussed testing the mural to determine whether it could be salvaged. Barry Bauman subsequently visited Lucy Flower and tested the mural to see if the overpaint could be removed successfully. His tests determined the mural could be saved by using a unique solvent process to break down the two layers of overpaint (one oil-base layer and one calcimine layer) on top of the frescoes. We informed Williams we would raise the funds needed to preserve the mural. She was skeptical at first, due to lack of past support, but soon realized we were committed to the project.

The Turning Point

By February 1995 the Chicago Conservation Center had committed to raise awareness and funds for the pilot project at Lucy Flower. The project took approximately one year to complete and cost $34,000. The school had no staff to devote to fund-raising; school fund-raising was not an option. I researched foundations to determine which would

consider the preservation project; grant applications were submitted in November 1995. By May 1996 the Field Foundation of Chicago[6] had contributed $10,000, and the Bay Foundation of New York[7] had contributed $3,000 for the Lucy Flower mural preservation project. A third of the project was funded, and we decided to proceed with the repairs, even though $21,000 still had to be raised.

Representatives of Chicago's cultural community were contacted to generate interest and additional funding. Moral and institutional support came from Michael Lash of the Chicago Department of Cultural Affairs; Chuck Thurow of the Chicago Department of Planning and Development; Robert Eskridge of the Art Institute of Chicago;[8] Adelle Simmons of the John D. and Catherine T. MacArthur Foundation; Lynn DaCosse of the General Services Administration; Sarah Solatoroff of the Chicago Community Trust; and Jean Follett of the Landmarks Preservation Council of Illinois.[9] The funding deficit continued to be a problem, but interest was growing.

By June 1996 potential local funding sources had been exhausted. It was time to approach the project from a different point of view, and it became obvious that the Lucy Flower pilot project was just the beginning of what could be done with Chicago's mural collection. The new approach led to a profound turning point. The city of "big shoulders" was about to establish itself nationally in the arts preservation and education arena with the Chicago Mural Preservation Project.—H.B.

Facing page: Edward Millman making the large sketches for the mural at Lucy Flower Career Academy High School, c. 1938.

Outstanding American Women, *Edward Millman, 1938–40, fresco, Lucy Flower Career Academy High School. After treatment, the original fresco is revealed.*

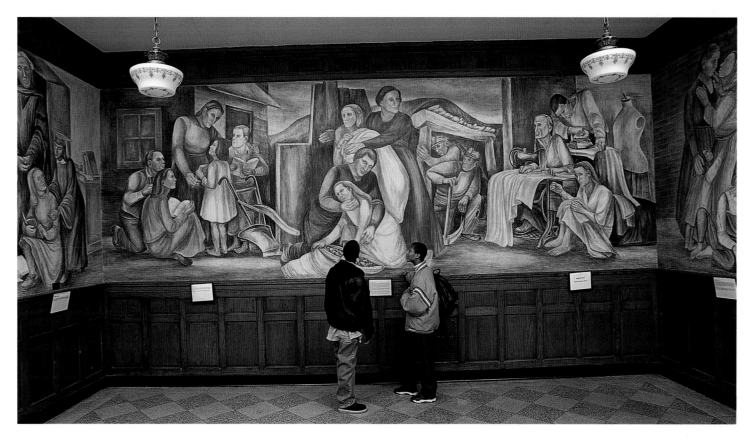

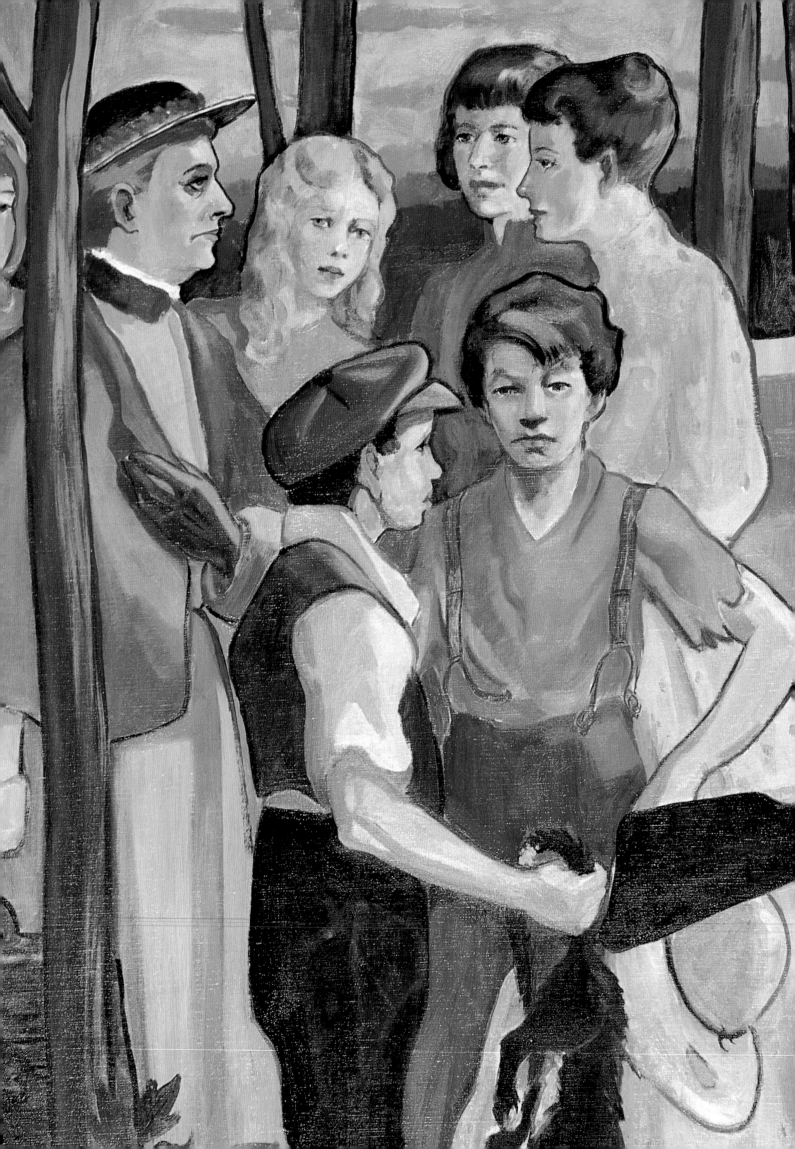

The Genesis of the Mural Preservation Project

by Heather Becker

In February 1996 the Chicago Conservation Center and project supporters pursued preservation funding for the entire Chicago Public School collection. A priority plan for conserving the murals was presented to the City of Chicago Board of Education. I was directed to Ben Reyes, then chief operating officer of the Chicago Public Schools. Barry Bauman and I met with Reyes in April about preservation needs for the murals.[1] Reyes and the Board of Education showed great interest, and other meetings followed.

Reyes understood the social impact of the murals. In addition, he was drawn to the collection's potential use as an educational tool within the Chicago school system. Reyes asked for an official proposal that included the remaining two-thirds of the Lucy Flower project and six other school projects chosen based on preservation needs and location, to spread the project evenly throughout Chicago communities. Therefore, Phase I of the Mural Preservation Project included seven schools.[2]

From the beginning, Reyes has been a committed supporter of the Mural Preservation Project: first as the chief operating officer of the Chicago Public Schools from 1996 to 1998; then as the executive director of the Public Building Commission of Chicago from 1998 to 1999; and currently as president of the Chicago company Millennium Three.

Unveiling the First Preserved Mural

A review process continued for six months before Phase I was approved by the school board in November 1996. We continued the restoration at Lucy Flower Career Academy High School and then began our work on murals in the remaining six schools. Lucy Flower Career Academy High School held the first mural unveiling ceremony in May 1997. This was a historic moment for the school, since its murals had been whitewashed and hidden since 1941. The ceremony was featured on the front page of the *Chicago Sun Times*.[3] The *Chicago Tribune* and several local television stations covered the event.[4] The publicity helped increase awareness about the project, and the media continued to cover the restoration work at each of the other six schools.

By 1997 the Art Institute of Chicago had established its art education pilot program *Chicago: The City in Art*,[5] with Lane Technical High School. By 1999 the program worked with five additional schools whose murals had been restored in Phase I. The schools benefited in various ways: Lane Tech students became docents of their vast collection; Ryerson Elementary students used their murals to study interpretations of American history. At Mozart Elementary, murals helped students learn music history. Nettelhorst Elementary students painted a mural inspired by their

Facing page: **Characters from Children's Literature, Charles Freeman, 1937, oil on canvas, Mozart Elementary School.**

Mural Preservation Project—Phase I Proposal

NAME OF SCHOOL	MURALS TO BE PRESERVED
Lucy Flower Career Academy High School	1 WPA/FAP mural in foyer
Albert G. Lane Technical High School	7 Progressive Era murals on first floor
Martin A. Ryerson Elementary School	2 WPA/FAP murals in auditorium
Sidney Sawyer Elementary School	5 WPA/FAP murals in auditorium
Wolfgang A. Mozart Elementary School	4 WPA/FAP murals in auditorium
Carl Schurz High School	25 non-WPA/FAP murals in library
Nettelhorst Elementary School	2 WPA/FAP murals in hallway and kindergarten room

Total preservation costs: $300,000

The Beginning of the Mural Preservation Project

by Ben Reyes

Ben Reyes in front of the Lucy Flower Career Academy High School mural.

It has been exciting to watch this project grow from its modest beginnings in 1994 into a program that we can all be proud of. Heather Becker and Barry Bauman undertook a massive independent research/fund-raising effort while a teacher and her students raised money through bake sales and school dances. Thanks to these initiatives and the support of the Board of Education, mural preservation has become a part of the Chicago Public Schools' system-wide capital improvement program. The Chicago Public School Mural Collection is a remarkable asset that only now, after painstaking restoration, we can fully appreciate and enjoy.

When I met with Heather and Barry in 1996, I took a look at their research and preservation initiatives and realized that something should be done to save this collection. There was no hesitation in my mind after reviewing the wealth of material collected on the mural collection's history and condition. These are great works of art, part of Chicago's history, part of each school's history, that had fallen into ruin due to years of neglect. There was no question action should be taken. I supported this unusual project for several reasons. Probably the most important reason was the project's local history. Any Chicagoan who has gone through the Chicago Public Schools can witness that these artists, back in the first half of the twentieth century, created art to make statements about what was going on prior to and during the American Depression. The murals are part of our cultural heritage that should be preserved and enjoyed.

I was also glad to see the educational component of the preservation plans offering an integration of the mural preservation process into each school. When I met Heather and Barry from the Center and took a look at their staff's conservation work and how they developed the whole program into each school's community, we knew the students and citizens would be fascinated and eager to learn more.

You are always going to find somebody to make a negative statement about how the board spends its dollars. As part of Mayor Daley's program to improve the city's libraries, park facilities, median planters, and Lake Shore Drive, he also decided to take a close look at the city schools. We reviewed the Board of Education in mid-1995 and understood that the schools needed money for capital improvements, computers, books, and much more. As part of the newly developed Capital Improvement Plan we made over $900 million available for computers in the classrooms, transportation system upgrades, renovating buildings, building additions, as well as new school facilities.

In 1996 Phase I of the Mural Preservation Project only required $300,000. So in terms of an investment, not only was it a unique program that drew the interest of the teachers and students, but it was also considered part of preserving the school facility. The murals should have been considered an important part of building preservation, just like the windows, classrooms, and roofs. All of this falls into the larger goal in Chicago to beautify the city. This was a small contribution toward that effort. By the time Phase II of the Mural Preservation Project was considered in 1997, for another $300,000, the Capital Improvement budget was up to $1.7 billion. Therefore, the ratio of expenditure on something this beautiful, that inspires the students and gives them pride in their schools, was more than justified in my mind.

In retrospect, I have been involved in many government projects, and this is one I have a special affinity for because of its many unique qualities. I was there at the Board of Education when we first pursued Phase I, and I have continued to be involved through its many progresses. Many years from now, I hope to see the project come to its conclusion when all the murals have been restored for future generations. It is something that twenty or thirty years from now, we can look back at this historic mural collection and realize that we had something to do with maintaining the history of Chicago for its citizens.

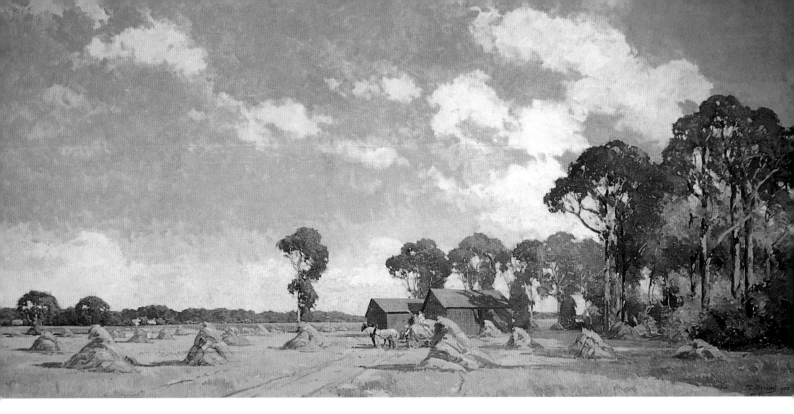

View from the School,
Frank C. Peyraud, c. 1920,
oil on canvas, Armstrong
Elementary School of
International Studies.

WPA/FAP mural. Finally, at Schurz High School, which was given landmark status, students focused on the history of literature through their library murals. The Board of Education was pleased that the *Chicago: The City in Art* program and the Mural Preservation Project were creating pride and artistic growth in the schools.

Phase II of the Mural Preservation Project

While Phase I of the preservation project proceeded over the next year, research for Phase II was gathered and presented to the Board of Education in September 1997. Because of the project's success, Reyes requested that Phase II include ten schools. The schools were chosen, again based on preservation needs and location (see chart below).

Phase II was approved by the Board of Education in January 1998. By this time, the program was well established. As the Center moved to the next school to begin restoration, our mural research was given to teachers and principals to use for student projects. Center conservators presented lectures to students on the subjects of the murals and the conservation techniques used to restore them. Chicago's Public Broadcast Station, Channel 11/WTTW, highlighted the Mural Preservation Project on its television series *Artbeat Chicago.*[6] This fostered an even greater awareness of the Mural Preservation Project in the Chicago community. It was a rewarding time for everyone involved.

Murals in six of the ten schools in Phase II had been treated when Reyes, Chico, and the CPS Board decided to move the project to the Public Building Commission (PBC), the city agency responsible for public buildings, upkeep and renovation of Chicago's

Mural Preservation Project—Phase II Proposal

NAME OF SCHOOL	MURALS TO BE PRESERVED
George B. Armstrong Elementary School	4 Progressive Era murals in hallway and auditorium
Frederic Chopin Elementary School	2 WPA/FAP murals in auditorium
Joseph E. Gary Elementary School	3 Progressive Era murals in auditorium
Helen C. Peirce Elementary School	11 Progressive Era murals in a classroom
John M. Smyth Elementary School	6 Progressive Era murals in auditorium
Edward Tilden Technical High School	50 Progressive Era murals in library
George W. Tilton Elementary School	3 Progressive Era murals above auditorium entrance
Carl Von Linné Elementary School	1 Progressive Era mural in hallway
William H. Wells High School	3 WPA/FAP murals in library
Daniel Wentworth Elementary School	29 Progressive Era murals in auditorium

Total preservation costs: $300,000

schools, parks, courthouses, police stations, libraries, and government facilities. Reyes became executive director of the PBC in April 1998. The project contract was transferred and conservation proceeded without delay. The restoration work on murals in four remaining schools was completed in 1999.

Phase III of the Mural Preservation Project

The proposal for Phase III included additional schools and partial funding for copies of this reference book to go to each of the Chicago Public Schools. The proposal was presented to the PBC in November 1998 and approved in April 1999. The positive record of the Mural Preservation Project allowed Phase III (under the direction of Eileen Carey, PBC executive director, and Raquel Loll, former chief of staff) to expand to include twenty-six projects in eighteen schools (see chart below).

Legal Ownership of the Collection

Over the years, questions have arisen as to the rights and ownership of WPA/FAP art. The federal agency responsible for the care of remaining WPA/FAP art is the General Services Administration (GSA).[7] They were contracted and pleased with the growing research and preservation initiatives in Chicago, yet stated the legal rights to the murals needed to be clearly understood by all involved. It should be mentioned that the legal rights and ownership of WPA/FAP works of art are currently a subject of tremendous

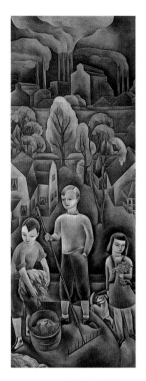

Seasons/Young Children at Play *(image 4)*, attributed to Mary Chambers Hauge, 1940–41, oil on canvas, Washington Elementary School.

Mural Preservation Project—Phase III Proposal

NAME OF SCHOOL	MURALS TO BE PRESERVED
Albert G. Lane Technical High School	4 WPA/FAP fresco murals in foyer of auditorium
	7 WPA/FAP fresco murals in lunchroom
	40 Century of Progress murals in hallways
	2 WPA/FAP murals in library
Henry R. Clissold Elementary School	5 WPA/FAP murals in auditorium
Frank I. Bennett Elementary School	3 WPA/FAP murals in lunchroom
	4 WPA/FAP murals in auditorium
Lincoln Park High School	1 mural in hallway
Daniel Wentworth Elementary School	3 WPA/FAP murals from the fourth-floor storage room
	2 Progressive Era murals from the fourth-floor storage room
Amelia Hookway Transition High School (now Partee)	8 WPA/FAP murals on auditorium balcony wall
	5 WPA/FAP murals on auditorium wall
John Harvard Elementary School	3 WPA/FAP murals in auditorium
Carl Von Linné Elementary School	1 WPA/FAP mural in room 211
Newton Bateman Elementary School	1 WPA/FAP mural in auditorium
	1 WPA/FAP mural in entrance hall
Luther Burbank Elementary School	2 WPA/FAP murals in auditorium
	2 WPA/FAP murals in room 104
Walter S. Christopher Elementary School	3 WPA/FAP murals in auditorium
Hugh Manley High School	3 WPA/FAP murals in auditorium (painted over)
Donald L. Morrill Elementary School	2 WPA/FAP murals in kindergarten rooms
Wendell Phillips High School	4 Progressive Era murals in entrance hall
Maria Saucedo Academy Elementary School	2 Progressive Era murals in auditorium
Harold Washington Elementary School	4 WPA/FAP murals in auditorium
Joseph E. Gary Elementary School	1 WPA/FAP mural in room 204
Julia Ward Howe Elementary School	1 WPA/FAP mural in auditorium

Total preservation costs: $918,595

debate. I asked Alicia Weber, chief of Fine Arts for the GSA, for an official statement regarding legal ownership of the Chicago Public School mural collection.—H.B.

WPA/FAP Public Art Collections

by Alicia Weber

GSA's Fine Arts Collection is one of the nation's largest and most diverse federal collections, consisting of circa 17,000 installed or associated paintings, sculpture, architectural, or environmental works of art, and graphics dating from the 1850s. These public works of art, located in federal buildings and non-federal repositories across the United States, are maintained by GSA as part of our cultural heritage and as a reminder of the important tradition of individual creative expression.

During the 1930s the federal government began the process of loaning or allocating (indicating a restricted transfer of title) to museums and other public agencies works of art produced under the various New Deal art projects. The Federal Property Administrative Services Act of 1949 transferred all functions of the Federal Works Agency, including New Deal artwork, to the GSA. To date, GSA has located and cataloged over 16,000 of these works in non-federal repositories, as well as artwork in federal buildings across the country.

Records indicate that the Central Allocations Section of the WPA/FAP Art Program in Chicago allocated "Paintings, Prints, Sculpture, and Ceramics" to the Board of Education, Chicago, Illinois, from January 1, 1943, to April 30, 1943.[8] It is GSA's responsibility to inform private citizens, art dealers, appraisers, and the museum community of the legal title to these WPA/FAP works of art. In response to numerous questions regarding legal ownership, title, and responsibility, we worked with our legal counsel to research original procedures and directives pertaining to the legal status of these WPA/FAP works of art. The fact sheet "Legal Title to Art Work Produced Under the WPA" addresses these issues and is available from our office. The following procedures for allocations would apply for the Board of Education in Chicago: The Works Projects Administration Operating Procedure No. G-5, January 10, 1940, Section 32, "Art Projects—Allocation and Loan of Works of Art" states: "For the purposes of this section the word 'allocated' shall mean the transfer of title."

However, Request for Allocation, DPS Form 8, clearly states: "It is understood that custody of the work listed will not be transferred and that the work will be exhibited for public use as indicated. Institutions desiring to be released of any work shall communicate with the Director of the Work Projects Administration—Art Program, Federal Works Agency, Washington D.C." In addition, page 4, paragraph 1 of the Procedure states: "If an agency or institution which has received a work of art on allocation or loan desires to be released from the responsibility of custody of the work, the official representative of the agency or institution shall communicate with the Director of the WPA/FAP Art Program, Washington, D.C."

Therefore, it appears to be the intent of the Operating Procedure, and it is the position of GSA, that allocated works of art were transfers of restricted title. The receiving agency or institution received legal title to the works of art limited by the purpose

Circus Scenes, Camille Andrene Kauffman, 1938, oil on canvas, Burbank Elementary School.

stated in the allocation forms and by the regulations. For example, if a WPA/FAP work was allocated and displayed in a public building by a state agency, and the state agency could no longer display the work, the legal rights to the work retained by the federal government would come into play. The state agency could not sell the work for profit, but must return it to the federal government. However, if the state agency would like to store the work, then display it again in the future, it can do so without triggering the reversionary rights of the federal government.[9]

The conservation and maintenance of these WPA/FAP works of art are essential for preserving part of the nation's cultural heritage for future generations. These works of art not only represent a specific period of our nation's history but also reflect the individual communities for which they were created. Therefore, conserving the murals in the Chicago Public Schools will ensure that a unique representation of both the City of Chicago and of the Great Depression is preserved.—A.W.

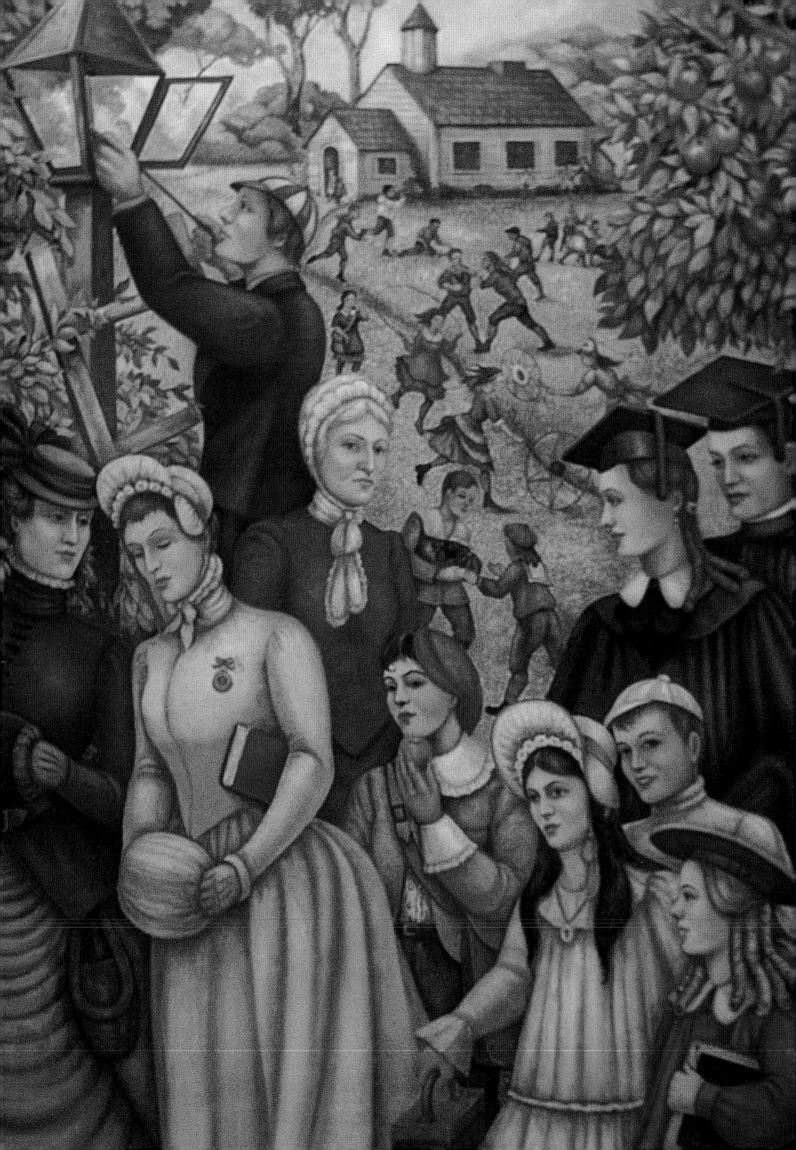

The Mural Preservation Project: A Mixture of Art, History, and Science

by Heather Becker

Cultural preservation has always been the essential purpose of the Mural Preservation Project. But the events that have transpired since the project's inception far surpass its original preservation aims. One example is the unique relationship that has been forged between professional conservators and Chicago Public Schools students and teachers.

Muralists frequently expressed their beliefs in the importance of creating their art in public. Many of the artists worked and installed their imagery in schools under the observation of students and teachers; in this way the artists met their audiences. The same connection has taken place during the recent preservation process some seventy years later. The conservators work in public, bringing the murals back to life; the students and teachers observe the work as the conservation process unfolds. Witnessing the progressive treatment of a mural that has aged and deteriorated since its creation in the early twentieth century is a unique opportunity. Geneva Ransfer, principal of Smyth Elementary School, commented, "It's as though all of the paintings have come alive."[1] Arlene Hersh, principal of Armstrong Elementary School of International Studies, wrote, "The beauty of the works, once cleaned of years of grime, is amazing. The children were awed by the transformation process going on directly under their watch."[2] Auburny Lizana, a student from Peirce Elementary School, said, "Our school is like a museum."[3] Anna Waywood, an art teacher at Sawyer Elementary, remarked, "The children really enjoyed watching the step-by-step cleaning and repair of the murals. The conservator working on the murals was also educating them about the murals. They were always asking him questions."[4] The students have developed a new sense of pride in their environment due to their involvement in this innovative project.

While standing in the library with the newly restored murals at Schurz High School, Gery Chico commented, "You bring professionals [conservators] like that

into the school and have them relate to the staff and the student body; good things happen. Kids want to know what this person does for a living, how their job works, and you form a nexus between the real working world and students who are learning along the way."[5] The children not only learned about the history of their murals; they began to understand the value of preserving America's past, what processes are involved, and what it takes to become a professional conservator.

Fine-art conservation is an unusual profession because of its marriage of three different disciplines: art, history, and science. The conservator's professional role is to maintain cultural and artistic heritage through preservation. The early theories and practices of art conservation were developed in Italy, Germany, Holland, and the United States. It was not until the late nineteenth and early twentieth centuries that extensive books on conservation appeared. Training facilities did not appear in the U.S. until 1925.

The profession of art conservation requires considerable training and apprenticeship: a master's degree in art or art history, followed by three years of study in a certified art conservation training program,

Facing page: **Historical Periods** *(detail of image 5),* Thomas Jefferson League, *oil on canvas, 1939, Clissold Elementary School.*

Barry Bauman lecturing to students at Nettelhorst Elementary School in front of Rudolph Weisenborn's Contemporary Chicago, *1936, oil on canvas.*

because of the degree of technical skill required within each area of focus, and then a three-year apprenticeship in a conservation laboratory. It is common practice for a training conservator to choose one medium for long-term study. For instance, he or she must make a choice between preserving sculptures, paintings, works of art on paper, textiles, or murals.

It is important to recognize some of the founding conservators, authors, and researchers in the field of fine-art conservation. Fr. G. H. Lucanus was a German conservator who wrote the *Complete Guide to the Preservation, Cleaning and Restoration of Paintings* (1842), an authoritative work on cleaning and varnishing techniques that included commentary on the growing need for training schools in the field.[6] Lucanus remarked, "only he [who] is capable of penetrating completely into the spirit of the work, should restore; only he will recognize and revere every peculiarity of the painting, and only to such a person can one entrust the most important work of art with good conscience."[7] Horsin Déon was a French conservator who wrote *The Conservation and Restoration of Pictures* (1851), which focused more on structural issues such as lining processes and painting transfers (when a painting is transferred from one support to another). The text also makes a plea for preserving the works of art in the Louvre, which would not take place for another century.[8] Italian conservator G. Secco-Suardo wrote *The Restorer of Paintings* (1866), a comprehensive work on all types of restoration processes.[9] Ulisse Forni was an Italian

Min Lee, head of in-painting at the CCC, in front of Dudley Craft Watson's Native Americans Watching a Dance, 1906, oil on canvas, Phillips High School.

George L. Stout, Edward Forbes, and John Gettens. Stout and Arthur Pope, another Fogg Museum conservator, went on to merge the field with science. Stout also wrote one of the essential books in the field, *The Care of Pictures* (1948).[12] Helmut Ruhemann was another highly revered conservator who began his career in the early 1920s in Berlin and then London. He went on to become a premier author in the field, writing several books often used for training, including *The Cleaning of Paintings* (1968).[13]

Scholars and historians played a large role in the development of conservation techniques. Charles Lock Eastlake wrote *Materials for a History of Oil Painting* (1847),[14] reviewing in great detail the methods and materials of the great master painters, influencing the methodology of conservation. Historian Mary Merrifield compiled a book well appreciated in the field on the history of painting techniques, *Original Treatises, Dating from the 12th to the 18th Centuries on the Art of Painting* (1849).[15] J. F. L. Mérimée was another significant historian who wrote *The Art of Painting in Oil* (1830), which chronicled painting methods but also highlighted the need for removal of discolored varnish and described the techniques used at the time. Mérimée states, "it is by the process of restoring, that discoveries are made of the various methods of the schools (of painting), as well as the particular method of the master (artist)."[16]

The field is considered a small niche profession. Yet the number of works in need of preservation continues to expand. Over the years, the field has been

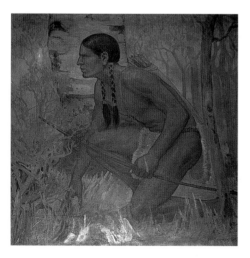

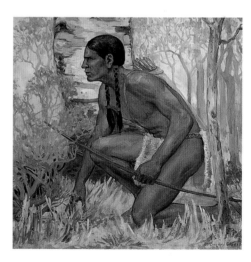

Before, during, and after conservation views of a James Edwin McBurney's mural from the Historical Scenes series (image 23), Wentworth Elementary School. The mural was coated with a heavy soot film.

conservator who wrote *Manual for the Painter-Restorer* (1866), which offers debates on how much to remove during the cleaning process and other ethical controversies.[10] German conservator Theodor Frimmel wrote *Knowledge of Painting* (1920), which documents the restoration of paintings from 1500 onward.[11]

In 1925 the first art conservation training school in the U.S. was established at Harvard University's Fogg Art Museum. Its founding conservators were

increasingly integrated with other related professions including art historians and other art faculty, museum curators, science laboratories, preservation associations, galleries, framers, private collectors, artists, auction houses, appraisers, authenticators, and insurance adjusters.

Quality, patience, and ethics are three primary concerns in conservation. Standards and ethics have been established through international and national

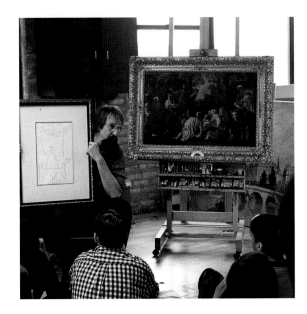

organizations, such as the American Institute for Conservation (AIC). Basic to the practice is the commitment to use and seek safe and reversible treatment methods while retaining the artistic integrity of the work. Conservation fees are to be based on time and materials, not on the value of a work of art. Ethical standards proscribe the conservator from becoming involved in the buying and selling of art, or appraising and accepting commissions on art sales.

Devoted and unassuming individuals often carry out the work of a conservator in remote workshops. In the quiet atmosphere of an art conservation laboratory, processes are slow and technical. For example, a conservator cleans a painting a section at a time using hand-rolled cotton swabs and an appropriate solvent. During retouching a conservator meticulously inpaints missing areas of paint with a brush the size of a needle using pigments that are color and light fast. A structural conservator may shave the plaster from the back of a canvas mural with a scalpel.

It is a challenge for a conservator to work on location. Sometimes high scaffolding and awkward working positions are required to treat murals. It is understandable that the mural images in the Chicago Public Schools went unnoticed for years. The gloomy, flat, and unrecognizable imagery was covered in grime, varnish, and surface scratches. The years of progressive deterioration obscured their colors and individuality. Very often what remains underneath can only be perceived by the trained eye of a conservator able to envision its true colorful brilliance.

A conservator is often asked, "What does conservation actually do to a work of art?" The goal of a conservator is to return a work of art to its original pristine condition. He or she attempts to reverse years of damage, while paying homage to the artist's intent at the time of creation. This is a challenging goal, especially when murals such as these have been

hanging on a wall for over seventy years collecting dirt and decaying with age. The public also commonly asks, "What makes a work of art worthy of conservation?" For preservation to be considered, the object's cultural value needs to be established.

The research for this book, which details the mural collection's historical record, social history, artistic merit, and potential educational use, firmly established the collection as worthy of conservation attention. Once a work of art, or collection as in this case, is determined worthy of conservation, technical concerns follow. Sometimes a work of art has suffered such severe damage that the integrity of the original may be lost and conservation may not be considered. New developments sometimes offer the ability to reverse extensive damage, previously considered irreversible. A priority listing of conservation needs was established by the Chicago Conservation Center after reviewing the murals in the CPS collection. Notes related to this survey work are found in the condition/conservation section of each mural entry in this book. In the essay below by Barry Bauman, a few examples of treatment procedures are reviewed in more detail.

The mural conservators have focused their work on one school mural at a time. Some of the smaller murals may take only days to treat while others require months. Murals with severe structural damage (deteriorating canvas, board, or wall supports) have required treatment at the Conservation Center laboratory to stabilize their condition safely. As the treatment work took place at each school, educational seminars were offered on location and at the Center laboratory, where students observed their murals being preserved.

Attached to a letter from Janice Rosales, the principal of Peirce Elementary school, was a list of remarks from students after their field trip to the Conservation Center laboratory: "you must have patience and dedication for this profession . . . I learned about Rembrandt and his teacher, Peiter Lastman . . . I learned that you have to love your profession . . . I learned that in order to restore paintings, you need to study art, history, drawing, chemistry and science."[17] Nancy Russell, an art teacher from Linné Elementary School, wrote, "The field trip offered the students a deep respect and value in art. It offered them a chance to see artists and serious adults working in related careers."[18] Mary Ridley, an art teacher from Nettelhorst School, wrote, "They learned how to look at this artwork and made some great connections with the things historically represented in the mural. We are thrilled to have our Weisenborn show its colors so brightly. We feel so lucky to have been a part of this worthwhile project!"[19]—H. B.

Preserving the Chicago Public School Murals

by Barry Bauman

The conservation of the mural collection in the Chicago Public Schools combines educational and preservation goals. The program has fostered renewed awareness of the city's artistic holdings. It has also created an opportunity for each student to learn from the social, political, and cultural icons that surround him or her. Students would stop and look at the progress daily and ask technical questions. The preservation work became a part of the academic curriculum: It's not only a classroom "without walls," but also a classroom "on the walls."

Restoration efforts are well documented throughout the history of art, but the synthesis of art and science as the foundation for conservation in the U.S. began in the 1940s at the Fogg Art Museum of Harvard University under the direction of George Stout and Arthur Pope. Cause and effect principles between art and its environment were tested and evaluated. The chemistry of paint films was studied to understand how to arrest and reverse the deterioration of painted objects and still preserve the integrity of the work of art.

Conservation should be distinguished from restoration. Conservation implies "to conserve the old," while restoration implies "to remake or redo." Conservation is the preferred method, for it puts the integrity of the work of art first. The allegiance is to what is perceived as the artist's intent rather than the desires of the present owner. By preserving the original character of the murals, they can be studied more adequately within their social context. The preamble of the Code of Ethics of the American Institute for Conservation states the goals of the working conservator, "The primary goal of conservation professionals, individuals with extensive training and special expertise, is the preservation of cultural property. Cultural property consists of individual objects, structures, or aggregate collections. It is material, which has significance that may be artistic, historical, scientific, religious, or social, and it is an invaluable and irreplaceable legacy that must be preserved for future generations."[20]

There are three areas of study of equal importance for the professional conservator. The conservator must have an art historical awareness of the objects entrusted to his or her care; an awareness, for example, of what the Renaissance or Baroque artist intended and how the final result could only have occurred during the period in which the object was made. The Progressive and New Deal era murals were produced during their own political, social, economic, and artistic age. The conservator must understand these historical principles.

The second area of study required for the professional conservator is organic chemistry. Cleaning a painting is a critical moment in the history of that painting. The conservator cannot be experimenting; a clear and well-constructed approach informed by a background in organic chemistry is required to remove discolored films without injury to the paint surface. Without this science, a work of art can be damaged or lost forever.

Drawing and painting comprise the third area of study for the trained conservator. Older paintings often suffer from abuse, deterioration, vandalism, and/or paint loss. As a final step in the conservation process, the conservator often has to apply pigment to areas of loss. This retouching, or "in-painting," is never applied directly to the paint surface. Instead, a buffering nonyellowing surface film is applied first. All modern-day retouchings are carried out on top

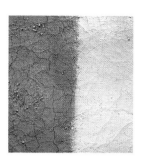

Detail of a cleaning line under a microscope, showing sixty years of dirt and grime on the left and an area cleaned with organic solvents on the right.

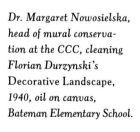

Dr. Margaret Nowosielska, head of mural conservation at the CCC, cleaning Florian Durzynski's Decorative Landscape, 1940, oil on canvas, Bateman Elementary School.

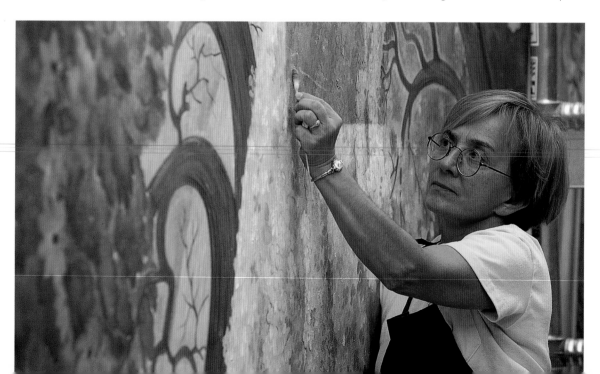

of the surface film. In this way, the conservator creates an ethical buffer between the original paint layer and compensating present-day additions.

Materials used to retouch art are both colorfast and lightfast, allowing the conservator to be confident that the work will hold its tone and value. This was not true for earlier restorers who used oil paint for retouching. Oil paint discolors as it ages, resulting in disfiguring effects to the surface. The conservator's surface coatings and retouching must be reversible in a mild solvent. This allows future generations to reverse any of today's work.

Mural conservation can be divided into two fundamental divisions: visual and structural repairs. Each presents a variety of challenges. Visual repairs require testing the paint surface using aqueous or organic solvents to determine whether or not it is safe to remove overlying discolored films. The conservator—who may conduct repairs on older European or other works—has to understand the techniques and styles of painters from the last fifteen hundred years. It is also necessary to understand the chemical composition of paint films and the solvents necessary to remove veiling varnish and dirt. This is the most critical part of any treatment. Some treatments require unique technical expertise. For example, the murals at Lucy Flower Career Academy High School required a cleaning method to remove both a calcimine layer as well as a layer of white oil paint that coated the delicate water-based fresco.

Structural repairs include consolidating loose paint layers and strengthening weakened canvas supports. On rare occasions, deteriorating Chicago Public School murals had to be removed and treated at the Center laboratory. The Phillips High School paintings, for instance, were removed from their wall location, treated at the Center, and reinstalled after all repairs were completed. Several Wentworth Elementary School murals were originally located in a fourth floor library, which has since been turned into a storage room. The paintings had to be removed, cleaned, restretched, and reinstalled in a public setting along the first-floor corridor of the school.

Each mural treatment has unique requirements and difficulties. Work at four locations is detailed here to illuminate the various issues that were addressed and the techniques used during the preservation process.

Lucy Flower Career Academy High School: The 1938–40 WPA/FAP fresco paintings at Lucy Flower Career Academy High School, by Edward Millman, presented a rare and unique conservation challenge.

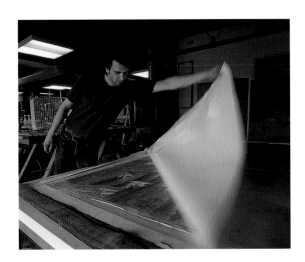

The mural was executed around an interior room. The total mural length was 54 feet wide by 9 feet high. The mural, as mentioned, was painted over with two paint layers. A white oil film was resting on top of a red calcimine layer. How could these layers be removed?

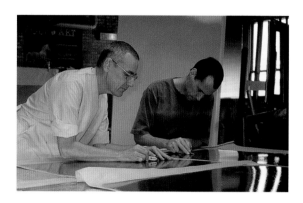

Robert Agne and Timothy Fox, conservators of the CCC, viewing a school mural's after-lining appearance.

Initial testing using normal organic solvents did not offer positive results: It took an excessive amount of time to remove the overpaint and this appeared to jeopardize the stability of the original paint layer. A series of tests then followed using a poultice paste of sodium hydroxide and magnesium hydroxide. The paste was applied to the surface and allowed to remain in place under varying lengths of time to determine optimum removal procedures. After a series of tests, it was determined a 60:40 mixture of these two compounds, remaining in contact with the wall for eighty-five minutes, produced the desired results. The top oil layer was softened to a point that allowed our conservators to successfully remove the paint using spatulas and palette knives. Remnants of the calcimine were removed fully using isopropyl alcohol. Areas no larger than 2 feet by 4 feet were treated at a time. Section by section, each area of the mural surfaced. Every day offered a new discovery. Numerous losses were present from posters, signs, and prints that had been nailed to the walls. These areas were filled with gesso (marble dust and rabbit-skin glue) and retouched to match the original in both value and hue with reversible colorfast and lightfast conservation pigments.

Few true frescoes remain in Chicago. The Lucy Flower paintings are perhaps some of the finest WPA/FAP frescoes in the United States. Their conservation offered a preservation challenge and a rewarding sense of success. Considerable media attention followed the discovery, including a front-page feature in the *Chicago Sun-Times*, May 19, 1997.

Tilton Elementary School: The three murals at Tilton presented a similar challenge. These paintings were painted over with a layer of lead-white paint. The murals were discovered rolled up in the school's basement by Heather Becker. The overpaint was carefully removed under binocular magnification. This

Pilgrims, Janet Laura Scott, 1911, oil on canvas, Tilton Elementary School. A CCC conservator removes the layers of overpaint using a scalpel.

delicate work was carried out without injury to the paint surface. During removal, the original signature of Janet Scott was discovered. Due to the paint layer's fragile condition, numerous areas of lifting paint had to be reset into place using a 1:10 gelatin adhesive. A layer of aged dirt and grime was removed using detergent solvents. The canvas supports were weak and brittle. To offer long-term stabilization, the paintings were reinforced to secondary canvases using a nonaqueous adhesive under controlled vacuum hot-table procedures at 1° of mercury. The paintings were then restretched onto custom-made auxiliary stretchers to precisely accommodate their arch-shaped format.

Several of the paintings showed large interior losses. These areas were filled with canvas inserts to reiterate the original canvas weave. Smaller losses were filled with marble dust and rabbit-skin glue. The paintings were then surface coated with nonyellowing varnish and losses were retouched using conservation pigments. All retouching was carried out on the isolating varnish. A final nonyellowing spray varnish completed the repairs. These paintings now assume their original appearance and are some of the oldest paintings in the city school collection.

Lane Technical High School: The John Walley 1936 WPA/FAP *Indian Fire Curtain* was a Lane Technical High School icon representing the school's logo. The image is positioned on the school's metal auditorium theater curtain. Walley is better known as an architect; this painting represents his only extant mural. The painting measures 20 feet high by 43 feet wide. In 1976, to celebrate the U.S. Bicentennial, an abstract painting in nine vertical sections was placed over the Walley mural. A weak wallpaper paste adhesive was used to attach the sections. Unfortunately, the canvas was primed in place using a titanium dioxide primer. The primer stained Walley's paint surface, causing a white, disfiguring dotted effect throughout. Due to the titanium component, the white stains were stubbornly resistant to removal. Mechanical tools and scalpels, coupled with alcohol-based solvents, were required to dislodge the primer. This work took almost a year to complete.

As a result of the curtain's inherent construction, scattered damage appeared along original seams and from former attempts to hang posters and signs. Vibrations from moving the theater curtain during performances and rehearsals also contributed to paint loss and instability. Weak areas of pigment were stabilized and losses were filled with Ren-Weld adhesive. This material is strong, hard, and can be easily sculpted. The fills were carefully retouched to

match using conservation pigments. The completed painting is now returned to "center stage." Numerous newspaper articles accompanied the treatment work, including a front-page feature in the *Chicago Tribune*, March 28, 1997.

Wendell Phillips High School: The Wendell Phillips High School murals presented a rare set of conservation problems. The school housed four murals, two on each side of an entrance stairwell. The 1906 murals were each painted by a different artist. The oil-on-canvas paintings were glued to plaster walls, which had deteriorated, causing cracking paint, chip losses, and curling supports. To save the paintings, it was necessary to remove them from their sites. The painted surfaces were first protected using Japanese tissue paper and a starch paste adhesive. Successful removal of the murals was carried out using mechanical tools.

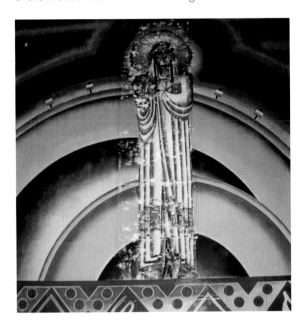

The paintings were then rolled onto protective tubes and transported to the Center laboratory. Wall plaster was adhered to the verso of each canvas. The paintings were placed face down and the encrustations were removed with paring knives and scalpels. The applied protective Japanese tissue paper was then removed.

A dirt and grime layer rested on a layer of discolored varnish. Both of these layers were masking the original color relationships in the paintings and flattening the three-dimensional quality of the scenes. The layers were removed using appropriate conservation solvents. The cleaning change was dramatic and the original compositions "reawakened." Lining the original canvas supports to Belgian linen using a nonaqueous adhesive strengthened the weakened canvases. The school was contemplating an architectural change to the site. To allow for the potential relocation of the paintings, they were restretched onto new redwood spring-stretchers. These stretchers

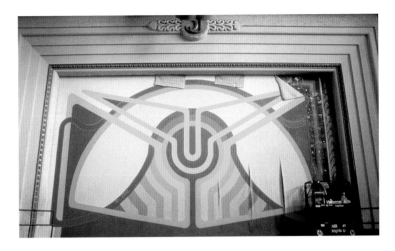

have the ability to expand and contract under varying humidity conditions, offering constant and even canvas tension. Small losses were filled with marble dust and rabbit-skin glue. A layer of nonyellowing varnish was applied and loss areas were retouched to match original paint value and hue using conservation pigments. A final nonyellowing spray varnish completed the repairs. The four paintings were reframed and reinstalled in their original location.

The Mural Preservation Project is the single most important endeavor I have undertaken in my career. While a painting conservator at the Art Institute of Chicago from 1972 to 1983, I met Flora Doody. At that time, she was working at the museum as a Board of Education Coordination Teacher. Flora went on to become a special-education teacher at Lane Technical High School and contacted me at the Chicago Conservation Center in 1994 to examine a large oil painting in the school's collection.

What began as an innocent examination of one painting unfolded into the nation's most extensive preservation program for Progressive and New Deal–era

Before, during, and after conservation, Native American Theme, John Edwin Walley, 1936, oil on curtain, Lane Technical High School.

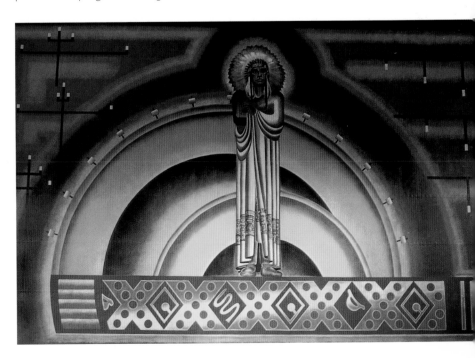

Facing page: American Youth (image 1), Florian Durzynski, 1937, oil on canvas, Wentworth Elementary School.

Native Americans Watching a Dance, *Dudley Craft Watson, 1906, oil on canvas, Wendell Phillips High School, during the lining process and after conservation.*

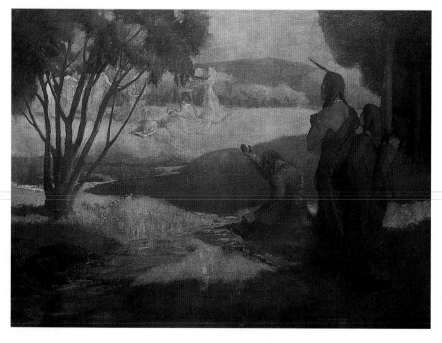

murals. The conservation project has allowed students to take a greater interest in their school's murals and to respect the significance of preservation. The Center's contributions have extended far beyond actual treatment work. It was important to allow the conservation efforts to be used as a teaching tool. Numerous seminars were offered at the Center facilities. This allowed students a rare opportunity to view many works of art in the process of restoration. On-location tutorials were also offered, permitting students direct contact with staff conservators as treatment unfolded. Two additional Center educational programs were established. Student interns were allowed to work at the Center laboratory, and the WPA-2000 Scholarship Fund was established to encourage excellence in education.[21] This fund awarded $10,000 in college scholarships to nine Lane Technical High School seniors for creative projects related to their collection.

The goals of the Mural Preservation Project were only surpassed by its success. It is hoped the program will continue into the future to welcome other schools and public buildings. The result will place Chicago as America's finest location for the pictorial study of Progressive-era and WPA/FAP murals. It has been a great honor for myself, and the Center staff, to be a part of this rewarding enrichment for the city of Chicago, its mural history, and all of the students who have been so positively affected by its benefits.—B. B.

The Mural: A Harbinger of Change

Through conservation's mixture of art, science, and history, the Chicago Public School mural collection has been made available for future generations to enjoy. The works of art featured in this book are the products of the vision and vocabulary of American artists before and during the Great Depression. It took over seventy years for these works to became the subject of great study, and now they are being welcomed into the classroom like a history textbook on American culture.

A people's experience has been found in the murals lining the walls of Chicago Public Schools. The murals speak for the masses during the early decades of the 1900s, representing their cultural, ideological, and political concerns. Despite the enormous suffering caused by the Depression, it was a time of extraordinary innovation and social consciousness. The mural images aimed to change the way Americans saw their world. This art illuminates the strengths and sometimes the weaknesses of modern life, affirming and glorifying a society's experiences. We are left not only to grapple with the meaning of this social art but also ultimately to question the social changes needed in our society today.

Changes in public education are inevitable and necessary to generate equitable outcomes for the children of future generations. The city of Chicago and the Chicago Public Schools should be commended for their efforts in this regard. Within the architecture and corridors of the Chicago Public Schools are public murals that can be viewed by children on their way to class every morning. Images from generations past are now preserved as part of their educational environment. Only with direct exposure to art can children comfortably absorb and experiment with art's immeasurable potential. This project has restored confidence in public education's use of art as an innovative and valuable form of child development. The Chicago Mural Preservation Project and its education initiatives are harbingers of positive change in public education.

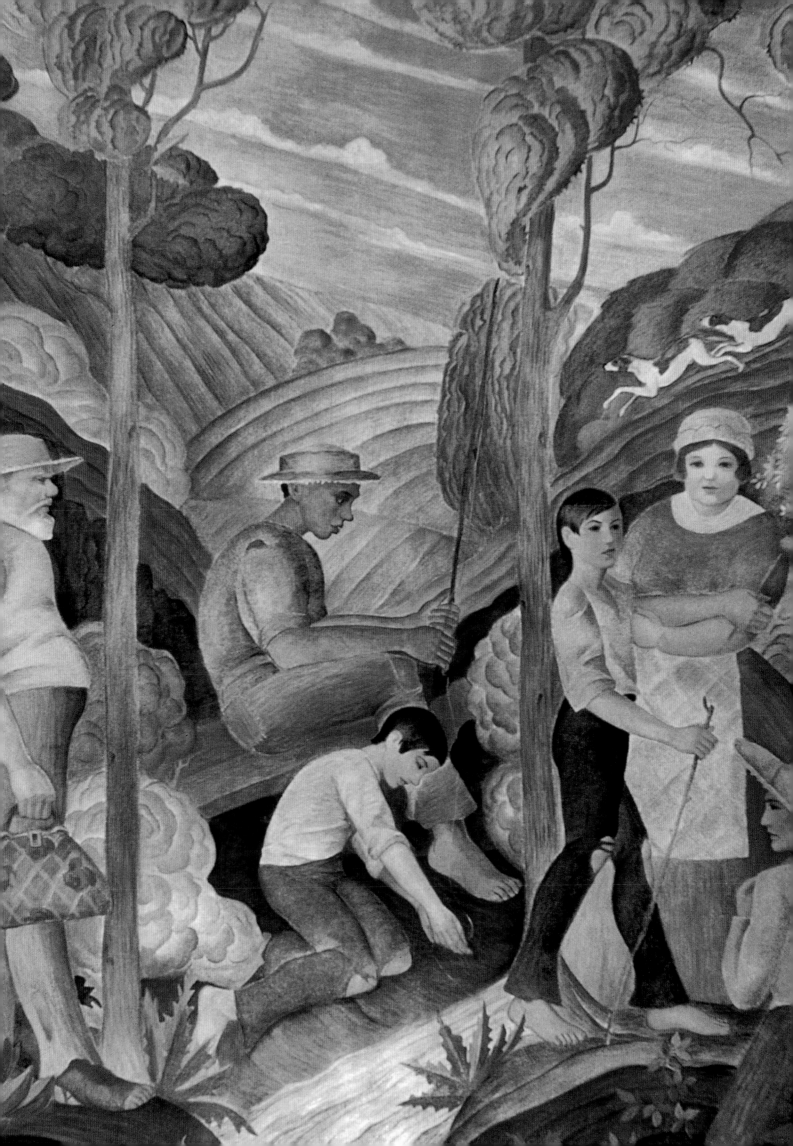

Preserving Public Art in Chicago

by Ed Paschke

Chicago has a very rich cultural legacy recorded in the Chicago Public School murals. Posterity owes a debt to the efforts being made to preserve them. The Mural Preservation Project creates a way to maintain continuity and integrity for the visual arts and history of Chicago. The city has had a long history of involvement with public art; the mural preservation and educational programs encourage a broad base of understanding, support, and sensitivity to the visual arts. The murals have historical aspects that create an even greater significance for these projects. I went through the public school system in Chicago, and my son went to Lane Tech, where many of these murals have been discovered and restored. This type of programming has a long-range effect with people over a long period of time. It enriches our lives in many ways, some of which are intangible.

Over the twenty years that I've taught art, my experience has been that people who take art courses usually are not art majors. They are rounding off the rough edges of a liberal arts education. The arts help to create a more complete human being. Whether you focus on the history of the murals

or break off into discussion groups with a specific focus, a saturating experience takes place. That type of experience leads to a higher level of sensitivity to one's visual environment.

One of the measurable things about art is its ability to create a record of the time in which it was produced, whether done in a specific illustrative sense, as with social murals, or by an artist acting as a filter of circumstances or environment. I was a student at the School of the Art Institute of Chicago; one of the major advantages of being a student there was the ability to go up into the galleries of the museum to experience these artworks first-hand. It is one thing to see a reproduction in a book or a slide in an art history class, but it is quite another experience to confront a real work of art. Humans have a certain physical scale. Experiencing the relationship between themselves and some of these large-scale public murals is a very important experience for young students. To see the original, to be in its presence, is priceless.

When I was in the Chicago Public School system, there were always pictures of George Washington and Abraham Lincoln in each class-

The Spirit of Chicago, Gustave Adolph Brand, 1939, oil on canvas, Carl Schurz High School.

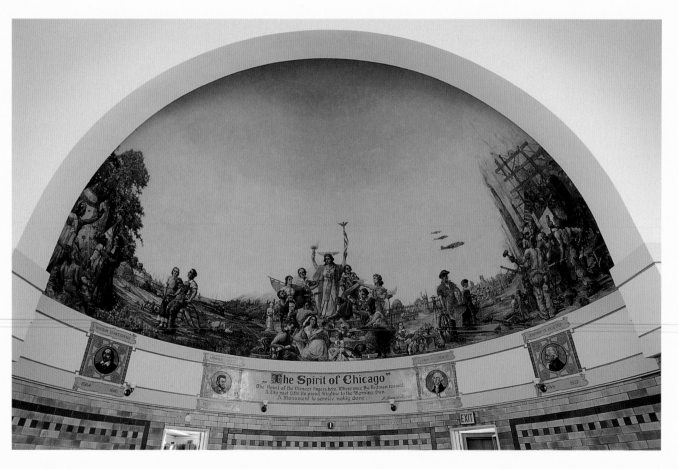

room. On many occasions, I have devoted specific pieces of my own art to the kind of iconic impression these pictures made on me. The impression of such images can be a conscious one or it can

The murals offer a window into the soul of the people who created these murals and the time in which they created them. They also act as a barometer of the period in which they were produced.

saturate your unconscious visual relationship with the world. One carries the effect of such imagery for the rest of one's life.

When budget time comes around, there are always two areas looked at in terms of where to make the first cuts. One of them tends to be sports and the other art. I think that both of these budget cuts are unfortunate because, as Plato or Aristotle so wisely said, to be a total and complete human being is to develop the physical, the mental, and the spiritual. That is what makes these unique preservation and educational efforts so important.

The issue of permanence is a very interesting one that has been challenged recently by artists who observe that we live in a society of planned obsolescence. Every product, every thing that we buy or consume has a built-in lifespan. I think one of the things about art, one of the motivations about making art, is the attempt to defy the mortality of life. There is this myth of immortality that we all carry around with us. Making art is like having children. It is something you produce that will hopefully outlive you. It is like a cultural relay race, in which you are passing on the DNA of this culture to the next. We have a built-in period of time in which we exist here. It used to be seventy-two years; it's probably around eighty now. Everybody will pass away, but art will live on. Therefore, preserving art, maintaining it in good condition, is a very important part of our cultural legacy.

We all have a curiosity about who we are and where we come from. How did we get this way? People ignorant of history are doomed to repeat it. The conservation efforts maintain a dialogue between past, present, and future. It is a comforting feeling for the artist to know that there are people around who specialize in preserving works of art. Some artists tend to do their work in a way that is blissfully unaware of precautions one must take to preserve art. Conservators exist to provide long-term care for works of art, thus the very important relationship between conservator and artist.

Some of the mural artists have historical significance as artists and others as recorders of the life in which they lived. I remember hearing a lot about the WPA/FAP when I was in school. During the Depression era, work was scarce and the WPA/FAP provided artists with an opportunity to continue to earn a living and to retain a measure of self-respect. Government patronage of the arts during the Depression is a model for future public art programs. Today, we only have one half of one percent to spend on art for each public building, whether inside or outside. This project acts as a continuation of the foresight and vision that our leaders began in the 1930s. It would be a shame if government patronage of the arts continues to dwindle. I hope the positive results of the Mural Preservation Project will inspire new agendas, programs, and patronage for the future of public art.

Contemporary Chicago, Rudolph Weisenborn, 1936, oil on canvas, Louis Nettelhorst Elementary School.

Progressive Era
1904 to 1933

Murals:

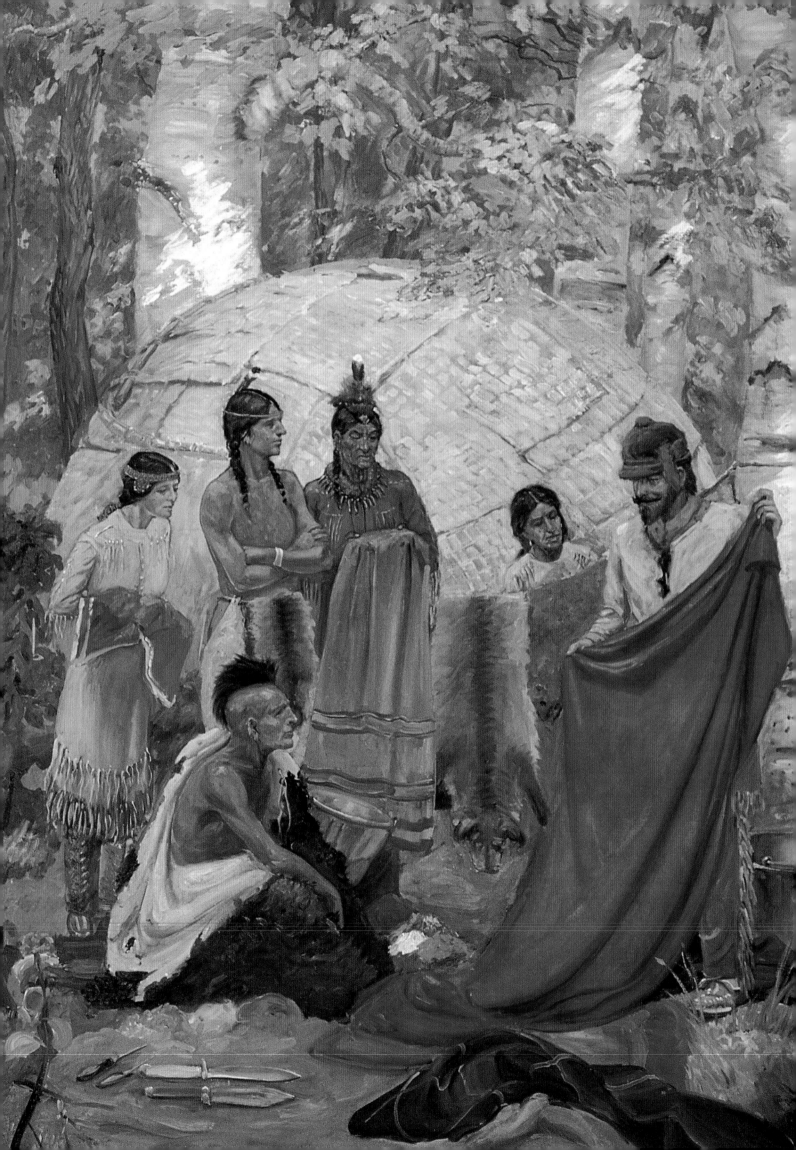

The Tradition of Murals in the United States: 1750 to 1933

by Heather Becker

By definition, a mural is a painting on a wall, making it a component of a shelter or structure that has a particular function in society, whether it is a cave, place of worship, home, factory, school, library, courthouse, or business. Mural painting is typically restricted by several conditions, including fixed spatial requirements, the purpose of architectural structure, and the appropriateness of subject matter for its audience. The muralist must consider all of these factors in the construction of his or her imagery. Easel painting is often an intimate endeavor for an artist, while mural painting consists of inherent social obligations that extend beyond the scope of the art community. If the mural is created for a public audience, the artist directs his or her efforts away from a purely personal vision to a broader form of communication that is often rooted in shared social beliefs.

To appreciate fully the significance of murals painted in the Chicago Public Schools from 1904 to 1933, it is necessary to place them in the context of the history of mural painting in the United States in general, and of the social and political values of the Progressive Era in particular.

The Mural in Colonial and Early America: 1750 to 1820

Murals dating from the seventeenth and eighteenth centuries in the United States have been described primarily as provincial, interior decoration for private homes.[1] The oldest attributed examples of wall painting in America are the Clark House in Boston and Marmion, a plantation in Stafford County, Virginia, built in 1674. The murals in these sites are often attributed to a Hessian soldier and date from the middle of the eighteenth century.[2] Among the earliest were those found in Portsmouth, New Hampshire, in the Warner House and others in Massachusetts, Vermont, Maine, and Connecticut, all created between 1782 and 1820. Michele Felicé (1752–1845) arrived

in America in 1799 and further helped establish early mural painting in the country.[3]

During the early nineteenth century, American artists produced few murals, in part because of their lack of training and commissions. Private residences were often decorated with pictorial wallpapers printed in France. The polymath Rufus Porter, during the 1820s, led a small group of limners from New England to Virginia who painted murals directly on living room walls for half the price of wallpaper and wrote the country's first manual on mural painting.[4]

Monumental Murals in the United States: 1820 to 1900

The first opportunity for American artists to create works in an important public building was a congressional commission for eight panels in the rotunda of the Capitol in Washington. Between 1819 and 1824 John Trumbull (1756–1843) painted four panels depicting Revolutionary War scenes: *Declaration of Independence, Surrender of General Burgoyne at Saratoga, Surrender of Lord Cornwallis at Yorktown,* and *General George Washington Resigning His Commission to Congress as Commander in Chief of the Army.* A second group of murals, depicting early moments in westward expansion, was painted between 1840 and 1855: John Vanderlyn (1775–1852) depicted the *Landing of Columbus;* William Powell (1823–79) painted the *Discovery of the Mississippi by De Soto;* John Chapman (1808–89/90) painted the *Baptism of Pocahontas;* and Robert Weir (1803–89) depicted the *Embarkation of the Pilgrims.* This tradition of painting murals in the Capitol was continued by Constantino Brumidi (1805–80), who came from Italy in 1849. From 1857 until his death, Brumidi produced many decorative and historical murals in the Senate corridors and rooms, as well as his masterpiece, the *Apotheosis of Washington* (1865), in the canopy of the large dome of the rotunda. Brumidi's paintings

Facing page: Historical Scenes *(image 4), James Edwin McBurney, 1926–28, oil on canvas, Wentworth Elementary.*

are considered to be the first major true frescoes, as opposed to works painted on dry plaster, in the country.[5]

Despite the many murals produced in France during the nineteenth century by such artists as Eugène

Apotheosis of George Washington, *Constantino Brumidi, 1865, fresco, Dome of the Rotunda of the U.S. Capitol, Washington, D.C.*

Delacroix (1798–1863), Théodore Chasseriau (1819–56), and Pierre Puvis de Chavannes (1824–98), mural painting was not a medium in which American painters were encouraged. Between 1878 and 1893 most murals were created as private commissions for houses, clubs, and hotels. Few public commissions were available.

The first major American mural movement, variously called the Academic, the American Renaissance, or the Beaux Arts, began in 1876 and lasted until about 1918. John La Farge (1835–1910) emerged as one of the most significant American mural painters in these years. His work stimulated a rise of interest in American mural making. In his designs for Trinity Church in Boston, and in many other churches, La Farge incorporated stylistic elements from progressive

French painting into religious murals. William Morris Hunt (1824–79) was another American artist who generated interest in murals. Hunt's allegorical murals in the State Capitol at Albany, New York, were daring and influential, but a new administration vetoed extending the project. Soon after, Hunt died, leaving a legacy unfulfilled. Financial panics caused a downturn in building activity, and mural commissions from government sources dwindled. Artists turned to the lucrative market in private decoration during the Gilded Age.[6]

It was not until 1893 that the World's Columbian Exposition in Chicago revived an interest for mural painting in America and the tide shifted to public commissions. The exposition fostered wide appreciation for mural art. The muralists chosen to create designs for the exposition buildings were J. Alden Weir, Edwin H. Blashfield, George W. Maynard, Robert Reid, C. S. Reinhart, Carol Beckwith, Walter McEwen, De Leftwich Dodge, Gari Melchers, and Kenyon Cox. All were novices except Maynard and Blashfield. Mary Cassatt and Mary MacMonnies also created murals for the Women's Building at the Chicago Exposition. The event offered the public unprecedented exposure to murals and art in general.[7] Even with the increasing amount of exposure, however, public mural making would not fully develop until the twentieth century.

The first group of American artists to promote mural painting was the National Society of Mural Painters, founded in New York in 1895. Founding members included John La Farge, Kenyon Cox, and Edwin Blashfield.[8] The society was inspired by the work of such French artists as Puvis de Chavannes and Paul Baudry (1828–86). The society's mission was to "establish and advance the standards of mural decoration in America; to promote cooperation among

Ascension of Our Lord, *John LaFarge, 1888, oil on canvas, Church of the Ascension, New York City.*

mural painters; to represent the interests of mural painters in major public issues; and to hold exhibitions and encourage sound education in mural decoration." The group worked successfully with the Architectural League and the Fine Arts Federation of New York to secure mural commissions throughout the nation.[9]

The accepted style was represented by the work of French artist Puvis de Chavannes. Among the most renowned public murals of this period are the panels he designed for the Boston Public Library. The artist executed them abroad, using his typical manner of stylized allegory and subtle palette. In contrast, John Singer Sargent, another artist commissioned to create murals for the library, took into consideration its architectural scheme while creating his mural designs. Sargent's murals are densely packed with figures representing mythological and religious thought as it unfolded from Egyptian and Assyrian times until the present. The Boston Public Library also has murals by Edwin Austin Abbey painted in an equally dense and decorative mode that illustrate the Arthurian legends.

Among the many mural painters of the time, the most notable at the turn of the nineteenth century were John La Farge, Edwin Blashfield (1848–1936) and Kenyon Cox (1856–1919). Their large compositions decorated many of the Beaux Arts–style state capitols of the period. Drawing on sources from the Italian Renaissance and contemporary French symbolist paintings, they worked closely with architects and government officials to define grand themes with historical allegories: Cox's *The Development of Civilization* at the Iowa State Capitol (1906), Blashfield's *Evolution of Civilization* at the Library of Congress (1897), and La Farge's *Episodes in the History of Law* (1904–5) at the Minnesota State Capitol are telling examples of how America was considered to be the inheritor of the greatness of the past.

Monumental Murals in the United States: 1900 to 1933

The early years of the twentieth century saw many academic murals painted in state capitols and courthouses around the country. There were also a small

number of modernist murals painted by artists such as Arthur B. Davies and Edward Steichen. Murals from this period often focused on mechanical inventions and their positive effects on industry and society. The murals for the Panama-Pacific International Exposition (PPIE) in San Francisco in 1915 demonstrated a move away from strictly academic allegory to a more down-to-earth manner of narrating the human condition. Like other world fairs, the PPIE promoted modern technology and industry and its murals helped visualize this theme.

During this period, modernism also began to have an influence on mural imagery in the U.S. Chicago artists began to form societies, clubs, and associations to promote their conservative or modernist objectives. Modernism was the subject of debate and dialogue among opposing art collectives, eventually gaining a stronghold in the Chicago art community. The Armory Show of 1913; the Independent Society of

Artists of 1916; the "Salon des Refusés" of 1921 (based on Napoléon III's original exhibition in 1863 Paris); and other jury-free exhibitions are a few of the events that helped assimilate modernism into the Chicago art scene during this period of change.[10]

After about 1918, business and advertising also began to have a strong influence on public murals. The patron's authority over content sometimes limited the subject matter muralists could use.[11] In the 1920s artists such as Eugene Savage (1883–1978), Ezra Winter (1886–1949), and Hildreth Meière (1892–1961) began to develop an art deco–style of mural painting

The Muses of Inspiration, Hail the Spirit, The Harbinger of Light, *Puvis de Chavannes, mural series in the stair hall, c. 1896, oil on canvas, the Boston Public Library.*

The Evolution of Civilization, Interior of the Dome, Reading Room, *Edwin Blashfield, 1895–96, oil on canvas, The Library of Congress, Washington, D.C.*

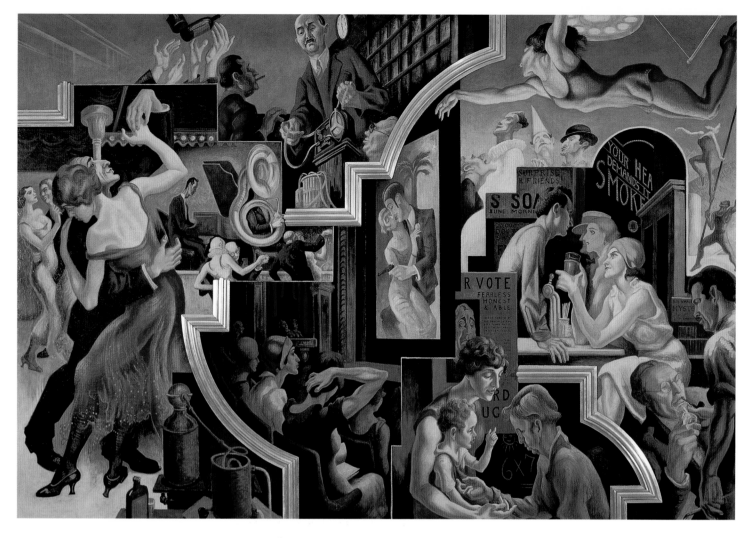

City Activities with
Dance Hall, *Thomas Hart
Benton, one of the big city
scenes from the original
north wall, 1930, distemper
and egg tempera with oil
glaze and gessoed linen,
the New School for Social
Research, New York.
©AXA Financial, Inc.*

that was more decorative than the first-generation
academics—and which can be seen in many painted
and low-relief sculptures at Rockefeller Center in
New York City.

By the late 1920s Thomas Hart Benton (1889–1975),
Boardman Robinson (1876–1952), and others began
to invent a modernist mural style. European cubism
had influenced Benton, but he chose to redesign

muralism into a medium with a strong American
identity, which came to be called Regionalism.[12] He,
along with John Steuart Curry (1897–1946) and
Grant Wood (1891–1942), focused on land and labor
in America and adopted a fundamentally realistic
style. Benton was by far the most active, and his walls
at the New School for Social Research (1930) and
the Whitney Museum of American Art (1932) were
typified by bright colors, diagonal movement, and
exaggerated figural forms and social types. He became
a champion of mural painting and American imagery
during the 1930s.[13]

A decade after the Mexican Revolution of 1910,
Mexican muralists had stunned the art world with their
revolutionary images. In the early 1920s, as a part of
President Alvaro Obregon's nationalist education
agenda, the Mexican Ministry of Education began
commissioning artists to create public murals. Three
of the primary muralists who quickly emerged,
Diego Rivera (1886–1957), José Clemente Orozco
(1883–1949), and David Alfaro Siqueiros (1898–1974),
became recognized as Los Tres Grandes, or "The
Three Giants." The Mexican artists used illustrations
of their cultural history to educate a primarily illiterate
audience. They also rendered the ideals of their
country's revolutionary leaders. Murals of this period

City Life, *Victor Arnautoff,
1934, fresco, Coit Tower,
San Francisco.*

helped to develop a strong relationship between the artist and the public. Mural art in Mexico became a collective sociopolitical art form; the movement's imagery, often termed social realism, was sympathetic to labor issues, social inequities, and cultural history.[14]

The Mexican mural movement therefore played an important role in the inception of Depression-era art. The Mexicans' work was highly influential when the U.S. government began funding mural production in 1933. By then, Rivera, Orozco, and Siqueiros had been featured in many exhibitions and had executed commissions in Mexico and the U.S. They also reintroduced the use of true fresco. Among other American artists, Chicago muralists Edward Millman, Mitchell Siporin, Edgar Britton, and Lucile Ward traveled to Mexico and studied the techniques being used there. In 1933 the U.S. government, aware of the Mexican example of government art patronage, followed Mexico's lead with New Deal policies that supported mural production on a massive scale across the country.

Between 1920 and 1930 the Mexican mural movement cultivated a symbolic language and iconography that addressed the working class public. Siqueiros stated in December 1923, "We praise monumental art in all its forms, because it is public property. We proclaim at this time of social change from a decrepit order to a new one, the creators of beauty must use their best efforts to produce ideological works for the people; art must no longer be the expression of individual satisfaction (which) it is today, but should aim to become a fighting educative art for all."[15] Rivera later stated, "Mexican muralism had for the first time in the history of monumental painting ceased to use

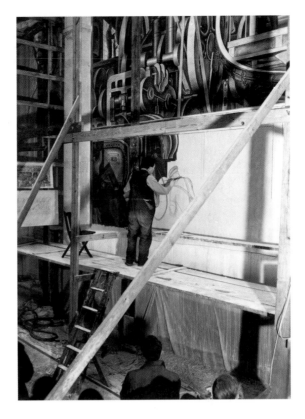

Detroit Industry, *south wall, Diego Rivera painting the frescoes, 1932–33, Detroit Institute of Arts.*

gods, kings, chiefs of state, heroic generals, etc. as central heroes . . . For the first time in the history of art, Mexican mural painting made the masses the hero of monumental art."[16]

The Mexican mural movement that flourished through the 1920s and early 1930s had a tremendous influence on American artists, exposing mural art's potential as a public forum. Artists in the U.S. began to use the medium to spread social consciousness and public concern.

Washington Crossing the Delaware, *Emanuel Gottlieb Leutze, 1851, oil on canvas, The Metropolitan Museum of Art.*

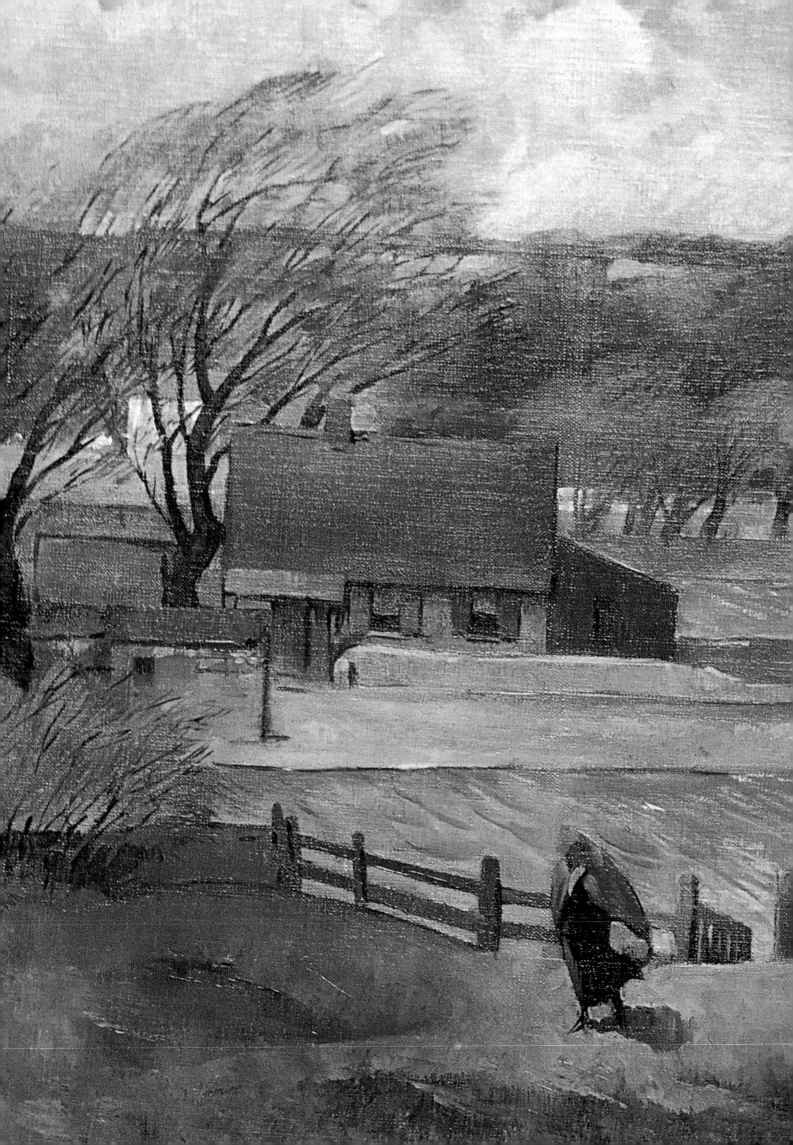

Mural Themes from the Progressive Era to the WPA Federal Art Project: 1904 to 1933 and After

by Francis V. O'Connor

It is important to recognize the historic origins of mural themes during the Progressive Era, in the years from the administration of Theodore Roosevelt through the New Deal of Franklin Roosevelt. These themes are evident in the Chicago Public School Mural Collection.

The Progressive Era[1]

In 1904, the year the first mural was painted in a Chicago public school, Theodore Roosevelt proclaimed during his presidential campaign a Square Deal for the American people. By that Roosevelt meant an administration dedicated to a number of policies concerning workers, women, the poor, the natural environment, and the country's role in the world. He had already initiated many of these, and his reelection by a wide margin gave him a mandate to continue in this vein through his second term. His policies, aimed in part at averting social unrest, came to define the goals of the so-called Progressive Era. These goals had their origins in the last decades of the nineteenth century, were highly controversial during the nearly eight years of Theodore Roosevelt's presidency, were neglected by his successor William Howard Taft, restored by Woodrow Wilson, and despite the establishment of a Progressive Party in 1924, were all but rescinded under the conservative Republican administrations of Warren Harding, Calvin Coolidge, and Herbert Hoover. With the onset of the Depression in October 1929, Hoover's stance during the first years of the 1930s against the government doing anything for the growing number of unemployed—who soon numbered over 8,000,000—reinvigorated progressive views. A new vision flourished during the extended tenure of the New Deal administration of Theodore Roosevelt's distant cousin, Franklin Delano Roosevelt.

The origins of progressivism go back to the rise of industrialism after the Civil War and its consequences for workers—many of them immigrants drawn into new business enterprises. New public issues arose over the situation of the poor in urban slums and the conditions under which workers—many of them women, children, and sometimes convicts—labored. This gave rise to the first labor unions, such as the Knights of Labor (founded 1869) and the American Federation of Labor led by Samuel Gompers (1881). The unions in turn prompted governmental industrial policies, notably the Sherman Antitrust Act (1890), which prevented any one company from monopolizing its industry, fixing prices and wages, and forcing competitors out of business.

The government's moves against the most blatant outrages of laissez-faire capitalism was accompanied by—and contributed to—the growth of a greater social consciousness in the late nineteenth century. The campaign for equal rights for women, begun in 1848, was ongoing in the suffragette movement. Jacob Riis's photographs and descriptions of conditions in the slums, published in his *How the Other Half Lives* (1890), challenged the conscience of an ever more affluent country. Social reformers and the settlement house movement, pioneered by Jane Addams at Hull-House in Chicago (1889) and Lillian Wald at the Henry Street Settlement in New York City (1893), helped the poor to deal with problems such as sweatshops, child labor, dangerous working conditions, long hours, starvation wages, and the denial of the right to unionize. Muckrakers such as Thorstein Veblen in his *Theory of the Leisure Class* (1899) and Lincoln Steffens in *The Shame of the Cities* (1904) further aroused awareness of intolerable attitudes and conditions, leading to principled government

Facing page: **The Months of the Year: March** *(one of eleven panels),* John Warner Norton, 1924–25, *oil on canvas, Peirce Elementary School.*

The Spirit of Vulcan,
Edwin Austin Abbey,
1908–10, oil on canvas,
lunette in the rotunda
of the Pennsylvania
State Capitol.

Steel Mill, Margaret
Hittle, 1909, oil on
canvas, Lane Technical
High School.

action. Similarly, the realism of such writers as William Dean Howells, Stephen Crane, Theodore Dreiser, Frank Norris, Upton Sinclair, Carl Sandburg, and Thomas Wolfe dramatized these themes in ways that were beyond the capacity of the visual arts.

Progressive Era Concerns as Reflected in Murals[2]

Mural painting flourished in the United States from the beginnings of the Progressive Era, and by the turn of the twentieth century artists were beginning to depict outstanding social issues on the walls of public buildings. Indeed, there had been a marked icono-graphic transition in murals at this time, from the neo-classical academicism of Edwin Blashfield that had held sway since the 1893 Chicago fair to the sensibil-ity of the Englishman, Frank Brangwyn, first seen at the Panama-Pacific Exposition in San Francisco in 1915.

Objective symbols gave way to subjective signs; the traditional image to individual metaphor; the artist as public instructor to artists who respected the viewer's intelligence. For the academic, the loss was history and tradition; for the modernist, the gain

was the clarity of personal expression rooted in transactions of feeling and experience only loosely connected to any collective idea.

Many murals of the time refer to the worker in various contexts, and to the industrialization of the country. They clearly indicate that these had become topics worthy of artistic expression.[3] None, however, can be classed as social realism as we have come to understand the term since the 1930s. They sel-dom protest what their authors obviously felt to be progress, nor the working conditions of those who contributed to that putative blessing. But this early, proto–social realism did, however, reflect the social reality that workers and the lower classes were all a growing fire in the country's moral and political awareness; a proud democracy could not countenance their exploitation.

Industrial Themes and Proto–Social Realism
The country's industrial might was widely recognized as the basis of its prosperity, and artists were open to celebrating this on the walls of public buildings.

Some good examples can be found in Edwin Austin Abbey's murals in the rotunda of the Pennsylvania State Capitol (1908–10).[4] Two of his four lunettes depict industrial themes and provide a good example of the transition from allegory to reality taking place in academic murals. The Spirit of Light is a quite remarkable conflation of oil derricks with an airborne bevy of female personifications of sparks. Opposite it is an evocation of the other major Pennsylvania industry, The Spirit of Vulcan, The Genius of the Workers in Iron and Steel, which shows a number of workers laboring at a forge, with an allegory of Vulcan hovering above them. At least three Chicago Public School murals depict versions of the forge of Vulcan theme (Lane [Hittle], Saucedo [Brand], and Tilden [Pollock, destroyed]).

Another important example of proto–social realism is Everett Shinn's The Roebling Steel Mills and the Mattock Kilns, painted for the Trenton, New Jersey, city hall—now state capitol—in 1911. It measures about 22 by 45 feet and presents the viewer with the

least idealized picture of the conditions of labor.[5] Depicting the manufacture of steel wire and pottery, both local products, Shinn's mural gives a hellish vision of factory interiors, with workers stripped to the waist and the melting pots and kilns blazing. Shinn's mural takes place in realistically depicted space and time and, as such, it is unique for its day—and for the artist. Yet, while showing work as it was, this mural was still open to being idealized. An anonymous article from the January 1911 issue of the *Craftsman* states that "Shinn . . . brought in [to the factories] with him, as all workmen do, a ray of sunshine and of happiness and permitted it to remain there . . . He tells of the joy of work and the joy of relaxation. He tells a story that is complete."[6] This rather belies the imagery on the wall but reflects the general attitude of the public toward the "happy worker," who along with the "happy darkie," had better be happy, if only to maintain the easy conscience of those who benefited from their grim labors.

By far the most monumental invocation of the idea of industry and labor can be found in John White Alexander's *The Crowning of Labor*, at the Carnegie Institute in Pittsburgh, Pennsylvania (1905–15). Alexander's murals literally give the female personifications a last flamboyant fling across the walls, dancing within clouds of steam and smoke generated by the numerous industrial scenes he painted round them. But their dominant subject, the worker celebrated by their personifications, places them here among early examples of proto–Social Realism.

The mural program begins in the Institute's low-ceilinged lobby on the first floor. There, fifteen horizontal panels placed over doors or at the top of the walls form a frieze of workers and furnaces. The great clouds of steam and smoke generated by the various industrial processes depicted rise up and are to be interpreted as gathering within the tall panels on the second floor.[7]

Symbolically (though not physically), the main wall of this gallery floor of the Institute's grand stairwell depicts beautifully painted women trumpeting the crowning of a male personification of Pittsburgh's steel industry. All too appropriately, he wears a suit of armor and becomes in the historical context a literal Knight of Labor whose long sword points downward to clouds of roiling, dark smoke representing impurities that billow from the refining processes below into the overdoor panel to his left, where their convolutions take the form of grotesque human demons. To his right are three panels filled with winged female figures representing tributes to the city such as Peace,

Prosperity, Luxuries, and Education. Similar allegorical figures fill the other three walls of the gallery, except for the alcoves to the sides. These contain dramatic depictions of buildings being erected with steel girders, along with railroads, boats, and blast furnaces. The narrowest, forming the sides of the alcoves, are filled with workers similar to those seen in the lower lobby—mostly silhouetted against smoke or sky. It is interesting that people hold a long rod that echoes the knight's sword in the coronation panel (see *The Crowning of Labor*, right).

Twelve panels filled with crowds of ordinary people realistically depicted, some of whom look directly out at the viewer, surround the well climbing the stairs to the third floor. This March of Progress was to lead a series of twenty-one panels on the third floor showing the fruits of labor: the arts and sciences represented in the work of the Carnegie Institute. These culminating panels were never executed because of Alexander's death.

Women's Issues

Although women would not win the right to vote until 1919, during the nineteenth century they had established their rights of inheritance, entered the professions, and made it plain that they could legitimately be considered the equal of men.

A number of muralists—all women—led by Mary Cassatt and Mary MacMonnies, had decorated the Women's Building at the 1893 Chicago fair. The successful career of Violet Oakley as a muralist is also notable. These events did not go unnoticed by male academic muralists and are implied in the many examples of female figures personifying abstract ideas. Compared to female personifications created about 1850—say by Brumidi and his atelier in the U.S. Capitol—these allegorical women have grown in stature, strength, and dominance (see *Allegories of Arts and Education*, above).

Allegories of Arts and Education *(image 2)*, Gustave Adolph Brand, 1916, oil on canvas, Saucedo Elementary Academy.

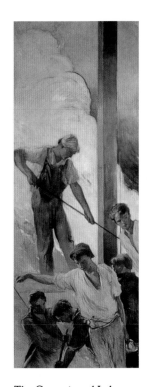

The Crowning of Labor: Apotheosis of Pittsburgh *(one of five panels)*, John White Alexander, *(1905–15)*, oil on canvas, Carnegie Museum of Art, Pittsburgh, Pennsylvania.

This can be seen in Frederick Deilman's *The Components of a Newspaper*, which consisted of seven lunettes in the lobby of the old Evening Star Building in Washington, D.C. (1900–1901).[8] These were arranged along the upper wall of the ground floor

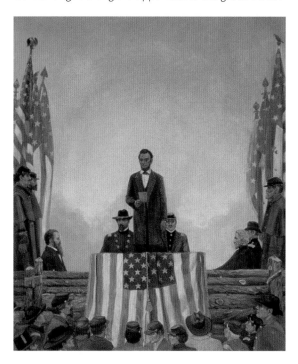

business office. The theme was the various activities of a city newspaper, and the subjects of the murals ranged from news gathering through the topics to be found in an urban paper, to the new technologies, such as steam, electricity, and the Linotype machine, which had revolutionized the printing process.

At first glance at the symmetrical compositions, each dominated by a female figure, these themes seem to be expressed by the usual academic allegories, as indeed the earlier of them are. The later murals, however, are more directly concerned with the application of technology to printing and presage things to come. This is especially true of the last, *Mechanical Development of Typography*, in which the central female figure is without overt attributes but stands in ordinary clothing, looking as if she is about to go to work with the typesetters and pressmen about her. Indeed, the artist might have derived this figure—the first female worker in American art—from a Riis photograph, and it reflects the influence of both the Progressive and Suffrage movements of the era.

Internationalism

Theodore Roosevelt's administration saw the need to counter the instinctive isolationism of the country with a greater reaching-out around the world. While we might today see this as a form of colonialism, it nevertheless indicated the first inklings of that globalism now the subject of such controversy. H. Lyman

Saÿen's four lunettes for the meeting room of the Committee on Insular Affairs in the House Wing of the U.S. Capitol in Washington, D.C. (1903–5), are a good example of Progressive Era policies reflected in art within the central legislature of the government.[9]

Although Saÿen is more noted as an early modernist, his four murals for the committee's chamber can be seen as an early attempt at international social realism. The murals on the sidewalls represent The Rule of Tyranny and The Rule of Justice; those on the end walls represent Primitive Agriculture and Good Government. They contrast the Spanish government of the Philippines with American rule, which was established on the islands as a result of the Spanish-American War in 1898, when Theodore Roosevelt was Secretary of the Navy.

Of far greater interest are Violet Oakley's murals in the Pennsylvania State Capitol.[10] She was first asked in 1905 to paint murals in the Governor's Reception Room in the new capitol on the theme of the Founding of the Colony of Pennsylvania. She did so with eighteen panels, which came to depict, after extensive research, the origins of that colony. Her *The Holy Experiment—The Founding of the State of Liberty Spiritual* portrayed the history of religious liberty in England, the rise of the Society of Friends, and William Penn's relationship to these events up to his voyage to America in 1682. The success of these murals led to a commission for others in the Senate chamber, completed in 1917 during Woodrow Wilson's administration. Oakley brought to her work a passionate belief in a moral and political universalism as humanity's best defense against war and oppression, a theme that was at the heart of Wilson's support for the League of Nations.

Other Progressive Era Themes

As we have seen, the murals of the time reflected contemporary concerns: industrialization and the worker, women's issues, and internationalism. But the proto–social realism in these works did not engage the grittier aspects of industrial monopolies' exploitation of the worker, the condition of the urban poor, and new related initiatives of land conservation and responsibility for the environment.

Progressive conservation initiatives were centered in the western states. The works of the naturalists John Burroughs, who wrote about the Adirondacks in New York and strongly influenced the thinking of Theodore Roosevelt, and John Muir, who wrote about California and promoted the establishment of national parks and forests, had enormous influence in making the general public aware of the environmental inter-

dependence of nature and society and the wisdom of conservation through government policy.[11]

One singular event, the Century of Progress World's Fair in Chicago (1933–34), provided the opportunity for muralists to elaborate on some Progressive Era themes.[12] Two murals stand out. In the Hall of Social Sciences, the National Council of Women commissioned the New York muralist and designer Hildreth Meière to paint *A Century of Woman's Progress through Organization*. This enormous work, some 60 feet long by 8 feet high, depicted distinguished American women from 1833 to 1933 who were engaged in the antislavery and equal suffrage movements, hospital service, and various professions. Among these were Elizabeth Cady Stanton, the first leader of the suffrage movement, Lucretia Mott and Lucy Stone, who were active abolitionists, Elizabeth Blackwell, the first female physician, and her sisters Antoinette and Emily, who founded hospitals for women in New York and Philadelphia, and professional women such as astronomer Maria Mitchell and author Julia Ward Howe. A grisaille frieze of women's activities that ran the length of the mural supplemented the main figures. This mural was the first to attempt to sum up the accomplishments of American women and no doubt influenced similar murals about women in Chicago Public Schools—such as those by Edward Millman at Lucy Flower Career Academy High School.

At the fair's mines and minerals exhibit, LaForce Baily created a major mural titled *Mineral Industries in Illinois* that showed a factory scene about 30 feet long by 6 feet high. This astonishing work clearly indicates the strong influence of Diego Rivera's *Detroit Industry* murals of the year before at the Detroit Institute of Arts. The abstract piling-up the factory environment and manufacturing processes below a high horizon line, the specificity of the ethnic origins of the workers, and the dramatic modeling of the figures were all characteristics of the Mexican style that would come to influence many other American muralists in years to come.

A number of other muralists at the fair worked on WPA/FAP projects. Among them was Edward Millman, who painted a mural depicting Labor in the fair's Agricultural Building. John Warner Norton did a series of murals in the Hall of Science that included a *Tree of Science; The Dimensions of Natural Objects in Miles; Wave Lengths*; and histories of technical and applied science. There were also several semi-abstract murals by William S. Schwartz and Davenport Griffen.

It took time for Progressive Era policies to be seen as a whole and as relevant to the entire country. The catalyst for a renewed awareness of social realities

American Scenes: Patriotism, *Hubert C. Ropp, c. 1920, oil on canvas, Parkside Community Academy Elementary School.*

was the Depression, which brought home to the entire country the often hidden afflictions of urban slums and rural mining towns. Between the start of the Depression in October 1929 and the inauguration of Franklin Roosevelt in March 1933, the entire country had become radicalized by rampant unemployment and the refusal of the Hoover administration to do anything effective about it. The four New Deal visual arts programs between 1933 to 1943 were thus far more open to depicting the full range of Progressive Era policies. This thematic evolution can be seen in many murals created for the Chicago Public Schools under the WPA Federal Art Project.

Progressive Era Concerns
as Reflected in New Deal Murals

New Deal social policies were focused on the immediate need to give nearly eight million people jobs on public works. Franklin D. Roosevelt had been in the Wilson administration as Assistant Secretary of the Navy and readily admitted his progressive convictions. He was squarely against conservative Republicans who all but destroyed the progressive agenda under Harding, Coolidge, and Hoover.

FDR's fundamental policy was outlined in his first inaugural address, when, with the defeated Herbert Hoover sitting a few feet away, and with a forceful rhetoric not heard since Theodore Roosevelt, he declared that "the only thing we have to fear is fear itself." He noted, "Plenty is at our doorstep, but a generous use of it languishes in the very sight of the supply" because the rulers of the exchange of mankind's goods assent to "a conduct in banking and in business which too often has given to a sacred trust the likeness of callous and selfish wrongdoing." He concluded that "the people have asked for discipline and direction under leadership [and] have made me the present instrument of their wishes. In the spirit of the gift I take it."

Under the leadership of the New Deal, the arts came into play as an offshoot of the general need to give people employment. The Public Works of Art Project (PWAP, 1933–34) got things started. Later the Treasury Section of Painting and Sculpture (Section, 1934–43) distributed art jobs on a commission basis and the WPA Federal Art Project distributed art jobs on the basis of need. As these projects developed, and as a national cadre of muralists began to work in public buildings, many of the themes they chose were those of the Progressive Era, where they had first been formulated and implemented.

Consider just a few examples of New Deal murals around the country that reflect Progressive themes for comparison with the rich collection of WPA/FAP walls to be found in Chicago Public Schools.[13] Industry and Technology is the theme of Arshile Gorky's series of ten semi-abstract murals (WPA/FAP, 1935–37) at the New Airport in New Jersey. This theme also appears in William Gropper's *Automobile Industry* murals (Section, 1941) in the Northwestern Branch Post Office in Detroit. The issue of social welfare is implicit in Marion Greenwood's mural *Blueprint for Living* (WPA/FAP, 1940) in the lobby of the Community Center at the Red Hook Housing Project in Brooklyn, New York, which was planned by the government. Workers appear in a large number of WAP/FAP and Section murals and are perhaps best exemplified in Edward Laning's series of eight murals, *The Role of the Immigrant in the Industrial Development of America* (WPA/FAP, 1937) in the Aliens' Dining Room,

The History of Ancient Writing (image 4), Harry Gage, c. 1920s, oil on canvas, Jahn Elementary School.

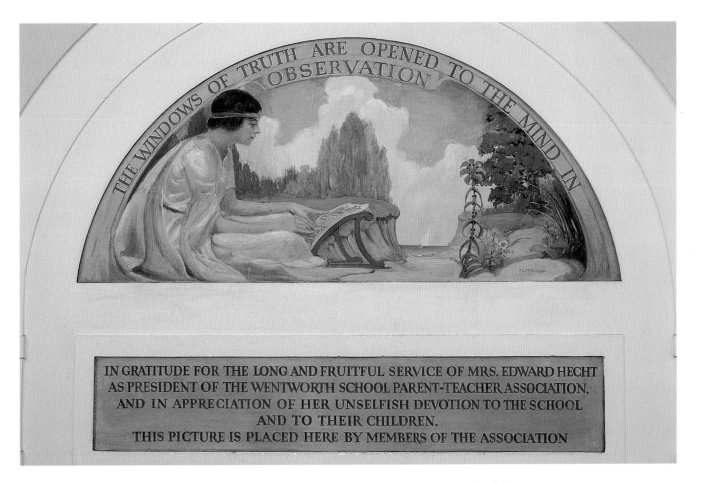

IN GRATITUDE FOR THE LONG AND FRUITFUL SERVICE OF MRS. EDWARD HECHT
AS PRESIDENT OF THE WENTWORTH SCHOOL PARENT-TEACHER ASSOCIATION,
AND IN APPRECIATION OF HER UNSELFISH DEVOTION TO THE SCHOOL
AND TO THEIR CHILDREN,
THIS PICTURE IS PLACED HERE BY MEMBERS OF THE ASSOCIATION

Ellis Island, New York, and by Philip Guston's monumental theme mural (1939) on the façade of the WPA Building at the 1939–40 New York World's Fair, which depicts a group of laborers and professional workers. Women's issues dominate Lucienne Bloch's *Cycle of a Woman's Life* (WPA/FAP, 1936) in the recreation room of the Women's House of Detention in New York City and are implicit in Harry Sternberg's *The Family–Industry and Agriculture* (Section, 1939) and in many other murals that use the family as a centerpiece. Also relevant is the striking mural in the Department of Justice by J. Symeon Shimin on the theme *Contemporary Justice—the Child* (Section, 1940). Conservation was popular all over the country, as the Section murals by Lee Allen, *Conservation of Wild Life,* in the Emmetsville, Iowa, post office (1940); Hollis Holbrook, *Reforestation* (1940) in the Haleyville, Alabama, post office; and William Gropper's *Building the Dam* (1939) in the Interior Department in Washington, D.C., testify. Internationalism is reflected in Earl Lonsbury's *Over There* (c. 1936), which depicts a troop ship leaving for Europe in World War I and is part of his *History of the 165th Regiment in American Wars* in the Regiment's Armory in New York City. Even Progressivism itself can be found in two Section competition sketches by Ben Shahn, for an unexecuted town hall mural depicting the La Follettes (Senior and Junior) and the growth of the liberal political movement in Wisconsin (1937).[14] The murals in the Chicago Public Schools reflected Progressive Era themes, and these themes continued to be the subject of New Deal murals.

Historical Scenes (image 27), James Edwin McBurney, 1926–28, oil on canvas, Wentworth Elementary School.

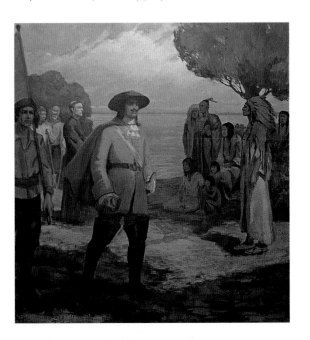

French Explorers LaSalle and Marquette, Beatrice Braidwood, 1910, oil on canvas, Smyth Elementary School.

CHAPTER 6

Progressive Era Murals in the Chicago Public Schools, 1904 to 1933

by Richard Murray, senior curator, Smithsonian Institution

Between 1904 and 1933 many Chicago muralists were members of local art organizations, such as the Illinois Academy of Fine Arts, the Palette and Chisel Club, and the Chicago Society of Artists'; association with these groups helped define styles and determine commissions. The Mural Research Project documents approximately 229 Progressive Era murals in Chicago Public Schools painted primarily by graduates of the School of the Art Institute of Chicago. They include William Edouard Scott, Lucile Ward, Gordon Stevenson, Ethel Spears, Margaret Hittle, Irene Bianucci, Gustaf Dalstrom, Thomas Jefferson League, Edward Millman, Ralph Henricksen, and Mitchell Siporin. Many of these artists later worked for the WPA/FAP.—H. B.

Chicago holds a special place in the history of mural painting during the Gilded Age (1870s–80s) and Progressive Era (1890s–1920s). The World's Columbian Exposition, held in the city in 1893, was the birthplace of a mural movement that swept through the nation until about 1920. The movement embraced a kind of civic religion that valued Progressive ideals: improving social and cultural conditions, labor as the underpinning of progress, and a usable history for a nation of recent immigrants. These themes were often used in Chicago's school murals during the Progressive Era.

Artists from New York dominated the national mural movement. Their professional and political connections brought them commissions in state capitols, courthouses, libraries, and schools from New York to California. Few Chicago mural painters worked on these projects, and few eastern mural painters painted murals in Chicago after the Columbian Exposition. Chicago soon developed its own school of mural painters, and kept them very busy. The names Frederick Bartlett, Edgar Cameron, Lawrence Earle, Oliver Grover, Albert Krehbiel, John Warner Norton, Allen Philbrick, and Newton Wells may not be as quickly

recognized among the national leaders of the mural movement—such as John La Farge, Edwin Blashfield, or Kenyon Cox—but they created some of the most beautiful murals in the nation, and their work inspired the plan for murals in Chicago Public Schools.

Within the national movement, murals in state capitols, country courts, and municipal buildings gained the most attention. Minnesota's gleaming Beaux-Arts capitol, designed by Cass Gilbert, featured magnificent, large murals by John La Farge, Kenyon Cox, Edward Simmons, and Edwin Blashfield, among others. Murals decorated state capitols in New York, Pennsylvania, Rhode Island, Iowa, Illinois, Michigan, Wisconsin, Kentucky, Arkansas, Missouri, Utah, South Dakota, Montana, and California. John Singer Sargent and Edwin Austin Abbey created murals for the Boston Public Library. In the Library of Congress, mural paintings by leading artists brought broad public attention to the movement. Because of its murals and sculptures, the Library of Congress became known as "Our National Monument to Art."[2]

The interiors of urban schoolrooms before the Progressive Era were bleak by comparison. A flag might add a spot of color, and one might find an engraving after a portrait of George Washington or Abraham Lincoln. Walls were generally a "ghastly grayish white, which imparted to the rooms an indescribably cheerless appearance," in the words of Winifred Buck.[3] This would begin to change during the late nineteenth century. Already in 1871 a corridor of the Girls' High School in Boston was decorated with engravings or photographs; about a decade later the Boston School Committee began a program to decorate the rooms with reproductions of famous pictures.[4] By the turn of the century, school decoration became a priority for politicians and school officials. Urban centers crowded with immigrant children required new school construction, and decorative schemes were planned. Chicago's park districts also created decorative projects

Medieval Scenes: King Arthur Meeteth Ye Lady Gweneviere, *Norman P. Hall, 1904, oil on canvas, Wentworth Elementary School.*

Abraham Lincoln Meeting
Frederick Douglass,
*William Edouard Scott,
c. 1920s, oil on canvas,
Shoop Academy of Math,
Science and Technology
Elementary School.*

for students to appreciate, which were placed in field houses designed with a mixture of Prairie School and Arts and Crafts styles.[5] Schoolroom decoration became a goal of some civic groups, such as the Art Committee of the Public Education Association in New York, a women's organization that raised funds to place photographs and casts of famous sculptures in schools. The committee organized the history of art into subjects according to student grade levels and suggested that certain works of art hang on walls facing students, while others hang facing teachers.[6]

Several large cities—New York, Indianapolis, Chicago, Minneapolis, and Cincinnati—created programs for murals in their schools. But they carried them out in different ways. In New York, the Municipal Art Society arranged most mural projects for the schools. The society began in 1893 as a city-beautiful organization inspired by Chicago's Columbian Exposition. The fair's architecture—its famous White City—became a model for numerous Progressive Era social and cultural organizations. The Municipal Art Society considered school murals an ideal means of instilling American history and cultural values. Allegorical paintings were not part of the society's mural program, for it wanted "textbooks in paint" for

the "vast armies of children [who] would go out into the world with tastes formed on correct lines and high ideals," according to one officer of the society.[7] All mural commissions were reviewed by the Art Commission of the City of New York, which made sure that well-known artists painted the compositions and executed them in an illustrative mode, rather than a modernist style.

Indianapolis enjoyed a much less systematic—and political—method of placing murals in public schools. Artists designed and painted murals for the cost of materials or for free. The movement began in the years 1914–15 as an artists' project to decorate the halls and rooms of the new Indianapolis Public Hospital. The group of sixteen artists included women and African American artist William Edouard Scott, who had also painted murals in Chicago schools. After the hospital project, these artists went on to paint murals in sixteen schools.[8] In Minneapolis, David Tice Workman decorated several schools with murals, but most schools hung photographs of contemporary mural paintings or historical art.[9] St. Louis and Cincinnati, too, organized programs under the auspices of the school board and arts groups of the cities.

The impulse behind school decoration in Chicago stemmed from the same concerns as in New York—Americanizing large numbers of immigrant children entering the school system and the culture at large. Chicago's population in 1890 was approximately one million people; the influx of immigrants doubled the number by 1910. To deal with a teeming population of children, the Playground Association of America, founded in 1906 in Washington, D.C., with Jacob Riis as vice president and with the support of Theodore Roosevelt, formed and held its first convention in Chicago in 1907. Its agenda was simple: to provide spaces and activities for children crowded into stifling, cramped tenements. Chicago's park system, especially South Park, or the "ghetto," was high on the list of urban spaces targeted for improvements. Eventually, park commissioners provided murals for numerous field houses constructed as spaces for immigrants to take classes, play sports, and bathe. A mural at Davis Field House shows how closely the Playground Association, the Park System, and artists worked together to produce a common theme.[10] William Edouard Scott's mural depicts boys on the left engaged in sports, while on the right girls in the costumes of their native countries perform a pageant of sorts, each carrying food or an object from their native culture. In the center young women represent the arts; one holds a palette, another a

Children's Fairy Tales,
*attributed to Roberta Elvis,
c. 1930s, oil on canvas,
Gary Elementary School.*

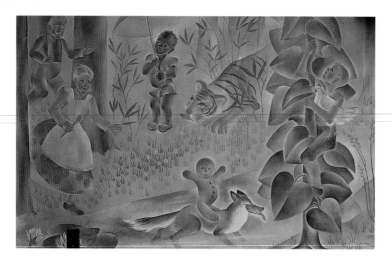

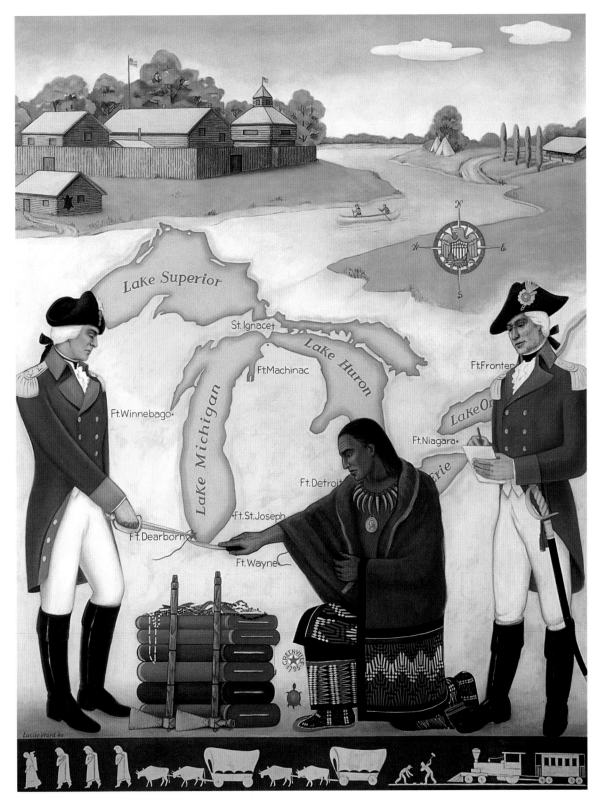

History of Chicago: Fort Dearborn *(image 2), Lucile Ward, 1940, oil on canvas, Sawyer Elementary School.*

book of literature, as they stand at the feet of a figure representing America who holds the light of learning and a wreath of victory. A motto of the Playground Association, "Constructive Recreation, and the Vital Force in Character Building," is written across the sky.

In 1907 the Art Institute of Chicago invited all art teachers in the state, from the kindergarten level to the State Normal School (founded in 1895 as the state teachers' college; it is now Eastern Illinois State University) level, to a meeting to consider ways to improve the quality of art produced by their students.

The objective, according to organizers of the meeting, was to "get more beauty in manual art products and more graphic art that is useful."[11]

As an instructor at the Art Institute, Thomas Wood Stevens responded to the call for improved training and quality of work with an idea that was both practical and politically astute. Knowing that a national mural movement was under way, and that few young artists had any experience in this special art form, he created a mural painting class at the School of the Art Institute. The training ground was

Landscape Scene *(image 1)*, *Robert Wadsworth Grafton, 1926, oil on canvas, Lafayette Specialty Elementary School.*

to be public schools in the city. His first class was held in the 1907–8 academic year; courses continued under his instruction until 1914. John Warner Norton then taught the class until 1929. Stevens echoed the park commissioners' political aims for the public school murals when he stated, "These hundreds of children must grope their way into American traditions, for the old world traditions of their fathers and mothers do not long hold out against the hard attrition of the American city. The children find in the paintings some hint of this America in the making."[12]

After gaining some experience, Stevens' art students at the School of the Art Institute of Chicago began painting murals for the many Chicago schools that requested them. Their methods followed standard

students, their projects, and methods in newspapers.[13] Funds for materials were obtained from the schools, or the Public School Art Society, presided over by Katherine Buckingham, formed to promote the production of murals and organization of lectures on art for the schools.[14]

Stevens launched a program that was distinguished by its extraordinary energy and creativity. Art students competed for places in the class; by 1913 they had painted some ninety panels for schools in Chicago and had extended the scope of activities to schools in Highland Park and Evanston. When Stevens left the School of the Art Institute of Chicago in 1913, John Warner Norton carried the project into more schools and field houses.[15] As school systems in the Midwest learned of the program, they, too, requested murals. Public schools in Hammond, Indiana; Grand Rapids, Michigan; and Appleton, Wisconsin, acquired murals by Art Institute students. Chicago, noted one Boston newspaper, had become a "mural painting center."[16]

Stevens and Norton wanted attractive, easily understood history. "Frankly," said Stevens, "we have encouraged the adaptation of subject pictures to decoration . . . the student [artist] concerns himself little with matters of archaeology and research and devotes himself to the composition and painting."[17] The Art Institute classes were remarkably egalitarian: Women and men were represented about equally, and the African American artist William Edouard Scott was among the more active, in Chicago and later

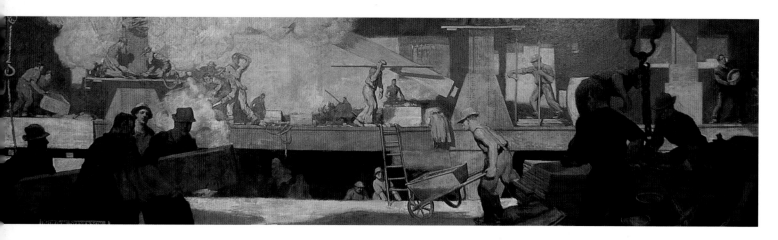

Construction Site, *Gordon Stevenson, 1909, oil on canvas, Lane Technical High School.*

practice stemming from nineteenth-century mural painting on canvas. An initial sketch for the entire composition was followed by studies for individual figures. These were brought together in a "cartoon," or a larger drawing for the entire composition, which was squared off, and then enlarged, or "scaled up," to the dimensions of the wall. The mural was painted in the studio and transported to the site, where it was fixed on the wall with glue or a mixture of varnish and white lead. Chicagoans could read about the art

in Indianapolis. Stevens and Norton were proud to show the murals to visiting eastern mural artists who came to Chicago to deliver the Scammon Lectures at the Art Institute, among them John La Farge, Kenyon Cox, Edwin Blashfield, and Will Low.

The subjects of the murals fall into general themes that were useful to schools. Literature, of course, was a prominent theme. The murals that George Brandt painted in 1913 for Lane Technical High School enlivened the words of Longfellow's *Song*

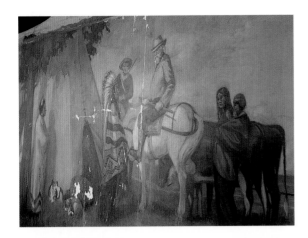

at the Shoop School, William Edouard Scott in about 1930 depicted Lincoln meeting Frederick Douglass. Murals depicting episodes of discovery were especially popular. At the John Smyth School, one of the earliest mural programs included Gordon Stevenson's 1910 rendition of a group of fancy-dressed English women and men landing at Jamestown, Virginia.

Others included Frank Makowski's image of Father Jacques Marquette (1637–75) encountering Native Americans, George Weisenberg's image of Sieur de La Salle (René-Robert Cavelier, 1643–87) meeting with native peoples, and Paul Sargent's image of George Rogers Clark (1752–1818) on his 1778 expedition of Kaskaskia and Cahokia, two Mississippi River settlements in present-day Illinois.[18] One of the strangest of these "encounter" scenes was Datus E. Myers's 1910 painting at Carl Von Linné School. Settlers with covered wagons and oxen have stopped at a teepee settlement to ask directions. The scene is carefully painted to suggest a moment of stillness. At the far right, with some curiosity, an Indian woman with her infant observes the approaching whites. At the far left, a white woman and baby wander among the Indian women, as though lost or confused. At the Gary School, Philip Sawyer painted three grand murals

of Hiawatha and presented students with an interpretation of Native American culture. From children's literature, characters such as *Puss n' Boots* and *Old King Cole* came to life. Landscapes depicting the American West, foreign to Chicago's urban students, filled the walls at Lafayette School. Celebration of the modern world took several forms. At Lane Technical High School subjects related to industrial production in steel mills (Margaret Hittle's *Steel Mill,* 1909), building a skyscraper (Gordon Stevenson's *Construction Site,* 1909), and the shipping of industrial products to and from the docks of Chicago (William Edouard Scott's *Commerce,* 1909). These images of the modern city were countered by eight panels depicting primitive industry painted for the assembly hall (these are no longer extant).

At Armstrong School, Frank Peyraud commemorated World War I in a view of a war-torn cathedral and city in rubble. A lone horseman, like a knight, rides away from the devastation, a reference to the noble contributions of Americans. Flanking the scene and the legend, "Past, Present, Future; We are American," are names of students who served in the war. Countering the remarkable fire-lit sky and purple, smoking ruins is a landscape of a summer farm field, an image of a peaceful and plentiful America untouched by invasion.

Historical scenes enlivened dull lessons by helping children envision the past. At Mount Vernon School, George Washington and Abraham Lincoln were represented in images modeled after well-known portraits. At the John Smyth School, Washington and his troops at Alexandria are seen in a 1910 mural;

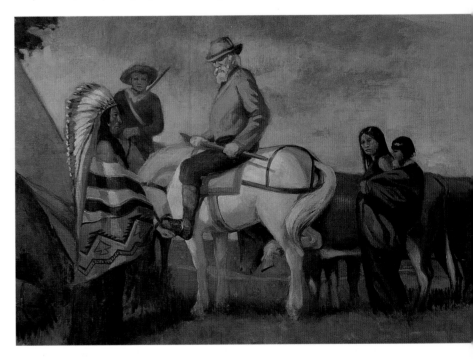

in 1915. At the right is a small settler village set peacefully next to Indian teepees (nice touch, but not quite historically correct); at the center, historical figures gather around an altar of progress, where Columbia, assisted by a young girl, shines her light on figures representing the arts and sciences; at the left, workers are busy at industry and farming.

Scenes of historical encounters emphasized a fundamental purpose of the Chicago schools. Although

these murals re-created a version of the past for children who had little knowledge or understanding of U.S. history, their subject was the meeting of different cultures, played out peacefully, as school administrators hoped would occur in the classroom among students of different cultures. These were idealized history paintings made into allegories for the present.

Among the most interesting artists to work on the school murals was African American artist William Edouard Scott (1884–1964). In addition to the murals mentioned above, he painted murals with encounter themes, such as *Landing of the Northmen* (1909) for the Felsenthal School, and on literary themes, as in *Canterbury Pilgrims* (1908) for the Highland Park School. Scott then went to Paris, like his counterpart William H. Johnson in New York, to study with Henry Ossawa Tanner. Scott remained in Paris from 1909 until 1914, and after his return he painted additional murals in Chicago and Indianapolis. Scott had a long and successful career, nurtured in part by comrades who worked with him on the public school projects in Chicago. According to the biographer William Taylor, Scott completed some thirty murals for schools and field houses in the Chicago park district and forty murals for Chicago-area churches during his career.[19]

John Warner Norton continued the school mural program at the Art Institute of Chicago, but few murals were painted after World War I. The national mural movement became less didactic and reflective of Progressive Era ideals, focusing on a more decorative and ornamental style. The large murals by Ezra Winter for the Cunard Building in New York, with their emphasis on pattern and decorative surface, exemplify this new approach.[20] Chicago artists, too, adopted this flat, linear, and colorful style, exemplified by John Warner Norton's work at the Chicago Stock Exchange, private clubs, and the library at Loyola University. The annual circulars for courses at the Art Institute of Chicago listed the schools that had been decorated, but beginning with the 1920–21 academic year, no schools are listed. Norton himself painted a delightful set of movable mural panels in 1924–25 for the Peirce School—they depicted activities for the months of the year—but during the 1920s he concentrated on private commissions such as his masterpiece for the Chicago Daily News Building concourse, *Gathering the News, Printing the News, and Distributing the News* (1929).

Norton stated, "In a structure dedicated to a modern newspaper, it was unthinkable to use the old conventions." Instead he drew from modernist art, including various cubist and futurist devices to depict the newspaper's activity.[21] One reviewer likened the mural to a kaleidoscope of the "rhythmic teamwork of man and machine" at a newspaper that has "shrunk the globe into one neighborhood."[22] As a "real allegory," Norton's work was an analogue to the activity directly above the mural, where the news was gathered, edited, and broadcast on station WMAQ, while rumbling trucks and trains below the mural distributed the *Chicago Daily News.* At one end of the space, facing the mural and throngs from commuter trains moving through the concourse, the front page of the latest edition flashed on a huge metal screen. Norton had shifted attention from the hundreds of immigrant children in Chicago Public Schools to the faceless crowd churning through vast spaces that did not teach but simply informed. The mural is now in storage, while the public awaits its hoped-for preservation and public installation.

As the Progressive Era drew to a close, Norton and other Chicago muralists found private commissions to sustain them. But the New Deal–era mural movement, which added hundreds of murals to the Chicago Public Schools, quickly bolstered the strong tradition of murals in public schools.

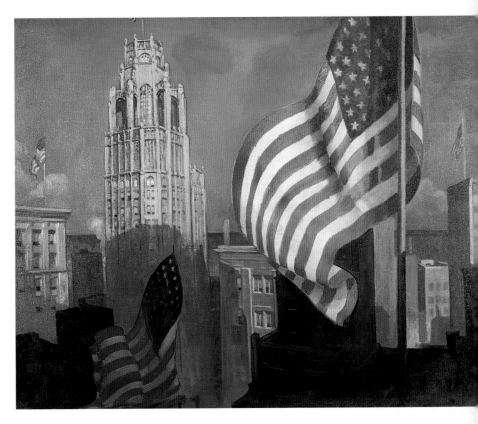

The Months of the Year: July, John Warner Norton, 1924–25, oil on canvas, Peirce Elementary School.

Portrait of William Edouard Scott, c. 1920s.

Facing page: The Chicago Daily News, *John Warner Norton, 1929, concourse of the Chicago Daily News building. This mural is currently in storage; it is hoped that it will be restored and exhibited again as a unique example of Chicago's mural heritage.*

WPA Federal
Murals: 1933 to

Art Project

943

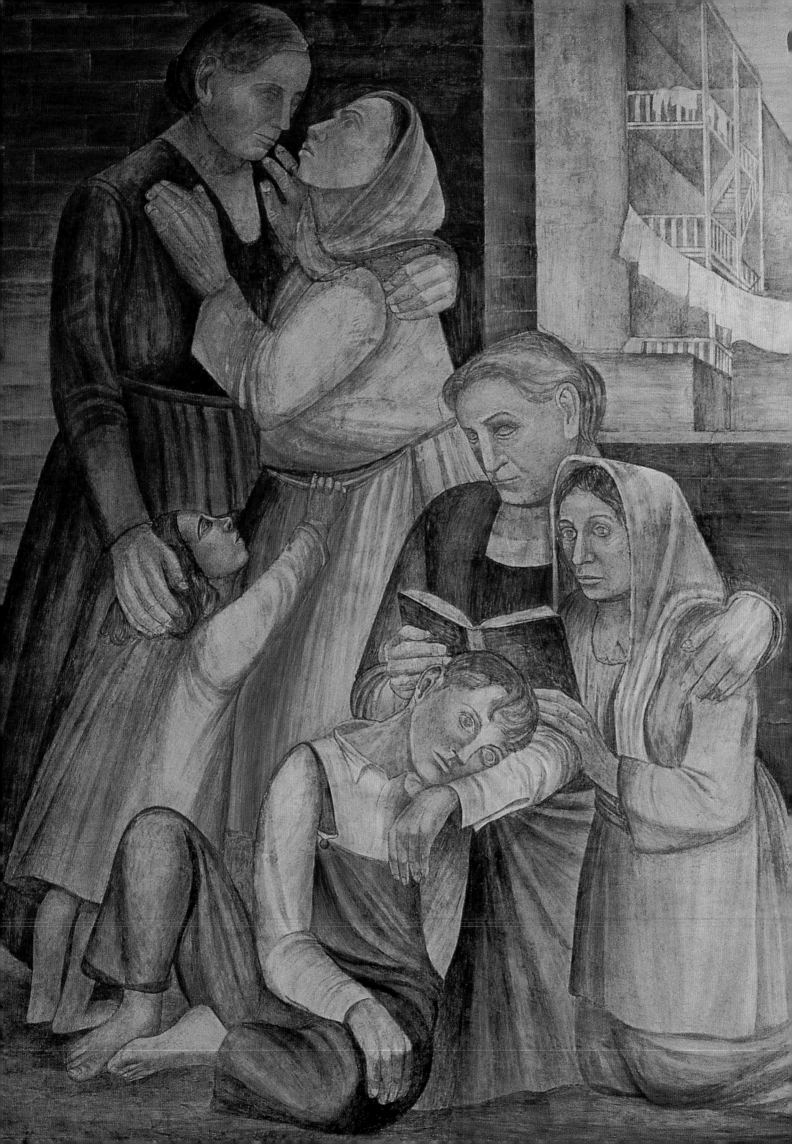

The Great Depression, the New Deal, and the WPA Federal Art Project

by Heather Becker

The Great Depression in the U.S. began when the stock market crashed on October 29, 1929. In a dramatic downward cycle of unemployment, a population of one and a half million out of work quickly rose to twelve million. A quarter of the American labor force was without work and the national income fell by half.[1] Decreased industrial production and factory closings helped fuel panic. More than five thousand banks collapsed when investors began demanding their deposits. In cities and towns people unable to pay mortgages lost their properties to foreclosure. Renters were evicted. Many people began living on the streets or found refuge in urban Hoovervilles—living in shacks built out of tarpaper, mattresses, and cardboard. Bread lines and soup kitchens grew rapidly.[2]

From 1930 to 1931 severe drought raged across the plains and Southwest, causing widespread dust storms; homes and farms were lost. As the rate of economic devastation accelerated in these regions, so did cases of malnutrition. Thousands of people migrated west to find respite from the harsh conditions, but only found more of the same. By mid-1932 public morale had hit rock bottom, and the lack of reprieve ignited a desire for change. A veterans' march in Washington resulted in a riot that required the intervention of President Hoover and the United States Army. The Hoover administration had elected to pass on most of the burden of providing relief to states and private agencies. In 1931 Hoover had vetoed legislation that would offer federal assistance to the unemployed. The stance was unpopular and the administration began to be blamed for the national condition.[3] To a majority of the American public, President Hoover was unable to govern in a way that would bring relief. The 1932 presidential election soon brought change.[4]

Franklin Delano Roosevelt

Franklin Delano Roosevelt is often called one of the most significant figures in the twentieth century. He was born on January 30, 1882, in Hyde Park, New York. Hyde Park was home to Roosevelt for his entire life and was his final resting place following his death on April 12, 1945. Franklin was James Roosevelt's second son, the only child from James's second marriage to Sara Delano. James Roosevelt was a financier, railroad executive, and lawyer. His parents and private tutors educated Franklin. He attended the prestigious Groton Preparatory School in Massachusetts from 1896 to 1900 and traveled throughout Europe, learning French and German. He was considered an active and determined student.

Roosevelt went to Harvard, earning a bachelor's degree in history in three years (1900–1903). At Harvard, he was much involved in extracurricular programs, at times ignoring his schooling. His fifth cousin, Theodore Roosevelt, was the twenty-sixth president at the time, and Franklin admired him greatly. After graduating, Franklin married a distant cousin, Anna Eleanor Roosevelt, on March 17, 1905. He attended Columbia University Law School in New York City. After three years he passed the bar exam on his first attempt. He left Columbia without needing to take a degree.

Roosevelt's political career began with his election in 1910 to the New York Senate. He became a significant leader of an upstate Democratic coalition. He supported Woodrow Wilson as the Democratic presidential nominee in 1912. Wilson appointed Roosevelt assistant secretary to the Navy in 1913, a position he held during World War I. In 1920 James M. Cox enlisted Roosevelt as his vice-presidential running mate. The Cox-Roosevelt ticket did not win against the Republican ticket of Warren G. Harding and Calvin Coolidge. The following year proved to be one of the most difficult personal hurdles in Roosevelt's life. He contracted poliomyelitis (infantile paralysis, or polio), which left him paralyzed from the waist down for the remainder of his life. He could not walk without assistance, crutches, or metal braces, and used a wheelchair in private. He helped other people

Facing page: Outstanding American Women: Jane Addams, *Edward Millman, 1938–40, fresco, Lucy Flower Career Academy High School.*

White Angel Breadline,
Dorothea Lange, 1932,
San Francisco.

stricken with polio by co-founding and directing the March of Dimes, which, after his death, funded the research that produced a polio vaccine.

Roosevelt's mother advised him to abandon politics, but Eleanor and his political mentor, McHenry Howe, an American reporter and journalist dedicated to Roosevelt, encouraged him to return to office. He resumed his career with a dramatic appearance on crutches to nominate Alfred "Al" Smith at the Democratic National Convention in 1924. Smith did not win the Democratic Party's nomination, but Roosevelt was back in public view. Roosevelt nominated Smith again in 1928, and this time he won the party's nomination. Smith persuaded Roosevelt to enter the New York gubernatorial race based on his upstate appeal. Roosevelt won by a narrow margin, while Smith lost the presidency to Hoover.

Franklin Delano Roosevelt was governor of New York (1929–33) when the Great Depression began in 1929. He acted swiftly to mobilize New York's

WORLD'S HIGHEST STANDARD OF LIVING

There's no way like the American Way

You Have Seen Their Faces, *Margaret Bourke-White, 1937, Louisiana.*

resources against the falling economy. As the Depression deepened, Roosevelt became identified with the cause of urban work relief. This positioned him as a leading candidate for the 1932 Democratic presidential nomination. His campaign offered a "New Deal" for the American people, a change from previous strategies for government spending. He won the election with twenty-three million votes (472 electoral) compared to Hoover's fewer than sixteen million votes (59 electoral).

During the four months preceding Roosevelt's inauguration, the devastating effects of the Depression continued. Factories and banks closed, agricultural

prices fell below the cost of production, and unemployment rose rapidly. When Roosevelt assumed office in 1933, he inherited the task of reducing a twenty-five percent unemployment rate, representing sixteen million people.[5]

New Deal Policy

In his inaugural address on March 4, 1933, Roosevelt sought to foster a much-needed confidence and optimism. The president pledged action and relief, reminding citizens of their resilient nature and asking them to demonstrate their courage and invincibility as a society.[6] The New Deal programs enacted in early 1933 offered a needed reprieve from the prior system's inequalities. Within eight days, Roosevelt initiated a radio series, his "fireside chats," in which he spoke to the American people about his proposals and continued to offer assurances. As more and more households acquired radios, knowledge grew about Roosevelt's New Deal concepts.[7]

During his first one hundred days, President Roosevelt summoned a special section of Congress and passed an impressive range of legislation. He gathered a group of advisors consisting of leading academic experts, known as the Brain Trust. His legislation formulated an extensive range of programs far-reaching in implications.

In the spring of 1933 several federally funded work programs passed through Congress. (The extensive list of program acronyms explains why the term "alphabet soup" is commonly used to describe them.) The most important economic programs related to banking reform. The New Deal created the Federal Deposit Insurance Corporation (FDIC), set up to safeguard bank depositors. The Home Owners Loan Corporation (HOLC) offered government loans for mortgages to farmers and homeowners. The Securities and Exchange Commission (SEC) placed regulations on the stock market, aiming to prevent another market crash.

Work relief was the focus of several other programs including the Federal Emergency Relief Administration (FERA), which granted states and municipalities funds to aid the unemployed[8]; the Civil Works Administration (CWA), which was similar to the emergency relief agenda of the FERA but was run on a federal level and assisted the unemployed; and the Civil Conservation Corps (CCC), which was an employment measure, authorized to provide work in reforestation, road construction, prevention of soil erosion, and flood control projects.

New Deal agendas also focused on agricultural concerns. The Agriculture Adjustment Act (AAA) was designed to boost prices of agricultural products

by subsidizing farmers, ultimately curtailing the production of certain crops and livestock. The Tennessee Valley Authority (TVA) created a federal power project offering electric power for the first time to rural people in a vast area.

Another major initiative was the National Industrial Recovery Act (NIRA). As a result of NIRA, laborers were given the right to collectively organize. Roosevelt's secretary of labor, Frances Perkins, played a prominent role in new labor legislature. She was also the first woman in the U.S. government to be a Cabinet member.[9] Under the NIRA umbrella were the National Recovery Administration (NRA) and the Public Works Administration (PWA). The NRA generated business and industrial codes designed to increase wages, maintain prices, and lower unemployment. The PWA financed over 34,500 federal and nonfederal construction projects and a job program for artists.

The PWAP

Harry Hopkins, who had worked with Roosevelt when he was governor of New York and was one of his most trusted advisors and director of the Civil Works Administration, agreed to use one million dollars for an artist relief program because artists were "hit just as hard by unemployment as any other producing worker."[10] In December 1933 Edward Bruce headed the New Deal's first art program as national director with funds transferred from the CWA. The first art project was called the Public Works of Art Project (PWAP), furnishing work to unemployed artists. Qualified artists were hired to produce aesthetically satisfactory work for nonfederal public buildings.

The successful initiatives of the PWAP led to a turning point for American public art via unprecedented large-scale production by American artists and the attempt to expose the general public to art. Edward Bruce stated, "The Project, in the short time it has operated, has definitely increased the art interest in the country. It has gone far to take the snobbery out of art and make it a part of the daily life of the average citizen"[11] One artist wrote to Bruce that the project provided "not only desperately needed funds, but hope and a feeling of being included in the life of my time."[12] The affirmation by the artists and the success of the PWAP bolstered the notion of government patronage for the arts. Its history, riddled with negatives and positives, served as a model for the later, larger programs.

Other New Deal Legislation

The growing involvement of the government in the arts is one example of the New Deal's attempts to bring about social change during the Depression. By 1935

another round of New Deal legislation was enacted. Labor issues were a focus during this landmark year of legislation with the initiation of the Wagner Act, known as the National Labor Relations Act (NLRA). The NLRA established a board to protect the rights of organized labor. The same year, the Works Progress Administration (WPA, renamed in 1939 Works

Projects Administration) was created to support various local work projects on a massive scale for the unemployed, including artists.

The notion that the federal government can create positive social change through legislation is an enduring legacy of the Roosevelt administration. Throughout the New Deal, political businessmen and members of Congress complained that government was intruding excessively into the economy and society. Roosevelt backers countered that the poor economy and social injustices demanded this government intervention. Meanwhile, leftists argued for more dramatic changes regarding labor and the American response to war and fascism in Europe.

Depression-era artists lobbied for their own labor rights as well as those of other blue- and white-collar workers.[13] The Left-leaning John Reed Club was founded in 1929 for artists and writers protesting discrimination, war, and fascism.[14] This organization was followed by two other groups, the Artists' Union (1933) and the American Artists' Congress (1935). These progressive organizations offered support for artists active in leftist causes and in economic need. Artists found they could be politically more effective as a group.[15] Social protest and some controversial art within and outside the New Deal art programs began to be produced to promote political and social change. The issues of social injustice presented by such artists were meant to expose a capitalistic system and an economy dictated by big business, call for employment programs and other government aid, and warn against fascist philosophies in Europe and the U.S.

Migration Family, Maricopa, Arizona, Dorothea Lange, 1940.

The New Deal and the First Federally Sponsored Art Program: The Public Works of Art Project (PWAP) 1933-34

by Thomas Thurston, Project Director, New Deal Network

When President Franklin D. Roosevelt took office, nearly ten thousand artists were out of work. As a group, artists represented a small part of the fifteen million unemployed in the United States; however, they were greatly affected by the Great Depression. The market for art, considered an expendable luxury item, virtually collapsed with the economic downturn, and artists found themselves in desperate straits. The situation for young artists, in particular, was especially dire, coming as it did on the heels of the booming decade of the twenties when, according to one study, the number of people employed in the visual arts grew from 35,400 to 57,265.[1]

Responding to the general problem of unemployment, in May 1933 the Roosevelt administration created the Federal Emergency Relief Administration. FERA provided grants to State Emergency Relief Administrations, which in turn dispersed the funds to local projects. FERA was the first of the New Deal "work relief" projects. Work relief differed from "the dole," the usual system of cash subsidies provided to destitute people. The idea of work relief was to counteract the stigma attached to the dole. New Dealers considered work relief to be crucial to preserving the knowledge and skills of the nation's workforce, idled by the Great Depression. Just as ambitious federal programs such as the Civilian Conservation Corps were developed to conserve the nation's natural resources, so would work relief programs conserve America's human resources. "We must preserve not only the bodies of the unemployed from destruction," said President Roosevelt, "but also their self-respect, their self-reliance, and courage and determination."[2]

The state work relief projects funded by FERA included some art projects, particularly in New York City. However, state relief administrators were often unsympathetic toward the plight of artists and other cultural workers. Efforts to alleviate the economic conditions of artists, wrote Suzanne La Follette in a 1933 article, remained "unsystematic and wholly incommensurate with the need."[3] Roosevelt sympathized with the plight of the artist.

In the past, the federal government had commissioned artists to supply paintings, sculptures, and architectural details for federal buildings, although not with the object of relief in mind; these commissions had been handled by the Treasury Department. In November 1933 the Advisory Committee to the Treasury on Fine Arts was created, with Edward Bruce as acting secretary. Bruce, an artist, lawyer, banker, and silver expert for the Treasury Department, began to lay the groundwork for a program of relief for artists, working in concert with Harry Hopkins, the administrative head of the newly created Civil Works Administration.[4]

The Civil Works Administration, a short-lived federal work relief program that bypassed the state relief organizations and directly funded projects, was begun in November 1933, under the direct authority of the National Industrial Recovery Act. Responding to the desperate conditions of impoverished Americans facing a bitter winter, the CWA did away with a means test for work and accepted anyone who was unemployed. At its peak in January 1934, the CWA provided emergency work to 4,300,000 unemployed workers. Although it was officially terminated in the spring of 1934, in its scope and ambitions the CWA set a precedent for the Works Progress Administration, which would operate from 1935 to 1943.

Most projects developed under the CWA provided employment for unskilled laborers, who constituted the great majority of those in need of relief. Significantly, however, the CWA established nearly one hundred professional and white-collar job classifications for work relief, which benefited thousands of out-of-work teachers, engineers, journalists, and artists. Providing material relief to those suffering from the effects of the Depression and a particularly severe winter, the CWA sought to preserve the skills and the morale of unemployed professionals by providing socially useful work. In doing so it was instrumental in setting policy for future New Deal programs. Among the innovations of the CWA was the establishment of the Public Works of Art Project, the first federally sponsored art program.

The PWAP rapidly mobilized, under the direction of Edward Bruce and with Forbes Watson serving as technical director. Harry Hopkins committed $1,039,000 of CWA funds to PWAP, with more funding to follow. The Washington staff worked with the sixteen regional directors of the CWA, who set up regional art committees to represent the individual states within each region. By December 12, 1933, the first artists were hired.[5]

Immediately the question was raised as to whether PWAP should be considered primarily a relief organization or an organization for the creation of public art. Artists on the PWAP did not compete for projects; they merely had to be unemployed. Yet it was expected that qualifying artists would possess the skills necessary to produce suitable art for public buildings. The tension between these two standards was never completely clarified. When asked how one could tell, "which are good and which are bad artists," Hopkins replied, "Fortunately, no one can tell that, so I don't have to worry about that."[6]

In all, the PWAP provided relief support to 3,749 artists who produced 15,633 works of art. PWAP received $1,312,000 in government funding, of which approximately ninety percent went directly for artists' wages. Art projects were sponsored by local entities that were expected to pay the costs of materials. Artists were paid $26.50 to $42.50 a week, according to wage scales and regional wage differentials set by the CWA. PWAP artists were directed to paint the "American Scene" and to stick to representational art.[7] Realizing that the short duration of the CWA was impractical for the completion of PWAP art projects, PWAP was continued into April. Thereafter artists were transferred to the state-administered agencies operating under the Federal Emergency Relief Administration. The PWAP officially ended on June 30, 1934.

Some of the works produced by PWAP artists include the Coit Tower murals in San Francisco; Ben Shahn's mural designs on the theme of Prohibition in New York; Paul Cadmus's *The Fleet's In*, which created a controversy at the PWAP's 1934 national exhibition at the Corcoran Gallery of Art; Grant Wood's collaborative murals project at Iowa State College; Aaron Douglas's *Aspects of Negro Life* at the Schomburg Library in Harlem; Isamu Noguchi's model for the earth sculpture *Play Mountain*; and the nine secco murals by Edgar Britton, *Scenes of Industry*, at Highland Park High School in Illinois.

Edgar Britton's signature on one of nine secco murals, Scenes of Industry, 1934, *Highland Park High School, Highland Park, Illinois. Britton was a PWAP muralist who went on to be a WPA/FAP muralist.*

Epochs in the History of Mankind: Egyptian, *Edgar Britton, 1936–37, fresco, Lane Technical High School.*

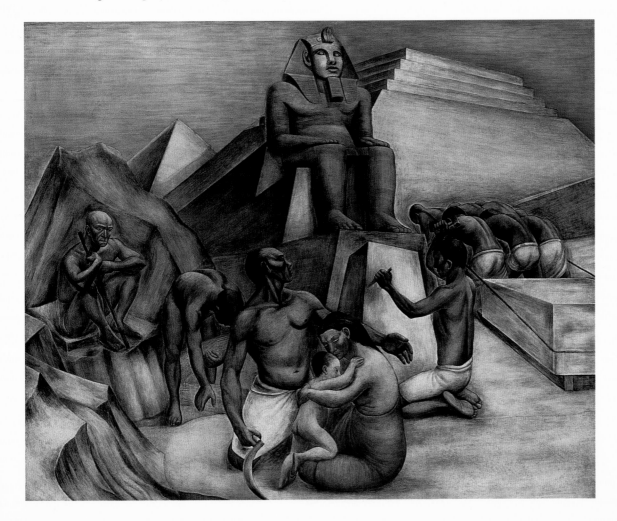

The Formation of the WPA/FAP

In January 1935 President Roosevelt proposed the largest and most comprehensive public works program of his first term. On April 8, Congress passed the Emergency Relief Appropriation Act that gave the president broad discretionary powers to spend close to five billion dollars on public works projects. On May 6 of that year the president authorized the creation of the Works Progress Administration.[16] Initially, most WPA projects were blue-collar construction projects; in August the WPA expanded its programs to provide work relief for artists, musicians, actors, and writers.

By August 1935 the WPA administrator Harry Hopkins had determined that a larger and more comprehensive program was needed to reach a wider

The Role of the Immigrant in the Industrial Development of America (detail, one of eight murals), Edward Laning, 1937. Originally from the Aliens Dining Room of the Immigration Station at Ellis Island, the murals were moved to the Emanuel Celler Federal Building, Brooklyn, New York in 1972. This image is from the cover of the book, The Heritage of American Art.

sector of the nation's unemployed artists. With this in mind, Federal Project Number One, or "Federal One," was created in October 1935. Under this umbrella, four cultural projects were sponsored: the Federal Theater Project (FTP); the Federal Writers' Project (FWP); the Federal Music Project (FMP); and the Federal Art Project (WPA/FAP).[17]—H. B.

::

The WPA Federal Art Project

by William Creech, Archivist, National Archives and Records Administration

In August 1935 the new Works Progress Administration set up Federal Project Number One within the Division of Professional and Service projects, the first comprehensive work relief program specifically set up for the arts. It consisted of four separate programs covering art, drama, literature, and music. Of these four, the Federal Art Project (WPA/FAP), directed by Holger Cahill, was set up to handle the plastic arts.[18] Cahill was a recognized authority on American folk art as well as an established writer and

critic. He had also held the public relations position at the Newark Museum of Art and the directorship of exhibits at the Museum of Modern Art. These positions had brought him in contact with many of the leaders of the arts community.[19]

In the opening paragraphs of the WPA/FAP's 1935 operations manual, Holger Cahill states, "The primary objective of the Project is the employment of artists who are on relief rolls. The Federal Art Project will draw at least ninety percent of its personnel from relief."[20] (The following year the percentage of artists drawn from relief rolls would drop to seventy-five percent.) Cahill goes on to say, "The plan of the Federal Art Project provides for the employment of artists in varied enterprises. Through employment of creative artists it is hoped to secure for the public outstanding examples of contemporary American art; through art teaching and recreational art activities to create a broader national art consciousness and work out constructive ways of using leisure time; through services in applied art to aid various campaigns of social value; and through research projects clarify the native background in the arts. The aim of the project will be to work toward an integration of the fine arts with the daily life of the community, and an integration of the fine arts and the practical arts."[21]

To reach as many people in as many communities as possible, Federal Project Number One was sponsored directly by the WPA. This meant that the WPA/FAP was not required, as other WPA programs were, to find state or local sponsors before setting up a project. Direct federal sponsorship made it easier for the WPA/FAP to set up projects in communities that on the local level might have been hesitant to initiate art projects. Federal sponsorship gave many artists an opportunity to work as artists regardless of whether they lived in a small rural community or a large urban center.[22]

Director Cahill and his staff were responsible for the overall organization and direction of the program; it became the task of a staff of regional directors to take the program to the states. They were assisted by state directors (chosen by Cahill, usually with the concurrence of state officials) responsible for working directly with state and local officials to ensure the projects were properly set up and followed WPA/FAP guidelines.[23]

National, state, and local advisory committees consisted of artists, museum directors, heads of art schools, and other professionals concerned with the arts. They acted as a type of quality control board at the state and local level and often suggested ways to improve specific programs.[24] Once this adminis-

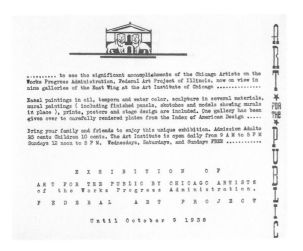

......... to see the significant accomplishments of the Chicago Artists on the Works Progress Administration, Federal Art Project of Illinois, now on view in nine galleries of the East Wing at the Art Institute of Chicago

Easel paintings in oil, tempera and water color, sculpture in several materials, mural paintings (including finished panels, sketches and models showing murals in place), prints, posters and stage design are included. One gallery has been given over to carefully rendered plates from the Index of American Design

Bring your family and friends to enjoy this unique exhibition. Admission Adults 25 cents Children 10 cents. The Art Institute is open daily from 9 A M to 5 P M Sundays 12 noon to 5 P M. Wednesdays, Saturdays, and Sundays FREE

EXHIBITION OF
ART FOR THE PUBLIC BY CHICAGO ARTISTS
of the Works Progress Administration,
FEDERAL ART PROJECT

Until October 9 1938

trative structure was in place at the state level, the next step was to determine the number of artists available and their qualifications. This process was initiated by the district art supervisor, who requested from the local office in charge of the relief rolls the names of all persons on relief in the arts, registered as artists, art teachers, or craftsmen. These names would be given to a person or committee, chosen by either the regional or state director, to decide on the qualifications of the artists on the list. A person recognized as technically qualified by the national director's office would decide the level of skill of each artist.[25] Once certified, the artist was then assigned to one of the four areas where his or her talents could be put to best use.

To meet the goals of the program, the WPA/FAP state programs were divided into four main areas of artistic activities:

1. The creation of art. This was the most extensive area of WPA/FAP activity and included easel painting in all media, murals, sculptures, and fine-art prints.

2. Art education. The WPA/FAP Division of Art Teaching often worked with local school systems (especially in large cities) to sponsor new art programs with the help and participation of WPA/FAP teachers.

3. Art applied to community service. The WPA/FAP helped set up a system of community art centers and galleries in which art classes were offered and traveling exhibitions of original project art were shown—often located in rural communities where many people had never had the opportunity to see original art. This program served one of the main goals of the project, to help integrate the arts into the life of the community.

4. Art in technical and archeological research. This program consisted primarily of work on the Index of American Design. The Index was conceived as a visual record of pre-twentieth-century American crafts and designs rendered in thousands of detailed watercolors.[26]

This was the basic organizational structure of the WPA/FAP from the fall of 1935 to the summer of 1939, when federal relief programs went through a major reorganization. The Federal Emergency Relief Appropriation Act for fiscal year 1940 required that all projects sponsored by the WPA be terminated by August 31, 1939. The WPA received a name change to the Works Projects Administration and was placed under the newly created Federal Works Agency. Federal Project Number One was abolished with all funding for the Federal Theater Project suspended, and the federal art, music, and writers' projects were combined into a single new WPA/FAP art program.[27]

Under the new WPA/FAP program Cahill was still national director, but unlike the old WPA/FAP, the administrative structure no longer centered on the

Announcement for the exhibition Art for the Public *by Chicago Artists of the Federal Art Project, Works Progress Administration, the Art Institute of Chicago, July 28–October 9, 1938.*

Historical Periods *(image 4), Ralph Henricksen, 1939, oil on canvas, Clissold Elementary School.*

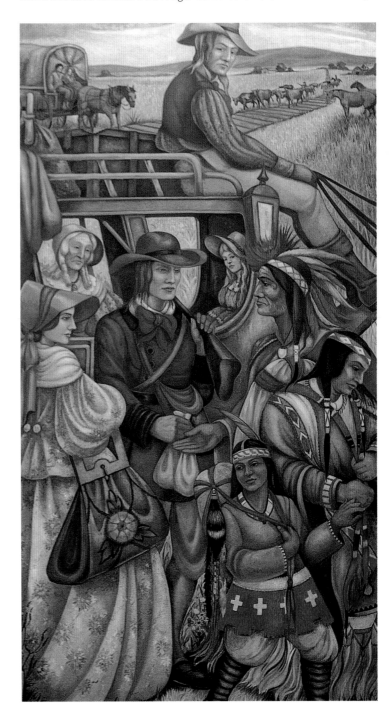

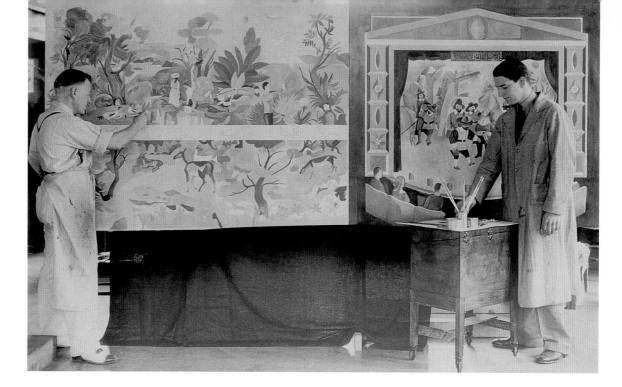

Rainey Bennett (right) painting Knights in Tournament/Rip Van Winkle *for the Crippled Boys' Ward in Chicago. His assistant Clifton Morrison works next to him on another mural. c. 1930s.*

national office. A state administrator, not Cahill, now chose the new state supervisors. The new program also required that twenty-five percent of its projects have a state or local sponsor, shifting more of the administrative and financial control from the federal to the state and local level. This produced a shift toward projects involving repetitive production, such as poster work, and away from the more creative aspects of the program. Poster work allowed the state and local sponsors to produce more art for less money.[28]

In March 1942 most of the WPA/FAP artists and facilities were transferred to the Graphic Arts Section of the War Services Program. This further limited the creative aspects of the project and narrowed the focus of the program to art for the war effort.[29] Finally the formal order for the liquidation of the WPA/FAP came in a letter from President Roosevelt to the director of the Federal Works Agency on December 4, 1942. The letter stated that the WPA/FAP as a national work relief program was no longer necessary, and that the operation should be closed down in as many states as possible by February 1, 1943.[30]

Although the last three years of the WPA/FAP found a scaled-back, less creative, less centralized program than had previously existed from 1935 to 1939, its overall accomplishments were still quite impressive. By the time the WPA/FAP closed its doors, the program had employed thousands of artists, the vast majority on relief, to create hundreds of thousands of artworks for display in public buildings nationwide. The WPA/FAP produced 2,500 murals, 18,800 pieces of sculpture, 108,000 easel works, 11,300 fine print designs, and 22,000 watercolors for the program's Index of American Design.[31]

In addition to the physical works of art produced, the WPA/FAP was also responsible, through its

community art centers, education programs, and gallery exhibits, for exposing hundreds of thousands of people to art nationwide, many for the first time. This segment of the program went a long way toward achieving the WPA/FAP goal of integrating the fine arts into the daily life of many communities across the country.—W.C.

The Federal Writers' Project; the Federal Theater Project; and the Federal Music Project

The Federal Writers' Project operated under the direction of Henry A. Alsberg and John D. Newsome between 1935 and 1943. The FWP was designed to put unemployed professional writers, teachers, librarians, ministers, lawyers, and newspaper employees back to work. The project was to create guidebooks to the forty-eight states, Alaska, and Puerto Rico, but in addition to the guides the FWP collected life histories, work histories, slave narratives, folklore, and conducted nature and ethnic studies, producing manuscripts, pamphlets, indexes, articles, and children's books. FWP notables include Studs Terkel, Conrad Aiken, Richard Wright, and Ralph Ellison. The legacy of their work is reflected in bookcases of materials and manuscripts that capture the United States during those years in its vast cultural diversity.[32]

The Federal Music Project was directed by conductor Nikolai Sokoloff. The purpose of the FMP was to employ out-of-work musicians so that their talents could mature and flourish. Included in the program were symphonic orchestras, dance bands, chamber ensembles, and chorus groups. In addition to performance art, the project fostered an educational sector in which artists repaired instruments, copied music, worked as music librarians, collected folk music,

The Legacy of the New Deal

by Anna Eleanor Roosevelt, granddaughter
of Franklin and Eleanor Roosevelt

The thing that struck me about both my grand-parents is that they respected and admired the rich lives of all people, not just the privileged, wealthy, or conventionally educated. People, it seems to me, engage in the arts to express their lives, thoughts, hopes, and dreams; and in the act of declaring them, people are reinforced, strengthened, and enlivened. The Depression had produced a crisis in daily lives, hopes, and dreams. The New Deal was a creative approach to government—government responding to the people's crises. All democratic government is a dialogue. Creativity in the arts was a natural component.

A wonderful part of the New Deal arts program was that it recognized the beauty and talent of diverse everyday lives and placed these works of art in the places where we lived each day—parks, schools, and post offices. As a result we grew in our understanding of ourselves as a unique culture, a lively culture, a creative culture, a culture that could achieve good, true, and beautiful things. Our elements of culture had, of course, existed before, but New Deal leadership brought it into unity and gave it a future.

The New Deal wasn't perfect; it was dynamic. The atmosphere of challenge and experiment, as well as preserving and recording, was mirrored in the arts program. Whether comfortable or not, art reflects some truths about who we are, and that's healthy for us. The New Deal for artists proved its benefit.[1]

The Circuit Rider, *Henry Simon, 1940–41, egg tempera on gesso coated panels, Wells Community Academy High School.*

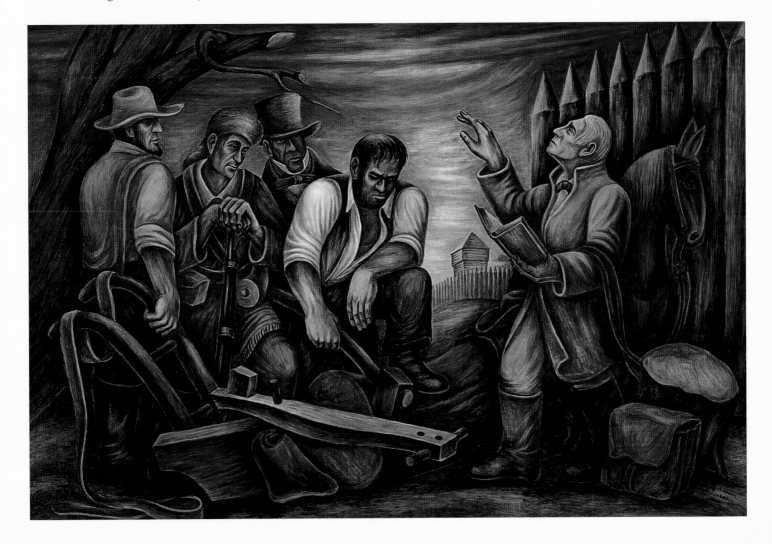

One of the Most Vital Cultural Movements in America, the WPA/FAP

by Harry Sternberg, WPA/FAP muralist (1904–2001)

The demand for Illinois Art Project murals was a testimony to the emerging relationship between artists and public. The presence of artists in area institutions encouraged the community to reconsider stereotypes about artists as isolated, immoral, or elitist individuals and to see them as workers with skills and ideas to contribute to society. The murals mirrored the lives of their audience, ordinary hard-working people. American stories were told through larger-than-life images that documented the social, industrial, political, agricultural, and domestic issues of the time. Viewers could relate to the realistic portrayal of dust-bowl landscapes, industrial workers, employment lines, or farmers working the land. A new relationship between artist and audience originated through the common social realities recorded in the murals' imagery. Edgar Britton wrote, "I find the constant vigilance of an audience a challenge . . . by executing work in public the mural artist is doing a great deal toward dissipating the halo of mystery surrounding works of art."—H. B.

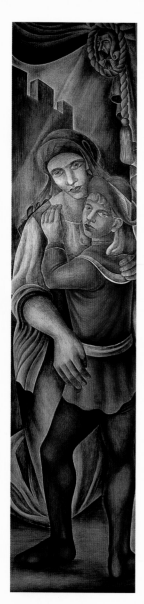

Teaching of the Arts: Teaching of Drama, *Mitchell Siporin, 1938, fresco, Lane Technical High School.*

In participating in the WPA, I felt that I was a part of one of the most vital and important cultural movements in America. Having a teaching job at the Art Students League made me ineligible for the WPA, but I was invited to be an expert advisor in graphic arts. This was of great assistance to me in publishing my book, the first text on silkscreen printing, *Silkscreen Color Printing* (published by McGraw-Hill Book Co. in 1942).

The dominant public attitude toward the WPA/FAP was negative. Never before had there been government support for the arts. The critics could not see that a great cultural revolution was taking place. For the first time—and unfortunately, the last time—in our history, artists, writers, dancers, and actors were given a small stipend, enough so that they could devote full time to their creativity. All over the country there were pictures displayed, books written, plays performed, a cultural blossoming such as had never been seen before in this country. It is important to note that almost every person who achieved fame in the arts based in that period had a start on the WPA.

Another result of the WPA/FAP was the appearance, for the first time, of live theater productions all over the U.S., many in little towns that had never had live theater before. I was living in New York City at that time and could not afford Broadway ticket prices, but I could afford the quarter or so admission price for the many Off Broadway WPA/FAP theater productions that were playing there. It was a glorious time!

Fortunately, at this same time, that trio of Mexican artists—José Clemente Orozco, Diego Rivera, and David Alfaro Siqueiros—conquered America with their murals. It was they who opened our eyes to the wonders of wall art and who inspired American artists. I was fortunate to be well-enough known to be offered a chance to compete for a mural project sponsored by the Section of Fine Arts. I had never painted a mural before, but had studied the Mexican murals. I was given a small space in the post office in Ambler, Pennsylvania; my next mural was located in Chester, Pennsylvania. I then painted an 8-by-40-foot mural at the Lakeview post office in Chicago. I had an assistant, Charles Keller, for this one. Since I painted the mural in oil on canvas in my New York studio, I had to hire a specialist to glue it to the wall in the post office. It was thrilling to move away from easel-size to mural-size painting.

New Deal heads, fearful of public criticism, tried their best to eliminate from the sketches we submitted anything at all controversial. My battles with the directors of the mural project were actually small skirmishes. I found the government altogether most supportive and helpful. This was so unlike privately supported mural projects, such as the disastrous one in Rockefeller Center. It was there that Diego Rivera was commissioned to do a fresco. When he finished his huge mural, the patrons discovered that he had included a portrait of Lenin, which he was asked to remove. When he refused, the whole mural was chopped off the wall. Interestingly enough, at this time an exhibition of invited artists was to be held in that building, and the Rockefellers were going to buy pictures from that show. In protest of the destruction of Rivera's mural, most of these artists refused to show.

My Chicago mural is still in a very good state. It would be a great loss to our history if the more neglected murals were allowed to further deteriorate.

and offered music classes. New performances by the
composers Aaron Copland and William Schuman
were debated in "Composer Forums" sponsored by
the FMP. The program exposed 150 million people to
music in schools, community centers, orphanages,
public parks, hospitals, settlement houses, prisons,
and urban and rural spaces.[33]

The Federal Theater Project, directed by Hallie
Flanagan, created theater productions regionally and
nationally, exposing the public to a multitude of forms
and offering many their first theater experience. The
project sponsored Shakespeare and other classical
repertoire, poetic drama, Yiddish vaudeville, a radio
division, dance theater, a theater for the blind, a Negro
youth theater, and a marionette theater. Although
Flanagan's vision of a national theater audience was
never fully realized, the FTP was responsible for
several memorable and groundbreaking productions.
Macbeth, directed by Orson Welles, was performed
by an all-black cast and was set in Haiti during the
revolt of the Haitians against French rule. *The Cradle
Will Rock,* a controversial opera set around a steel
strike, directed by Welles with music by Mark Blitzstein,
was banned along with some productions of the
children's play *Revolt of the Beavers* because of what
some critics considered "socialist" content.[34] Among
the four art projects, the Federal Theater Project was
the most controversial artistically and politically.[35] The
unique events surrounding the FTP can be partially
explained by the confrontational formats and themes
of its productions. Especially arousing were its "Living
Newspapers," enactments of current political and
social debates on such topics as communism, slum

housing, disease, and industrial power. The contentious
reputation of the FTP brought the project to an early
end by an act of Congress in June 1939. The other three
art projects continued in reduced forms until 1943.

Art Emerges

A wealth of information about the four WPA Federal
One projects remains uncharted. Francis O'Connor,
one of the founders of New Deal research, remarked,
"Art cannot subsist in the vacuum of the 'NOW' any
more than the millions can mature culturally without
learning from the past."[36] The myriad achievements
of the fine-art and practical art programs of Federal
One fostered the integration of art and artist into
American society; and they offered men and women
of numerous classes, ethnicities, and races a chance
to appreciate the arts' ability to enrich daily life
and culture. Art emerged as a manifestation of the
government's attempt to lift the American spirit
during the Depression.—H.B.

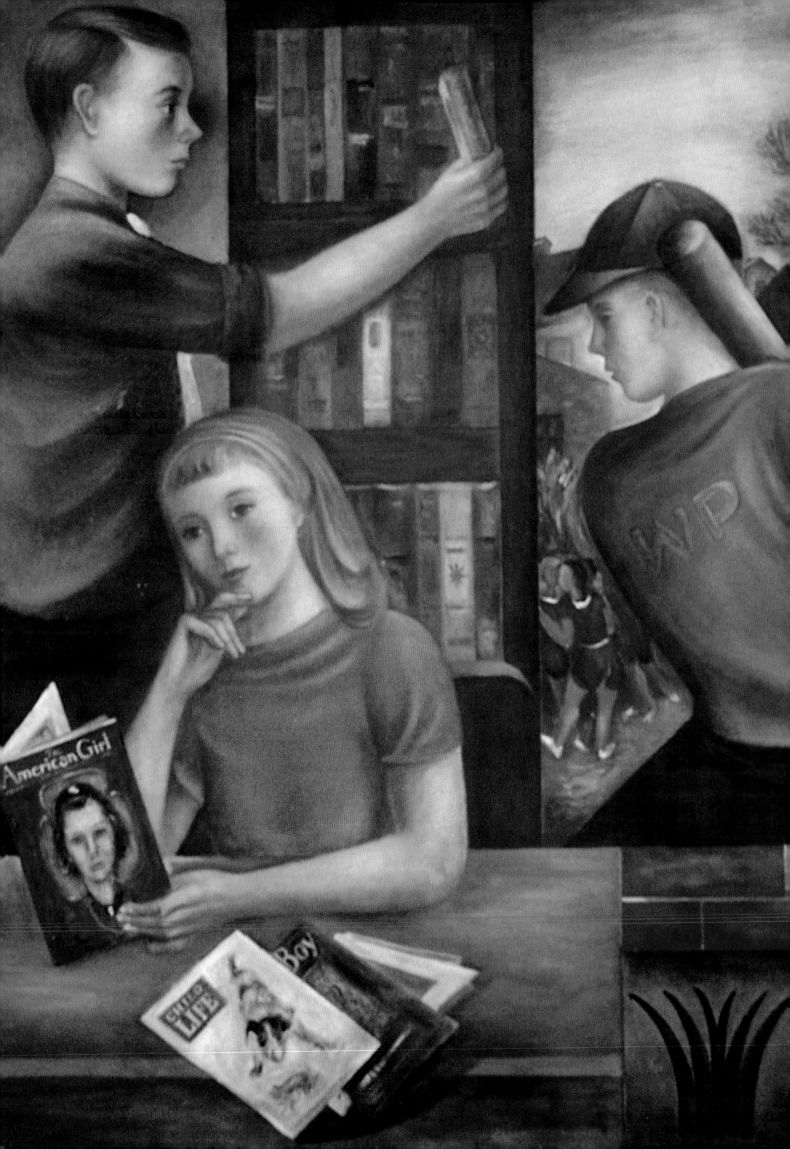

The Illinois Art Project of the Federal Art Project: 1935 to 1943

by Heather Becker

During the WPA/FAP years, Illinois established its reputation as home to one of the most distinguished state projects. Historian William F. McDonald has said, "The Chicago Project . . . could point not only to an original school of muralists but also to outstanding artists in other forms who combined to produce a 'Chicago style,' which made that project the cynosure of artistic eyes throughout the country."[1] A diverse generation of artists came of age in Illinois during the Illinois Art Project, and Chicago became recognized as a center of art making.

Before 1933 Chicago's art and architecture culture teemed with societies, clubs, art centers, and organizations. Regardless of Chicago's then seemingly provincial perspective on contemporary art, its artists championed many revolutionary agendas prior to and during the Illinois Art Project.[2] The origin of this progressive artistic movement is often attributed to the Armory Show of 1913. Over the following twenty-five years various arts organizations and societies were founded in Chicago, giving rise to its national perception far beyond the support fostered by the Art Institute of Chicago (founded in 1893) and elite art patrons.

The Chicago No-Jury Society of Artists (1922)[3], under the leadership of Rudolph Weisenborn, Carl Hoeckner, Ramon Shiva, and Raymond Jonson, made it possible for any artist to exhibit publicly for a small membership fee. The Chicago Artists' Committee for WPA/FAP Jobs (1935)[4] was founded by eleven prominent artists, including Edward Millman, Gustaf Dalstrom, Mitchell Siporin, Aaron Bohrod, and Edgar Britton. These artists were committed to fighting for various employment rights related to competency and need. The WPA/FAP-sponsored South Side Community Art Center (dedicated by Eleanor Roosevelt in May 1941)[5] helped launch the careers of many black Chicago artists, including Charles White, Margaret Burroughs, and Archibald Motley. The center became

a dynamic cultural institution that remains active today. These divergent organizations and the Illinois Art Project coalesced into a powerful art community. Robert Jay Wolff, a member of the Chicago Artists' Union, wrote, "Over a period of four years the [Illinois Art Project] has enlarged what was once a small professional art community to include the thousands of lay citizens whose schools, libraries, and hospitals contain the work of local artists. These thousands constitute a new patronage whose enthusiastic acceptance of the Project's work has given to the artist what the old, isolated art community could never give: vital encouragement and a respected and useful place in the scheme of things. The Union, which in the beginning was the voice of artists demanding the chance to work, is finally becoming the collective voice of this new and fruitful patronage."[6]

The Illinois Art Project, headquartered at 433 East Erie Street and with a gallery at 211 North Michigan Avenue, was the place to be for young and aspiring artists; many gave up jobs just to join. Artists' salaries ranged from $55 to $94 a month based on classification levels.[7] Some worked on location, some in their own studios and others at project studios. The studios on Erie Street were described in a news release in 1938: "A visit through the various sections of the four well-lighted floors reveals the great activity going on within the building. Every form of fine and industrial art is represented. Chicago artists who have regularly exhibited in Art Institute of Chicago annual exhibitions are conspicuous by their number and the quality of the work. In one spacious gallery hang oil paintings by: William S. Schwartz, Fritzi Brod, Jean Crawford Adams, Elise Donaldson, Aaron Bohrod, Lester O. Schwartz, Gustaf Dalstrom, Constantine Pougialis, Marshall D. Smith, Edgar Miller, Fred Biesel, Irving Manoir, Ethel Spears, George Lusk, Todros Geller, Ivan Albright, and many other names high in the roster of Chicago painters. Peterpaul Ott and Edwouard

Facing page: American Educational System, *Ralph Christian Henricksen, 1941, oil on canvas, West Pullman Elementary School.*

Illinois Art Gallery, 211 North Michigan Avenue, interior of gallery, c. 1930s.

Street view of the Illinois Art Gallery, 211 North Michigan Avenue, c. 1930s.

Work in progress, Sidney Loeb, center, working for the Illinois Art Project sculpture division, c. 1930s.

Chassaing are giving their talents to the sculpture department. There are mural paintings, sculptures, easel paintings, dioramas, posters, advertising designs, printing in colors, ceramics, wood carvings."[8] By 1940 the Illinois Art Project had produced approximately 316 murals, 563 sculptures, 4,923 easel paintings, and 750,362 posters.[9]

George Mavigliano, historian and coauthor of *The Federal Art Project in Illinois, 1935–43,* offers an account of the Illinois Art Project.—H.B.

The Illinois Art Project: An Overview

by George Mavigliano

Holger Cahill, who worked unrelentingly for a broader and socially acceptable base for American art, headed the WPA/FAP. He had also been an advocate for government subsidy of American art. Cahill's main goal was to ensure that the scope of the WPA/FAP would be broad enough to encompass every degree of artistic skill and large enough to accommodate as many unemployed artists as possible.[10]

The Illinois Art Project was one of the country's largest WPA/FAP programs and was ably managed by Mrs. Increase Robinson. She had been an administrator with the PWAP, a well-known Chicago artist,

and gallery owner.[11] Over its lifetime (1935–43) the Illinois Art Project employed approximately 775 artists and administrators.

The Illinois Art Project was a "need"-based program, giving work to unemployed artists. One of Robinson's major responsibilities was to hire and maintain quotas regarding the total number of artists employed and to ensure that at least ninety percent of these artists qualified for relief. An important factor in the history of the project was the constant, sometimes frustrating adjustments necessary to meet ever-changing federal requirements for employment.

The project was an extensive program accommodating the multitalented artists of Chicago and downstate. The Easel Division employed more than half of the project artists. Painters such as Aaron Bohrod, Rainey Bennett, Archibald Motley Jr., and Charles White were among those hired. Illinois could boast a nationally recognized mural program led by Mitchell Siporin, Edward Millman, and Edgar Britton. Holger Cahill wrote to Siporin that Chicago had experienced a "period such as she has not seen before in her art history, and . . . the windy city's cultural development has been extraordinary, because of you, Millman, and Britton."[12] John Walley, one of Chicago's finest design educators, headed an innovative design program.[13] The Illinois Art Project also included divisions for sculpture, graphics, poster making, fine-art printmaking, ceramics, photography, dioramas, art education, and the Index of American Design.

On average, artists submitted one work per month. They were supposed to put in thirty hours of studio time per week in return for a paycheck that

averaged approximately $94 per month. Once artworks were submitted, they were evaluated. If accepted, they went to the carpenter's shop to be matted, framed, and tagged with the WPA/FAP imprint. Most works, other than murals, were two-dimensional, but a sizable number of three-dimensional pieces were also produced.[14] From the carpenter's shop all works were sent

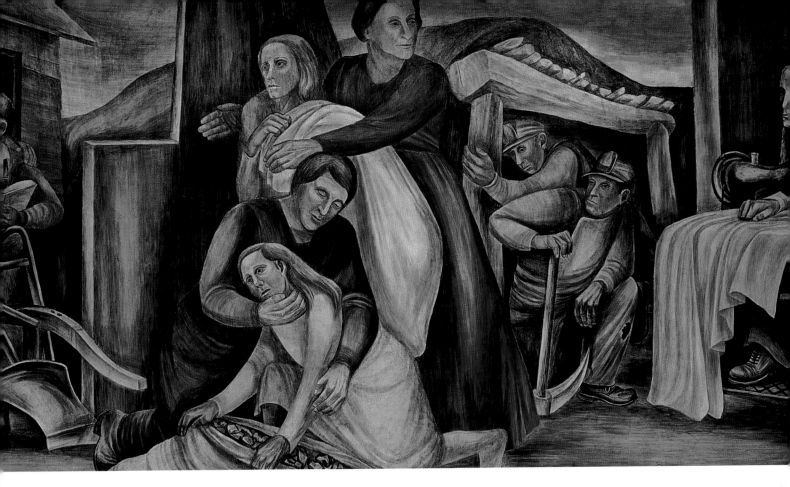

to the Exhibition Division to be placed on exhibit or purchased by sponsors.

Art produced by the Illinois Art Project was given public exposure in several ways. Works were often sent to nonprofit public institutions on extended loan. These institutions included schools, hospitals, libraries, and public facilities. Sometimes institutions sponsored murals or other work for their buildings. The project managed an art gallery on Michigan Avenue, and project artists' work circulated in nationwide exhibitions sponsored by the federal program. Probably the largest and most impressive show was *New Horizons in American Art,* which opened in 1936 at the Museum of Modern Art, New York.[15]

Robinson's tenure as director of the Illinois Art Project came to an end on March 1, 1938. She had been, by all accounts, the perfect match for the fledgling program. Energetic, with concrete goals and ideas as to how the project should be run, Robinson ruled her "ship" with an iron glove. But as the Illinois Art Project grew and prospered, and as artists became comfortable with their new roles working for the federal government, they began to resent her dictatorial nature. She came to symbolize the kind of authority most artists opposed. As conflicts between Robinson and projects artists escalated, Cahill was forced to ask for her resignation. This was a difficult decision on Cahill's part because he held her in high regard, and as a consequence, she stayed with the federal program for a period as Cahill's assistant.

George Thorp, a congenial sculptor from New York, ran the Illinois Art Project until 1941. The difference between Thorp and Robinson was fundamental. Thorp approached his responsibilities not as an administrator but from the perspective of a project artist. Thorp's affability, however, was no match for the mounting difficulties threatening the program nationally. Political changes altered congressional views toward Federal Project Number One, and in June 1939 Congress severely reduced the WPA/FAP's operations. After September 1939, the Illinois Art Project was renamed the Art Program of the Work Projects Administration and could not continue without legal sponsorship from within the state. This change was a terrible setback to many programs across the country, but in Chicago and other large metropolitan centers, sympathetic and committed arts supporters sponsored project activities, and though hampered, work continued.[16]

That the project continued to run harmoniously was a testament to George Thorp's ability and his commitment to project artists. But stress and long hours took their toll. Thorp resigned his position in September 1941. Fred Biesel became the third and final director of the Illinois project. Biesel had served in various administrative positions and was an assistant to Thorp. He was a graduate of the Rhode Island School of Design and had studied with Robert Henri, George Bellows, and John Sloan. As an artist, he had a very broad view and was tolerant

Outstanding American Women: Frances Perkins, Edward Millman, 1938–40, fresco, Lucy Flower Career Academy High School.

of most schools of artistic thought. He was able to handle administrative duties less intently than his predecessor.

Thorp's administrative style was to hunker down in Chicago and run the program statewide from there. Biesel, in contrast, spent long periods of time away from Chicago, traveling throughout the state even though these areas constituted less than five percent of the total artistic workforce in Illinois. Biesel believed that even though the Illinois Art Project had always been fundamentally a Chicago-based operation, competent artists and economic need could be

boasted numerous outstanding African American artists who trained on the Illinois Art Project and worked for the South Side Community Art Center. A tribute to the center's success is the fact that it remains in existence as one of only a handful of centers (there were 102 nationally) that survived.

Once the United States entered World War II, sustained interest in "make-work" programs such as the WPA/FAP dwindled. By March 1942 the entire project was working with instructional facilities on Army and Navy bases. Its name was changed to the Graphic Section of the War Services Division. At

John Walley lecturing at the South Side Community Art Center (left), c. 1930s.

Office workers at the South Side Community Art Center (right), c. 1930s.

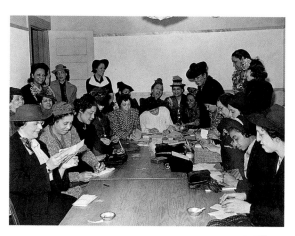

found throughout the state. His particular interest was in developing the crafts communities outside the Chicago area, especially in downstate Illinois. Between Thorp and Biesel, the Illinois project took on the additional responsibility of providing technical supervision for museums throughout the state. Their aim was to help publicly owned and operated museums, schools, and colleges make available to the general public information and knowledge about their collections.

Another example of the diversification of the Illinois project during its later years was the Community Art Center program. The CAC was established to provide space for exhibitions, gallery talks, demonstrations, and art classes for children and adults in communities that otherwise would not be exposed to art. One of the project's strengths was its attempt to target young audiences. Beginning in December 1939 and running sporadically for two years, WGN Radio aired a series of broadcasts for children. Members of the Illinois Writers' Project wrote each of the fifteen-minute programs. The broadcasts were held in conjunction with special exhibitions at the Art Institute of Chicago.

A major contribution to the CAC program was the founding of the South Side Community Art Center in 1941. Eleanor Roosevelt came to Chicago for its dedication. It housed a gallery, meeting hall, and classrooms. The center was an attempt to stimulate cultural development for members of all races. Illinois

the same time, most of its personnel enlisted, were drafted, or sought work in the private sector. On May 15, 1943, the WPA/Illinois Art Project closed down for good. After preparing the Illinois Art Project's records for microfilming, Fred Biesel submitted his resignation.

The Federal Art Project remains an important part of our nation's cultural history. It helped break down the age-old barriers between the artist community and the public at large, not only in urban areas such as Chicago but in small towns as well.—G.M.

Researching the Illinois Art Project

There is a vast amount of information still to be discovered and compiled about each of the twelve Illinois Art Project divisions. The Midwest Chapter of the National New Deal Preservation Association is working toward this by undertaking oral histories of artists who worked for the Illinois Art Project.[17] Extensive oral histories compiled by George Mavigliano have been donated to the Smithsonian Institution Archives of American Art in Washington, D.C.[18] The Center for New Deal Studies,[19] Illinois State Archives, the Art Institute of Chicago and its Martin A. Ryerson Library, the Chicago Historical Society, the Illinois State Museum, and the Chicago Public Library are local sources for research.

Illinois Art Project Printmaking

by Liz Seaton, art historian

The Federal Art Project's sponsorship of fine-art printmaking helped contribute to the flourishing of the medium during the 1930s. The government's economic support allowed an estimated eight hundred project artists in some thirty-six cities, including Chicago, to explore complex printmaking methods, such as color lithography and wood engraving, that had been eclipsed for decades by the more popular etching technique. Unhindered by the tastes of art dealers and private collectors, printmakers abandoned landscape and architectural subjects in favor of candid and often critical portraits of contemporary America. Because printmaking resulted in multiple original impressions (FAP editions ranged from twenty-five to fifty impressions) and was inexpensive to produce, project participants saw it as among the most promising routes to increasing audiences for the fine arts.

Most of the largest U.S. cities, including New York, Philadelphia, Cleveland, San Francisco, and Los Angeles, had central printmaking workshops, spaces in which artists had access to supplies such as lithographic stones, etching plates, paper, ink, and presses tended by master printers. Although it had no central workshop, Chicago was the third largest (after New York and San Francisco) printmaking center: some seventy artists contributed an estimated 460 print designs between 1935 and 1941. Artists in Chicago worked on their own presses or shared presses. Equipment also was available at community centers such as Hull-House and the South Side Community Art Center, where the public could enroll in free WPA/FAP printmaking classes. Eleanor Coen taught in an after-school program at the Jewish People's Institute; she depicted children making watercolors in a 1940 WPA/FAP color lithograph, *WPA Art Class—Painting*. Rendered as pudgy forms in Coen's characteristic style, the racially diverse group works busily. With its numerous colors and textures, Coen's print is evidence of the sophisticated lithography work executed by artists employed by the WPA/FAP in Illinois, most of whom, like Coen, did their own printing. Black-and-white lithography had gained enormous ground in the U.S. by 1935, but fine-art color lithography, which required several stones and printings, was uncharted

territory for most American printmakers before WPA/FAP assistance.

Nationally, WPA/FAP artists made more than 12,000 print designs, or some 250,000 individual impressions.[1] These works are diverse in appearance, but one thing that distinguishes them from other government-sponsored art such as murals, sculpture, and easel paintings are the political subjects their makers adopted. Compared to other media, prints were not subjected to the same degree of scrutiny by project administrators and public sponsors; this permitted greater freedom to artists who sought to bring politics into their work. For many artists of the 1930s the print was the ideal form in which to forward leftist opinion because of its reproducibility and historical use as a vehicle of political expression. WPA/FAP prints provide an index of issues that were important to American

WPA/FAP Art Class— Painting, *Eleanor Coen, 1940, color lithograph.*

leftists during the late 1930s: supporting work relief for the unemployed, organizing industrial laborers, opposing racism and war.

Illinois Art Project print supervisor Carl Hoeckner, a socialist affiliated with local chapters of the Left-led Artists' Union and American Artists' Congress, was a staunch pacifist. His father, an etcher in Munich, had sent him to the United States in 1910 to prevent him from serving in the German military. Hoeckner brought his antiwar sentiments to project prints such as *Machine Fodder,* a lithograph from about 1939–40. In the highly detailed, fantastic image, a sea of munitions workers and military men move from left to right across the picture, while the vague outline of a female figure—symbol of the spirit of these individuals—floats from their bodies out of the upper left-hand corner. Like leftist politics, modern styles such as abstraction, cubism, and surrealism are also more evident in WPA/FAP prints than in other project media (except perhaps easel painting,

which has been less studied); leftist American artists were interested in exploring the use of non-realist styles to enhance the emotional impact of the political messages in their art.

Illinois Art Project supervisors mailed about one quarter of each government print edition to Washington, D.C., for inclusion in national exhibitions.[2] Other prints hung locally at the Art Institute of Chicago, the Illinois Art Project Gallery, and tax-supported spaces such as schools, hospitals, libraries, and military buildings. When the WPA/FAP closed in 1943, major collections of prints went to Illinois institutions, including the Art Institute of Chicago and the Illinois State Museum in Springfield. The Mary and Leigh Block Museum of Art at Northwestern University acquired a group of prints saved by a Chicago public school art instructor from destruction during the 1950s.[3]

Machine Fodder,
Carl Hoeckner, c. 1940,
lithograph.

Susan Weininger, a Chicago art historian, has focused years of research on the Illinois Art Project's Easel Painting Division and offers the following overview.—H.B.

Government-Supported Easel Painting in Illinois, 1933–43

by Susan Weininger

The easel paintings produced in Illinois under the government-supported New Deal art projects were, like many of the other paintings produced in the area during this period, representational and easy to read. Unlike the work made under the more tolerant and open conditions in the New York project, for example, the paintings produced in Illinois were moderate rather than radical, figurative rather than abstract, and adhered to the mandate to treat subjects depicting the American Scene. As of January 1940, three years before the program was officially terminated, nearly five thousand easel paintings were produced, only a small fraction of which can be located now.

Increase Robinson, a Chicago artist and gallery owner supportive of progressive artists, was involved in the leadership of the project in Illinois from its initiation, serving as state director of the Illinois Art Project from 1935 to 1938. The character of the project in Illinois was determined in large part by Robinson's strong ideas and commitment to quality, rather than need, in hiring artists for the project. Like many others in America in the 1920s and 1930s, she felt strongly that art should "make a lively record of our time and place" without any provocative political statements, European-inspired abstraction, or nudity. This attitude is reflected in the relatively conservative quality of the work produced for the Illinois Art Project. Some artists were unable to work under these conditions. Paul Kelpe, for example, a European-born and -trained artist who was employed briefly on the Illinois project, found it so difficult to modify his own abstract style to fit the strict state requirements that he moved to New York, where he was able to work in his avant-garde mode.

The estimated 227 artists making easel paintings for the Illinois project had to submit one moderate-size painting per month to earn the approximately $94 monthly salary.[20] They could work at home or in a communal studio space. Since most of them were able to produce more than one painting in this time, they could choose which work the project would get—some would give their best effort, some their

least successful effort, some simply gave the first thing that they produced that month. Any work that an artist could sell once the commitment to the government was met meant additional personal income, but it also threatened continued employment should enough be earned to lose eligibility for relief. Various tax-supported institutions—primarily schools, libraries, hospitals, and state, county, and municipal government buildings—were then able to acquire these paintings for the price of materials.

Initially, the government specified that ninety percent of the artists employed had to be on relief rolls; although this was later changed to seventy-five percent, Robinson often bent the rules to accommodate artists whose work she thought worthy of support, even if they did not meet the test required for relief eligibility. Herman Menzel, ineligible because his wife had a full-time job, was invited to submit a painting in 1936. Menzel painted two versions of the red lighthouse that once stood at the end of a pier in Lake Michigan; his wife thought they were too good to be given to the Illinois Art Project, so he produced a third one that he submitted.

Despite the generally conservative milieu, there was some variety in the subjects and style of the paintings done for the Illinois project. Many of the artists painted images that glorified small-town life in America or the potentially productive and fertile farmlands of the Midwest. Examples of images that embodied the possibility for recovery from the disaster of the Great Depression are numerous and are found in the work of artists ranging from Aaron Bohrod

History of the New World: City Life, *Ralph Henricksen, 1938, oil on canvas, Partee Academic Preparatory High School.*

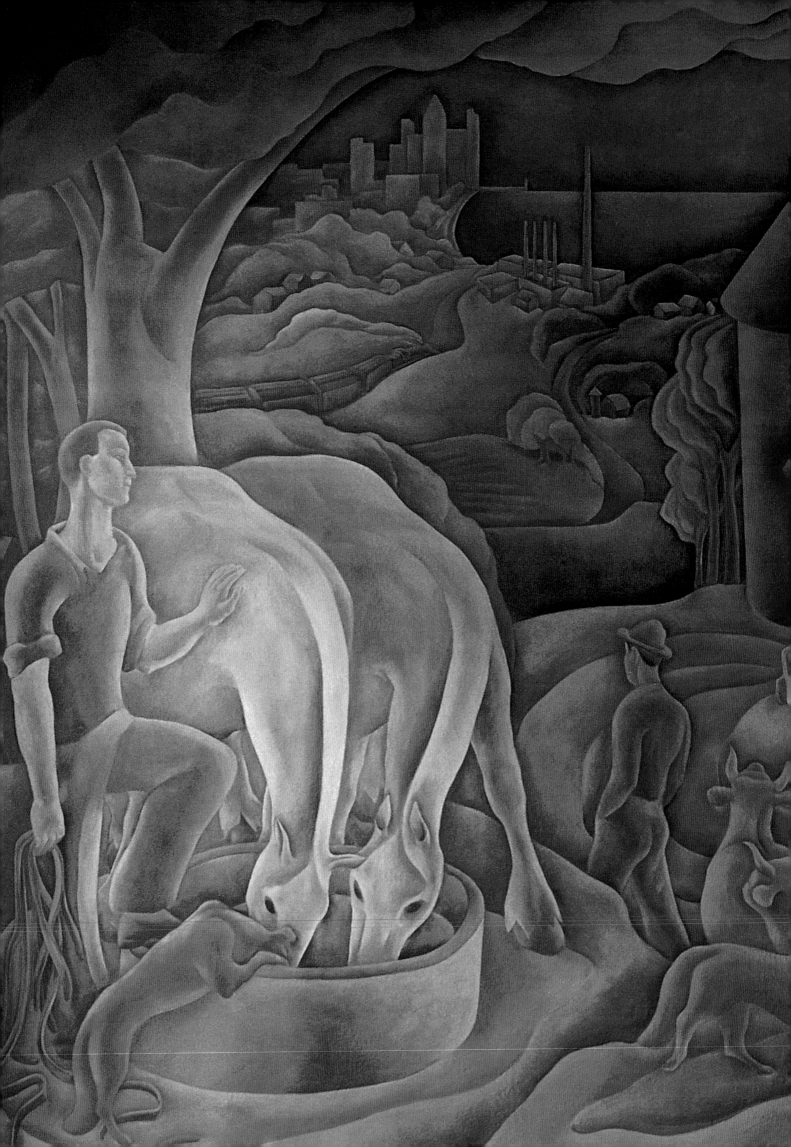

to William Schwartz to the much more idiosyncratic Gertrude Abercrombie. Abercrombie credited the WPA/FAP with starting her career as an artist. She was twenty-five when she was employed by the PWAP; she also had a job at Sears drawing gloves for their catalogue. Her subsequent employment on the Illinois Art Project, with a $94 paycheck every month, enabled her to move out of her parents' home into her own apartment and provided her with validation of her talents and worth as an artist, giving her the confidence to pursue painting professionally. She is an example of the success of the program in achieving one of its aims—sustaining and enabling artists to survive and develop during a time when there were no other outlets for selling their work.

Other artists in Illinois produced work that stressed the correction of social ills, in a mode known as social realism, which was popular in urban areas. Bernice Berkman, Charles Davis, Edward Millman, Archibald Motley, Jr., and Mitchell Siporin are among the many artists who detailed grim realities of the period in their work. Artists such as Gertrude Abercrombie, Macena Barton, Raymond Breinin, Julio de Diego, and Julia Thecla began to develop a kind of quirky, personal idiom that flourished in Chicago beginning in the 1930s. Like other artists employed on the projects, these midwestern "surrealists" modified their work to suit the prevailing norms of the projects. And although their most imaginative and idiosyncratic work was not done for the government, the support they received allowed them the time to begin to develop their personal vision of the world.

Windswept Barn, *Edward Millman, c. 1930s, egg tempera, Easel Division of the Illinois Art Project.*

The paintings produced on the Illinois Art Project, like those done elsewhere in the United States during this period, attempted to communicate clearly and simply values that were considered typically American—hard work, cooperation and teamwork, and dedication to the farms and towns that were the foundation of the country. These values—the very qualities that would insure that the country would emerge from the disaster of the Depression—were conveyed to audiences of ordinary people who saw these pictures on a daily basis, giving them reason for optimism about the future.—S.W.

Classroom Scenes *(image 2), Ethel Spears, 1937, oil on canvas, Kozminski Elementary Community Academy.*

Facing page: Spring, *Mary Chambers Hauge, 1937, oil on canvas, Dixon Elementary School.*

The Illinois Theater Project and Writers' Project

by Studs Terkel

Historian Studs Terkel, who was employed on the Illinois theater and writers' projects, documents how the various art projects mingled.—H. B.

I think one of the most exciting periods in the world of art in the United States was during, believe it or not, the Great American Depression. The government stepped in when free enterprise, as we know it, fell on its fanny. The trade paper *Variety* headlined "Wall Street Lays an Egg" when the crash occurred in late October 1929, and the Depression followed. There was a big agricultural depression before the market crash, but the Great Depression officially began on that October day.

The big boys, whom we quote today, hadn't the faintest idea what happened and the government saved their butts! In fact, the government saved the daddies and granddaddies of those who most condemn Big Government. Ronny Reagan's father got a job with the WPA and saved his self-esteem as well as life, I suppose. In any event, there was a big project called the WPA. It was an acronym for the Works Progress Administration. It was a case of the government stepping in and creating jobs as private enterprise objectively pleaded, "Oh, please, Uncle Sam, save us!" This, we have forgotten.

The government provided work where industry and private companies could not. There was the building of roads, schools, highways, but there was also an arts project involving theater, music, writing, and the visual arts. For a time, you could pass through post offices or Lane Tech High School and see wonderful and marvelous murals on the walls. The government employed the artists and they received enough money to live on.

One of the most exciting projects, of course, was the Federal Theater Project. Chicago and a number of other cities had WPA federal theater projects. New techniques were employed. The government hired actors and directors. Orson Welles was one of them. He created some marvelous stuff, such as *Black Macbeth*. Welles also created and produced a marvelous story by Mark Blitzstein called *The Cradle Will Rock*, a folk opera. A new form of theater, equivalent to multimedia theater today, called "Living Newspaper," came into being.

All sorts of plays were produced that might not have existed.

People came to see plays, and many of them had never seen a play. They paid the minimum price, 25 cents. Vassar graduate Hallie Flanagan, who was head of the Federal Theater Project, writes in her memoir *Arena* of certain moments in small towns where poor white and black people were seeing live actors for the first time in their lives! I remember one troupe performed Shakespeare's *Twelfth Night* for a farm group of poor people. After the play ended, there was a silence and the actors thought they had flopped. It wasn't the case. The people came back to say they were so moved and ready to applaud but they thought they might interfere with the actors! This is what the federal theater and the federal arts projects were about.

I became a playgoer at an early age. When I was about fourteen, press agents at the theater near my hotel would give me a couple of tickets if I would put up a poster of the play that was forthcoming. There were also some art movie houses around that theater near the Loop so I saw all kinds of stuff at an early age. I didn't very much want to be a participant in the plays. My dream was to have a 9 to 5 job. All the Depression children wanted a 9 to 5 job, civil service preferably. With a 9 to 5 job, I could still see plays, movies, and baseball games.

When I realized I wasn't cut out to be a lawyer, I became involved in the Federal Emergency Relief Administration, or FERA. There I met a certain guy who was directing a play called *Waiting for Limpty* by Clifford Odets. He was the playwright for the Group Theater in New York. The play told the story of a taxicab strike. I was at the theater visiting this director friend of mine, and during rehearsals the actor never showed up. I went on stage to read something and the director said, "You got the role!" I was not a member of the WPA actors. Soon after, there were radio soap operas in Chicago. I became a gangster on them: "Ma Perkins," "Mary Martin," and "Love after 35," by Helen Trent, subtitled "Can a Woman Find Love After 35?" And I played the same role. The scripts

were all the same. I was the gangster. That's how I broke in as an actor.

I joined the Federal Writers' Project later in 1939. Nelson Algren, Richard Wright, and Saul Bellow belonged. Many of us found our "golden moments" during that period. I became part of the radio division of the Writers' Project. We scripted radio projects for the Art Institute. One of our missions included radio scripts of certain artists. We worked with curators. There were scripts about Albert Pinkham Ryder, Winslow Homer, Thomas Eakins, Honoré Daumier, and Vincent van Gogh. You could hear them performing at WGN, the Colonel McCormick station. The irony is that he loathed Roosevelt and the WPA. Yet on his very station they would carry the program! The colonel wrote a letter to our supervisor describing how much he enjoyed the program. I'm convinced this was before he heard the credits at the end. The credits were the WPA and the writer, as well as Harry Hopkins, the head of the WPA. Colonel McCormick despised Hopkins more than Roosevelt. I'm convinced he fell asleep before the credits came on and that's why he liked our program!

Later on, when I became an actor, I joined Actors' Equity, of course. I was a member of AFRA, the American Federal Radio Artists, and later a member of AFTA, the American Federal Television Artists. There's a 1939 photo of our very first meeting in Chicago and I have black hair! Lawrence Tibid made the initial speech. He was a great opera singer and a very strong union man. Even though it came out of a terrible thing called the Depression, I feel the time was a very great moment in American cultural history. Strangely enough, it was a glorious period in American culture. I can't describe how it affected my personal career. It tremendously altered my life. The time was very exciting. Everything converged, the Depression, the New Deal, the Arts Project, the Federal Writers' Project, the Federal Theater Project, all at one moment. Being with my companions and hearing my scripts performed over WGN highlighted my involvement. It changed my life, of course. I hope for the better! We forget this. We forget we're the only country in the world that does not have state-subsidized art. All countries do, except the United States. During a moment of crisis the government, in the hands of enlightened people, of course, came through.

Remembrance of this period is the most important thing I can do. I have all these hours of tapes

including people who were on the WPA arts project and others. These voices recount that terribly exciting moment. We have preserved those tapes at the Chicago Historical Society for students to refer to.

The murals that were created by artists on the WPA/FAP are still to be seen at certain post offices and schools. Although many of the murals have been destroyed by developers, those that remain must be retained because of their relationship to the Great Depression—that must not be forgotten.

The murals in Chicago Public Schools should remind students that the government can do things. We don't have to depend on private charities or private companies for the arts. It is something that enriched us all. It is just as important as a post office or matters of health because the arts enrich our lives if performed or created well. Young people must remember having artists at work is terribly important. The government can step in as it has in many countries of the world, yet we are the poorest when it comes to subsidizing the arts.

The History of Writing: Illuminated manuscripts of the Middle Ages, Gustave A. Brand, 1939, oil on canvas, Schurz High School.

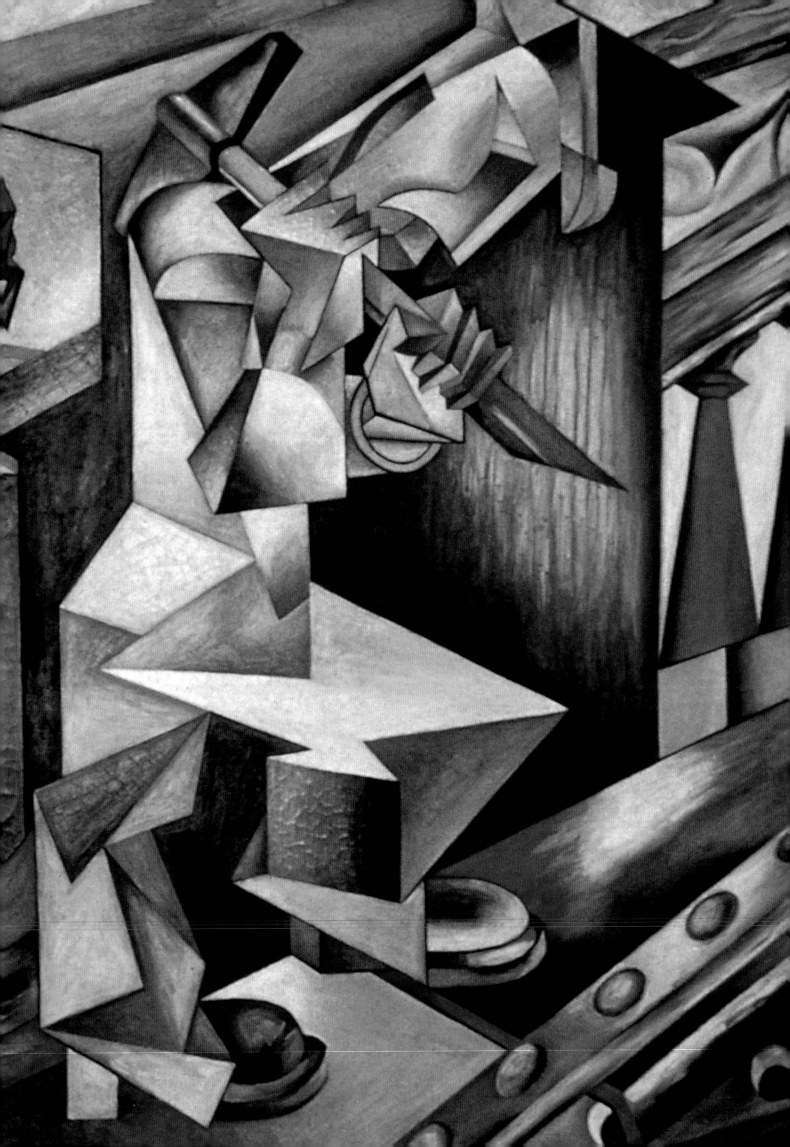

Styles and Themes of the Chicago Mural School

by Heather Becker

On a national scale, WPA/FAP murals were allocated for schools, hospitals, colleges, libraries, and government buildings. Before long, there was a waiting list for murals throughout the country. According to the historian William F. McDonald, "A token of the popularity of the mural and of the general acceptance of the project's standards was the demand on the part of institutions for their installation. Throughout the life of the project requests consistently outran the project's ability to fulfill them, and at the close of the Federal Art Project a backlog of orders had been accumulated that would have occupied its workers for a considerable time."[1] By the end of the Federal Art Project in 1943, experiments had been undertaken to find faster ways of producing large-scale murals, and Chicago was at the forefront of this endeavor.

Commissions began with an institution's request for a mural. The institution was responsible for the cost of supplies; the federal project provided everything else. Mural supervisors such as Gustaf Dalstrom and Merlin Pollock met with potential sponsors to discuss ideas, potential artists, and logistics. Once an artist was chosen, representatives from the sponsoring location met with him or her to decide on style, subject matter, and theme. For schools, this was commonly the role of the principals and art teachers. Cartoons or sketches were created and approved by the Illinois Art Project art director, advisory committee, and the sponsoring location. Procedures were always prefaced with a directive from Holger Cahill insisting the artists' interpretation of the theme be given equal consideration, while not jeopardizing the quality of the work produced.[2]

Chicago muralists included Aaron Bohrod, Edgar Britton, Gustaf Dalstrom, Florian Durzynski, Roberta Elvis, Ralph Henricksen, Thomas Jefferson League, Edward Millman, and Archibald Motley Jr.[3] Some of the Illinois Art Project muralists became nationally known. Because of their artistic ability, the Treasury Section

offered some Illinois project muralists commissions in other states. From 1935 to 1943 the Illinois Art Project allocated 316 murals, of which 233 were completed throughout the state (849 nationwide). Out of the 233 WPA/FAP mural locations completed in Illinois, approximately 150 still exist today.[4]

Our on-location visits to a few hundred original mural sites revealed a diversity of subject matter and style. The American Scene and social realism describe two areas of subject matter found in 1930s art. Subjects were rendered in several styles, ranging from literal to those reflecting Mexican, cubist, abstract, or surrealist influences. By the 1930s artists were searching for what was American in a variety of formal styles and subjects.[5]

Artists in the U.S. began severing ties with European art traditions opposing the idiosyncratic individualism and European art associations of the 1920s. Societal changes during the late 1920s initiated a need to differentiate America's cultural identity from that of Europe. Socially and politically the movement "attests to the dilemmas of a country caught between conflicting standards of values, as rural America

was on the wane and urban America on the rise."[6] Artists began a genuine quest to capture and define what was happening around them, whether realistically confrontational or radical in style.

Edward Millman in front of his mural, The Blessings of Water, *1937, fresco, City Hall, Service Center, Chicago, Works Progress Administration Federal Art Projects photograph.*

Park and Country Scenes, *Ethel Spears, c. 1930s, oil on canvas, the University of Illinois Medical Unit, Girls' Ward.*

Facing page:
Contemporary Chicago *(detail), Rudolph Weisenborn, 1936, oil on canvas, Nettelhorst Elementary School.*

A Market Perspective on New Deal Art

by Robert Henry Adams, Chicago historian and art dealer (1955–2001)

The artists of the New Deal celebrated American life on a human scale. The work is a truly democratic form of art, accessible to all who encounter it. One sees radical differences in style and subject matter from artists who were working simultaneously: styles such as regionalist, abstract-geometric, precisionist, surrealist, and magic-realist; subjects as varied as industrial scenery, rural landscape, the common laborer, a Midwestern homemaker, a social protest, and a county fair. One of the most wonderful legacies of the WPA/FAP is this variety of visual experience.

A certain artistic democratic ideal succeeds in the works of art created during the New Deal because the heroes of many of these paintings are not lofty, mythic figures from ancient stories, but recognizable characters from the drama of our own lives. Eternal human questions are not addressed by depictions of the supernatural, but in the small moments: diner life, pick-up baseball games, the small farm, or neighborhood block life. A degree of nostalgia comes into play when viewing these paintings, as contemporary life is now so dominated by corporate structures and expressions of a generalized, mass culture. The images from the WPA/FAP stem from communities of people with shared, local experiences. However, these depictions of the American experience were not always celebratory. Even when the subjects are difficult to confront, portraying the downtrodden and the less fortunate, we embrace the necessity to look and remember. The paintings are a record of American history that we have to acknowledge, especially during times of prosperity, with hope that our society and culture have evolved.

As an art dealer, I can report that during the last few years the frequency of requests for works from this period has increased dramatically. The interest comes in part from new scholarly and critical contributions and efforts to restore and preserve existing public works in their original locations. The interest also stems from new attitudes about our country's past and its metamorphosis into an urban culture. The public continues to gravitate to the scenes of social life of the 1930s for nostalgic reasons and on the basis of the works' merit. The restoration of this city's murals and the focus on historic Chicago artists are an inspirational part of an evolving American democratic experience.

Colonial Settlers with Native Americans, *unknown artist, 1940, oil on canvas, Penn Elementary School.*

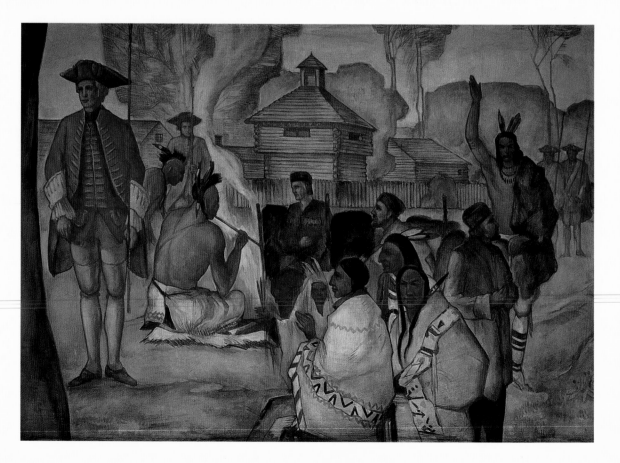

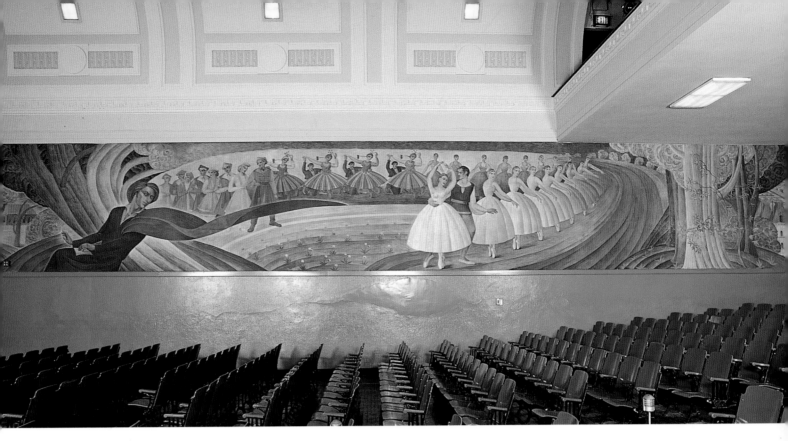

and the visual arts and try to establish American analogs (Stephen Foster in the same breath as Chopin), Siporin presents schoolchildren as artists whom he shows playing the violin, painting at an easel, and presenting theatrical performances. Siporin's monumental murals promoted the importance of the arts in the education of all students, including those in vocational and technological schools.

The themes and subjects of Chicago's New Deal murals portray values and experiences such as hard work, education, and social service, which were perceived to be central to American culture during the 1930s. While today's students might appreciate the murals that decorate their schools, they also express that they feel some distance from the scenes. Students articulate a desire to see more imagery that depicts them, including their many races; most images present European Americans as the protagonists, and in doing so neglect a holistic sense of American history.[33] For murals to be enjoyed and understood, the lessons on the walls must be integrated into art rooms and classrooms, and made part of the daily experiences of students.—D.L.L.

Intrinsic Value

America's cultural "coming of age" converged in American imagery by the early 1930s.[34] R. L. Duffus wrote in 1928, "there can be no doubt that America, having expressed herself politically, mechanically and administratively, is on the point of attempting to express herself aesthetically. This has been thought

before . . . but now one begins to believe it true."[35] The guideposts of American Scene imagery were American heroes, myths, moods, patterns, experiences, and aspirations.[36] The Chicago muralists portrayed them with vitality. Their powerful depictions were the coalescence of environment, artistic talent, social turmoil, and timing.

Many forms of American culture can be found on the walls of the Chicago Public Schools; the children of Chicago have museums in their midst, potentially spawning personal investigations, inspirations, and individual strengths. The inspiration of the Illinois Art Project muralists to reveal the essence of America has been traced in research and preservation efforts, but art education is the true fountainhead of this collection. The once ignored, defaced, water-damaged, and deteriorated murals are now recognized for their intrinsic value as expressions of American culture. The Windy City has discovered public art's untapped well; the future of this resource lies in the outgrowth of arts education.—H.B.

Frederic Chopin, *Florian Durzynski, 1941, oil on canvas, Chopin Elementary School.*

My Involvement as an Artist in the WPA/FAP

by Lucile Ward Robinson (written in 2000 at age 94)

From left to right: unknown, Carter H. Harrison, Lucile Ward, and George Thorp.

Mural projects also changed the lives of many painters. Historians, administrators, and artists have noted that the Illinois Art Project played a prominent role in building and sustaining artists' careers. Many artists had positive experiences with the WPA/FAP.[1] The project afforded artists the ability to continue making art during the Depression. It gave women and black artists an opportunity to establish their place within the art community. It also provided young artists the encouragement to continue their careers. Illinois Art Project muralist Rainey Bennett attests, "In the 30s, the government art projects were the place for an artist to be. That's where everything exciting was happening."[2]—H. B.

In 1929, at the age of twenty-three, I came to Chicago from Hermann, Missouri, a small town steeped in German tradition about ninety miles west of St. Louis to pursue formal art studies at the world-renowned School of the Art Institute of Chicago. Prior to this I had completed my college studies in liberal arts at Lindenwood College in St. Charles, Missouri, and had employment as a tutor and governess for the young teenage children of a leading St. Louis family.

Unfortunately, at the very time that I moved to Chicago and enrolled at the Art Institute to pursue my formal art studies, America was teetering on the brink of the Great Depression! In 1935, as the Depression deepened and with it widespread unemployment, the Franklin D. Roosevelt administration established the Works Progress Administration. Fortunately for me, this initiative led to the creation of the Federal Art Project (WPA/FAP). At the state level in Illinois, the Illinois Art Project formally coordinated such activities. A well-known Chicago art gallery owner spearheaded the early efforts of the Illinois Art Project—a woman by the name of Increase Robinson (no relationship to my eventual husband, Roy Robinson).

Via my contacts at the Art Institute (having by then completed my fine-arts degree there), and in Chicago art circles, I was introduced to Ms. Robinson, and was offered a position as easel painter/muralist. Shortly after, I was assigned to my first project—the creation of a series of murals for the kindergarten room of Pasteur Elementary School on Chicago's southwest side. This was followed by similar assignments over the succeeding

five years, most even grander in scale and complexity (Harrison Technical High School [now Saucedo School, the murals are gone]; Morrill Elementary School; Sawyer Elementary School; and Cook County Children's Hospital). The assignments ended when the Illinois Art Project's activities were wound down about 1941–42, as America successfully emerged from the Depression and the "winds of war" (World War II) were strongly blowing! I had also recently married (in March 1941) a Chicago businessman, Roy Henry Robinson, and in my case would have no longer been in a position to devote full time to my previous mural activities, enjoyable as they had been.

By way of brief insight into the day-to-day functioning of the WPA/Illinois Art Project, from the outset I can assure you that I and all of my WPA/FAP art colleagues at the time were extremely grateful to find such employment, particularly in our field of expertise and training, while many others throughout the country remained unable to find employment of any kind. As I recall, we were only paid a salary of about $90 a month and did not have recourse to unionization, but this was a lot better than what millions of others were experiencing during those difficult years!

The work was very rewarding in a number of important respects. There was a considerable degree of flexibility in how the assignments could be carried out, with little or no interference from a governing bureaucracy. For example, the Illinois Art Project would simply determine locations for my murals, without any detailed brief. I was then given completely free rein to proceed on my own initiative. I would choose my own subject matter (occasionally involving detailed historical research, particularly as in the cases of Saucedo and Sawyer), undertake complete design work, and then paint the murals in their entirety myself.

There was also a feeling of strong camaraderie with my Illinois project colleagues; many remained lifelong friends. There was a true sense of common purpose in making what we firmly believed to be meaningful contributions to the artistic and cultural heritage of our nation. Although there were many skeptics and naysayers at the time, history by now would appear to have fully vindicated our view. In this same context, and on a personal level, I am of course thrilled that most of

my own works have been preserved, and that they are now in the process of being professionally restored. I am of the firm opinion that many of the extant works undertaken by Illinois Art Project artists make a lasting contribution to the artistic heritage of our nation.

During the Illinois Art Project I made many of the greatest friends of my life—far too numerous to mention here—both among the artists themselves and among other people connected with the individual projects. A few stand out in my mind. Within the Illinois project itself, one of my closest colleagues, who was liked and respected by one and all, was George Thorp. He succeeded Increase Robinson and was in charge of the Illinois Art Project from about 1938 to 1941. George, who was a sculptor by training, was not only a highly effective administrator but also, in every sense, an "artist's artist." It was felt that he truly represented all of our interests, and he was politically adept when it came to dealing with the impersonal government bureaucracies—even with the sweeping budget cutting and reallocation of funds that began to be experienced during his tenure. When he finally decided to move on, he was greatly missed.

Other of my particularly close Illinois Art Project colleagues included Frances Badger, Ethel Spears, Mildred Waltrip, Fred Biesel, John Fabian, Hildegarde Crosby Melzer, John Stephan, John Cadell, Emannuel Jacobson, John Walley, James H. Clopton Vail, Addis Osborne, Rainey Bennett, and Don Vestal, but there were of course many more, and many of these have remained close friends ever since.

As I look back now, the Illinois Art Project period undoubtedly represents one of the happiest and most productive periods in my life. As a relatively young woman, I was meeting many interesting, kind, intelligent, and talented people; gaining a great deal of confidence, experience, and knowledge; and, I am convinced, immediately and directly participating in what will eventually and unambiguously be recorded as a genuine "Landmark for the Arts" in the history of America!

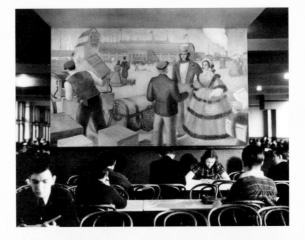

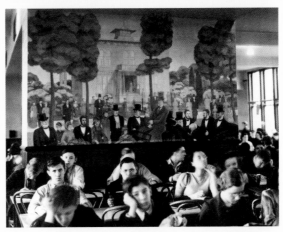

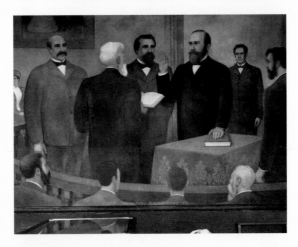

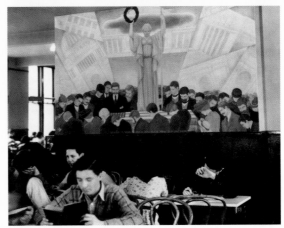

The four Lucile Ward murals for Harrison Technical (now Saucedo) were destroyed:

(a) Carter Harrison Sr. and his wife arriving in Chicago from Lexington, Kentucky, in 1855.

(b) Harrison Sr.'s return from Washington, D.C., in 1878 after serving in Congress.

(c) Harrison Sr. being sworn in as Chicago Mayor.

(d) Harrison Sr. as Governor Altgeld presents the key to the city to a descendant of Christopher Columbus at the opening of the World's Columbian Exposition of 1893.

The WPA/FAP's Impact on Arts Education

by Heather Becker

Education that placed art at its core was central to the mission of the Progressive and New Deal eras. Discussions in community art centers, exhibitions, galleries, and art classes made concrete the period's philosophy of bringing art to the public, and especially to children. "The glory of the [community art] centers lay in their children's classes, for if art instruction meant a leisure time activity to most adults, to children it represented a primary and, as the project soon discovered, a necessary form of expression . . . children, with that simple spontaneity that distinguishes their character, immediately made the center their home," said William F. McDonald.[1] The children's classes were "directed toward making the child's contact with art an enjoyable experience and an adventure in self-expression . . . the object of these classes was not to develop artists but to provide the child with an aesthetic experience."[2] The art centers allowed young and old an opportunity to participate actively in the arts.

The Chicago Public School murals remain symbols of these Progressive and New Deal–era goals; the murals are teaching tools that will help restore arts education where it has been absent in our public schools. Kevin McCarthy, former principal at Clissold

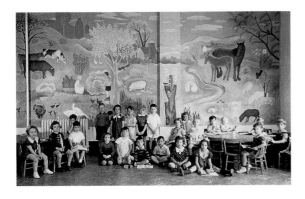

Elementary School, which houses murals on the history and folklore of the region, says, "It is very important that we educate children, and that is more

than math, science, history, and English . . . the arts are the way we transmit our culture. Our mural is an excellent example of the commitment of our city to preserving the fundamental framework of art education."[3] The arts are a necessary part of a well-rounded

education, and it is important that the arts be connected with broader educational goals. Gery Chico, former president of the Chicago Board of Education, also says, "Education is not simply about reading, writing and math . . . the total student is what we are after. We have to teach an appreciation for art, music, literature."[4]

It is becoming increasingly difficult to prepare children for life and work challenges in a global society. Arts education expands a traditional learning environment and can be used to help young children deal with the rapid growth of societal demands. The arts teach students different ways to communicate and connect with others in society. Discovering art from different times and places, appreciating the artistic achievements of others, students are better able to distinguish different cultures and periods of history. The arts also further develop perception, conceptual and cultural understanding, and personal expression. They also support children's many different ways of experiencing and understanding the world.

Evolution of the Book,
Peterpaul Ott, 1934–36,
carved mahogany reliefs, in
the library with students
at Lane Technical High
School.

Rural Landscape, Gustaf
Oscar Dalstrom, c. 1930s,
oil on canvas, with students at Laurel School,
Wilmette, Illinois.

Facing page: **The Alphabet**
(detail), Lucile Ward, 1937,
oil on canvas, Pasteur
Elementary School.

History of Books,
Gustaf Oscar Dalstrom,
1937, oil on canvas, detail
of section 15 cleaned on
the right half, Bennett
Elementary School.

Connecting the arts with other disciplines such as math, writing, reading, and science often assists students' comprehension, because they are learning in creative ways. Integrating the arts into other disciplines encourages students to stretch their limits by experimenting with different ways of thinking. The arts make learning fun, interesting, and tangible. If a student is comfortable in his or her learning environment, confidence and awareness can be enhanced, naturally accelerating educational goals.

The Chicago Public School murals also make children proud of their school environment. Anna Waywood, a teacher at Sawyer Elementary, which houses murals on the history of Chicago, has said, "We absorb our environment, and in today's world there is so much negativity. The children are always bombarded with these negative elements of the world around them. I think it is very important that adults bring attention to special things like these murals, so the children can really learn to observe, and take in the wonderfulness of their environment."[5] Many children have commented on how much they enjoy having museum-quality murals in their school. Jonathan Butler, a student at Nettelhorst Elementary, remarked, "The mural is inspiring. I was very moved by our painting. I see that Weisenborn [the artist] painted about Chicago's history. My favorite part is the man working on the railroad."[6] Another student, Giovann Raymond, wrote, "I like our WPA mural. It is a wonderful painting! It is the kind of mural that makes me think about Chicago and its wonders."[7]

As outlined in Chapter 1, Flora Doody initiated the art education program in 1994 at Lane Technical High School with class curriculum studies based on the school's murals. She also started a student docent program. The concept was expanded in 1996 by the Art Institute of Chicago's program *Chicago: The City in Art,* working with eleven schools to integrate their preserved murals into language arts, math, science, writing, and social science classes. Robert Eskridge, director of museum education, has stated, "Our goal is to help teachers understand the factual history behind the form and subject matter of these murals— but more importantly, it is to stimulate an imaginative response to them and make them part of the class curriculum."[8] Mary Ridley, one of the teachers involved in the first *Chicago: The City in Art* program, remarked, "The kids are seeing a piece of history in their school being respected. Today, people, property, and history don't get the attention needed. This experience has been worth the attention."[9]

The preservation process has also initiated a level of excitement leading to independent school efforts. When the murals were being restored at Clissold Elementary School, in the neighborhood of Morgan Park, the students became so interested in the preservation of their murals the school decided to base a play on their history. The play was performed during an unveiling ceremony of the restored murals. Katherine Kampf, a teacher and director of the play at Clissold School, remarked, "We could hardly resist doing something that would include the murals, so the kids could understand what it was like in the 1930s. What the Depression was. What the WPA was. We always try to integrate art and history into our other subjects but it does not always work. This worked."[10]

American Scenes,
Hubert C. Ropp, c. 1920,
oil on canvas, Parkside
Community Academy
Elementary School.

Going to School Surrounded by Art

by Maria Gibbs, Lane Technical High School graduate, class of 2000

Maria Gibbs was one of the first students involved in the educational programs initiated at Lane Technical High School. She offers her perspective on how the arts education programs affected her as a student in the Chicago Public School system.—H. B.

I'd like to tell you about my experience as a docent during the four years that I have attended Lane Technical High School. I entered Lane as a freshman in the fall of 1996. Having graduated from an elementary school populated by only 550 students, the size of the building as well as the number of people filling the halls made me feel like an ant in New York City. However, it didn't take me long to find my niche at Lane.

I quickly became involved in the Stage Crew and the Arts Fellowship Club. Backstage, I learned to work patiently with fellow students as well as adults of various characters. I also learned how to take on the role of leadership. I was appointed the crew chief my junior year and continued with the position through senior year. It was rarely an easy job, but it taught me how to be responsible and to look out for the safety and interests of others.

In Arts Fellowship, sponsored by Mr. Vernon Mims, I was able to socialize with other students who enjoy the arts, as I do. We discussed poetry and music, as well as drama, paintings, and sculptures. We went on field trips to museums and plays, and worked on a number of simple projects during the meetings. It was through Arts Fellowship that I met Mrs. Flora Doody and became a Lane docent.

I had already noticed the beautiful paintings that adorned the hallways and different rooms of the school, but I had no idea where they came from or their histories. Mrs. Doody had recently begun a tour program that would provide part of the funding for the renovation of the school's artwork. She was looking for tour guides and came to our club because there she would find students who were already interested in such programs. At first Mrs. Doody showed a video about the collection and explained how she came to learn about the artists and, in some cases, their relationships to the WPA. She later guided us on several tours of all the artwork, teaching us, first-hand, how to be docents. We were given written material to study

as well. After learning so much about what hung on the walls of my school, I was overwhelmed.

I couldn't believe that there was so much beauty all around me and very few people in the school, including teachers, knew anything about it. They would pass through the halls day in and day out, and barely ever glance up. When I conducted my first tour, I had a partner docent, and we worked like that for the next few tours, but I was still very nervous. That nervous feeling slowly diminished as I taught more and more people about the treasures of Lane Tech. It was the knowledge that I was helping to spread Chicago's cultural awareness and make known the necessity for its preservation that allowed me always to work with a smile on my face and a confident attitude. These are the traits Mrs. Doody helped to bring out of me.

During junior and senior years, I served as the Arts Fellowship Club's president. I wanted to teach club members what I learned as a docent, and I want them to continue the tradition of the Arts Fellowship-Docent relationship. I led them on tours of the building, and next year many of them will be training with Mrs. Doody to become docents. While working backstage, I would always take the opportunity to talk to someone who was performing or even to the other stage crew members about the John Walley fire curtain in the auditorium and the four frescoes, *Teaching of the Arts*, in the auditorium's foyer.

I believe what affected me the most as a docent were the paintings above the library and along the walls of the first floor. These works portray hard-working Americans doing their best to make a living and put food on the table for their families. This affected me so much because I know that most of these Americans were actually immigrants from other countries . . . I myself am an immigrant, like the rest of my family, and I can definitely relate to the hardships they went through . . . in some ways, I feel as if I am also building a foundation for the next generation.

Integrating the Murals into Class Curriculum

by Diane Chandler

In February 1996 a resolution was passed creating an innovative partnership between the School Reform Board of Trustees and the arts education community of the City of Chicago. The resolution affirmed the study and practice of the arts in Chicago Public Schools (CPS) as a critical component in the academic, social, and cultural education of its students. It stated that CPS students are entitled to comprehensive and sequential instruction in the arts that meets national, state, and city educational standards. This resolution reinstated the arts as an important element in the education of our youth. In the Spring of 1996 the Arts Education Task Force was appointed by the CPS administration, co-chaired by Maggie Daley, Chicago's first lady, and commissioner Lois Weisberg. At the same time, the Bureau of Cultural Arts, a new division of CPS, was established.

The goals of the Bureau of Cultural Arts, currently housed in the Office of Language and Cultural Education, are twofold: 1) to provide a broad

These goals, under the guidance of former board president Gery Chico, the School Reform Board of Trustees, and former chief executive officer Paul Vallas, have fostered a renaissance of arts education in CPS. This vision has promoted the growth of arts partnerships, programs, and services throughout the system by utilizing arts training and arts appreciation as key tools to assist with the task of providing quality education. It reinforces that an education of the "whole child" requires the arts to be a vital component of the student's educational experience. The continued role of the arts, as an important component of the holistic education of our children, is a commitment also endorsed by the new administrative team of CPS, headed by board president Michael Scott and chief executive officer Arne Duncan.

The murals of CPS are of historic and artistic significance. Painted by artists from the Illinois Division of the Works Progress Administration–Federal Art Project (WPA/FAP), these murals provide the perfect backdrop for unique and exciting learning experiences and instruction. In 1998 a team of CPS teachers, artists, and consultants convened to develop a comprehensive arts curriculum, the *Chicago Public Schools Fine Arts Standards*. This document was developed according to state standards, benchmarks, and performance indicators. Its mandated goals and standards are an excellent resource to facilitate critical and analytical thinking skills.

The Office of Language and Cultural Education's Bureau of Cultural Arts in partnership with the Office of Instruction and Curriculum is currently developing the Chicago Public Schools Mural Curriculum. This will allow classroom instructors to further educate their students through the study of the WPA/FAP mural art displayed on the walls of many public schools in Chicago. The curriculum will contain ten lessons of aesthetic, historic, and social significance that can be taught through the study of subjects and techniques found in the murals. Each lesson is designed to develop a student's appreciation for the creative process and the circumstances in which the mural was produced. Each lesson includes biographical

Students with Physical Education *(image 2), Louise Carolyn Pain, 1937, ceramic relief, Luke O'Toole Elementary School.*

range of fine-arts opportunities, programs, and new initiatives resulting in a well-rounded educational experience for the students of CPS; and 2) to enhance the skills of the instructional staff of CPS by offering additional resources and staff development opportunities.

information about the artists; historical background about the era in which the works were created; suggested activities; questions for journal writing and discussion; assessment tools; references; and recommended modifications to suit special-education and bilingual students.

Recognition of these great works would not have been possible without the contributions and assistance of the Chicago Conservation Center and the Art Institute of Chicago. The expertise of these institutions has facilitated the creation of a remarkable teaching instrument for CPS educators.

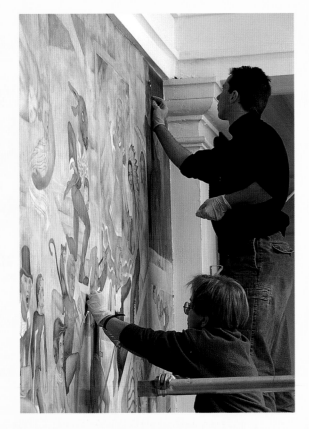

Generations of students will be able to explore, question, and learn from the school murals. This is a legacy of which we can all be proud.

Learning from these artists can inform our thoughts, beliefs, and ideas for the future development of society as a whole. Historically, it has been the artistic expression of the past that has provided a visionary projection of the future. Great revelations and foresight have been gained from an appreciation of the deciphered symbols and pictures left by a previous society. The significance and role of artists and the arts must also be considered as valuable to each generation's development as have been the ongoing advances in science and technology, if for no other reason than as an analysis of the relationship each played in the development of the historical template of events and advances. There are connections and relation-

ships between the arts and all other academic areas that scholars consider of merit.

As documented in the pages of this book, these murals have touched the lives of the many generations of people who have been exposed to them. In viewing these works, we find ourselves asking questions about the nature of artistic expression and creation. What is it that the artist wanted us to understand about his or her work? Each piece requires us to better know the circumstances of the artists. What was life like during the era in which they lived? How are those times different from or similar to the circumstances of today? It has been said, "One cannot know where he is going without knowing where he has been." This simple truth highlights our responsibility to comprehend the past so that we can value the present day and use these insights to carefully craft the future. An understanding and appreciation of the arts are vital for the elevated development of all societies.

What perhaps is the most exciting element of this project is the fact that these murals are a part of the architectural history of Chicago and CPS. On the walls of a vast number of the public schools of Chicago are original works, documenting a specific time and place in history. In the hallways of these schools, where students stroll today, stood historians, storytellers, visionaries, and artists at a far different time. Through what is visible, as well as what is missing, the themes of these murals articulate a story or illustrate a timeless message for the viewer's interpretation. Each brushstroke of the artist, the color and media chosen, produce a visual stimulation for the senses. This type of study and approach are instrumental in creating an interesting learning environment for students. To learn how to appraise works of art as reflections of the past while using them as insights to the present can be extremely empowering for the learner.

As we go forward, I encourage those interested in the development of a well-rounded education for all students to continue to advocate for the arts in our schools. The arts education renaissance we are currently experiencing is still in need of continued support. The previous experience of the arts being cut from our schools locally was also experienced nationwide. Partially, it stemmed from a lack of support and understanding of the importance of the arts in the educational development of the student. Fortunately, recent research demonstrates the need for inclusion of the arts as a vital educational tool in the learning experience of all students.

Dr. Margaret Nowosielska and Christopher Woitulwics of the CCC, preserving the mural attributed to Roberta Elvis, Characters from Children's Literature, *1937, oil on canvas, Bateman Elementary School.*

My Uncle, Mitchell Siporin: A WPA/FAP Muralist

by Noah Hoffman

Teaching of the Arts: Teaching of Music, *Mitchell Siporin, 1938, fresco, Lane Technical High School.*

I came to know my late uncle, Mitchell Siporin, not through the traditional ways a young person might interact with a relative—at holiday gatherings, through correspondence, or even regular phone discussions. My uncle was a distant and nearly mythical figure to me as a kid growing up in the Midwest. In a public school building just a few miles from where I am raising my own children, there exists a group of monumental images he made, permanent as the building itself. Spending four years as a volunteer with the mural education and restoration project at Lane Technical High School gave me the opportunity to get to know my uncle—the artist and the person—in a deeply personal and profound way.

The Siporin murals at Lane Tech, *The Teaching of the Arts,* pay homage to monumental figures in the history of world art and literature—Shakespeare, Walt Whitman, Beethoven—as well as unknown people—an art instructor and a violin teacher—possibly modeled after people from Mitch's own artistic development. What these figures convey is the continuity of artistic heritage and the nurturing of prodigious talent. I believe that my uncle, like many of his colleagues on the government art projects, had strong beliefs that the public work they created would, in some way, go beyond drawing attention to their individual talents and inspire and transform viewers to be participants in both creative and social activism.

Mitchell Siporin, American-born son of Chaim and Jenny Siporin, was raised in a family rich in Yiddish culture and socialist politics. He carried the torch of this potent heritage into the realm of public art. His legacy as an American master of fresco includes murals in two high schools and two post offices, mostly historic visions of the Heartland. Before he reached the age of thirty, he had so impressed the national leadership of the arts projects that his sketches, along with the proposals by his collaborator, Edward Millman, were selected over dozens of more established artists, including the most prominent of midwestern regionalists, Thomas Hart Benton, for the St. Louis post office. The 3,000-square-foot St. Louis murals were the art projects' largest commission. The

frescoes depict the history of St. Louis. This project was the culmination of Mitch's five years as a government muralist, a journey that began in the foyer of the auditorium of Lane Technical High School in 1937.

To paraphrase my uncle, "Art that is important to me should have social significance. Artists should be an important link in every civic enterprise and become an important part of society." The efforts in the Chicago Public Schools to restore their many murals and begin the process of using the murals as a teaching resource are consistent with how many of the muralists envisioned the long-term impact of their labor. A sense of communal ownership has now emerged, and through this process I am hopeful that the arts will be rejuvenated as an integral part of public education.

Portrait of Mitchell Siporin, c. 1937.

Arlyne Cohan, 2nd grade teacher, in front of the John Warner Norton series, **The Months of the Year,** 1924–25, oil on canvas, Peirce Elementary School.

and preservation of the Chicago Public School murals provide insight into a fascinating period of American history. Robert Henry Adams stated, "These are records, images of what we once were, but they also reflect who we are today."[13] The murals tell of American lives prior to and during the Depression and how people survived the experience with a vitality affirmed in their art.

Today, with the preservation of the mural collection in the Chicago Public Schools, teachers and students have their own cultural legacies on school walls that can be used to educate. This can be accomplished with the integration of arts education into class curriculum. Arts education has become a focus of Mayor Daley and the Board of Education, especially since this collection was rediscovered and currently is in the process of preservation. In 1996 Mayor Daley stated, "I believe that nothing is more important to the future of our cities than the quality of our public schools."[14] The mural project attests to these efforts to improve public schools, not only with renovated structures, windows, computers, and books, but also with something expressive and historical lining the walls of Chicago's schools. As writer Dorothy Shipps said, "Chicago demonstrates that with a combination of corporate political resources and big ideas, urban school systems can be radically changed altering the basic relationships between communities and public schooling."[15]

Educational policies are shaped through the interaction of various institutions and individuals. Art programming in Chicago is being shaped today by the Chicago Public Schools, the Art Institute of Chicago, the City of Chicago Department of Cultural Affairs,[16] the Chicago Architecture Foundation,[17] Museums and Public Schools, [18] the Landmarks

Preservation Council of Illinois,[19] the Public Building Commission, the City of Chicago Park District,[20] Art Resources in Teaching, principals, teachers, art educators, and historians. These institutions and people share a goal to create confidence in the current system of public education and better education for the student. Given the degree of politics in public

Teacher and students in front of **Seasons/Young Children at Play,** attributed to Mary Chambers Hauge, 1940–41, oil on canvas, Washington Elementary School.

education nationwide, it is exciting to see, in this instance, all of these parties recognizing the distinguished value of constructing new art programs in Chicago.

The research, preservation, and educational efforts under way in Chicago are being recognized across the country as a model of arts education programming. As with the WPA, the glory of these efforts does not lie in the bureaucracies that have helped bring them about. Instead, the true significance of these art programs endures in the lives of teachers, students, and other audiences who contribute to and benefit from them.—H.B.

Mural Referer

Mural Reference Guide

A List of 437 Murals in 68 Schools

NAME OF SCHOOL	Progressive Era Murals	WPA/FAP Murals	Other Murals	Date of Building
George B. Armstrong Elementary School of International Studies	5			1912
Newton Bateman Elementary School		2		1921
Hiram H. Belding Elementary School		1		1901
Frank I. Bennett Elementary School		5		1928
Luther Burbank Elementary School		4		1929
Chicago Vocational Career Academy High School		14		1939
Frederic Chopin Elementary School		2		1917
Walter S. Christopher Elementary School		3		1927
Dewitt Clinton Elementary School			2	1926
Henry R. Clissold Elementary School		5		1930
Zenos Colman Elementary School			1	1889
Christopher Columbus Elementary School (painted over)		1		1886
John W. Cook Elementary School (painted over)		3		1925
Arthur Dixon Elementary School		2		1929
Laughlin Falconer Elementary School		1		1919
Lucy Flower Career Academy High School		1		1885/1927
Fort Dearborn Elementary School		13		1925–27
Joseph E. Gary Elementary School	3	3		1911
William P. Gray Elementary School	1			1911
John Harvard Elementary School		3		1905
Julia Ward Howe Elementary School		1		1896
Friedrich L. Jahn Elementary School	6			1908
Thomas Kelly High School			3	1928
Kelvyn Park High School	5			1918
Joyce Kilmer Elementary School	4			1931
Alfred D. Kohn Elementary School		2		1911
Charles Kozminski Community Academy		6		1897
Marquis Jean de Lafayette Elementary School	4			1893
Lake View High School (painted over)	13	2		1898
Albert G. Lane Technical High School	50	16		1908/1934
Lincoln Park High School			1	1898
Carl Von Linné Elementary School	1	1		1895
Hugh Manley High School		3		1927–28
Horace Mann Elementary School		3		1926
Roswell B. Mason Upper Grade Center		8		1922

NAME OF SCHOOL	Progressive Era Murals	WPA/FAP Murals	Other Murals	Date of Building
Francis M. McKay Elementary School		3		1928
Donald C. Morrill Math & Science Specialty Elementary School		1		1926
Mount Vernon Elementary School			2	1928
Wolfgang A. Mozart Elementary School		4		1911
Louis Nettelhorst Elementary School		2		1893
Luke O'Toole Elementary School		3		1927
Parkside Community Academy Elementary School	9			1917
Cecil A. Partee Academic Prep. High School (Hookway prior)		13		1928
Louis Pasteur Elementary School		2		1927
Helen C. Peirce Elementary School	11			1915
William Penn Elementary School		4		1907
Wendell Phillips High School	4			1904
Martin A. Ryerson Elementary School		2		1891
Maria Saucedo Academy Elementary School (Harrison prior)	2			1912
Sidney Sawyer Elementary School		5		1901
Franz P. Schubert Elementary School		2		1930
Carl Schurz High School			25	1883
John D. Shoop Elementary School		2		1926
John M. Smyth Elementary School	6			1897
Graeme Stewart Elementary School		3		1905
Leander Stone Elementary School	2			1928
Roger C. Sullivan High School (painted over)		1		1926
Charles Sumner Elementary School			1	1892
George B. Swift Elementary School	2			1914
Mancel Talcott Elementary School		1		1895
Edward Tilden Technical High School	60		7	1905
George W. Tilton Elementary School	3			1906
Lyman Trumbull Elementary School	3			1909
James Wadsworth Elementary School	4			1883
Harold Washington Elementary School		4		1920
William H. Wells Community Academy High School		3		1935
Daniel Wentworth Elementary School	31	3		1890
West Pullman Elementary School		3		1894
Total Murals	**229**	**166**	**42**	

Catalog of Schools and Murals

George B. Armstrong Elementary School of International Studies

NAMESAKE
George B. Armstrong (1872–71) was the founder of the U.S. Railway Mail Service. Armstrong put his first railway car to use on the Chicago and Northwestern Railway between Chicago, Illinois, and Clinton, Iowa, on August 28, 1864.

ADDRESS
2111 West Estes
Chicago, Illinois 60645

ARCHITECT
Saul Samuels

TITLES

1. Fairies

2. Woodland Scenes

ARTIST
Marion Mahony Griffin

CREATED
Progressive Era

SIZE
2 murals: each H 5' x W 12'

MEDIUM
Oil on canvas adhered to wall

DATE
c. 1932

LOCATION
First-floor corridors

CONDITION
In 1996 the murals were coated with a heavy layer of dirt, grime, and air pollution; areas of canvas were

lifting; cracks appeared throughout the surface; and small areas of canvas were missing.

CONSERVATION
In 1998 the Chicago Conservation Center restored the murals as part of Phase II of the Mural Preservation Project. The paint surfaces were cleaned using conservation solvents; areas of lifting canvas were reset into place using a syringe-injected adhesive; small missing sections were patched, textured, and toned to match the original; and a final nonyellowing varnish was applied.

MURAL DESCRIPTIONS
In 1998–99, Armstrong Elementary School participated in a program entitled *Chicago: The City in Art,* at the Art Institute of Chicago. At the program's reception, students performed a play based on the murals, with several poems written by Armstrong students about the paintings. In the artist's unpublished autobiography, *Magic in America,* Griffin wrote that fairies existed as helpers to humans and that teaching children to believe in fairies would help expand their creativity and imagination. She created a visual manifestation of this belief in the Armstrong murals, which bridge a former doorway.

1. In the left panel, three fairies perch in a birch tree, helping a mother heron feed her hatchlings in the nest.

2. In the right panel, two fairies help the father heron secure food for his young by skimming the water's surface with nets. Griffin's careful attention to the figures and the

landscape is reminiscent of her architectural drawings and shows her interest in Japanese landscape painting. Deep earth tones add a somber quality to the murals; gilded colors enhance their ethereal subjects.

TITLES

1. Past, Present, Future: We Are America

2. View from the School

ARTIST
Frank C. Peyraud

CREATED
Progressive Era

SIZE
2 murals: each H 4' x W 5'

MEDIUM
Oil on canvas adhered to wall

DATE
c. 1920

LOCATION
Auditorium, over doorway and to left and right of stage

CONDITION
In 1996 the murals were heavily coated with grime, which distorted the original color relationships and three-dimensional quality of the scenes. The murals also suffered water damage, scattered staining, paint losses, and lifting seams.

CONSERVATION
In 1998 the Chicago Conservation Center restored the murals as part of Phase II of the Mural Preservation Project. The removal of overlying films using conservation solvents

Fairies and Woodland Scenes (detail of image 1), Marion Mahony Griffin, c. 1932, George B. Armstrong Elementary School of International Studies.

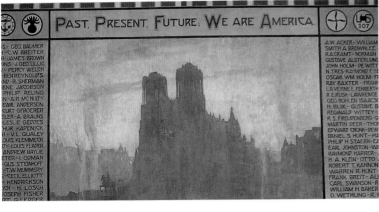

Newton Bateman Elementary School

ADDRESS
4220 North Richmond
Chicago, Illinois 60618

NAMESAKE
Dr. Newton Bateman (1809–97) taught in the public schools and served as principal in Jacksonville from 1851 to 1858. In 1858, he was elected second superintendent of Public Instruction for the State of Illinois.

ARCHITECT
Arthur Hussander

Past, Present Future: We Are America, Frank C. Peyraud, c. 1920, George B. Armstrong Elementary School of International Studies.

TITLE
Decorative Landscape

ARTIST
Florian Durzynski

CREATED
WPA/FAP

SIZE
1 mural: H 30' x W 40'

MEDIUM
Oil on canvas (thin) adhered to wall. Small 18" left and right portions tempera on dry plaster (secco). The canvas was painted in sections.

DATE
1940

LOCATION
Auditorium

CONDITION
The unvarnished mural had experienced serious water damage with streaking throughout the top quadrant and severe flaking along the right side. The canvas edge was lifting from the wall; heavy layers of grime masked the original color relationships and flattened the

European Market Scene, Anita Willets Burnham, c. 1925, George B. Armstrong Elementary School of International Studies.

produced a dramatic color change. Lifting areas of paint were reset using a conservation adhesive, seams were reset using an emulsion adhesive, losses were retouched, and a final non-yellowing varnish was applied.

MURAL DESCRIPTIONS
1. The 110 names in the mural to left of the stage memorialize members of the Rogers Park community who served and died in World War I. (The predominantly Swedish, German, and Luxembourgian names on this list reflect the trends in immigration to this area in the early twentieth century.) The central image shows a small equestrian figure before Notre Dame Cathedral in Paris, recognizable by the towers and central stained glass window. Circular symbols near the perimeter of the painting represent the insignia of divisions of the armed forces.

2. The mural to right of the stage shows the Rogers Park neighborhood during the early nineteenth century. Neat piles of hay and well-tended farmhouses illustrate Peyraud's nostalgic view of Midwestern farm life. Incorporated as part of Chicago in 1893, Rogers Park remained predominantly rural until the early decades of the twentieth century. When this mural was completed, the neighborhood was rapidly transforming into a more urban environment.

TITLE
European Market Scene

ARTIST
Anita Willets Burnham

CREATED
Progressive Era

SIZE
1 mural: H 3' x W 4'

MEDIUM
Oil on canvas

DATE
c. 1925

LOCATION
Auditorium entry hall

CONDITION
In 1996 the mural was heavily coated with dirt and grime, which distorted the painting's original color relationships and three-dimensional quality.

CONSERVATION
In 1998 the Chicago Conservation Center restored the mural as part of Phase II of the Mural Preservation Project. The surface of the mural was cleaned using conservation solvents and a final nonyellowing varnish was applied to protect the surface.

MURAL DESCRIPTION
This small mural shows a European market scene. The word "Nuremberg" on the yellow building on the right locates the scene in the Bavarian city in southern Germany. Burnham probably chose a German scene to honor the large German immigrant population in Rogers Park. Her work as an illustrator of children's books is evident in the use of vivid colors and the simple handling of forms.

Decorative Landscape
(detail), Florian Durzynski,
1940, Newton Bateman
Elementary School.

three-dimensional quality of the painting. Numerous cuts, tears, graffiti, scuffs, and holes marred the paint surface.

CONSERVATION

In 2000 the Chicago Conservation Center restored the mural as part of Phase III of the Mural Preservation Project. The mural was cleaned using distilled water and a mild site-formulated cleaner. Mild ammonium hydroxide (NH4OH) followed by a mild cleanser were used to clean the embedded dirt in the whites. Structural damage was extensive; the larger holes were filled with plaster and canvas fills were constructed. Jade conservation adhesive was then syringe-injected into the tears and cuts and the canvas was realigned. An acrylic-based varnish was applied as an ethical buffer and protective layer before retouching work was carried out using conservation pigments. A spray matte varnish was applied as a final protective layer.

MURAL DESCRIPTION

One of the largest murals in the city school system, the right and left portions painted in tempera on dry plaster appear to be later additions to the original oil-on-canvas composition. The lyrical landscape filled with rolling hills and farmland is typical of Durzynski's work. He created several school murals using a similar land-scape motif.

TITLE

Characters from Children's Literature

ARTIST

Unknown
(possibly Roberta Elvis, not signed)

CREATED

WPA/FAP

Characters from Children's
Literature, *artist unknown*,
1937, Newton Bateman
Elementary School.

SIZE

1 mural: H 7' 11" x W 11' 6"

MEDIUM

Oil on canvas adhered to wall

DATE

1937

LOCATION

Main entrance hallway

CONDITION

In 1995 the mural was in critical condition showing severe surface abrasions, water streaks, stains, graffiti, edge damage, and a thick layer of grime.

CONSERVATION

In 2000 the Chicago Conservation Center restored the mural as part of Phase III of the Mural Preservation Project. The mural was cleaned using distilled water and mild conservation solvents; edge damage was repaired using a syringe-injected adhesive; and an acrylic-based nonyellowing varnish was then used as an ethical buffer and protective layer before retouching work was carried out using reversible

conservation pigments. A spray matte varnish was applied as a final protective layer.

MURAL DESCRIPTION

The mural, immediately visible when one enters the school, illustrates several scenes from works of children's literature including *Alice in Wonderland*, by Lewis Carroll; *The Adventures of Tom Sawyer*, by Mark Twain; *The Tale of Peter Rabbit*, by Beatrix Potter; *David Copperfield*, by Charles Dickens; and *Treasure Island*, by Robert Louis Stevenson. One of the earliest classics of children's literature was a fairy tale collection by Charles Perrault, written in 1697 and translated from French into English in 1729, entitled *Tales of Mother Goose*. Among the stories included in this work were *Cinderella*, *Little Red Riding Hood*, *Puss in Boots*, and *The Sleeping Beauty*. The figures occupy a space reminiscent of an elaborate stage set; stone partitions, stairs, and pedestals frame the figures and add structure to the energetic scene. The individual scenes blend and overlap, enhancing the sense of movement in the painting.

Hiram H. Belding Elementary School

ADDRESS

4257 North Tripp
Chicago, Illinois 60641

NAMESAKE

Hiram H. Belding (1835–90) was one of the Belding brothers, Chicago silk merchants who established the Belding Silk Company.

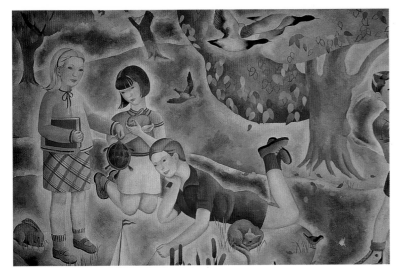

ARCHITECT
William B. Mundie

TITLE

Children's Activities

ARTIST

Roberta Elvis
(signed lower right, 1938)

CREATED
WPA/FAP

SIZE
1 mural: H 5' 4 " x W 14' 8 "

MEDIUM
Oil on canvas adhered to wall

DATE
1938

LOCATION
First floor, north end of building

CONDITION
In 1995 the three-paneled mural was in critical condition. Severe water damage had caused areas of lifting and the canvas was separating from the wall. Surface scratches, drip stains, edge paint loss, and grime were evident.

CONSERVATION
Not yet restored

MURAL DESCRIPTION
The mural wraps around the north interior of the school building. The multifigured composition depicts leisure activities of school children. The subject of children playing was a common theme in WPA/FAP elementary school murals. In the central panel, a pastoral landscape, young boys and girls play with toy sailboats, kites, carts, and rollerskates. Rabbits, birds, squirrels, and a schnauzer play near the children. The central panel is

flanked on either side by single figure panels. On the left, a young girl in a yellow dress stands on her tiptoes to gather red apples from a tree. On the right, a young boy dressed in overall shorts prepares to climb a tree. The composition is unified by a rolling autumn landscape.

Frank I. Bennett Elementary School

ADDRESS
10115 South Prairie Avenue
Chicago, Illinois 60628

NAMESAKE
Frank Ira Bennett (unknown–1925) was a partner in the law firm Bennett & Higgins, and Alderman of the Seventh Ward. Bennett later became vice-president of the Chicago Planning Commission.

ARCHITECT
John Christensen

TITLES

Children's Subjects

1. Art

2. History

3. Science

4. Music

ARTIST

Grace Spongberg
(signed lower right)

CREATED
WPA/FAP

SIZE
4 murals: each H 11' x W 6'

MEDIUM
Oil on canvas adhered to wall

DATE
1940

LOCATION
Auditorium

CONDITION
In 1995 the unvarnished murals were coated with a light film of grime; their elevated location offered protection from marks, scratches, and graffiti.

CONSERVATION
In 2001 the Chicago Conservation Center restored the murals as part of Phase III of the Mural Preservation Project. The murals were cleaned using distilled water and a mixture of mild conservation solvents to remove the embedded dirt and stains. A nonyellowing varnish was applied as an ethical buffer and protective layer before retouching was carried out using conservation pigments. A final matte spray varnish was applied as a protective layer.

MURAL DESCRIPTIONS
The murals depict four major educational subjects: art, history, science, and music.

1. *Art* is a multilayered composition illustrating an architect at a drafting table, a young girl painting, and

Children's Activities (detail), Roberta Elvis, 1938, Hiram H. Belding Elementary School.

Children's Subjects: Science, Grace Spongberg, 1940, Frank I. Bennett Elementary School.

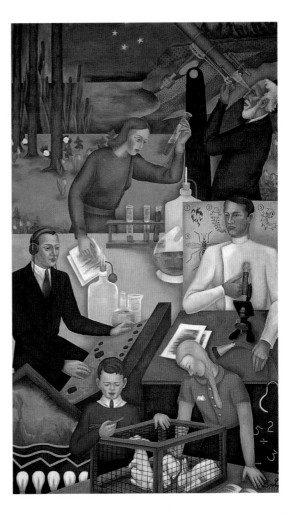

another young girl throwing a vase on a potter's wheel. Above, a young boy sculpts a bust of a woman. At the apex of the composition, a young African American male is depicted grinding a lithographic stone, representing printmaking. Three orders of classical columns are rendered in the upper left, alluding to achievements in the history of art. A stained glass window is painted on the right side of the composition.

2. In the second mural, *History*, a Native American is shown handing a bird to a Pilgrim in a peaceful gesture; another Pilgrim sews with a book on her lap; settler children paint a white picket fence, while an African American man stands holding his hat in his hand. The composition thus makes indirect reference to the displacement of Native Americans and to slavery.

3. In the third mural, *Science*, several inventions and methods of research are depicted. The top of the composition highlights astronomy and the telescope; below, a woman conducts a science experiment. A man seated at a radio, listening with earphones, makes reference to the invention of the long-distance radio by Guglielmo Marconi. To the right is a man using a microscope. At the bottom of the composition stand a boy and girl, symbolizing the future of scientific studies.

4. In the fourth mural, *Music*, singers, musicians, musical notes, and a modern radio represent the history and widespread appreciation of music. Below is a conductor shown with a musical score. Below to the left is a woman playing a piano. To the right is a woman playing a violin. At the bottom of the composition are two chorus singers and a man playing a xylophone.

::

TITLE

History of Books (15 sections)

ARTIST

Gustaf Oscar Dalstrom

CREATED

WPA/FAP

SIZE

1 mural frieze (covering 3 walls with 15 sections): H 4' 6" x W 70'

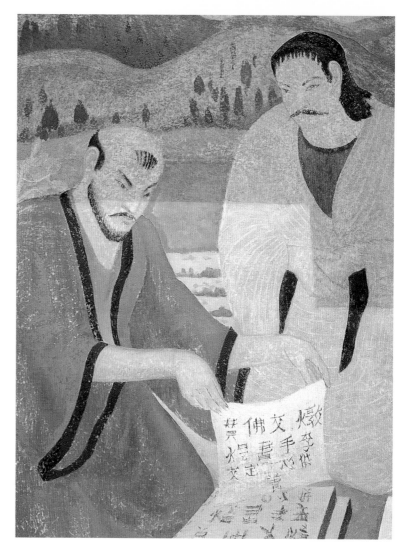

History of Books (detail of image 2), Gustaf Oscar Dalstrom, 1937, Frank I. Bennett Elementary School, partially cleaned.

MEDIUM

Oil on canvas adhered to wall

DATE

1937

LOCATION

Lunchroom

CONDITION

In 1995 the unvarnished mural was coated with thick layers of grime and grease. Surface abrasions, scratches, cracks, nicks, drip stains, and spills were evident throughout. The damage was largely attributed to the lunchroom environment.

CONSERVATION

In 2000 the Chicago Conservation Center restored the mural as part of Phase III of the Mural Preservation Project. The mural was cleaned using distilled water and a site-formulated cleaner. A mild mixture of conservation solvents was used to clean the embedded dirt and drip stains. Scratches and chips were secured and filled with gesso. A nonyellowing varnish was applied as an ethical buffer and protective layer before retouching was carried out using conservation pigments. A final matte spray varnish was applied as a final protective layer.

MURAL DESCRIPTION

The frieze, painted around the upper perimeter of the school's lunchroom, depicts the history of books and printing. Broken down into fifteen visual sections separated by vertical white lines, the panels are meant to read like pages in a book, but they do not follow in correct historical order.

1. The frieze is bracketed on each end by images of contemporary children holding schoolbooks. At the beginning of the frieze is a boy; at the end, a girl (section fifteen).

2. The second section begins a storyline on the history of bookmaking. The first in the storyline depicts a scene in China, where the first printed book is thought to have originated in the ninth century. Two men appear seated in a river valley printing from woodblocks.

3. This is the first of three sections focusing on printing and bookmaking in Renaissance Europe during the fifteenth century. All relate to the invention of movable type. The first shows two men in a workshop studying a book, with a block of type on the worktable nearby.

4. The fourth section is a scene in a fifteenth-century printing workshop with three men working with a Gutenberg-era press.

5. The fifth section, also a Renaissance scene, depicts the process of bookbinding.

6. The sixth section depicts monks making illuminated manuscripts in a medieval scriptorium. Practicing an art that reached its height around 1200, a manuscript illuminator is seated at a workbench, embellishing hand-lettered Gothic script with illustrations and elaborate capital letters.

7. At this point the frieze extends to the next wall. The seventh section refers to Greek and Roman influence on bookmaking in the pre-Christian era. Two seated figures survey scrolls, with classical architecture in the background.

8. The next scene depicts an early-American classroom: students are shown listening to a teacher read from a book.

9. The ninth scene, a corner piece, as the frieze shifts to another wall, depicts a ship/Pilgrim crossing, hence the spread of books from Europe.

10. In the tenth section, the frieze shifts to modern bookmaking. Three men work in a printing workshop, one running a metal press, another hanging printed pages to dry, and another stacking the dried sheets.

11. In the eleventh section, a woman with her back to the viewer is shown feeding printed pages into a binding machine.

12. In the twelfth section, two workers are shown reviewing text; in the background are two cylinder presses.

13. The thirteenth section depicts three men in a workshop using technologies developed in the nineteenth and early twentieth centuries, such as offset printing and rotogravure.

14. The fourteenth section depicts serigraphy, a color silkscreen printing process.

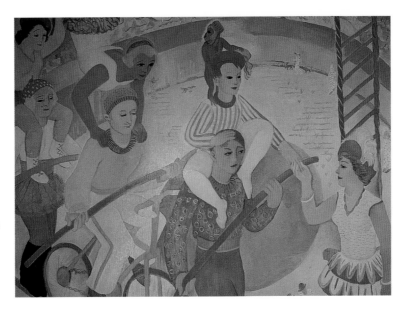

Circus Scenes (detail of image 1), Andrene Kauffman, 1938, Luther Burbank Elementary School.

15. In the final section, a girl in a blue dress holds a book. The first and last panels represent the beneficiaries of bookmaking; they also function as an analogy to the front and back covers of a book.

Luther Burbank Elementary School

ADDRESS
2035 North Mobile Avenue
Chicago, Illinois 60639

NAMESAKE
Luther Burbank (1849–1926) was an American horticulturist, plant breeder, and author. Burbank developed more than eight hundred hybrids of flowers, vegetables, and fruits. He is known for the Burbank potato, Shasta daisy, and seedless navel orange.

ARCHITECT
John C. Christensen

TITLE
Circus Scenes

ARTIST
Andrene Kauffman
(signed lower left, 1938)

CREATED
WPA/FAP

SIZE
2 murals: each H 10' x W 10'

MEDIUM
Oil on canvas adhered to wall

DATE
1938

LOCATION
Auditorium

CONDITION
In 1995 the unvarnished murals were coated with a thick grime layer, which dulled the colors and distorted the painting's spatial relationships. Paint splatters were also visible.

CONSERVATION
In 2001 the Chicago Conservation Center restored the murals as part of Phase III of the Mural Preservation Project. The murals were cleaned using conservation solvents; stains and splatters were removed mechanically and retouched to match the original. A final nonyellowing layer was applied to protect the surface from air pollution and other damage.

MURAL DESCRIPTIONS
Andrene Kauffman's square murals, presenting marvels of the circus, flank the main auditorium stage.

1. The left mural depicts a group of performers on a high wire. The circus ring below is dotted with clowns and other circus figures. The safety net looming beneath the performers contributes to the sense of anticipation in the scene.

2. In the right panel, the circus is shown in full motion. Acrobats swing from rope to rope and tumble through the air. Garish, masked faces gaze upward at the acrobats. The overhead view adds to the general sense of vertigo and drama. The wild color scheme, the circularity of the central ring, and the curving lines of the nets and ropes, combined with the daredevil maneuvers of the performers, enhance the feeling of nervous energy in the mural.

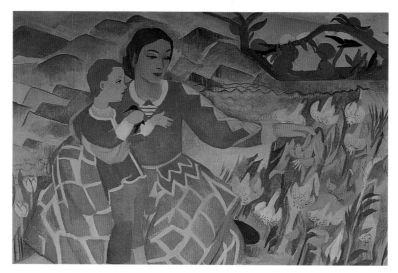

Incidents in the Life of Luther Burbank (detail of image 1), Andrene Kauffman, 1937, Luther Burbank Elementary School.

TITLE
Incidents in the Life of Luther Burbank

ARTIST
Andrene Kauffman
(signed lower right, June 1937)

CREATED
WPA/FAP

SIZE
2 murals: each H 4' x W 20'

MEDIUM
Oil on canvas adhered to wall

DATE
February (or June) 1937

LOCATION
Classroom 104 (formerly the library)

CONDITION
In 1995 the unvarnished, oil-on-canvas murals were glued to the wall and covered with a thick layer of grime, which dulled the colors and distorted the paintings' spatial relationships. Paint splatters and marks disfigured the images.

CONSERVATION
In 2001 the Chicago Conservation Center restored the murals as part of Phase III of the Mural Preservation Project.

MURAL DESCRIPTIONS
The two murals trace the life of Luther Burbank, an American plant breeder who produced many useful fruit, flower, vegetable, grain, and grass varieties. He greatly encouraged the scientific development of plant breeding, which has also influenced the study of genetics. He was highly influenced by Charles Darwin. His breeding methods resulted in more than eight hundred new strains and varieties of plants including berries, prunes, plums, and lilies. The murals indicate some of the significant accomplishments of Burbank, who conducted as many as three thousand experiments involving millions of plants and wrote several books.

1. In the first panel, Burbank, dressed in overalls and a hat, is cultivating a new variety of potato, known as the Burbank potato (derived from the Idaho russet). In the center of the left mural, accompanied by his dog, the white-haired Burbank kneels and investigates a new variety of the daisy. On either side, children look at different varieties of flowers. Burbank's early interest in horticulture is indicated at the end of the left mural: shown as a toddler, he sits on his mother's lap looking at a flower garden.

2. In the second panel, Burbank is seen riding a train to California, where he established the nursery gardens, greenhouses, and experimental farms that have become famous worldwide. A newspaper placed next to a female passenger indicates the year, 1879, and his destination, Los Angeles.

Chicago Vocational High School

ADDRESS
2100 East 87th Street
Chicago, Illinois 60617

NAMESAKE
Chicago Vocational High School is one of the largest buildings in the Chicago Public Schools system, as the school was originally a naval base. The foyer and auditorium have elaborate Art Deco–style inlaid floors, light fixtures, iron details, and wall designs.

ARCHITECT
John C. Christensen

TITLE
Unknown
(Industry, Commerce, and Modernity)

ARTIST
Unknown

CREATED
WPA/FAP

SIZE
14 murals: (2) H 7' 5" x W 3' 3" ;
(8) H 7' 6" x W 4' ; (4) H 7' 6" x W 11'

MEDIUM
Carved, inlaid wood panels

DATE
1939

LOCATION
Auditorium balcony

CONDITION
In 2000 the wooden panels were coated with a considerable layer of soot and grime. Scattered drip stains, buckling, and warping of the wood were present in all of the panels.

CONSERVATION
Not yet restored

MURAL DESCRIPTIONS
The fourteen panels, lining the upper left and right walls of the auditorium balcony (seven on each side), depict architectural landmarks in Chicago as well as industrial scenes and equipment. The series highlights images of industry, commerce, and modernity ranging from the Gutenberg press to contemporary industrial production.

Left wall:

1. The first panel is an exterior view of Chicago Vocational High School in the lower left portion of the panel and a view of the school stage and audio room in the lower right, and a depiction of a large crane and oil derrick jutting into the air in the top portion. The first attempt at drilling oil wells occurred near Champaign, Illinois, in 1853, but the wells produced no oil, only "swamp gas" or "drift gas."

2. The second panel depicts an electric power generator, power lines, and towers in a landscape. The use of electric power in its early stages was expensive. In Chicago it was used for motoring streetcars. As technology improved, electric power generators were devised to provide inexpensive

electricity to the masses. This panel depicts an industry significant to a vocational training program.

3. The next panel also relates to a vocational training school due to its focus on technological advancements in transportation. This panel depicts the transition from the wagon, the primary form of transportation in America in the 1700s, to the passenger locomotive, the first of which was run in 1825. By the 1860s Chicago's railway system was helping to make the city a major industrial hub for commerce, transportation, and trade.

4. The next panel focuses on the transition in the transportation industry from the railroad to the airplane. With the invention of the airplane by the Wright brothers in 1903, transportation and trade flourished at a rapid rate. Following World War I, the U.S. government established a ground and air transportation division, which transported parcels, money, and goods. This scene features the Air Express Division, with a man delivering parcels along the bottom of the composition, while above are various views of airplanes used for transport.

5. The fifth panel depicts a back view of the Art Institute of Chicago and Chicago loop. The center of the city became known as the "loop" around 1897, from the elevated railway trains that form a circle around the thirty-five-block city center. The Art Institute of Chicago was built in 1893, becoming the focal point of the arts in Chicago from that point forward. Also included in this scene are the old railway tracks running under the museum.

6. The sixth panel depicts the famous Chicago Board of Trade Building, built in 1930. Established in 1848, the Board of Trade was created as a centralized grain market in response to the rapid growth of trade that farmers were bringing by wagon, rail, or barge. The building's Art Deco design gives it a sleek, machinelike appearance, topped by a cast aluminum statue of Ceres, the Roman patron of corn traders, a symbolic reminder of the Midwest's agricultural heritage.

7. The seventh panel depicts the Chicago Merchandise Mart Building, pylons, and a barge progressing down the Chicago River as a plane flies overhead. The Merchandise Mart Building is considered to be the largest commercial building in the world, covering ninety-five acres, two city blocks, and housing 4 million square feet of floor area devoted to commercial and wholesale activities. This panel illustrates the expansion of Chicago as a commercial center.

Right wall:

8. The next panel depicts the Chicago Tribune Tower, completed in 1925. The neo-gothic structure was modeled after a French cathedral with its decorative buttresses at the top of the thirty-fourth-story building. The Tribune building also relates to vocational training because of the newspaper's role in printing and paper milling, another prominent Chicago industry.

9. This panel depicts the manufacturing process in a steel mill. A steel vat similar to the Bessemer converter, an invention that revolutionized steel manufacturing, is shown in the corridor of a large steel factory.

10. The next panel also relates to steel production. In the scene, a steel structure sits on a barge floating down the Chicago River. In the background is the silhouette of a steel mill, a typical industrial site in the city that created the first steel skyscraper in 1885.

11. The next panel depicts a detail of an industrial factory, representing Chicago's industrial heritage; the city is known for manufacturing metals, rubber products, steel, food products, electrical machinery, and printed materials.

12. The next panel focuses on the history of printing and the use of the Gutenberg press invented by Johannes Gutenberg (1390–1468) in 1436. The press mechanized the printing process, allowing book production to quickly increase. In this scene, three figures are shown working independently in a printing workshop. The figure in the background is setting type, while another works the press in the foreground, and a standing figure proofreads the text. Printmaking and publishing have been a primary industry in Chicago, an appropriate focus of study at a vocational high school.

13. The next panel is broken up into six angular sections, including illustrations of various production lines and trades appropriate to a vocational school setting, including car, tire, and airplane production lines as well as a traditional carpentry shop class where a student is building a staircase. This scene acts as a composite of the mural series and connects it to the vocational school setting.

14. The last panel depicts the industrial future. This scene includes an aerial view of a modern city resembling Futurama, a building created by Norman Bel Geddes for the New York World's Fair in 1939. This panel ends the series inspired by the future of industry and technology.

Unknown (Industry, Commerce, and Modernity) (image 6), artist unknown, 1939, Chicago Vocational High School.

Henry R. Clissold Elementary School

ADDRESS
2350 West 110th Place
Chicago, Illinois 60643

NAMESAKE
Henry Rowland Clissold (unknown–1930) was a printer and community activist in the Morgan Park area between 1881 and 1930. He was also member and president of the Board of Education of Morgan Park, as well as a member and president of the Illinois Baptist Convention, and president of Morgan Park Trust and Savings Bank.

ARCHITECT
John C. Christensen

TITLE
Historical Periods

ARTIST
Thomas Jefferson League
(signed lower left, second mural)

CREATED
WPA/FAP

Historical Periods (detail of image 2), Thomas Jefferson League, 1939, Henry R. Clissold Elementary School.

SIZE
5 murals: (4) H 11' 1" x W 6' 2";
(1) H 7' x W 6' 2"

MEDIUM
Oil on canvas adhered to wall

DATE
1939

LOCATION
Auditorium

CONDITION
In 1995 the unvarnished murals were coated with a heavy layer of soot and grime. The four larger murals were structurally in good condition with only minor cracks, abrasions, and scratches. The smaller mural, the map of the Morgan Park/Beverly area, had four holes and a 5" gouge in the lower right area.

CONSERVATION
In 1999 the Chicago Conservation Center restored the murals as part of Phase III of the Mural Preservation Project. The mural was cleaned using distilled water and a site-formulated solvent. The structural damage was repaired using gesso to fill the losses, and an acrylic nonyellowing varnish was applied as an ethical buffer to protect the paint layer before retouching was carried out using conservation pigments. A matte spray varnish was applied as a final protective layer.

MURAL DESCRIPTIONS
The school dedicated the murals on May 4, 1939. In 1999, the school held a mural rededication ceremony, based on the original 1939 ceremony, "On the Wings of Time." The murals trace the history of the Morgan Park and Beverly neighborhood. Barbara Bernstein, a Chicago historian, wrote, "Four richly populated and lovingly detailed historical panels hang high above the seats in Clissold's auditorium. Once again a WPA/FAP artist has immortalized four stages in the growth of America, here the Indians have a whole section to themselves. Tucked away in the balcony is a small, illustrated map of Morgan Park about 1860. It's another testament to the careful research into local history that went into some WPA/FAP art."[1]

1. The mural cycle begins with a painted map of the early Beverly/Morgan Park neighborhood (designated as a landmark in 1981) on the southwest side of Chicago, one of the historic areas of Illinois. The hilly area, 50 to 80 feet above Lake Michigan, was often referred to by early settlers as "Blue Island," because of the blue mist that covered the land ridge. While this map marks roads and intersections, it is ultimately more concerned with recording anecdotal scenes of the community. Stylized trees, white wooden houses, and groups of running deer at the top of the composition characterize the community as a typical small Midwestern town.

2. The second panel depicts events that occurred over many centuries, beginning with the last Ice Age to the settlement of the Potawatomi Indians in the "Blue Island" region. At the top of the composition a large mammoth, imprisoned in a block of ice, dominates the upper right corner and locates this part of the image in the Ice Age. Native Americans who migrated to the region shortly after the glaciers receded are represented in the scene by a young man carrying a canoe, another figure wearing an elaborate headdress and mask, and a woman tending to a baby swaddled in a cradleboard. The figures are set in a colorful landscape filled with cornstalks and indigenous flora and fauna. The Potawatomi settled in Michigan and Wisconsin around the thirteenth century, encroaching on the territory of the Iroquois. The Indian tribes began to be driven out of the region starting in the 1670s with the arrival of French explorers. The Potawatomi eventually settled in Illinois, taking possession of part of the state by 1765.

3. Panel three spans the thirteenth to the seventeenth century. The scene includes Native Americans, who flourished in the area around the thirteenth century, Marco Polo (1254–1324), who began to explore China, and Kublai Khan (1215–94). European explorers in North America are depicted meeting the Native Americans. The Europeans are represented dressed in clothing styles typical of various groups who settled in the New World. They include the black-robed Jesuit priest and explorer Father Jacques Marquette (1637–75). The artist presents trade between indigenous peoples and Europeans as the main interaction; the Europeans are shown presenting cloth to the Native Americans.

4. The fourth panel suggests events of the eighteenth and nineteenth centuries. Covered wagons, cultivated land, domesticated animals, horses, and settlers' suitcases fill the composition. Two groups converse near a newly formed road now known as Western Avenue. Native Americans appear in only a small portion of the panel, a signal of their decreasing presence.

5. In the fifth panel, League shows the Beverly and Morgan Park community at the turn of the twentieth century. The emphasis is on education and technological progress. A schoolhouse and a gas lamp, children holding books, and two graduates representing the 1930s serve as reminders of the goal of education; a paved road and electric lamps testify to the link between education and technological achievements. The playing children and the lush landscape filled with blooming trees suggest that leisure time and abundance are the natural outcomes of this synthesis.

Zenos Colman Elementary School

ADDRESS
4655 South Dearborn
Chicago, Illinois 60609

NAMESAKE
Zenos Colman was a baptist minister born in Geneseo, New York, who migrated to Chicago and became prominent in his Southside community. The school was established for the employees of the Rock Island Railroad car shop.

ARCHITECT
Unknown

TITLE
Unknown
(Classroom Scene)

ARTIST
William Edouard Scott

CREATED
Not WPA/FAP

SIZE
1 mural: H 4' x W 9' 6"

MEDIUM
Oil on canvas

DATE
c. 1940

LOCATION
Kindergarten Room

CONDITION
Unknown

CONSERVATION
Not yet restored

MURAL DESCRIPTION
The interior kindergarten scene depicts ethnically diverse students, teachers, and/or parents in groups throughout the room, highlighting art, science, geography, and other activities. Two large landscapes on the classroom walls and the inclusion of a painting easel further indicate the value of the arts as an integral part of student education.

Christopher Columbus Elementary School

ADDRESS
1003 North Leavitt
Chicago, Illinois 60622

NAMESAKE
Christopher Columbus (1451–1506) was the master mariner and explorer credited as the first European to land in the Americas.

ARCHITECT
Arthur Hussander

TITLE
Landscape

ARTIST
Unknown

CREATED
WPA/FAP

SIZE
1 mural: H 6' x W 14'

MEDIUM
Unknown

DATE
1940

LOCATION
Auditorium

CONDITION
In 1995 the mural was not visible; we discovered traces of a painting near a light fixture on the stage wall. A scalpel was used to gently chip away several layers of overpaint in a small area, revealing greenish brushstrokes resembling part of a landscape. In some areas, there was no bond between the mural and the overpaint; these areas appeared to be easily retrievable. Mechanical removal with a scalpel will be necessary for most of the composition, with the use of conservation paste to soften the overpaint in some areas.

CONSERVATION
Not yet restored

MURAL DESCRIPTION
This large landscape mural is hidden under layers of overpaint. The mural has not been visible for many years and it is not known when the mural was whitewashed.

John W. Cook Elementary School

ADDRESS
8150 South Bishop
Chicago, Illinois 60622

NAMESAKE
John W. Cook (unknown–1922) was a principal in Brimfield, a teacher at Normal, and eventually became president of Northern Illinois State Normal at Dekalb, Illinois, in 1899.

ARCHITECT
John C. Christensen

TITLE
Unknown

ARTIST
Thomas Jefferson League

CREATED
WPA/FAP

SIZE
3 murals: each H 10' x W 6' 8"

MEDIUM
Unknown

DATE
1940–41

LOCATION
Auditorium

CONDITION
In 1995 we discovered the murals underneath several layers of paint on the upper left auditorium wall. After closer examination, a small area of overlaying paint was carefully chipped away using a scalpel, revealing what appeared to be three murals.

CONSERVATION
Not yet restored

MURAL DESCRIPTIONS
Three large painted-over panels similar to those at Columbus, Flower, Manley, Lake View, and Sullivan schools were discovered. It is unknown when the murals were painted over.

path toward a red barn. Factory smoke stacks and a cluster of sky-scrapers appear on the horizon and contrast with the rural scene in the foreground.

2. The companion panel on the right celebrates winter. In this scene, the artist uses a palette of deep umbers and browns to illustrate the season. A heavily clad figure in the foreground shovels snow while a child holding a sled gazes at the landscape. In the background a lakefront dotted with skyscrapers vaguely resembles that of Chicago. The lack of greenery, farm animals, or rural architecture suggests a more urban setting than that of its companion.

Winter, Mary Chambers Hague, 1937, Arthur Dixon Elementary School.

Arthur Dixon Elementary School

ADDRESS
8310 South St. Lawrence
Chicago, Illinois 60656

NAMESAKE
Arthur Dixon (1837–1917) established a retail grocery store and started a transfer business, Arthur Dixon Transfer Company. He was one of the leading organizers of the 1893 World's Columbian Exposition.

ARCHITECT
John C. Christensen

TITLES
1. Spring
2. Winter

ARTIST
Mary Chambers Hague

CREATED
WPA/FAP

SIZE
2 murals: each H 12' x W 10'

MEDIUM
Oil on canvas adhered to wall

DATE
1937

LOCATION
Auditorium

CONDITION
In 1995 the unvarnished murals showed water damage due to a prior leaking roof. The mural depicting winter showed considerable cracking

throughout due to heavy water damage. The surfaces of both murals were coated with a heavy layer of grime and scattered scratches were present.

CONSERVATION
Not yet restored

MURAL DESCRIPTIONS
1. In this spring scene, a farmer dressed in blue clothing stands on the left side of the composition as his horses and dog drink from a water trough. To the right, another farmer, also dressed in blue, leads three cows down a meandering

Laughlin Falconer Elementary School

ADDRESS
3000 North Lamon Avenue
Chicago, Illinois 60641

NAMESAKE
Laughlin Falconer (dates unknown) was a farmer and builder who purchased 160 acres of government land in the mid-1880s between Diversey and Belmont. He established the first school of the district on his farm and acted as a school trustee for forty years.

ARCHITECT
Arthur Hussander

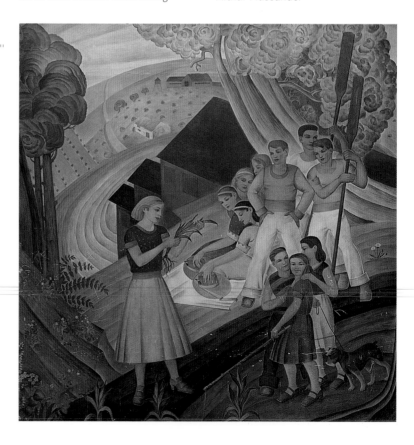

Landscape with Children, Florian Durzynski, 1940, Laughlin Falconer Elementary School.

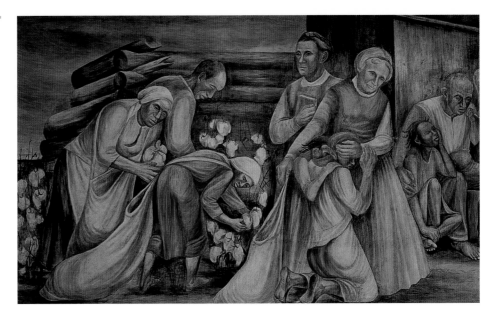

TITLE
Landscape with Children

ARTIST
Florian Durzynski
(signed lower right, "Durzynski 1940")

CREATED
WPA/FAP

SIZE
1 mural: H 11' 5" x W 11' 2"

MEDIUM
Oil on canvas adhered to wall

DATE
1940

LOCATION
Front entrance hall

CONDITION
In 1995 the mural showed severe damage from graffiti, deep scratches, abrasions, and grime, predominantly due to its location at floor level.

CONSERVATION
Not yet restored

MURAL DESCRIPTION
This mural is rendered in Florian Durzynski's trademark lyrical style. The curving lines of the paths and land draw the eye into a rural landscape with cultivated fields and well-tended farmhouses. Children are shown interacting with the landscape. In the foreground, to the left, a girl examines a cornstalk plucked from rows of corn, denoting the significance of the spring crops spotted throughout the farmland in the distance. Four young girls sit on a picnic blanket, as a group of boys, standing, look on. The boy on the far right leans on a shovel, indicating that he has been working with the soil. The scene is framed on both sides by massive tree trunks.

Lucy Flower Career Academy High School
(formerly known as Lucy Flower Vocational High School)

ADDRESS
3545 West Fulton Boulevard
Chicago, Illinois 60624

NAMESAKE
Lucy Louisa Flower (1837–1921) was a member of the Chicago Board of Education, a trustee of the University of Illinois, and a Chicago philanthropist. She worked for the establishment

of manual training and domestic arts in schools as well as for the adoption of kindergarten in public school. Because of Flower's efforts, women teachers in Chicago are paid on the same salary schedule as their male counterparts.

ARCHITECT
John C. Christensen

TITLES
Outstanding American Women or Women's Contribution to American Progress
1. *Lucy Flower*
2. *Grace Abbott*
3. *Frances Perkins*
4. *Allegorical Scene of Women Sewing*
5. *Jane Addams*
6. *Susan B. Anthony*
7. *Harriet Tubman*
8. *Harriet Beecher Stowe*
9. *Clara Barton*
10. *Allegorical Scene of Women's Fight for Peace*

ARTIST
Edward Millman
(signed lower left, first panel, "Edward Millman 1938–1940")

CREATED
WPA/FAP

SIZE
1 mural (6 fresco panels):
(2) H 9' x W 7' 9"; (2) H 9' x W 4' 5";
(2) H 9' x W 9' 2"

MEDIUM
Fresco

DATE
1938 to April 30, 1940

LOCATION
Main foyer

CONDITION
In 1995 the mural was found covered with two layers of paint; the first was a calcimine layer and the second an oil-based layer. Painted over in 1941, the mural was hidden and protected under these layers.

CONSERVATION
From 1997 to 1998 the Chicago Conservation Center restored the mural as part of Phase I of the Mural Preservation Project. This mural was the first mural to be preserved in the project. A pilot project was initiated in 1995 through the efforts of the Chicago Conservation Center, which obtained start-up funds from the Field Foundation of Chicago and from the Bay Foundation of New York. The remainder was funded by the City of Chicago Board of Education as part of Phase I of the Mural Preservation Project (see chapter 2). This mural was considered the most difficult and challenging treatment within the Chicago Public School mural collection (see chapter 3 for treatment details).

MURAL DESCRIPTIONS
Along with Edgar Britton and Mitchell Siporin, Millman was one of the most renowned Chicago muralists during the 1930s. He studied with Diego Rivera in Mexico and learned both the techniques and politics of Mexico's most famous post-revolutionary

Outstanding American Women *or* Women's Contribution to American Progress: Harriet Tubman/Harriet Beecher Stowe, *Edward Millman, 1938–40, Lucy Flower Career Academy High School.*

artists. Millman's affiliation with leftist politics, however, sometimes interfered with public acceptance of his works, including one of his best-known murals, *Outstanding American Women*. Millman, Siporin, and Britton were often perceived as artists of protest or dissent, which made for a volatile environment around Millman's work by 1941. That year school board officials deemed Millman's fresco inappropriate for the school. They declared the representation "misery laden"[2] but attributed its ultimate censorship to "poor lighting"; eighteen months after it was completed this impressive mural cycle was covered with white paint and remained unseen by the public until its restoration. It is important to note that Millman and Siporin received the Section of Fine Arts' largest commission, for $29,000, to decorate the St. Louis Post Office; the work is still visible today.

The cycle spans the six walls of the entrance foyer of the school and comprises eight historical portraits and two allegorical scenes. The ten scenes are placed along the top perimeter of the room.

1. The sequence begins with the school's namesake, Lucy Flower, depicted overseeing women's education.

2. Next is a depiction of Grace Abbott (1876–1939), a reformer who exposed the exploitation of children and immigrants and also campaigned for child labor laws. Abbott was the Director of the Child Labor Division of the U.S. Children's Bureau from 1921 to 1934.

3. In the next scene Frances Perkins (1882–1965), the first female presidential cabinet member, comforts a miner's wife. FDR appointed Perkins his Secretary of Labor in 1933. As Secretary, a position she held for twelve years, she had a key role in New Deal legislation. Her most important contribution was as Chairman of the President's Committee of Economic Security, which was responsible for the establishment of the Social Security Act of 1935.

4. Women's struggles in the workplace are exemplified in this scene of the apparel industry, in which women were often exploited in urban sweatshops.

5. Chicago's "patron saint" of immigrants and founder of Chicago's Hull-House, Jane Addams (1860–1935) is shown in the fifth scene. Committed to social reform, Jane Addams opened Hull-House (1889), a settlement house or community center, to accommodate the huge influx of immigrants, many of whom were forced to settle in slums and live in poverty. Addams was involved in the Progressive Movement, whose members worked for political, economic, and social reform to help people overcome the dehumanizing effects of rapid industrialization.

6. A depiction of Susan B. Anthony (1820–1906), crusader for women's rights, shows her holding the suffrage scroll. Anthony cofounded the National American Woman's Suffrage Association and helped to found the International Woman Suffrage Alliance. She devoted her final decades to seeking a constitutional amendment giving women the right to vote. Belisario Contreras, a New Deal historian, writes, "In Millman's mural the figure of Anthony assumes the appearance of a militant arch-angel, asserting women's rights in all stations of life, whether it be a mother with her children, a young girl looking to the future, or a farmer's wife working in the fields . . . Rendered in profile, Susan Anthony appears like a figurehead on a ship, symbolically pursuing a determined course. In the composition the curved lines of various women accentuate the stern, uncompromising figure of Anthony, whom Millman sees as an 'ultimate symbol.'"[3]

7. Millman makes reference to women's involvement in the nineteenth-century abolitionist movement through the inclusion of Harriet Tubman (1820–1913), leader of the Underground Railroad. Reared in slavery, she married John Tubman, a free black man, in 1844. He opposed her plans to flee slavery, so in 1849 she decided to escape alone through the Underground Railroad. She became known as the "Moses of her people" by leading almost three hundred Maryland slaves, including her parents and siblings, to safety through the Underground Railroad.

8. Harriet Beecher Stowe (1811–96), author of the slave narrative *Uncle Tom's Cabin*, is shown holding a book next to a slave. Born in Connecticut and educated at a female seminary where she later taught, she married and pursued her writing interests while raising seven children. *Uncle Tom's Cabin* was published in 1852 as a two-volume novel after it appeared in weekly installments from 1851 to 1852 in the abolitionist newspaper the *National Era*. By the beginning of the Civil War more than a million copies of the book had been sold, making a significant impact on Northern attitudes toward slavery.

9. Clara Barton (1821–1912), founder of the American Red Cross, is depicted helping war survivors. The Massachusetts-born Barton began organizing frontline provisions during the Civil War, while operating as a freelance frontline nurse. In 1864 she became superintendent of nurses for the Army. After the war she worked for the International Red Cross offering relief to the French during the Franco-Prussian War. Upon her return to the United States, she established the American Red Cross in 1881 and proceeded to head the agency for the following twenty-three years.

10. A scene representing women's fight for peace closes the monumental cycle. The large bell-like figures and their strong facial features are typical of Millman's dramatic style and show Rivera's influence. Millman creates visual continuity between the figures and the scenes through recurring motifs such as books and through his dramatic rendering of hands.

Fort Dearborn Elementary School

ADDRESS
9025 South Throop Street
Chicago, Illinois 60620

NAMESAKE
The school is named in honor of the original Fort Dearborn, a U.S. army post on the Chicago River built and destroyed in the early 1800s, and of General Henry Dearborn (1751–1829), who earned fame for his daring exploits during the Revolutionary War.

ARCHITECT
John C. Christensen

TITLES

1–5. History of American Progress

6–13. Century of Progress

ARTIST

Elizabeth Merrill Ford
(signed lower right, "E. M. FORD")

CREATED

WPA/FAP

SIZE

13 murals: 5 *History of American Progress* panels: (4) H 11' 2" x W 6' 1"; (1) H 7' 8" / 5' 6" (angled canvas) x W 6'1"; 8 *Century of Progress* panels: each H 2' x W 3'8"

MEDIUM

History of American Progress: 4 oil on wood panels screwed to the wall, 1 painted directly on cement wall; *Century of Progress*: all oil on canvas adhered to wall

DATE

1935–36

LOCATION

Auditorium

CONDITION

In 1999 the eight *Century of Progress* murals were coated with a thick layer of grime with scattered drip stains and smudges. The five *History of American Progress* murals were also in poor visual and structural condition, coated with a heavy grime layer that distorted the colorful palette; stains and streaks added to the poor visual condition. The five panels were warped and cracks were evident in several areas. The fifth panel, painted directly on the cement wall, had suffered the most damage. The paint surface was abraded and corroded, disfiguring the image. Cracks and losses were also apparent.

CONSERVATION

Not yet restored

MURAL DESCRIPTIONS

The five panels of *History of American Progress* present significant stages in the development of American civilization, with an emphasis on Chicago history.

1. The first panel shows a vast rolling green landscape inhabited by Native Americans canoeing on what would later be called the Chicago River and participating in daily-life activities. Pioneers are shown arriving in covered wagons, denoting the influx of European immigrants in North America during the eighteenth century, and both log cabins and teepees are shown, indicating the coexistence of the two disparate cultures. Fort Dearborn and a church dominate the background. In the clouds, the artist has rendered architectural landmarks from around the world identified by country names such as Russia, Ireland, and France.

2. The second panel depicts colonial life later in the eighteenth century in the same landscape. In this scene, a grand Georgian home has replaced Fort Dearborn, and the church is larger and significantly more stylized. Steamboats fill the river and coaches dot the landscape, indicating new forms of transportation. There is no sign of Native American life, but more pioneer settlements appear in the background.

3. The third panel shows a landscape cluttered with smokestacks, steamships, and other evidence of industrial advancements during the late nineteenth and early twentieth centuries. Factories now replace the Georgian home. The once-simple white church is now a grand cathedral. A train on a bridge bisects the scene. In the foreground workers climb electrical poles. An automobile is shown driving through the bustling urban street scene, and one of the town buildings is labeled with the Ford emblem. Clouds form factory smokestacks and hidden in them are the names of the industrial giants Armor and Swift.

4. The fourth panel depicts an early-twentieth-century modern city, with streamlined curving bridges and streets, a zeppelin and planes in the air, large ocean liners in the water, and a skyline filled with skyscrapers. Sophisticated urban dwellers are shown enjoying leisure time on rooftops overlooking the river and urban landscape.

5. The final panel shows a globe with a swirling yellow and blue line emanating from it, a painted rendition of the logo of the 1933 Century of Progress Exposition in Chicago. It serves as a transitional image between the mural cycle described above and the eight panels in the narrow space along the balcony.

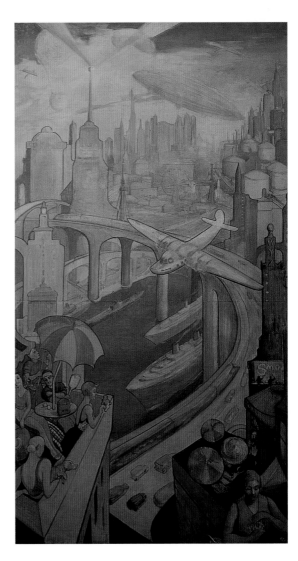

The eight *Century of Progress* panels represent the architecture and attractions of the Century of Progress Exposition held in Chicago in 1933 and 1934. The fair was located along the lakefront, on the south side of downtown from 12th to 39th streets. The exposition highlighted major technological and industrial achievements of the time and promoted modern architecture. Ford's small panels are reminiscent of photographic views of the fair published in official guidebooks. Her crisp lines and vibrant palette capture the modern feeling of the fair. Few figures are present.

6. The first *Century of Progress* panel depicts the Pantheon Building *(Pantheon de la Guerre)* on the left, and the Sears, Roebuck and Company building, designed by George C. Nimmons of Nimmons, Carr, and Wright, on the right.

7. This scene features the Enchanted Island, a day-care and playground facility for children and families visiting the fair.

History of American Progress *(image 4), Elizabeth Merrill Ford, 1935–36, Fort Dearborn Elementary School.*

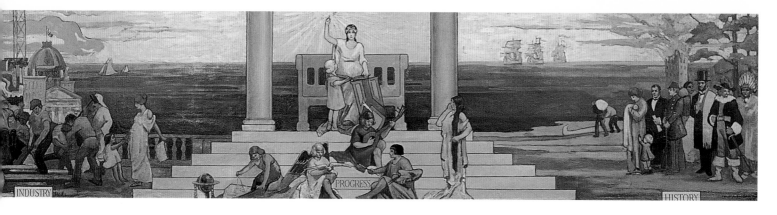

Progress, *Philip Ayer Sawyer, 1915, Joseph E. Gary Elementary School.*

8. This panel depicts the Breathing Dome of the Travel Building, modeled after the suspension bridge on the left. The building on the right is the Transport Building. In the background are the towers of the "Sky-Ride."

9. Unknown

10. This panel depicts the General Motors Pavilion on the left. The General Motors Pavilion housed the forty-eight "States" murals by Gaspar, Wick, and Linus, which now hang in the corridors of Lane Technical High School (see page 149). The structure in the center is the Chrysler Motors Building, designed in 1933 by Holabird and Root. To the right is a band shell.

11. In this panel the silver and gold building on the left is the Illinois Host House, which welcomed international audiences to the fair. The structure in the center of the composition is the Hall of Science, designed in 1933 by Raymond Hood and Paul Cret. To the right is the "Avenue of Flags," located near the north entrance of the fair.

12. In this scene, the building on the left is the Planetarium, designed by Ernest Grunsfeld Jr. in 1930. To the right is the U.S. Government Building, also known as the Federal Building. The three pylons signify the three branches of the government: judicial, executive, and legislative.

13. The structure at right in the scene is the Dairy Building, which held an exhibit focusing on the westward movement of civilization after the first cows were brought to the Plymouth colony. The building on the left is unknown.

Joseph E. Gary, *Elizabeth F. Gibson, c. 1930s, Joseph E. Gary Elementary School.*

Joseph E. Gary Elementary School

ADDRESS
3740 West 31st Street
Chicago, Illinois 60623

NAMESAKE
Judge Joseph E. Gary (1821–1906) was elected judge of superior court in 1863 and presided over the 1886 Chicago Haymarket Riot trial.[4]

ARCHITECT
Dwight Perkins

TITLES

1. *Industry*

2. *Progress*

3. *History*

ARTIST

Philip Ayer Sawyer
(signed lower right, "Philip Ayer Sawyer 1915")

CREATED
Progressive Era

SIZE
3 murals: each H 6' x W 30'

MEDIUM
Oil on canvas adhered to wall

DATE
1915

LOCATION
Auditorium

CONDITION
In 1996 the murals were coated with a layer of grime, canvas seams were lifting, and several areas of loose paint were evident.

CONSERVATION
In 1998 the Chicago Conservation Center restored the murals as part of Phase II of the Mural Preservation Project. The murals were cleaned using conservation detergents, loose areas of paint were reset into place using a gelatin adhesive, canvas seams were reset using a syringe-injected adhesive, and a matte non-yellowing surface film was applied. Retouching was carried out using conservation pigments to match the original.

MURAL DESCRIPTIONS
In this three-panel series, Sawyer renders the abstract concepts of Industry, Progress, and History using a combination of allegorical images

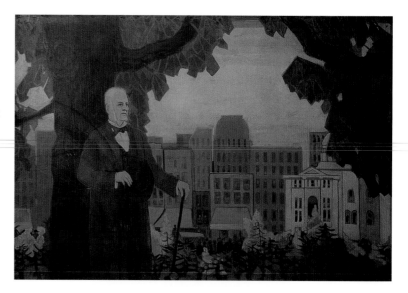

and representations of historical figures. This series indicates "social realism" in the Progressive Era, which parallels the social realism of the New Deal era.

1. The left side of *Industry* is a portrayal of agricultural production. The landscape merges with a depiction of a group of muscular men in the foreground at right. Other men using picks and anvils create a cloud of dust that signifies the rapid growth of industry.

2. The long central scene, *Progress,* continues the series. Slightly outside the scene is a woman clad in white handing a scroll to a young child, the link between the scenes representing Industry and Progress. Other working men appear on the far left; in the background appear the results of their labors, elegant buildings rising from the horizon. In the center of the panel is a depiction of Columbia, the personification of progress, holding a shield with the letter Y (symbol for the three branches of the Chicago River), shining her light on the figures below who represent the arts and sciences. These historical figures are gathered around, arranged in a traditional pyramidal composition and placed amid elements of classical architecture. The figures hold objects related to the arts such as a lute, a book, a palette, and a compass. To the right, beyond Columbus's three ships in the background's vast blue waters, a procession of famous and anonymous figures, including a Native American chief, Christopher Columbus, Abraham Lincoln, a Union soldier, and Illinois governor John Altgeld (1847–1902), represent significant historical events in U.S. and Chicago history.

3. In the final scene, *History,* Father Marquette opens his book of prayer as another expedition leader, presumably Louis Jolliet (1645–1700), shakes hands with a Native American chief. Native Americans going about their daily-life activities in a teepee settlement appear in the foreground. A fort, signaling the settlement of pioneers, hovers in the background.

TITLES

1. *Abraham Lincoln*
2. *Joseph E. Gary*

ARTIST
Elizabeth F. Gibson

CREATED
Possibly WPA/FAP

SIZE
2 murals: each H 6' x W 7'

MEDIUM
Oil on canvas adhered to wall

DATE
c. 1930s

LOCATION
Auditorium

CONDITION
In 1996 the murals were coated with a heavy layer of dirt and grime, and scattered abrasions were apparent. The portrait of Gary was extremely dark, making the image difficult to distinguish, and the signature was not legible.

CONSERVATION
Not yet restored

MURAL DESCRIPTIONS
Flanking Sawyer's murals, *Industry, Progress,* and *History,* are two pendant portraits by Elizabeth Gibson. The portraits depict two figures involved in social and racial issues: Abraham Lincoln, who fought for the abolition of slavery, and Judge Joseph E. Gary, who presided over the trial of anarchists accused of involvement in the Haymarket Affair (an 1886 demonstration over workers' rights at Haymarket Square in Chicago that developed into a riot in which an unidentified person threw a bomb, killing several policemen and wounding others).

1. Abraham Lincoln is shown standing under a tree in the first composition. In the distance are rows of Union soldiers who fought during the American Civil War. Farther in the distance is the White House, a reference to Lincoln's tenure as the sixteenth president of the United States.

2. Judge Joseph E. Gary, the school namesake, appears in the second portrait. In the distance at right are figures outside a building in the Chicago skyline. An austere neoclassical courthouse sits to the right.

TITLE
Children's Fairy Tales

ARTIST
Unknown
(possibly Roberta Elvis)

CREATED
WPA/FAP

SIZE
1 mural: H 5' x W 28'

MEDIUM
Oil on canvas adhered to wall

DATE
c. 1930s

LOCATION
Room 204 (former library room)

CONDITION
In 1996 the mural was coated with a thick film of soot; the canvas was stapled to the wall in several areas; shelving covered part of the image; and structural damage was evident.

CONSERVATION
In 2001 the Chicago Conservation Center restored the mural as part of Phase III of the Mural Preservation Project. The mural was cleaned using conservation solvents, staples were removed, cracks were stabilized, and losses were retouched to match the original. A final nonyellowing varnish was applied to protect the surface from future damage and air pollution.

MURAL DESCRIPTION
The former school library at Gary Elementary School is decorated with a mural of scenes from well-known children's fairy tales. From left to right, the panoramic mural includes scenes from *Jack and Jill; Little Black Sambo; The Little Gingerbread Boy;*

Children's Fairy Tales (detail), artist unknown, c. 1930s, Joseph E. Gary Elementary School.

Dutch Landscape (detail), W. F. Madden, c. 1920s, William P. Gray Elementary School.

Jack and the Beanstalk; Goldilocks and the Three Bears; Little Red Riding Hood; Mary, Mary Quite Contrary; and *The Three Little Pigs.* In each scene, the artist captures a pivotal moment in the story. In the foreground, for example, Jack and Jill are shown tumbling down a hill with an overturned pail of water, and the Little Gingerbread Boy is shown escaping on the back of the tiger that will eat him.

William P. Gray Elementary School

ADDRESS
3730 North Laramie Avenue
Chicago, Illinois 60641

NAMESAKE
William P. Gray (dates unknown) donated his farmland for the construction of a school, which was named after him.

Harvesting of Grain: Spring and Fall, Florian Durzynski, 1939, John Harvard Elementary School.

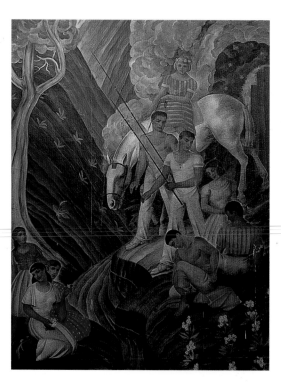

ARCHITECT
Arthur Hussander

TITLE
Dutch Landscape

ARTIST
W. F. Madden
(signed lower right, "W. F. Madden")

CREATED
Progressive Era

SIZE
1 mural: H 3' 10" x W 23' 7"

MEDIUM
Oil on canvas adhered to wall

DATE
c. 1920s

LOCATION
Kindergarten room 105

CONDITION
In 1999 the mural was extremely dirty, the white clouds appeared gray, and a large tear was found in the left quadrant where the canvas was separating from the wall. A pipe ran through the upper left quadrant of the scene, and scattered paint losses were present.

CONSERVATION
Not yet restored

MURAL DESCRIPTION
The large, horizontal mural depicts a Dutch landscape scene. Dutch and German people inhabited the school's neighborhood in the early twentieth century, when the artist painted this mural. The scene is believed to relate to Dutch and German settlement in North America during the seventeenth and eighteenth centuries. In the mural, windmills and small cottages bracket a scene filled with women in traditional Dutch attire, children, farm animals, and a flock of geese on the left. A ship at sea in the distance makes reference to immigration to the New World.

John Harvard Elementary School

ADDRESS
7525 South Harvard
Chicago, Illinois 60620

NAMESAKE
John Harvard (1607–38) was a teacher and minister of the Charleston Church in Massachusetts and is best known for bequeathing his estate for the funding of Harvard College (1638).

ARCHITECT
Dwight Perkins

TITLE
Harvesting of Grain: Spring and Fall

ARTIST
Florian Durzynski

CREATED
WPA/FAP

SIZE
2 lunettes: each H 5' x W 9'11";
1 mural: H 12' x W 9' 11"

MEDIUM
Oil on canvas adhered to wall

DATE
1939

LOCATION
Auditorium

CONDITION
In 1995 the paintings were in critical condition and in jeopardy of being lost. The unvarnished mural, *Spring,* was poorly adhered to the plaster wall and the glue was separating in several areas. The soot-covered murals had structural damages, severe cracking, ripples, and drip stains throughout. The lunette above the missing *Fall* mural was also adhered to the plaster wall, with severe water damage, oxidation, and drip stains. The engineer informed us that the *Fall* mural had been thrown away because of its damaged condition. There were six similar wall panels in the auditorium; each panel may have originally contained a mural, but only these two, *Spring* and *Fall,* are recorded in reference sources.

CONSERVATION
In 2002 the Chicago Conservation Center will restore the murals as part of Phase III of the Mural Preservation Project.

MURAL DESCRIPTIONS

The style and subject matter of this mural group are typical of the work of Florian Durzynski, whose murals often depict the American landscape and seasons. In this partially destroyed series relating to spring and fall, Durzynski focuses on the community celebration during harvesting seasons, bringing attention to agriculture as a primary element of the culture. The undulating hills, high horizon lines, and fluffy cotton-candy treetops are trademarks of the artist's style. In addition, the parallel and curving lines that run through the composition lend the piece a poetic quality apparent in other Durzynski works. In the large *Spring* mural, female figures pick spring flowers, young men fish in a stream, while other men and women enjoy a picnic. Another young girl, wearing a floral wreath, sits astride a white horse, appearing like an allegory of spring. The yellow flowers she holds reappear on the opposite bank and unify the scene visually. The second lunette is similar in composition to the scene depicting spring, and the large panel depicting fall is missing.

Julia Ward Howe Elementary School

ADDRESS
720 North Lorel Avenue
Chicago, Illinois 60644

NAMESAKE
Julia Ward Howe (1819–1910) was a social worker and activist who promoted the women's suffrage movement. Howe is best known for her poem "The Battle Hymn of the Republic." At Howe Elementary School, during the WPA a print shop was established in the basement and a weekly newspaper published by the students was distributed through the community.

ARCHITECT
Unknown

TITLE
Landscape

ARTIST
Florian Durzynski

CREATED
WPA/FAP

SIZE
1 mural: H 10' x W 20'

MEDIUM
Oil on canvas adhered to wall

DATE
1938

LOCATION
Auditorium

CONDITION
In 1995 the mural was coated with a considerable soot film and marred by graffiti, tacks, tape, and staples. The canvas was separating from the wall in several areas. Water damage and staining were prevalent, resulting in abrasions and flaking of the paint layer.

CONSERVATION
Not yet restored

MURAL DESCRIPTION
On the rear wall of the auditorium stage is a lush landscape set in a symmetrical design. The small stream in the foreground center subtly bisects the composition and serves as a visual focus point for the viewer. The distant horizon, cotton-candy treetops, and rich palette are trademarks of Florian Durzynski's work. The yellow prairie flowers in the foreground locate this landscape in the Midwest. The absence of a firm narrative or figural subjects, in addition to the low vantage point, indicates that this mural may have been intended as a backdrop for stage performances.

Friedrich Ludwig Jahn Elementary School

ADDRESS
3149 North Wolcott
Chicago, Illinois 60657

NAMESAKE
Friedrich L. Jahn (1778–1852) is considered the father of gymnastics. During the 1800s in Germany he was an avid proponent of physical fitness.

ARCHITECT
Dwight Perkins

TITLES

1. American Frontier: Indians and Traders

2. American Frontier: Pioneer Family

ARTIST
Unknown

CREATED
Progressive Era

Landscape, Florian Durzynski, 1938, Julia Ward Howe Elementary School.

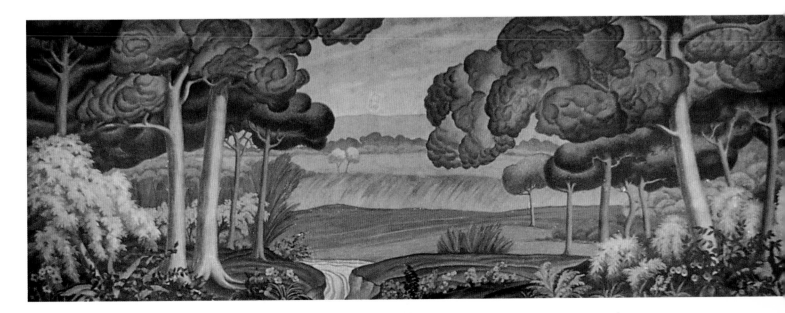

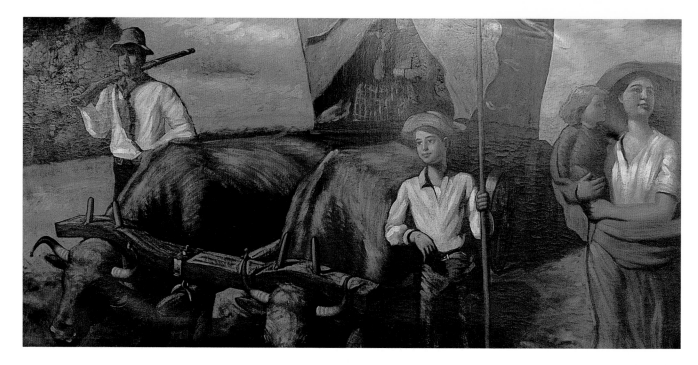

American Frontier: Pioneer Family, *artist unknown, c. 1920s, Frederick Ludwig Jahn Elementary School.*

SIZE
2 murals: each H 3' 8" x W 7' 10"

MEDIUM
Oil on canvas adhered to wall

DATE
c. 1920s

LOCATION
Second-floor corridor

CONDITION
In 1996 it was noted that the murals were mounted above the railing and were coated with a layer of grime; they appeared to have been cut along the bottom portion.

CONSERVATION
Not yet restored

MURAL DESCRIPTIONS
These two finely rendered horizontal canvases depict scenes of trading between pioneers and Native Americans and a pioneer family's move westward.

1. In the first panel, a Native American community on the left is juxtaposed with a settlers' camp on the right. Women holding children and carrying pottery represent the Native American community. The log cabin on the right identifies the white figures as settlers. Women stand in the doorway to the cabin, which is guarded by men with rifles. Representatives from each camp trade goods such as animal skins, textiles, and beads in the painting's center. The scene takes place in a river valley, potentially locating this scene along the Chicago River.

The History of Ancient Writing *(image 3), Harry Gage, c. 1920s, Frederick Ludwig Jahn Elementary School.*

2. In the second panel, a pioneer family appears to be in the middle of their westward move. In this tightly cropped composition, the figures are pushed far into the foreground, their position conveying a sense of immediacy. On the left, the family patriarch walks alongside a cattle-drawn covered wagon with a rifle over his shoulder wearing a typical pioneer outfit: a white shirt and red handkerchief tied around the neck. The bright, open face of a young boy to the right of the wagon shows the promise and exhilaration of the westward move. The billowing folds of the matriarch's shawl at right frame the figural group and parallel the billowed cape of the wagon, conjuring the feeling of the open prairie winds. The cloudy sky and prairie stretch behind the figural group as they move across the land.

TITLE
The History of Ancient Writing

ARTIST
Harry Gage

CREATED
Progressive Era

SIZE
4 murals: each H 5' x W 9'

MEDIUM
Oil on canvas adhered to wall

DATE
c. 1920s

LOCATION
Auditorium

CONDITION
In 1996 the murals were coated with a heavy soot film; scattered abrasions, paint loss, and lifting edges were present.

CONSERVATION
Not yet restored

MURAL DESCRIPTIONS

This four-panel mural series traces the history of the early written word, from prehistoric man to the Phoenician civilization around 1250 B.C. Smaller horizontal text panels describing the painted scenes originally accompanied all four panels. Only two remain, below the first and fourth murals.

Left wall:

1. The first scene depicts prehistoric men demonstrating tool-making skills and writing on tablets with rudimentary instruments. On the right, a man holds a stone tablet, while another stands in a loincloth. In the background, a tribal killing of a woolly mammoth is rendered in an open plain surrounded by a heavily wooded area. The text below reads, "Primeval men numbered their achievements in notches hewn on a stick with axes and flint." The artist makes reference to the first forms of writing on sticks and stone tablets with sharpened tools. This form of record keeping was primarily used for ceremonial and agricultural purposes.

2. The second mural portrays the Sumerian culture around 3000 B.C. This urban civilization in Mesopotamia developed cuneiform writing used by scribes to record trading transactions. The focus of the image is the turbaned man writing with brush and ink (although cuneiform first appeared on clay tablets and the writing tools were "wedge" styluses). His instrument is a forerunner to the brush and quill pens. Also in the scene, a man sits sewing a textile, another pours dye, and others observe the scribe. A busy market scene furnished with exotica such as elephants fills the background, and fresh exotic fruits fill baskets in the foreground. The textiles, foods, and animals shown symbolize the immense influx of trade in the region, which led to the spread of knowledge and agricultural development.

Right wall:

3. The third mural, an Egyptian scene, is filled with pyramids, camels, and hieroglyphs. The scene focuses on a seated scribe holding a papyrus scroll with hieroglyphic notations; he renders on it a female figure in flowing Eastern garments. The writing tools, various scrolls, ink, pots, and brushes add wonderful detail to the elaborate scene.

The Nile River in the distance represents trade routes, and the pyramids denote the architectural achievements of the Egyptian civilization.

4. The last panel depicts the Phoenician culture, which made the most significant contribution to the development of writing, with the first script alphabet of twenty-two letters, considered the ancestor of the Greek and Roman alphabets. The text panel below the fourth scene reads, "Phoenicians inscribing their records on clay tablets invented the phonetic alphabet." The scene depicts a person rinsing textiles while another stirs a vat of dye. Meanwhile, a massive construction effort is under way in the background; men work in unison to heave heavy beams, raise pillars, and carry bricks. The scribe, as the text panel indicates, documents the scene on a primitive clay brick.

Thomas Kelly High School

ADDRESS
4136 South California Avenue
Chicago, Illinois 60632

ARCHITECT
Shepley, Rutan and Coolidge

NAMESAKE
Thomas Kelly (unknown–1843) was a community businessman and land developer. A significant part of Chicago's industrial history has transpired in the school's

surrounding communities of Brighton Park, McKinley Park, New City, and Bridgeport.

TITLE
Unknown
(History of Archer Avenue Community)

ARTIST
Unknown

SIZE
3 murals: H 6' 1" x W 29' 6" (south wall); H 6' 2" x W 7' 4" (north wall); H 6' 1" x W 13' 4" (east wall)

MEDIUM
Oil on canvas adhered to wall

DATE
c. 1930s

LOCATION
Cafeteria

CONDITION
In 1999 the murals were coated with a heavy film of grime and marred by food stains, drip stains, scratches, and smudges. Several of the seams were separating and the canvas was lifting in several areas.

CONSERVATION
Not yet restored

MURAL DESCRIPTIONS
Nine horizontal panels of various lengths decorating the school cafeteria depict the history and community life of the neighborhood. The dramatically different palettes, styles, and panel compositions indicate that different artists may have produced

Unknown (History of Archer Avenue Community) (detail of image 2), artist unknown, c. 1930s, Thomas Kelly High School.

Unknown (Great Explorers and Leaders), Edgar Miller, 1933, Kelvyn Park High School.

them. Three appear to be an older series from the 1930s, and six others appear to be from the 1970s or later. The bright palette and contoured figures in the three older murals are easily differentiated from the later works, in a monochromatic palette with contemporary subjects. The variety of themes and styles among the works creates a montagelike mural cycle that captures the history and spirit of the community surrounding Kelly High School.

Left wall:

1. The first scene depicts American settlement. To the right early settlement is represented by horse-drawn wagons and cattle. In the center a more advanced civilization, with horse-drawn carriages and stone settlement houses, is shown, while in the background a farmer and horse-drawn plow work a fertile flatland.

2. The second panel from this period depicts the Chicago railway system, established in the middle of the nineteenth century, which played a large role in local commerce and development. The production of railway lines in this community, for livestock and

grain trade, provided jobs for many local laborers. In this scene, workers are shown laying railway girders along wooden planks, while men with hammers stand next to horses pulling slabs of brick for building.

3. The third panel depicts culture along the American waterways. A riverboat filled with women, children, farmers in overalls, and an African American man playing an instrument represents early immigration to the south and west along the Midwest waterways, including the Chicago River, which played a significant role in the development of the Brighton Park community, as serving a link between the Mississippi to the south and the Great Lakes to the north. Several bridges were built to transverse the Chicago River, allowing transportation and trade to become an integral part of this community.

Kelvyn Park High School

ADDRESS
4343 West Wrightwood
Chicago, Illinois 60639

NAMESAKE
The original Scottish settlers in the surrounding community named the school and neighborhood in memory of Glasgow native Kelvyn Grove (dates unknown).

ARCHITECT
Arthur Hussander

TITLE
Unknown
(Great Explorers and Leaders)

ARTIST
Edgar Miller

CREATED
Progressive Era

SIZE
5 stained glass mural panels: each H 2' x W 4' (possibly a total of 7 originally)

MEDIUM
Stained glass

DATE
1933, dedicated by the principal, Mr. C. E. Lang, and the January and June classes of 1933

LOCATION
Library, room 100

CONDITION
In 1996 the five stained glass murals were coated with a layer of grime, yet no panels were cracked or falling apart.

CONSERVATION
Not yet restored

MURAL DESCRIPTIONS
The graduating class of 1933 commissioned local artist Edgar Miller to create stained glass panels for the school. Miller believed education should be a visual and exciting experience, so he designed panels portraying great explorers and leaders. Even though stained glass is not considered a mural medium, the five stained glass panels at Kelvyn Park High School rank among the highest quality artworks in the Chicago Public Schools. Their function, subjects, and location are very similar to those of mural paintings; therefore, they have been considered part of this collection. Each of the five large panels is multi-layered and subdivided into several registers. The historical subjects, rendered in this medieval medium of stained glass, lend an almost spiritual quality to the school's library.

1. The first panel includes Eric the Red (950–unknown), a Norse chieftain, the discoverer and colonizer of Greenland; Leif Eriksson (970–1020), the son of Eric the Red and the Norse discoverer of America; Henry the Navigator (1394–1460), a prince of Portugal who contributed to the progress of exploration and navigation; Alonso de Ojeda (1466–1515), a Spanish conquistador who joined Columbus on his second journey; and Amerigo Vespucci (1454–1512), an Italian explorer after whom America was named.

2. The second panel includes portraits of Odoric Pordenone (1286–1331), a Christian missionary who traveled to the court of the Great Khan and remained there for three years; Contu (dates unknown); Benedict Goes (1562–1607); Vasco da Gama (1469–1524), a Portuguese navigator and the first European to journey by sea to India; Bartolomeu Dias (unknown–1500), a Portuguese navigator and the first European to journey around the Cape of Good Hope; de Soto (1496–1542), a Spanish explorer who landed in Florida in 1539 and crossed the Mississippi; and Vasco Nuñez de

Balboa (1475–1519), a Spanish conquistador and the discoverer of the Pacific Ocean.

3. The third panel includes Willem Barents (unknown–1597), a Dutch navigator who made three consecutive voyages to find the Northeast Passage to Asia; Henry Hudson (1565–1611), an English navigator and explorer who was the first European to travel the river now known as the Hudson; Sir Martin Frobisher (1539–94), an English mariner who made three voyages to the arctic region and later became knighted for his services in the defeat of the Spanish Armada in 1588; Richard Hakluyt (1552–1616), an English geographer who collected and published narratives of voyages and travels; Samuel de Champlain (1567–1635), a French explorer and the chief founder of New France, now known as Canada; Jacques Cartier (1491–1557), a French navigator who made three voyages of exploration to North America to survey the coasts of Canada; John Smith (1580–1631), an English colonist who became a member of the Jamestown settlement in Virginia and explored the surrounding regions; and Petrus Stuyvesant (unknown–1672), the governor of New Netherland in 1647 who saved the colony from the disastrous policies of his predecessor, Willem Kieft.

4. The fourth panel commemorates well-known rulers, warriors, and philosophers, such as Aristotle (384–322 B.C.), a Greek philosopher, scientist, physician and one of the great figures in the history of Western thought; Alexander the Great (356– 323 B.C.), the king of Macedonia and the conqueror of a large portion of Asia; Augustus (63 B.C.– A.D. 14), the first Roman emperor and the grandson of the sister of Julius Caesar; Constantine (288–337), a Roman emperor who encouraged Christianity and tolerated paganism; Charles Martel (688–741), a Frankish ruler and the grandfather of Charlemagne; Alegio of England (dates unknown); Richard Lion Heart (1157–99), the king of England in the late twelfth century, known for his military skill and chivalry; William of Normandy (1027–87), the illegitimate son of Robert, Duke of Normandy, who became king of England in 1066; and Jeanne d' Arc (1412–31), a French saint and national heroine who fought for the king but was burned at the stake for witchcraft.

5. The fifth panel also depicts well-known rulers, such as Francis I (1830–1916), the emperor of Austria and the king of Hungary, whose attack on Serbia in 1914 precipitated World War I; Elizabeth I (1533–1603), queen of England during the height of the Renaissance, one of that country's most powerful periods; Catherine I of Russia (1683–1727), the wife of Peter the Great and czarina of Russia in the early eighteenth century; Gustavus Adolphus (1594–1632), the king of Sweden in the early seventeenth century, known for a military battle with Russia in which Sweden obtained Ingermanland; Charles XII (1682–1718), the king of Sweden in the late seventeenth and early eighteenth centuries who invaded the enemy territories of Russia, Poland, Saxony, and Denmark only to be defeated by Russia in a later skirmish; Giuseppe Garibaldi (1807–82), an Italian patriot and soldier, revered as a revolutionary hero; Thomas Jefferson (1743–1826), the third president of the United States and the author of the Declaration of Independence; and Abraham Lincoln (1809–65), the sixteenth president of the United States, known for his opposition to slavery and for his assassination in 1865.

Joyce Kilmer Elementary School

ADDRESS
6700 North Greenview Avenue
Chicago, Illinois 60626

NAMESAKE
Alfred Joyce Kilmer (1886–1918) was a poet whose fame rests primarily on his work "Trees," which starts with the line, "I think that I shall never see, a poem lovely as a tree." Kilmer also enjoyed a brief career as a teacher before moving into journalism.

ARCHITECT
Paul Gerhardt

..

TITLE
The Four Seasons

ARTIST
Unknown

CREATED
Progressive Era

SIZE
4 murals: each H 9' 2" x W 3'

MEDIUM
Oil on canvas adhered to wall

DATE
c. 1920s

LOCATION
Auditorium

CONDITION
In 1999 the framed and unvarnished murals were heavily coated with a film of grime, the canvas panels were separating from the walls in several areas, and the surfaces had scattered mars and abrasions.

CONSERVATION
Not yet restored

MURAL DESCRIPTIONS
Each of the four large, vertical panels on the side walls of the auditorium depicts one of the four seasons. Above the stage is a phrase from a Kilmer poem, stating, "Poems are made by fools like me, only God can make a tree." The four murals display a European influence closely related in subject and style to works by Puvis de Chavannes (1824–98). The soft palette and flat depictions resemble genre and pastoral mural paintings created in Europe during the nineteenth century.

**The Four Seasons
(image 1), artist unknown,
c. 1920s, Joyce Kilmer
Elementary School.**

Landscape Scenes (image 2),
Robert Wadsworth Grafton,
1926, Marquis de Lafayette
Specialty Elementary School.

angle of light creates strong shadows in the foreground and along the slopes in the distance.

2. The second mural is a naturalistic rendering of a waterfall and rapids in a canyon of a mountain range. Pine trees are perched along the top ridge and to the side of the waterfall.

3. The third mural is also a depiction of a waterfall, but rendered from a greater distance. Again the waterfall is set in a canyon in a mountain range, surrounded by pine trees.

4. The fourth scene is executed from a lower perspective, next to a placid lake in the fertile valley of a mountain range. The dramatic panoramic views are reminiscent of American landscape painting of the nineteenth century.

Lake View High School

ADDRESS
4015 North Ashland
Chicago, Illinois 60613

NAMESAKE
The community received its name because of its proximity to Lake Michigan. Lake View was organized as a township in 1857, and as a town in 1865. The high school features two relief panels made by Chicago artist Renee Townsend: a Tiffany window that crowns the Irving Park entrance,

Old and Modern School
Systems, Gregory Orloff, 1936,
Lake View High School.

and original stained glass windows in the library.

ARCHITECT
Norman Patton

...

TITLE
Old and Modern School Systems

ARTIST
Gregory Orloff

CREATED
WPA/FAP

SIZE
2 murals: (1) H 6' 4" x W 21' 10";
(1) H 6' 4" x W 23' 5"

MEDIUM
Oil on canvas

DATE
1936

LOCATION
Library

CONDITION
In 1996 we discovered that these two murals had been painted over. Beneath flaking paint on a wall in the library fragments of an original scene were visible. An attempt will be made to remove the overpaint and preserve the original murals, but it is unknown at this time whether they are completely salvageable.

CONSERVATION
Not yet restored

MURAL DESCRIPTIONS
In the one visible mural, Orloff contrasted the solitary learning methods of the nineteenth century with the collaborative education practices of the early twentieth century. He shows images of young girls in late-nineteenth-century attire reading books alone juxtaposed with images of modern group learning activities, collaborative projects, and games on the school grounds.

...

TITLE
Thirteen American Authors

ARTIST
Karl Peter Andreas Ouren

CREATED
Progressive Era

SIZE
13 murals: each H 2' x W 2' (roundels)

MEDIUM
Oil on canvas roundels

DATE
c. 1910s

LOCATION
Auditorium

CONDITION
In 1996 the murals, arranged in an arch high above the stage in the exceptionally large auditorium, were coated with a severe film of soot and several murals showed cracks, flaking paint, and stains.

CONSERVATION
In 2000 the Chicago Conservation Center restored the murals as part of Phase III of the Mural Preservation Project. The murals were cleaned using distilled water and ammonium hydroxide (NH4OH) for the embedded dirt in the whites, followed by a mild cleanser. Jade conservation adhesive was syringe-injected into the cracks to secure the areas of lifting paint. An acrylic based varnish was used as an ethical buffer and protective layer before retouching work was carried out using conservation pigments. A spray matte varnish was applied as a final protective layer.

MURAL DESCRIPTIONS
Thirteen painted roundels depict famous American authors.

1. Mark Twain (Samuel Clemens) (1835–1910), the American writer, lecturer, and humorist, is best known for his writings about youth, including *The Adventures of Tom Sawyer, Life on the Mississippi,* and *The Adventures of Huckleberry Finn.*

2. Ralph Waldo Emerson (1803–82), the American essayist, poet, and lecturer, founded an independent literary group known as Transcendentalists and published an anonymous compilation of his new philosophy called *Nature.*

3. Nathaniel Hawthorne (1804–64), an American short-story writer and novelist, is noted for his novels including *The House of Seven Gables* and *The Scarlet Letter.*

4. William Dean Howells (1837–1920), a critic, novelist, and supporter of literary realism, worked for the *Atlantic Monthly* and was a confidant of Mark Twain and Henry James.

5. Benjamin Franklin (1706–90) was an American renaissance man known for his achievements as an author, publisher, printer, inventor, scientist, and diplomat.

6. James Russell Lowell (1819–91) was a poet, critic, editor, diplomat, and scholar.

7. Henry Wadsworth Longfellow (1807–82) was one of the first and most famous American poets and one of the first American writers to focus on Native American life and slavery, of which the *Song of Hiawatha* and *Poems of Slavery* are his best-known examples.

8. John Burroughs (1837–1921) was an American naturalist and essayist committed to the study and appreciation of nature in the manner of Henry David Thoreau.

9. Washington Irving (1783–1859) was a scholar and author of short stories including "The Legend of Sleepy Hollow" and "Rip Van Winkle."

10. Oliver Wendell Holmes (1809–94) was an American poet, humorist, and physician noted for his medical research in teaching. At age twenty-one he won national acclaim for the publication of *Old Ironsides,* about the American fighting ship from the War of 1812.

11. Walt Whitman (1819–92) is one of America's most renowned literary figures, known for his achievements as a poet, essayist, and journalist and for his poems of wisdom and wit in *Leaves of Grass,* self-published in 1855.

Thirteen American Authors, Karl Peter Andreas Ouren, c. 1910s, Lake View High School.

Mark Twain (Samuel Clemens) (image 1), Karl Peter Andreas Ouren, c. 1910s, Lake View High School.

12. John Greenleaf Whittier (1807–92) was an American poet and abolitionist who produced the pamphlet "Justice and Expediency."

13. William Cullen Bryant (1794–1878) was a poet and the editor of the *New York Evening Post* for more than fifty years.

Albert G. Lane Technical High School

(formerly Thomas Hoyne Manual Training School)

ADDRESS
2501 West Addison
Chicago, Illinois 60618

NAMESAKE
In 1908 the Thomas Hoyne Manual Training School was moved and renamed Albert Grannis Lane Technical High School after Albert Grannis Lane (1841–1906), a highly recognized educator. Beginning in 1891, Lane was the Cook County superintendent of schools for nineteen

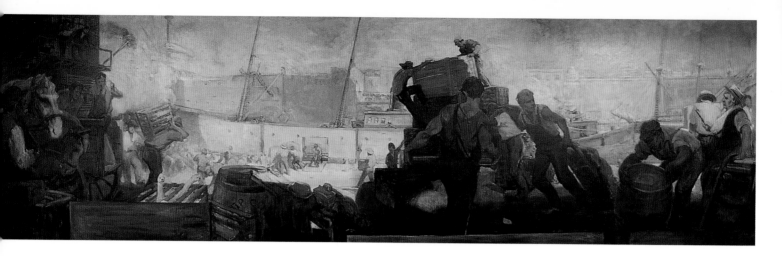

Dock Scene, *William Edouard Scott, 1909, oil on canvas, Lane Technical High School.*

years. He believed in "educating the hands as well as the mind" and established the creation of a large high school dedicated to manual training. The present Lane Technical High School was dedicated in 1934. Lane Technical High School holds one of the largest art collections of any public school in the country. The collection is home to sixty-six murals and two cast-stone fountain figures. Dating from 1908 to 1943, the collection falls into the three categories listed below.

ARCHITECT
Paul Gerhardt

TITLES

1. Steel Mill
(signed lower left, "M. HITTLE")

2. Dock Scene
(signed lower left, "Wm. E. Scott, Art Institute 1909")

3. Construction Site
(signed lower left, "Gordon Stevenson, Art Institute 1909")

ARTISTS

1. Margaret Hittle

2. William Edouard Scott

3. Gordon Stevenson

CREATED
Progressive Era

SIZE
3 murals: each H 5' x W 18'

MEDIUM
Oil on canvas, on new redwood spring-stretchers

DATE
1909

LOCATION
Second floor, outside library

CONDITION
In 1995 the murals were coated with such a heavy film of soot that the signatures were illegible. The murals were in poor condition with holes, scratches, and areas of paint loss, and the canvases were weak and brittle.

CONSERVATION
Due to the poor condition of the murals, they were removed from the walls and transported to the Chicago Conservation Center for treatment in May of 1995. The murals were cleaned using mild organic solvents under binocular magnification. During cleaning of the *Dock Scene*, William Edouard Scott's signature was revealed. After cleaning was completed, the three murals were then lined to Belgian linen using a nonaqueous adhesive. Next, the murals were varnished. Cracks and losses were retouched using colorfast and lightfast conservation pigments, then sprayed with a nonyellowing varnish to protect the paint from fluids and air pollution. These three murals were the first in the collection to be preserved. They were funded by school bake-sales and other fundraising activities before the Board of Education began Phase I of the Mural Preservation Project in 1996.

MURAL DESCRIPTIONS
Katherine Buckingham, president of the Chicago Public School Art Society, commissioned the three murals in 1908. They were moved from the original site to the new school location on Addison. The three artists (Hittle, Stevenson, and Scott) were chosen from a student competition at the School of the Art Institute of Chicago. In a 1915 letter to Mrs. Buckingham, Chas. I. Ginrich, senior

class president, wrote, "The painters seem to have caught the spirit of industry and to have embodied it in a vivid and realistic manner ... The subject matter is very appropriate for a technical school. The walls would be bare and dreary were it not for these murals."[5] The scenes depict three major labor sites in American industrial centers. Together these three pieces form an impressive triptych devoted to labor in a modern society.

1. In Margaret Hittle's *Steel Mill*, shirtless, muscular workers surround a fiery forge in a steel mill, exemplifying industrial production. The high contrast of light and dark, the rendering of the male figures, and the subject itself recall Baroque paintings of the forge of Vulcan (the god of fire and metal).

2. William Edouard Scott, one of few African American muralists in Chicago at the time, created his *Dock Scene*, showing several workers, including two African Americans, on a wharf loading and unloading cargo from the large steamships docked in the harbor. A white foreman leans on a barrel watching the workers.

3. Gordon Stevenson's *Construction Site* is modern in its subject and style. The image is thought to be a rendering of the building of a skyscraper, although it may actually represent the building of the elevated train tracks. In the bustling scene, workers surround the red steel girder that dominates the composition. The structure appears to be the same height as the tall buildings in the background.

TITLES

1. *Village Scene I*
(unsigned)

2. *Village Scene II*
(signed lower right, "H. Geo. Brandt, '13")

3. *Indians in Canoes*
(signed lower right, "H. Geo. Brandt, '13")

4. *Buffalo Hunt*
(unsigned)

5. *Processional*
(signed lower right, "H. Geo Brandt, '13")

6. *Forest Dance*
(signed lower right, "H. Geo. Brandt, '13")

7. *Homage to Nature*
(unsigned)

ARTIST

Henry George Brandt

CREATED

Progressive Era

SIZE

7 murals: (6) H 2' 6" x W 15';
(1) H 2' 6" x W 30'

MEDIUM

Oil on canvas, on original stretchers
with molding frames

DATE

1913

LOCATION

First-floor lobby

CONDITION

In 1995 the paintings were severely
coated with a film of soot that ren-
dered the images hard to decipher.
The surfaces had cracks, holes,
scratches, and areas of loss. Overall,
the pieces were in poor condition.

CONSERVATION

In 1997 the Chicago Conservation
Center restored the murals as part
of Phase I of the Mural Preservation
Project. The murals were transported
to the Chicago Conservation Center
for treatment. The murals were
cleaned using mild organic solvents
under binocular magnification. They
were then lined to Belgian linen using
a nonaqueous adhesive. The murals
were varnished before retouching
work was carried out. They were sprayed
with a nonyellowing varnish to protect
the pieces against damage from fluids
and air pollution.

MURAL DESCRIPTIONS

The seven long and narrow murals
painted in a Beaux Arts style by Henry
George Brandt celebrate Native
American life. The calm and serene
scenes are some of the earliest works
donated to Lane Technical High School.
The delicately rendered panels convey
a sense of admiration for Native
American culture in Chicago before
foreign settlement took hold in the
middle of the nineteenth century.
Shown are images of Native Americans
at peace with nature, honoring the
agricultural heartland and abundance
of the Chicago region.

3. The next scene, *Indians in Canoes*,
features a serene view from the bank
of a river. Three Native Americans are
shown, each in his own canoe, pad-
dling down a river. Trees on both ends
of the scene balance the composition.

4. In the winter scene *Buffalo Hunt*, a
hunter kneels behind a large tree
while aiming his bow and arrow
directly at the buffalo in the center of
the scene, standing alone on a flat
bed of white snow. In the foreground
stands another hunter, who points a
spear directly at the buffalo; a figure
to his right hides behind a tree.

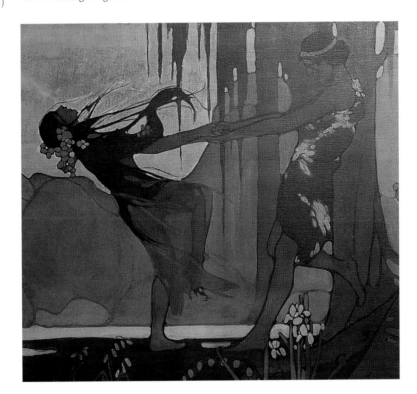

Forest Dance *(detail),*
Henry George Brandt, 1913,
Albert G. Lane Technical
High School.

1. The first *Village Scene* takes place
in a village settlement surrounded by
trees on the far left and right, with a
river far off in the background. In the
center of the composition, placed on
the ground, is a large ceremonial bowl
from which a billowing trail of smoke
elegantly winds in the air around a
totem. The focus of the composition
is ceremonial worship. To the right of
the center bowl a nude figure bends
over in prayer, while other figures are
shown dancing around a fire, wor-
shipping, kneeling, and weaving.

2. The second *Village Scene* depicts
the bank of a river in a Native
American settlement and focuses on
the making of arts and crafts. Figures
are shown painting on stretched
animal skin and making pottery.

5. The *Processional* scene features
various groups of figures wandering
down a path, including women
collecting flowers, a man carrying
bunches of grapes, and a mother
holding a baby. A lion and an ox
walk along with the humans. A
boy accompanied by a goat leads
the processional.

6. The scene that is most romantic in
style and nature is the *Forest Dance*.
On the far left, under thick willow
trees at the side of a river, a boy plays
a flute while hiding behind a tree. To
the right, a couple dance beneath a
tree as the woman's long hair blows
in the wind. The trees on the far ends
of the composition balance the scene;
mountains appear in the distance.

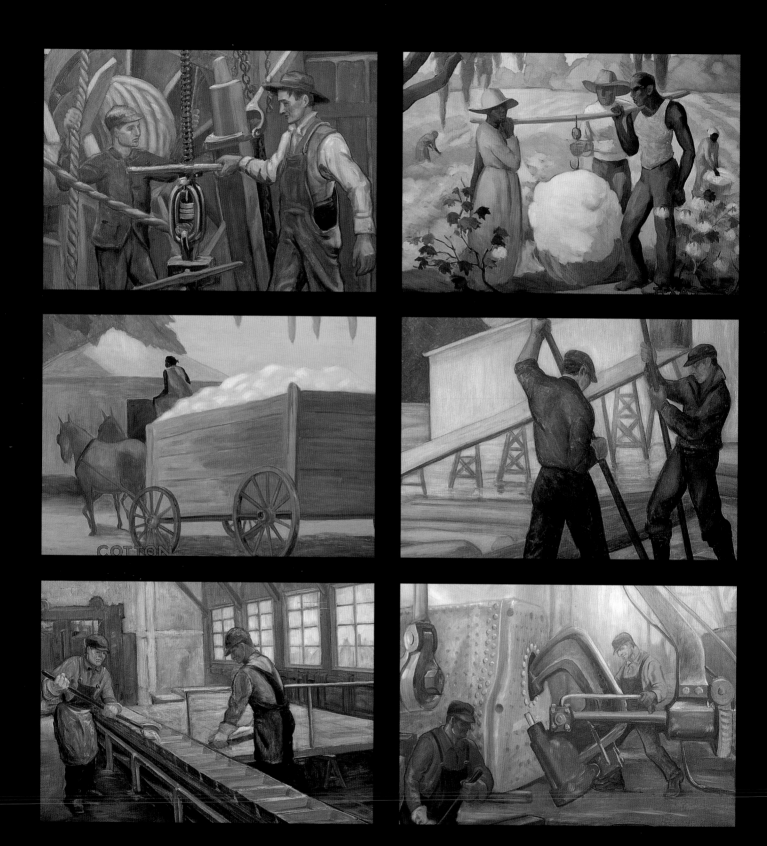

7. In *Homage to Nature*, a female figure representing the abundance of nature is shown surrounded by three other female figures. Farmers wearing hats and oxen pulling carts carry offerings to the nature goddess. Student Chas. I. Gingrich wrote, "A plethora of fruit and grain abounds and happiness gleams from the faces of the harvesters as they garner the sheaves."[6]

..

TITLE

The States

ARTISTS

Miklos Gaspar
(13 murals; also project advisor)

Axel Linus
(8 murals)

S. Wick
(19 murals)

CREATED

Century of Progress Exposition, 1933–34

SIZE

40 mural panels: each H 4' x W 20'

MEDIUM

Oil on canvas on wood

DATE

1933

LOCATION

First-floor hallways

The States

State	Subject Matter	Artist/Signed
Arizona	Hides, copper	S. Wick
Arkansas	Manganese, lumber	Linus, 1933
California	Lumber, oil, borax, gold	Linus, 1933
Colorado	Silver, tungsten, gold	Miklos Gaspar, 1933
Florida	Sugarcane, by-products, pigskin	Linus, 1933
Georgia	Textile	Miklos Gaspar, 1933
Idaho	Lumber, wool	S. Wick
Illinois	Glass	S. Wick
Indiana	Steel, limestone	S.Wick
Iowa	Zinc	Miklos Gaspar, 1933
Kansas	Grain, grain products	S. Wick
Kentucky	Coal, porcelain	Miklos Gaspar, 1933
Louisiana	Sulfur, oil, lumber	Linus, 1933
Maine, New Hampshire, Vermont	Paper, wood pulp	Miklos Gaspar, 1933
Maryland, Delaware	Paint, lacquer	Miklos Gaspar, 1933
Massachusetts, Connecticut Rhode Island	Textile, machinery	Miklos Gaspar, 1933
Michigan	Copper, lumber	S. Wick
Minnesota	Iron, lumber	S. Wick
Mississippi, Alabama	Cotton	S. Wick
Missouri	Zinc, lead, aluminum	Miklos Gaspar, 1933
Montana	Hair, oil, copper	S. Wick
Nebraska	Hides	Linus, 1933
Nevada	Borax, copper, silver	S. Wick
New Jersey	Chemicals	Miklos Gaspar, 1933
New Mexico	Hides, silver, copper	S.Wick
New York	Paper, electrical equipment	Miklos Gaspar, 1933
North Carolina	Turpentine	S. Wick
Ohio	Lamps, machinery, rubber	Miklos Gaspar, 1933
Oklahoma	Lumber, oil	S. Wick
Oregon	Wood products, lumber	S. Wick
Pennsylvania	Steel	S. Wick
South Carolina	Textile	S. Wick
South Dakota, North Dakota	Silver, hides	S. Wick
Tennessee	Oil	Miklos Gaspar, 1933
Texas	Oil, mercury, wool, cotton	Linus, 1933
Utah	Wool, copper	Linus, 1933
Washington	Lumber	S. Wick
West Virginia, Virginia	Coal, glass, lumber	S. Wick
Wisconsin	Lead, paper	Miklos Gaspar, 1933
Wyoming	Oil	Linus, 1933

CONDITION

In 1995 the paintings were coated with grime and air pollution and the surfaces showed areas of flaking paint. Previous attempts at restoration were visible in areas of flaking paint that had been painted with an adhesive to secure the paint layer into place.

CONSERVATION

In 2000 the Chicago Conservation Center restored the murals as part of Phase III of the Mural Preservation Project. Cleaning was difficult due to the weakened paint layer, areas of overpaint, and the hardened glue. Removal of the overlaying films required controlled use of inorganic and organic solvents. Cleaving paint was reset as cleaning proceeded. When cleaning was completed, a matte surface film was applied to each panel. Retouching was carried out using Maimeri conservation pigments.

MURAL DESCRIPTIONS

The States murals adorn the long corridors of Lane Technical High School. They were originally produced for the General Motors Pavilion at the 1933–34 Century of Progress Exposition in Chicago, which celebrated the city's one hundred years of achievement in science, commerce, and industry and focused on new products and the technology used to produce them. This forty-panel mural series originally hung high along the walls of the General Motors Pavilion exhibit hall, complementing the automobile assembly line below.[7] The murals portray the then-forty-eight states, detailing each state's contribution to automobile production. Gaspar, Linus, and Wick show the natural and human resources used to assemble modern vehicles. For example, in the panel representing Maryland and Delaware, Gaspar shows the factory production of paint and lacquer used for the exterior of cars. New Jersey's panel depicts scientists in a laboratory producing the chemicals necessary for the proper functioning of a car. The panel representing Georgia depicts a textile factory and the production of cloth for vehicle interiors. The panel representing Illinois shows men quarrying the natural resources used in glass manufacturing (metal oxides, sand, soda, and lime). When the Century of

Facing page: The States (details), Miklos Gaspar, Axel Linus, and S. Wick, 1933–34, Albert G. Lane Technical High School.

Abraham Lincoln, *Elizabeth Merrill Ford, c. 1930s, Mount Vernon Elementary School.*

Facing page: Characters from Children's Literature *(details), Charles Freeman, 1937, Wolfgang A. Mozart Elementary School.*

Characters from Children's Literature *(image 2), Charles Freeman, 1937, Wolfgang A. Mozart Elementary School.*

CONDITION

In 1999 the unvarnished murals were in very poor condition, with severe holes, scattered tears, bulges, layers of grime, and drip stains.

CONSERVATION

Not yet restored

MURAL DESCRIPTIONS

Depicted in the murals flanking the stage are scenes from the lives of two American presidents: George Washington and Abraham Lincoln.

1. The first panel shows George Washington dressed in full military uniform, triumphantly returning on horseback to his plantation home, Mount Vernon, near Alexandria, Virginia. Ford shows crowds of women, children, African American laborers, housemaids, and musicians lining the road and joyously welcoming the hero. Washington's glorious Mount Vernon home rises in the background, the shoreline dotted with majestic naval vessels recalling the president's accomplishments.

2. In the second panel, the artist portrays a scene from Abraham Lincoln's early career, before he became the sixteenth president of the United States. The young Lincoln, dressed in country clothing, looks at a vast, hilly landscape as he leans against a tree. In this scene, Lincoln holds several books and looks toward the horizon, in which we see a representation of the White House. In contrast to the neoclassical style of the White House, a rustic log cabin, representing Lincoln's modest roots, is shown in the valley below. At Lincoln's feet, two loyal dogs rest, a symbol of Lincoln's fidelity to his country.

Wolfgang A. Mozart Elementary School

ADDRESS

2200 North Hamlin
Chicago, Illinois 60647

NAMESAKE

Wolfgang Amadeus Mozart (1756–91) was an Austrian composer and master of the violin.

ARCHITECT

Arthur Hussander

TITLE

Characters from Children's Literature

ARTIST

Charles Freeman

(signed lower right, "Chas. H. Freeman 1937")

CREATED

WPA/FAP

SIZE

2 murals: each H 6' x W 20'

MEDIUM

Oil on canvas, framed

DATE

1937

LOCATION

First-floor stairwells (previously located in room 203)

CONDITION

In 1995 the murals were coated with a heavy film of grime and a thick layer of yellowed varnish. The murals also suffered from numerous scratches, holes, and tears; water damage from a leaking roof had caused streaks and stains throughout.

CONSERVATION

In 1997 the Chicago Conservation Center restored the murals as part of Phase I of the Mural Preservation Project. The murals were transported to the Center and cleaned using organic solvents, relined to Belgian linen using a hot-table technique, and restretched onto new redwood spring-stretchers. The chips, holes, and tears were filled with gesso and retouched to match the original. A nonyellowing varnish was applied to protect the paintings against future damage and air pollution.

MURAL DESCRIPTIONS

These two panels by Charles Freeman portray well-known characters from classic nursery rhymes, fairy tales, folklore, and other story collections for children. Mary tugs at her stubborn little lamb; Jack and Jill carry their pail, and Rip Van Winkle sports a beard that betrays his long sleep. A written border names the cast. The arrangement of figures gives the image the quality of a chaotic class picture. Although Freeman's murals now hang in the school corridor, they

may have been intended for the school library, where murals of similar subjects are often found.

1. Tales represented in the left panel include "Mary Had a Little Lamb," by Sarah Josepha Hale; *Alice in Wonderland,* by Lewis Carroll; "Aladdin and the Lamp," from *Arabian Nights,* by Antoine Galland; "Old King Cole" (which has a variety of perceived origins); "Tom, Tom the Piper's Son," from *Mother Goose;* "Rip Van Winkle," by Washington Irving; "Jack and Jill," also from *Mother Goose; Peter Pan,* by James Barrie; "Robinson Crusoe and His Man Friday," by Daniel Defoe; and "The Pied Piper of Hamelin," by Robert Browning.

2. Tales represented in the right panel include *The Adventures of Huckleberry Finn,* by Mark Twain; *William Tell and Gessler,* a play by German dramatist J. C. Friedrick Von Schiller; "Robin Hood and His Merry Men," a twelfth-century English folk tale first recorded in a book by William Langland; "Cinderella" from *Tales of Mother Goose,* by Charles Perrault; *Treasure Island,* by Robert Louis Stevenson; "Song of Hiawatha," by Henry Wadsworth Longfellow; *The Deerslayer* (1841) by James Fenimore Cooper; *Little Women,* by Louisa May Alcott; and *The Adventures of Tom Sawyer,* by Mark Twain.

Mozart at the Court of Maria Theresa—1762 *(detail), Elizabeth Gibson, 1937, Wolfgang A. Mozart Elementary School.*

TITLES

1. Mozart at the Court of Maria Theresa—1762

2. Michelangelo in the Medici Gardens—1490

ARTISTS

1. Elizabeth Gibson
(signed lower right, "Elizabeth F. Gibson")

2. Helen Finch
(signed lower right, "Helen Finch")

CREATED
WPA/FAP

SIZE
2 murals: each H 10' x W 15'

MEDIUM
Oil on canvas adhered to wall

DATE
1937

LOCATION
Auditorium

CONDITION
In 1995 the murals were buckling, dented, torn, and crumpled along the edges. Water damage had caused streaks and stains, and scratches and paint drips were present. The murals were coated with heavy layers of yellowed varnish and grime layers. The murals were so dark that the signatures and imagery were hard to decipher; therefore the artists' signatures were unknown until the paintings were cleaned.

CONSERVATION
In 1997 the Chicago Conservation Center restored the murals as part of Phase I of the Mural Preservation Project. The murals were cleaned on location using cotton swabs and a conservation solvent mixture. Paint drips were removed using a

scalpel. The loosened and bulging areas were reset into place using a syringe-injected adhesive. Areas of loss were retouched using Maimeri conservation pigments and the murals were varnished with a non-yellowing surface film.

MURAL DESCRIPTIONS
These two skillfully rendered murals commemorating composer Wolfgang Amadeus Mozart and artist Michelangelo Buonarroti celebrate the early accomplishments of these child prodigies and artistic geniuses.

1. Johann Chrysostom Wolfgang Amadeus Mozart (1756–91) is recognized as one of the greatest composers in Western history. Born in Salzburg, Austria, Mozart began composing at age five and quickly mastered the violin. In this scene he is shown at age six performing for Austrian monarch Maria Theresa, who would become his most important patron.

2. The companion mural depicts Michelangelo di Lodovico Buonarroti Simoni (1475–1564), the Italian Renaissance painter, sculptor, architect, poet, and one of the most influential artists of all time. In this scene he is shown at age fourteen carving a sculpture in the gardens of the San Marco in Florence as an aristocratic audience looks on.

Louis Nettelhorst Elementary School

ADDRESS
3252 North Broadway
Chicago, Illinois 60657

NAMESAKE
Louis Nettelhorst (1851–93) was a prominent German immigrant who was the president of the Chicago Board of Education from 1888 to 1892. During his term, Nettelhorst was instrumental in bringing physical education into the public school curriculum.

ARCHITECT
John Flanders

TITLE
Horses in Children's Literature

ARTIST
Ethel Spears

CREATED
WPA/FAP

MOZART AT THE COURT OF MARIA THERESA · 1762

SIZE
1 mural frieze (14 subjects):
H 3' 2" x W 86' 6"

MEDIUM
Oil on canvas adhered to wall

DATE
1940

LOCATION
Kindergarten room

CONDITION
In 1996 the mural appeared severely damaged in the corners due to water damage. Stains, streaks, and areas of lifting canvas were present. The frieze was also coated with a heavy film of grime.

CONSERVATION
In 1997 the Chicago Conservation Center restored the murals as part of Phase I of the Mural Preservation Project. The mural was cleaned using conservation solvents and detergents. Lifting areas of canvas were reset using conservation adhesive. The mural was varnished with a nonyellowing surface film, and minor retouching was carried out using reversible conservation pigments.

MURAL DESCRIPTION
Intended for the school library, Spears's mural includes pivotal scenes from famous mythological and children's stories in which horses play important roles. The highly linear and decorative style is typical of Spears's work. Here Spears employed a pinkish palette with gold accents.

The frieze includes depictions of the following:

1. Al Borak, a winged Arabian horse that was brought by Gabriel to carry Muhammad, the great prophet, from earth to the seventh heaven. The horse had the face of a man with brilliant eyes and wings like an eagle. The horse also spoke in the voice of a man and sparkled with light.

2. Warpaint, a horse that roamed the prairies of the western frontier and heroically led a group of horses to safety during a flood. Warpaint and several other horses became trapped by rising waters. Warpaint decided to escape the flood by crossing the river. The other horses were afraid to follow. He decided to convince them to swim to safety. They followed his admirable lead and crossed the river to safety.

3. Bayard, a magical horse of the Middle Ages known for his adventures with four outlaw brothers who owned him, and for his ability to change his length and height based on the size of the rider or riders that mounted him. Duke Aymon left the horse to his four sons, who rode together on many daring trips with Bayard. The adventures of the four young men took place in France during the reign of King Charlemagne. They became known as outlaws throughout the country, and the magical horse was ordered to die and drowned in the Seine River, bringing an end to the stories of the four young outlaws.

4. Pegasus, a winged horse from ancient Greece that sprang from the blood of the dead Medusa killed by

the hero Perseus. A man named Bellerphon began to search for the special horse. The only one who believed in the horse was a young boy. The boy told Bellerphon to wait for the horse by the Fountain of Perene. When Pegasus flew down to drink from the fountain, Bellerphon threw his magic bridle around the horse and mounted him. Together they set out in an adventure to kill a dragon with heads of a goat, lion, and snake. The monster was named Chimera. Bellerphon and Pegasus succeeded in killing the monster.

5. Gargantua's giant mare, a horse measuring six times the size of a white elephant. There was once a fairy tale about a giant mare owned by an African king. The horse was big and useless to the king, measuring six times the size of a white elephant. The king decided to give the mare to a

giant named Gargantua in southern France. It took four ships to transport the horse, one ship for each hoof. The horse safely arrived in France to Gargantua's delight and together they went on many adventures near Paris. During one adventure Gargantua was riding the giant mare through a forest near Paris. Along the ride in the forest flies began to disturb the horse. When the giant mare waved her tail at a fly, the entire forest was leveled and not one tree stood.

6. Sol and Maane, two children who were forced, like horses, to drive two fierce magical chariots. Sol's and Maane's father talked so much of his children the people began to hate them and eventually planned to kill them both. In the country were also two known chariots that rode without

drivers because of their fierce character. Instead of killing the two children, the people decided to have the two children drive the chariots, and they rode off into fairyland, where no one would tire of them.

7. Black Beauty, a horse whose dramatic life story is told in the Anna Sewell novel of the same name. There are many tales about the colt named Black Beauty. He had a white star on his forehead and one white hoof. Eventually Black Beauty was broken in by his owner and sold to Squire Gordon. Upon arriving at his new home he met another horse named Ginger and they soon became friends.

8. The horses belonging to Poseidon, the god of the sea in Greek mythology. When Zeus became king of the gods, the kingdom of the sea was given to Poseidon. Poseidon then built a palace for his kingdom. The floor was

Horses in Children's Literature *(detail of image 9), Ethel Spears, 1940, Louis Nettelhorst Elementary School.*

made of snow-white shells and red coral with walls of mother-of-pearl. When the waves of the sea became rough, Poseidon would ride in a chariot behind his hoofed horses over the surface of the sea to trample the waves and calm the waters.

9. Rakush and Rustem, a colt and a boy who were known for their adventures. Rustem was an eight-year-old boy, skilled in weaponry, and desirous of a special horse. His father promised a reward for anyone who could find the best horse in the land, but not one was found suitable for Rustem's skills. Rustem noticed a wild mare and colt. They were not wanted by the herdsman because of the mare's fierce character. Rustem was challenged by the mare and fought her, eventually mounting the colt named Rakush in defeat. Rakush and Rustem became known for their adventures, such as entering the forest and cutting off the head of a dragon awakened and emerging from its den. Eventually Rakush and Rustem vanish and the fable ends.

10. Odin and his horse Slighpner, about whom is told a common northern riddle, "Who are the two that ride over the rainbow? Three eyes have they together, ten feet, two arms, and a tail and thus they journey through the world." The answer to the riddle is Odin and his horse named Slighpner. Odin has one eye and the horse has two. Odin has two feet and Slighpner has eight. He has two sets of legs for long journeys; when one set is tired the other is used to give them rest. Odin has two arms and Slighpner has a tail. In the morning Odin rides Slighpner and his ten counselors follow as they cross over the rainbow. On the other side, the rainbow ends under an ash tree, which symbolizes the universe.

11. Don Quixote and his horse Rozinate, characters in the Miguel de Cervantes novel *Don Quixote de la Mancha*. Don Quixote was a rich man who decided one day that he would become a knight, since there were no more Spanish knights. He found some old armor attributed to his great grandfather. He then found and named his horse Rozinate, which means "common horse before," and named himself Don Quixote of La Mancha. During one of his many humorous adventures, he rode off on

his horse to hunt giants. The giants were actually windmills. Don Quixote's servant, Sancho Panza, pleaded with him not to charge. As he began to approach, the windmills began to spin. Don Quixote claimed a magician had changed the giants into windmills when he was charging them.

12. The Enchanted Horse, whose encounter with the prince of Persia led to the prince's marriage to the princess of Bengal. The tale of the enchanted horse took place in the kingdom of Persia, during its biggest feast and festival that celebrated the New Year. After a day of watching events of the festival, the king was about to release his court around sunset, when suddenly before his throne an Indian on horseback appeared. The Indian told the king the horse was capable of miracles, unlike anything he had seen earlier that day during the festival. To prove the magic qualities of the horse, the king asked the Indian to bring him back a leaf from the land far off in the distance and he returned successfully. (An inventor had made the horse, and the Indian exchanged it for his only daughter and promised the inventor to respect its magical abilities.) Meanwhile the prince of Persia agreed to test the horse's abilities. Before the Indian could tell him how to return from a journey, he disappeared on the horse; the Indian was imprisoned until the prince returned. The prince of Persia eventually returned after saving the princess of Bengal from the Sultan. They were soon married and an alliance was made between the two countries.

13. Prosperina, a young girl who was kidnapped by Pluto, the Roman god of the underworld, in a chariot pulled by four sable horses. Prosperina was a cheerful young girl with a mother named Ceres. One day the mother became overwhelmed with work in her various crops. While the mother went to work her wheat, barley, and corn fields, the daughter was asked to go play along the shore with the protective sea nymphs. Her mother asked her not to stray or wander. After playing with the nymphs for a while, Prosperina decided to make them wreaths made of flowers as a sign of her appreciation. So she went into the fields to gather flowers and came upon a beautiful shrub. She tugged

on the shrub until it finally loosened from the ground and as she lifted it into her arms the hole it left behind started to widen and grow into a big cavern. All of a sudden out came four sable horses and a chariot carrying a crowned man. His name was King Pluto, god of the underworld. He then whisked her off by the horse-driven chariot as she screamed for her mother. She was taken to his dark palace to enlighten the dreary atmosphere of its corridors with her sweet smile, where her mother eventually found her.

14. Beaufort, whose story is unknown.

TITLE

Contemporary Chicago

ARTIST

Rudolph Weisenborn
(signed lower left, "Rudolph Weisenborn 1936")

CREATED

WPA/FAP

SIZE

1 mural (4 sections): H 7' x W 23'

MEDIUM

Oil on canvas adhered to wall

DATE

1936

LOCATION

Main corridor

CONDITION

In 1995 the mural had been adhered to the wall in two sections and was covered with almost sixty years' worth of grime. Scrapes, splatters, bulges in the canvas, and abrasions were apparent. Severe cracking in the paint layer was the result of prior water damage. Several holes, pencil marks, and drip stains were visible. The canvas was lifting along the right edge and central seam.

CONSERVATION

In 1997 the Chicago Conservation Center restored the murals as part of Phase I of the Mural Preservation Project. The mural was carefully cleaned with mild conservation detergents and cotton swabs. The two canvases were reattached to the wall where lifting had occurred. Edges and the central seam were reset using a syringe-injected PVA emulsion adhesive. Areas of cracking and lifting paint were reset with warm gelatin applied with a small brush into the

cracks and under the lifts. A light surface varnish was applied to protect the paint from fluids and air pollution.

MURAL DESCRIPTION

Rudolph Weisenborn, also known as "the Chicago Picasso," was one of Chicago's most important WPA/FAP artists. Weisenborn's highly abstract style was rare among Illinois Art Project murals. He was one of the first artists to exhibit abstract paintings at the Art Institute of Chicago. The mural shows his interest in modern European cubist painting, with fractured space, jagged lines, and primary colors conveying Chicago's vibrancy and modernity during the 1930s. Susan Weininger, a Chicago art historian, wrote, "It is in the work of Weisenborn . . . that we see the emergence of a true Chicago modernism . . . Weisenborn's work, however, combined references to cubism, expressionism, and even fauvism, and represented a unique marriage of the modernist formal vocabulary with a contemporary Chicago subject."[16] Weisenborn, Carl Hoeckner, Raymond Jonson, and Ramon Shiva were a group that formed the No-Jury Society of Artists in 1922.[17] The group allowed all artists, for a small membership fee, the opportunity to exhibit their work regardless of their subject matter or style.

The composition is broken into sections, which read from left to right.

1. Chicago's nightlife, with its lively jazz and blues scene, is represented on the far left by an abstracted portrait of a seated woman tipping her hat at the viewer.

2. The next section represents forms of transportation, such as small commuter planes and boats, and

Belmont Harbor, making reference to Chicago's reputation as a leader in transportation, commerce, and trade during the twentieth century. Settlement and trade began in Chicago in 1779, when Jean Baptiste Du Sable, a fur trader of French-African descent, built the city's first settlement at the mouth of the Chicago River. By the mid 1800s, Chicago established itself as an interior land and water hub due to its strategic location. The city's rapid expansion was influenced by its geographic location, urban setting, close approximation to rural communities downstate, old Indian trails leading northwest and southwest, central railroad lines, and connecting waterways leading north and south. This unique combination helped to establish Chicago quickly as one of the world's richest industrial and commercial complexes.

3. The next, highly detailed section depicts the history of the massive Chicago stockyards and meatpacking industry. The scene, which includes cattle and a cowboy on horseback, highlights how the city became the main shipment center for grain and livestock in the Midwest during the nineteenth century. On the Southside of Chicago, between 39th and 47th streets, and from Halsted to Ashland Avenue, was one of the world's largest meat processing and livestock markets in the nation. This was due largely to the city's position as a central hub in the American railway system. The scene includes cattle and a cowboy on horseback.

4. The Industrial Age is the focus of the last section, representing the Chicago and Indiana steel mills and the significance of steel in the rebuild-

ing and expansion of the city after the Great Chicago Fire in 1871, and in the development of the skyscraper. The city began to rapidly rebuild as an industrial power with the development of skyscrapers and other modern architectural innovations. Steel production became a significant element of this expansion. Chicago is home to the world's first skyscraper, the Home Insurance Building, designed in 1885 by William Le Baron Jenney. Depicted in this scene is a muscular steelworker swinging a hammer; below him is a steel-framed structure and behind him steel mills. The scene renders Chicago's image as a "blue collar" city of laborers and factory workers. During the Industrial Revolution, the city became quickly populated with European immigrants and former slaves from the South, creating great ethnic diversity and immigrant communities.

Luke O'Toole Elementary School

ADDRESS

6550 South Seeley
Chicago, Illinois 60636

NAMESAKE

Luke O'Toole (unknown–1923) was a sixty-year resident of the community who owned a saloon frequented by politicians. He was an active participant in civic affairs and the school board at the town of Lake, the original name of the community.

ARCHITECT

John C. Christensen

Contemporary Chicago, Rudolph Weisenborn, 1936, Louis Nettelhorst Elementary School.

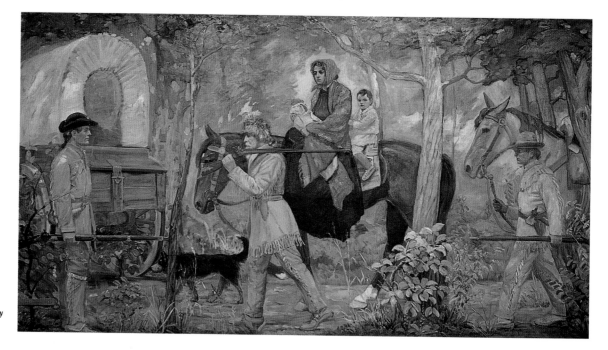

History of Illinois Territory (image 4), James E. McBurney, c. 1927–28, Parkside Community Academy Elementary School.

2. The second panel illustrates the quote. At the center of the composition, a missionary in black garb talks to George Rogers Clark (1752–1818), a frontier military leader during the American Revolution who acquired two Mississippi River settlements, Kaskaskia and Cahokia, now part of Illinois. Frontiersmen holding rifles and axes, settler families, and Native Americans surround the two figures. After befriending Pierre Gibault (a Roman Catholic missionary priest and patriot in the American Revolution) at Kaskaskia in 1778, Clark gained the support of the French at the city of Vincennes, in southeastern Indiana, and attacked the British fort there. Clark's victory over the British at Vincennes gave ownership of the land in the Midwest to the United States, helping to bring an end to the American Revolution.

3. The central scene depicts Clark and a Native American chief seated opposite one another at a desk, signing a land treaty that would bring about further settlement to the Midwestern territory, including present-day Indiana, Illinois, Michigan, and Wisconsin.

4. The next scene portrays Clark leading settlers into the Midwestern territory. The composition and autumn-toned palette are reminiscent of McBurney's depiction of the Lincoln family's move from Kentucky to Illinois at Wentworth School. Here a male figure in buckskins walks alongside a mother, baby, and child

on horseback, accompanied by a covered wagon, the primary mode of transportation for settlers.

5. The far-right text panel describes the scene: "In order to secure the Illinois territory for the colonies, Clark brought settlers to hold it permanently. This region has since been divided into the states of Indiana, Illinois, Michigan, Wisconsin, and part of Minnesota."

Cecil A. Partee Academic Preparatory High School

(formerly Amelia D. Hookway Transitional High School)

ADDRESS
8101 South LaSalle
Chicago, Illinois 60620

NAMESAKE
Amelia Dunne Hookway (1863–1914) was a teacher and principal of the Howland School. The building was sold to Monument of Faith Church in the mid-1990s and repurchased by the Board of Education in 1999 and renamed Partee School. Cecil A. Partee (1921–present) is an African American legislative leader who served in the U.S. House of Representatives from 1957 to 1967 and the U.S. Senate from 1967 to 1977.

ARCHITECT
Unknown

TITLES
History of the New World
1. Discovery of America
2. Arrival of Pilgrims
3. Early Settlers
4. Modern Life
5. City Life

ARTIST
Ralph (or Ralf) Christian Henricksen
(signed lower right, *Modern Life*, "R. Henricksen")

CREATED
WPA/FAP

SIZE
5 murals: (1) H 8' x W 6' 2";
(4) H 10' 10" x W 6' 2"

MEDIUM
Oil on canvas adhered to wall

DATE
1938

LOCATION
Auditorium

CONDITION
In 1995 the unvarnished murals were coated with a considerable film of grime, and abrasions were apparent throughout.

CONSERVATION
In 1999 the Chicago Conservation Center restored the murals for the Chicago Public Schools when the building was renovated. Scaffolding was installed and the murals were

cleaned with mild conservation solvents and retouched where necessary with colorfast and lightfast conservation pigments. The murals were coated with a nonyellowing varnish to protect them from air pollution and surface damage.

MURAL DESCRIPTIONS

The five panels depict the history of the United States. The first four panels follow the same format, in which a central figure is flanked by a secondary figure at his foot and tertiary figures shown in profile. The pyramidal format is further enhanced by a depiction of a form of transportation typical of the time period at the top. A broad band showing plant life frames the bottom of each panel.

1. The first mural depicts the era of exploration. In this scene Christopher Columbus, carrying a sword and dressed in red, stands at the center. A prostrate Native American is at his feet. His fellow European explorers, clad in armor, are shown in profile and ships are depicted in the background. White flowers representing the flora discovered in the New World adorn the bottom of the composition.

2. American Pilgrim life dominates the second mural. At the center stands a man in Pilgrim garb holding a rifle. At his foot is a woman holding what appears to be a Bible, representing the Pilgrims' Puritan faith and the spread of literacy and religion. A broad band of grass runs along the

bottom of the scene, symbolizing the land settled by European immigrants.

3. The third mural shows early settlers and westward expansion. A man holding a rifle and a woman and child at his feet represent a typical pioneer family. The covered wagons at the top and sides represent the transportation crucial to their westward movement. The band of cacti at the bottom symbolize the flora of the American West, the pioneers' apparent destination.

4. The fourth mural represents modern life in the image of an aviator, possibly Charles Lindbergh (1902–74), who manned the first nonstop solo flight across the Atlantic in 1927. The two children at his feet represent the future. The plane at the top of the canvas depicts the most advanced mode of transportation of the era. Images of propellers and skyscrapers surround the central figural group. The band of metal fleurs-de-lis at the bottom is a humorous spin on the organic plant life shown in the first three panels.

5. The progress of American history culminates in the fifth mural. The dynamic composition of long, sleek horizontal and diagonal lines shows train tracks, cars, and traffic lights, departing from the style of the earlier panels. A bridge over streamlined boats on a river bisects the composition. "Chicago" is written on the canvas, leaving no room for doubt about the location. The scene highlights the city's role as one of the nation's primary transportation, trade, and industry hubs.

TITLES

History of Chicago

1. Father Marquette

2. Fort Dearborn

3. Kinzie Cabin

4. Water Tower

5. Great Chicago Fire 1871

6. State Street 1880

7. World's Columbian Exposition 1893

8. Century of Progress 1933

ARTIST

Unknown
(possibly Ralph [or Ralf] Christian Henricksen)

CREATED
WPA/FAP

SIZE
8 murals: each H 22" x W 46"

MEDIUM
Oil on canvas adhered to wall

DATE
1940

LOCATION
Auditorium

CONDITION
In 1995 the small canvas murals were coated with a heavy film of grime, and cracks were scattered throughout. Rips near the tacking edges were present. During another visit in 1999, it was discovered that the *Kinzie Cabin* panel had been stolen and the *Father Marquette* and *Fort Dearborn* panels had been torn off the wall.

CONSERVATION
In 1999 the Chicago Conservation Center restored the murals when the building was renovated. The paintings were cleaned using conservation solvents, and losses were filled and retouched. The *Father Marquette* and *Fort Dearborn* panels were transported to the Center laboratory for relining and considerable in-painting. The *Kinzie Cabin* panel was re-created using a similar palette, style, and composition, based on earlier on-location photographs and notated as nonoriginal. The three murals were reattached in their original locations using cold Beva film adhesive.

MURAL DESCRIPTIONS
The eight horizontal panels represent key moments in Chicago history. Common WPA/FAP themes, explorers, pioneers, and industry are included.

1. The first mural depicts Father Jacques Marquette, the French Jesuit missionary and explorer, and Louis Jolliet (1645–1700), the French-Canadian explorer and cartographer, meeting a Native American chief in the center of the composition. To the left appear the chief's tribe and settlement along the Chicago River, where Marquette camped during his journey to reach the Illinois Native Americans and found a mission among them. To the right, the explorers traveling with Jolliet and Marquette bring their canoes ashore.

2. The U.S. army post Fort Dearborn, a wooden blockhouse, is the focal point of the second mural. Built in

History of the New World: Modern Life, *Ralph Christian Henricksen, 1938, Cecil A. Partee Academic Preparatory High School.*

The Months of the Year, February, *John Warner Norton, 1924–25, Helen C. Peirce Elementary School.*

MURAL DESCRIPTIONS

These paintings are some of the most valuable art treasures of the Progressive Era. The murals were part of a project intended to pay homage to Helen Peirce's long-standing commitment to early-childhood education and aesthetically pleasing learning environments. Three well-known contemporary Chicago artists, George Grant Elmslie, Jens Jensen, and John Warner Norton, were commissioned for this project. Elmslie designed the school and kindergarten room in Prairie School style. Landscape artist Jensen redesigned the garden and playground to complement Elmslie's architectural design, but it was never built. Norton painted twelve panels for the kindergarten room, each representing a month of the year (June is missing from the cycle). Norton's murals stress the seasonal changes in Chicago.

1. A barren, snow-covered tree branch and a small red house in a valley set against blue hills beneath a winter sky typify *January* in the Midwest.

2. *February* is the only month set indoors, with an image of a cat seated by a warm fire.

3. Norton shows *March* with blustery winds blowing against bare trees. A hunched woman covers herself with a red shawl.

4. Heavy showers and storm clouds dominate the *April* panel.

5. Blossoming cherry flowers, flying birds, and a placid lake scene represent *May*.

6. *July* is the only panel that makes a distinct reference to Chicago. A series of American flags is shown against the Chicago skyline, which highlights the Tribune Tower.

7. The hot Chicago *August* is represented by sailboats on the lake with a lighthouse in the background. The turbulent waters and stormy sky allude to the month's changeable weather.

8. *September* is depicted in a full harvesting scene, with a golden sheaf of hay on the ground and a black crow flying over the periwinkle sky.

9. Ducks fly over the lake in *October*.

10. Withering cornstalks and two well-fed turkeys in the *November* panel make reference to the month's primary holiday.

11. Finally, *December* is shown as a quiet snow-covered scene on a sleepy winter night. A small white country church covered with a blanket of snow is the focus of the scene and refers to the month's Christian holiday. The golden lighting emanating from the church brings warmth to the panel in the otherwise desolate scene.

William Penn Elementary School

ADDRESS

1616 South Avers
Chicago, Illinois 60623

NAMESAKE

William Penn (1644–1718) was a Quaker from England who founded the colony of Pennsylvania in 1681. Before returning to England in 1684, Penn framed the liberal government for the colony and established relations with the regional Native Americans.

ARCHITECT

Dwight Perkins

TITLES

Unknown
(Historic Scenes)

1. European Settlers and Native Americans

2. Settlers

3. City of the Future

4. Colonial Settlers with Native Americans

ARTIST

Unknown

CREATED

WPA/FAP

SIZE

4 murals: (2 end panels) each H 4' 9" x W 7' 2"; (2 middle panels) each 4' 9" x W 9'

MEDIUM

Oil on canvas adhered to wall

DATE

1940

LOCATION

Auditorium entrance

CONDITION

In 1996 the murals were coated with a heavy film of grime and were separating from the walls in several areas. Smudges, scratches, abrasions, paint losses, and water stains were scattered throughout.

CONSERVATION

Not yet restored

MURAL DESCRIPTIONS

Three of the four panels in this history series depict subjects that appear frequently in New Deal murals, but the third panel is devoted to an imagined future, a rare topic in this art form.

1. The cycle begins with a representation of interactions between European settlers and Native Americans in the sixteenth century. The central focus of the scene is the fur trade between the two parties in the foreground. To the right, a European conquistador presides over the transaction. In the background, a large gathering of Native Americans listen attentively to a standing missionary dressed in black and holding a cross.

2. The second panel depicts a town settlement. Wooden structures, cattle, horse-drawn wagons, and community dwellers dominate the

Facing page: **The Months of the Year,** *John Warner Norton, 1924–25, Helen C. Peirce Elementary School.*

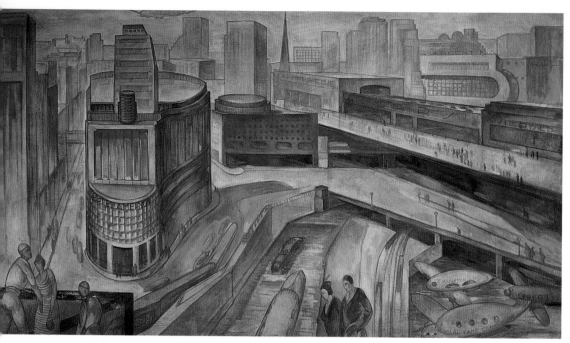

City of the Future, *artist unknown, 1940, William Penn Elementary School.*

composition. A tall wooden structure in the background is reminiscent of artistic renderings of Fort Dearborn.

3. In the third panel, the artist renders a futuristic scene filled with multistoried buildings and steel-and-glass skyscrapers. An elevated train on the right side of the composition creates a strong diagonal line. Small commuter planes and a large commercial airliner are shown. The artist uses smooth lines, strong diagonals, and primary colors to depict this sleek, streamlined city. In the foreground, modern city dwellers dressed in sophisticated contemporary attire gaze at the wonders of their modern world.

4. The final panel illustrates the negotiations between white colonial soldiers and Native American tribes, representatives of whom are shown smoking a pipe together, demonstrating the supposed peaceful negotiations between the two groups. Armed British soldiers flank the negotiators, and a Native American chief raises his arm in obedience on the left. A representation of Fort Dearborn fills the background and locates the scene in early Chicago.

Wendell Phillips High School Academy

ADDRESS
244 East Pershing Road
Chicago, Illinois 60653

NAMESAKE
Wendell Phillips (1811–84) was a political reformer born in Boston.

Ranked with Edward Everett and Daniel Webster as an orator, Phillips was a delegate to the World Anti-Slavery Convention in London (1840). He opposed the Mexican War and annexation of Texas, advocated dissolution of the Union, and vehemently denounced slaveholding. After the fifteenth amendment to the U.S. Constitution enfranchised African Americans, Phillips continued his agitation for social reforms, including prohibition, women's suffrage, abolition of capital punishment, currency reform, and labor rights.

ARCHITECT
John C. Christensen

TITLES

Historical Scenes
1. Father Marquette Preaching to Native Americans

Historical Scenes: Greek Orator with Students, *Gayle Porter Hoskins, 1906, Wendell Phillips High School Academy.*

2. Native Americans Watching a Dance
3. Greek Orator with Students
4. Classical Scene with Five Figures

ARTISTS
1. Lauros Monroe Phoenix
2. Dudley Craft Watson
3. Gayle Porter Hoskins
4. Albert F. Giddings

CREATED
Progressive Era

SIZE
4 murals: each H 4' x W 6'

MEDIUM
Oil on canvas on new redwood spring stretchers, framed

DATE
1906

LOCATION
Main entrance staircase

CONDITION
In 1997 the varnished murals were in critical condition. Discolored varnish and a heavy film of grime disfigured the images. The surfaces showed splatters, graffiti, holes, and cracks throughout. The third panel was separating from the wall due to water damage.

CONSERVATION
In 1999 the Chicago Conservation Center restored the murals as part of Phase III of the Mural Preservation Project. Facing them with Japanese tissue and starch paste stabilized the mural surfaces. They were separated from the walls with mechanical tools and transported to the Chicago Conservation Center laboratory.

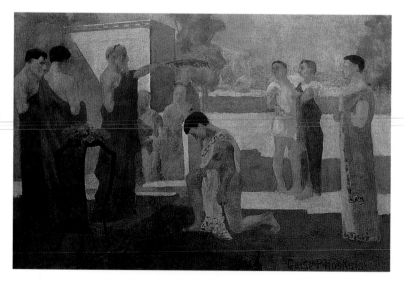

The plaster remaining on the verso of the murals was then removed with mechanical tools. The murals were cleaned of overlaying films of varnish and dirt using solvents. The weakened canvases were lined to Belgian linen and a nonaqueous adhesive using a hot-table treatment. Holes and losses were filled with gesso. A nonyellowing varnish was applied, and retouching was carried out using reversible conservation pigments. The murals were transported to the school and rehung in their original locations. In addition, the frames were cleaned, repainted, and reinstalled.

MURAL DESCRIPTIONS

This four-panel mural cycle is among the oldest in the Chicago Public Schools, depicting a series of social rituals and historic moments.

1. In the first panel, Father Jacques Marquette preaches, with his arm raised, to a group of seated Native Americans in an untouched Midwestern landscape.

2. In the second panel, the artist depicts three Native Americans hiding in the brush and watching a ritualistic dance being performed by a group of women dressed in white. The panel is marked by its bipartite construction created by the curving stream in the foreground and by the demarcation of light and dark colors.

3. The third panel is devoted to a classical landscape, in which a Greek orator wearing a golden toga kneels before an older figure who holds a laurel wreath (or a wreath made of olive leaves). This scene could be interpreted as a depiction of the crowning of a poet.

4. The final panel also displays a classical setting. Five figures in a classical building overlook a blue background similar to a lake.

Martin A. Ryerson Elementary School

ADDRESS

646 North Lawndale
Chicago, Illinois 60624

NAMESAKE

Martin Antoine Ryerson (1856–1932) was a businessman and collector educated in Europe and at Harvard

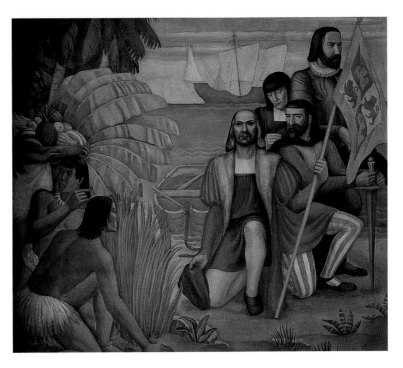

Discovery of America: Landing of Columbus, Irene Bianucci, 1940, Martin A. Ryerson Elementary School.

Law School. He took over the family lumber business and then served as director of several companies, but he retired in his forties to devote himself to collecting art. He amassed a considerable collection of French Impressionist paintings, which he donated to the Art Institute of Chicago.

ARCHITECT

Unknown

TITLES

Discovery of America
1. Landing of Columbus
2. Landing of Pilgrims

ARTIST

Irene Bianucci

CREATED

WPA/FAP

SIZE

2 murals: each H 6' x W 8'

MEDIUM

Oil on canvas adhered to wall

DATE

1940

LOCATION

Auditorium

CONDITION

In 1995 the murals were coated with a heavy layer of grime and the upper canvas edges were lifting from the wall. Paint splatters and drips stains were also present.

CONSERVATION

In 1997 the Chicago Conservation Center restored the murals as part of Phase I of the Mural Preservation Project. Scaffolding was installed and the murals were cleaned using distilled water and organic solvents. The lifting canvases edges were reattached with a syringe-injected adhesive. The murals were coated with a nonyellowing varnish to protect against future damage and air pollution.

MURAL DESCRIPTIONS

The paintings depict two historical scenes, one located on each side of the main stage.

1. Christopher Columbus is shown meeting Native Americans, while other natives peer over lush foliage at the Europeans. A Native American woman stands holding a basket containing bananas, pineapples, apples, and other indigenous fruits. To their right, Columbus faces the viewer and holds the Spanish flag as a symbol of his allegiance to his country. Behind Columbus a soldier with a sword kneels and a missionary couple stand, representing the various people who arrived with the Europeans. The boat in the background further emphasizes the exploration of the New World.

2. Bianucci shows the arrival of Pilgrims on the American shore. A male Pilgrim holds an axe over his right shoulder. To his left, a woman bends over a wash bucket to clean a piece of cloth; in the foreground, two women fold a large white cloth. On

the left side, two armed men represent the less-than-peaceful settlers who arrived alongside the Pilgrims.

Maria Saucedo Elementary Academy

(formerly Carter Harrison High School)

ADDRESS
2850 West 24th Boulevard
Chicago, Illinois 60623

NAMESAKE
The school was formerly named after Carter Harrison (1825–93), a charismatic democratic Chicago mayor who was popular with the working class and served two terms. He was assassinated in 1893 at the World's Fair by a disgruntled office seeker. In 1981 Harrison School closed due to a severe drop in enrollment and subsequently reopened under the name of Maria Saucedo (1954–81), a teacher and community activist who died in an apartment fire. She advocated for a Hispanic principal for Benito Juarez High and labored for the farm workers' movement, equality for women, and the independence of Central American countries from U.S. intervention.

ARCHITECT
Arthur Hussander

TITLE
Allegories of Arts and Education

ARTIST
Gustave A. Brand
(signed, "Gustave A. Brand 1916")

CREATED
Progressive Era

SIZE
2 lunette murals: each H 9' 10" x W 52'

MEDIUM
Oil on canvas

DATE
1916

LOCATION
Auditorium

CONDITION
In 1996 the murals were coated with a severe film of grime, which distorted the scenes and signature.

CONSERVATION
In 2001 the Chicago Conservation Center restored the murals as part of Phase III of the Mural Preservation Project. The murals were cleaned using a mild detergent and cotton swabs, then cleaned with distilled water to neutralize the surface. During the cleaning process, the signature and date were revealed. A final nonyellowing varnish was applied to protect the surfaces.

MURAL DESCRIPTIONS
The auditorium contains two large and elegant lunettes.

1. This vaguely classical scene shows a group of allegorical figures amid classical structures in the center, a gathering of peasants on the left, and an industrial labor scene on the right. The peasant scene is reminiscent of eighteenth- and nineteenth-century European pastorals in its emphasis on romantic exchange and joyous communal activity. The labor scene is similar to earlier artistic renditions of the forge of Vulcan.

2. The second lunette is a similar composition. Here the central allegorical group relates directly to the arts.

One woman holds a globe, while another holds a small sculpture of a classical orator. To the right another classically dressed woman sketches and writes.

Sidney Sawyer Elementary School

ADDRESS
5248 South Sawyer
Chicago, Illinois 60632

NAMESAKE
The school and street were named after Sidney Sawyer (dates unknown), a farmer who donated the land for the building of the schoolhouse.

ARCHITECT
Arthur Hussander

TITLES
History of Chicago
1. Father Marquette
2. Fort Dearborn
3. Great Chicago Fire of 1871
4. World's Columbian Exposition of 1893
5. Century of Progress World's Fair of 1933

ARTIST
Lucile Ward

CREATED
WPA/FAP

SIZE
5 murals: (2) H 10' x W 6';
(3) H 10' x W 9'

MEDIUM
Oil on canvas

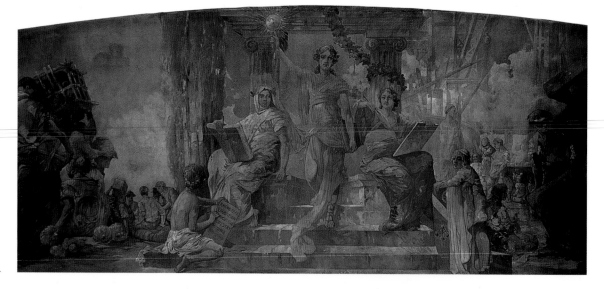

Allegories of Arts and Education (image 1), Gustave A. Brand, 1916, Maria Saucedo Elementary Academy.

followed by an image of Marquette and a Native American holding hands in a gesture of unity and peace.

2. In the second panel, Ward shows the land where Fort Dearborn was built in 1804, which was purchased from the Native Americans with promised goods in the Greenville Treaty of 1795. Prior to this time, wars were fierce over the land in the Great Lakes region. To the right, a uniformed general takes notes on the territory. In the predella below, silhouettes of covered wagons and trains represent the dominant modes of transportation at the time.

3. The third panel depicts the Great Chicago Fire of 1871. Ward shows a bird's-eye view of Chicago and the meeting of the major rivers. Flames are superimposed over the entire scene as firefighters emerge from the water tower and run toward the nexus of the fire. Ward alludes to the legend of the source of the fire through the inclusion of Mrs. O'Leary and the back of her infamous cow (said to have kicked over a lantern, igniting the blaze) at the epicenter of fire.

4. The fourth panel portrays the 1893 World's Columbian Exposition in Chicago. The composition includes a reference to Columbus's receipt of money from Queen Isabella for his historic voyage: Columbus, with maps and globe to describe his plan, kneels on a red carpet before the monarch. The explorer's three ships are shown on a large globe. The Midway Plaisance and grand architecture of the fair are shown in the background. American flags dot the composition and echo the Spanish flag on Queen Isabella's ermine coat. The floating light bulb on the left-hand side of the composition and the trolleys and trains in the predella below signify the growing modernization and technological developments of the period.

5. In the final panel, Ward depicts the 1933 Century of Progress World's Fair in Chicago. The modern aspects of the fair are rendered in the artist's abstract creation of the scene. Sleek and statuesque figures stand in an arcade of flags. Planes flying in formation overhead and an enormous shadow of a plane on the ground dominate the picture. Strong intersecting diagonals create a dynamic composition.

History of Chicago: World's Columbian Exposition of 1893, Lucile Ward, 1940, Sidney Sawyer Elementary School.

DATE
1940

LOCATION
Auditorium

CONDITION
In 1995 the murals were coated with grime and drip stains. In several areas the canvases had separated from the board supports, resulting in severe buckling.

CONSERVATION
In 1997 the Chicago Conservation Center restored the murals as part of Phase I of the Mural Preservation Project. The fourth and fifth panels were dismantled due to poor structural condition and taken to the Chicago Conservation Center for treatment while the plaster walls were repaired on location. The other three were treated on-location. The overlying grime films were removed from all the panels using a mixture of conservation solvents and cotton swabs. The two transported canvases were reattached to the panel supports using Beva-371 film adhesive. Scratches and small losses were filled with gesso and retouched to match using conservation pigments. A nonyellowing varnish spray was applied to all the panels to protect the surface. The murals restored at the Center were then reinstalled in their original locations.

MURAL DESCRIPTIONS
In the series Ward represents significant episodes in the history of Chicago. She unifies the panels through the repeated use of maps, silhouettes, and a consistent palette dominated by blue hues.

1. In the first panel, Ward depicts Father Jacques Marquette (1636–75) meeting a group of Native American men upon his arrival in 1773, as one member of the group holds out a ceremonial pipe (a calumet) in a gesture of peace. The explorer and trader Louis Jolliet (1645–1700) is dressed in buckskins as he stands to the left of Marquette. The word *Chicago* is generally described by historians as being a derivative of the terms "great" and "strong," yet another common derivative are the Native American words for "skunk" and "wild onion"; note the skunks at the feet of the men in the composition. In the background is a painted map of New France as described by Jolliet, and a painted note to Lord Frontenac from Jolliet describing the land and the route. Below the figures, a line of buffalo and Native American males are

Franz P. Schubert Elementary School

ADDRESS
2727 North Long Avenue
Chicago, Illinois 60639

NAMESAKE
Franz Peter Schubert (1797–1828)
was a composer from Vienna, known
for his poetic musical style.

ARCHITECT
John C. Christensen

TITLES
1. The Hurricane
2. The Life of Franz Schubert

ARTIST
George Melville Smith
(signed lower left, both murals,
"George Melville Smith")

CREATED
WPA/FAP

SIZE
2 murals: each H 9' x W 9'

MEDIUM
Oil on canvas adhered to wall

DATE
1938

LOCATION
Auditorium

CONDITION
In 1995 damage to the first mural

due to a poor repair from a previous
restoration was apparent. A tear had
buckled and another severe tear along
the bottom left quadrant was apparent.

CONSERVATION
Not yet restored

MURAL DESCRIPTIONS
These two murals are examples of
modernism in WPA/FAP painting
within the Chicago Public Schools.

1. Smith uses a vaguely futuristic style
to depict the medieval folk tale of
"The Hurricane." At the center of the
composition, a bearded older man
on a white horse steals away with a
blond toddler in a swirl of movement.
Gasping and pleading women in the
foreground implore the rider to return
the boy while two men on the left
clench their fists in anger.

2. Smith's portrait of Austrian
composer Franz Peter Schubert is
equally energetic and modern in style.
In this portrait, the distinguished
composer, known for his poetic
musical style, is seated in the center
of the composition, wearing his trade-
mark glasses. While casually leaning
on a black grand piano, he holds a
sheet of music in his right hand.
The table on the right holds an ink-
pot, stacked books, and a violin. The
shifting perspectives and fractured
planes show Smith's interest in
cubism and contribute to the dyna-
mism of the work.

Carl Schurz High School
(Chicago architectural landmark, 1960)

ADDRESS
3601 North Milwaukee Avenue
Chicago, Illinois 60641

NAMESAKE
Carl Schurz (1829–1906) was a
German American speaker, reformer,
and journalist in the political arena
who served in the Civil War and was
appointed minister to Spain by
Lincoln. He fought for political moral
reform during a period of notorious
negligence and corruption. He later
became the editor of the *New York
Evening Post* and *The Nation*.

ARCHITECT
Dwight Perkins

TITLE
The Spirit of Chicago

ARTISTS
*Gustave Adolph Brand and
Schurz High School students*

SIZE
1 mural (apse shaped): H 15' x W 30'

MEDIUM
Oil on canvas adhered to wall

DATE
Not WPA/FAP, 1940

LOCATION
Library

CONDITION
In 1995 the mural was in severe
condition as a result of water damage
from a leaking roof. The surface was
marred by drip stains, lifting paint,
cracks, losses, grime, and areas of
lifting canvas.

CONSERVATION
In 1997 the Chicago Conservation
Center restored the murals as part
of Phase I of the Mural Preservation
Project. Areas of lifting canvas were
reset into place using PVA emulsion
adhesive. Discolored layers of grime
and water staining were removed
using conservation solvents. Areas of
lifting paint and cracks were consoli-
dated and returned to plane, and areas
of loss were filled with gesso. The
paintings were coated with a non-
yellowing surface film and retouched
to match using conservation pigments.

MURAL DESCRIPTION
In 1940 Gustave A. Brand, a well-
known mural artist, worked with the

*The Life of Franz Schubert,
George Melville Smith,
1938, Franz P. Schubert
Elementary School.*

students and art teachers of Schurz to create a group of library murals, including *The Spirit of Chicago*. At age seventy-eight, Brand supervised the project with the assistance of Schurz students, who learned oil painting techniques in the process.[19] Brand considered his mural work in the Schurz High School Library "the finest thing I have done in all my seventy-eight years."[20] Here, the history and spirit of Chicago are represented in a vast panorama in the apse of the school library, beginning with Jacques Marquette shown meeting Native Americans. The history of the city continues with depictions of pioneers plowing the land, the Great Fire of 1871, the 1893 World's Columbian Exposition, and finally modern machinery and airplanes. In the center, on a stepped classical structure, allegorical figures represent the arts, liberty, and education. The central figure, representing the enduring spirit of Chicago, stands at the pinnacle of the group in a pose that resembles that of *The Republic*, a gilded sculpture in the 1893 World's Columbian Exposition. The focus on architecture and technology showcases the city's revival after the Great Fire and its role in the modern era. The inscription below reads, "The Spirit of Chicago. The spirit of the pioneer lingers here. Where once the Redman roamed, a city vast lifts its proud skyline to the morning sun. A monument to service notably done."

..

TITLES

The History of Writing

1. Prehistoric pictograms on stone slabs

2. The Phoenician alphabet and its descendants

3. Illuminated manuscripts of the Middle Ages

4. The Gutenberg press invented in 1436

ARTIST

Gustave Adolph Brand

CREATED
Not WPA/FAP

SIZE
4 murals: each H 20' x W 8'

MEDIUM
Oil on canvas adhered to wall

DATE
September 1, 1939

LOCATION
Library

CONDITION
In 1995 the murals were in severe condition as a result of damage from a leaking roof. The surfaces were marred by drip stains, lifting paint, cracks, losses, grime, and areas of lifting canvas.

CONSERVATION
In 1997 the Chicago Conservation Center restored the murals as part of Phase I of the Mural Preservation Project. Areas of lifting canvas were reset into place using PVA emulsion adhesive. Discolored layers of grime and water staining were removed using conservation solvents. Areas of lifting paint and cracks due to water damage were consolidated and returned to plane, and areas of loss were filled with gesso. The paintings were coated with a nonyellowing surface film and retouching was carried out with conservation pigments.

MURAL DESCRIPTIONS
The four spandrel paintings in the school library depict the history of writing from prehistoric times to the development of the Gutenberg press.

1. In the first mural, the first writing instrument, which appeared around 2200 B.C., is represented. During this time, writing instruments were used largely to record hunting, agricultural, and ceremonial pictograms. A prehistoric man carves a buffalo symbol onto a stone slab using a sharpened stone. Behind him, in a fertile valley landscape, two men in loincloths carry a large stone slab down from the mountain into the valley, as an elder hunter stands behind them. Far in the distance are glacial and mountainous forms.

2. The second mural depicts a Phoenician scene and suggests the rapid expansion and development of writing throughout the Mediterranean around 1500 B.C. By then, the Phoenician alphabet had started to appear, replacing pictograms. Phoenician merchants and sailors spread writing and the use of the alphabet throughout the Mediterranean to Italy, North Africa, southern Spain, and Greece, where the Greek alphabet—the ancestor of all Western alphabets— eventually developed. The scene includes an elaborately attired ruler overseeing a seated scribe chiseling a script into a stone slab. In the foreground a gypsy woman plays a harp. Grand architectural structures and a waterway filled with sails can be seen in the background.

3. The third mural represents sacred writing, which was firmly established in monasteries during the Middle Ages in western Europe. From the time of Charlemagne's initial reign, beginning in A.D. 768, European

The Spirit of Chicago, Gustave Adolph Brand and Schurz High School students, 1940, Carl Schurz High School.

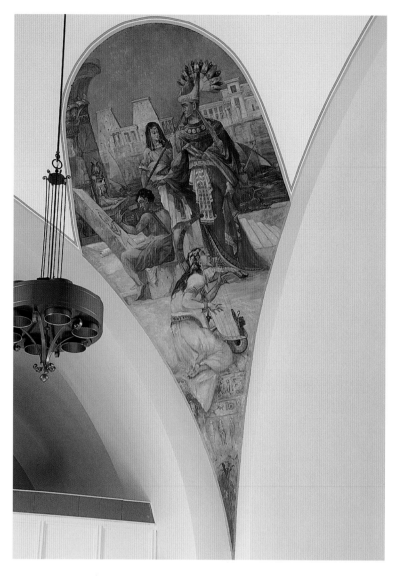

The History of Writing:
The Phoenician alphabet
and its descendants, *Gustave
Adolph Brand, 1939, Carl
Schurz High School.*

LOCATION
Library

CONDITION
In 1995 the secco murals were in severe condition as a result of damage from a leaking roof. The surfaces were marred by drip stains, lifting paint, cracks, losses, and grime.

CONSERVATION
In 1997 the Chicago Conservation Center restored the murals as part of Phase I of the Mural Preservation Project. Areas of lifting canvas were reset into place using PVA emulsion adhesive. Discolored layers of grime and water staining were removed with conservation solvents. The severe cracks and lifts were carefully consolidated and returned to plane, and areas of loss were filled with gesso. The paintings were coated with a nonyellowing surface film and retouching was carried out using reversible conservation pigments.

MURAL DESCRIPTIONS
The perimeter of the library is adorned with portraits of historical figures. Each portrait is painted in a roundel, with a faux scroll above containing the person's name and a painted scroll beneath bearing his or her birth and death years.

1. George Washington (1732–99) was the American general and commander in chief of the colonial army during the American Revolution. After the British surrendered in Yorktown and the new constitution was ratified, Washington became the first president of the United States. (Painted by unknown student.)

2. Johann Wolfgang von Goethe (1749–1832) was a German poet, playwright, novelist, and philosopher during the Romantic period in German literature. His influential and lyrical writing was greatly inspired by love and nature. His masterwork, *Faust,* was finished just a few months before his death. (Painted by Robert Whalgren, age 17.)

3. John Dewey (1859–1952) was an American educator and philosopher who was a pioneering figure in progressive education through experimentation and practice, psychology, and philosophy. (Painted by Betty Lou Frederick, age 17.)

4. Marie Curie (1867–1934) was a Polish-born French physicist and winner of two Nobel Prizes, for

monks were trained as copyists of biblical text onto papyrus, and later parchment and vellum, raising the practice of Carolingian letter writing to the art of manuscript illumination. In this scene, tonsured monks examine books and parchment scrolls in an austere library setting complete with religious paintings. Meanwhile, an abbot clad in a red robe oversees the production of the religious tomes. The globe and skull propped on top of a shelf represent worldly learning and the passage of time. The gothic architecture and detail on the chair locate the image in the medieval period.

4. The final mural in the series shows the development of the Gutenberg press, invented in Mainz, Germany, in 1436. By 1400 wooden blocks were used for type and hand rubbed or pressed onto paper with a board support. The screw press developed by Gutenberg mechanized this method and sped up the process of book production, resulting in the spread of knowledge. This scene

depicts a printing workshop where each person completes a specific task. One person arranges type; another holds the leather stamps covered in felt used for inking the press; a third figure proofreads the text; while the bottom figure carries off the stacked printed pages for binding.

TITLE
Historical Portraits

ARTISTS
*Gustave Adolph Brand
and Schurz High School
students*

SIZE
20 murals (roundels): each H 24" x W 24"

MEDIUM
Oil directly on the plaster walls

DATE
1937

physics and for chemistry. She is best known for her work on radioactivity. (Painted by Eleanor Klak, age 15.)

5. Thomas Alva Edison (1847–1931) was an American inventor, responsible for more than 1,093 patents. He also created the world's first laboratory for industrial research. He is best known for inventing the first commercial electric light and power system. (Painted by Marion Mirguet, age 15.)

6. Alexander Graham Bell (1847–1922) was a Scottish-born American inventor and audiologist who came from a family that had studied deafness and speech correction for two generations. He is best known for his 1876 invention of the telephone. (Painted by Leon Weisgerber, age 16.)

7. Ralph Waldo Emerson was an American essayist, poet, and lecturer who initiated an independent literary group promoting Transcendentalism. He published an anonymous compilation of his new philosophy, *Nature*, in 1836. (Painted by Robert Meyers, age 16.)

8. Michelangelo Buonarroti was an Italian Renaissance painter, sculptor, architect, and poet. His frescoes on the ceiling of the Vatican's Sistine Chapel are among his most famous works. Some of his most significant sculptures are *The Pieta, David*, and *Moses*. (Painted by Betty Lou Frederick, age 17.)

9. Charles Dickens (1812–70) was a prolific English novelist during the Victorian era. His universally appealing works are noted for their social reflections, character development, and often satirical style. Some of his most famous works are *Oliver Twist, A Christmas Carol, David Copperfield*, and *Great Expectations*. (Painted by James Smetana, age 16.)

10. Thomas Jefferson (1743–1826) was the third president of the United States. In 1776 he was chosen to compose the draft of the Declaration of Independence, which he wrote in a classic literary style documenting a then-radical democratic philosophy. The declaration was adopted on July 4, 1776. (Painted by Virgene Pratt, age 15.)

11. Winslow Homer (1836–1910) was a late-nineteenth-century American painter. He is known for his naturalistic marine scenes in oil and watercolor. His most recognized work, *The Gulf*

Stream, is an example of his focus on man in nature. (Painted by Evelyn Nitschke, age 16.)

12. Dante Alighieri (1265–1321) was an Italian writer, poet, philosopher, and political thinker during the medieval period. He is best known for *The Divine Comedy*, an epic poem written from a Christian perspective about the destiny of man. (Painted by Betty Lou Frederick, age 17.)

13. Albrecht Dürer (1471–1528) was a German Renaissance painter and printmaker. His religious paintings,

altarpieces, portraits, copper engravings, and woodcuts are considered some of the greatest German Renaissance works. (Painted by Vally Ringstmeyer, age 17.)

14. Frederic Chopin (1810–49) was a Polish-French pianist and composer during the Romantic period, best known for his solo music for piano. (Painted by Helen Dachs, age 14.)

15. Ludwig von Beethoven (1770–1827) was a German composer during the Classical and Romantic periods. His compositions are known for their expression of emotion, human will, and passion for freedom. Some of his most important works were composed during the last ten years of his life, when he was deaf. (Painted by Jack DeBartolo, age 16.)

16. Richard Wilhelm Wagner (1813–83) was a German theorist and composer whose operas and musical works, including *Lohengrin* and *Tanhauser*, had a great influence on Western music. His innovation of merging music with dramatic content in *The Flying Dutchman* was perceived as revolutionary. (Painted by Frances Anderson, age 15.)

17. Samuel Clemens (1835–1910), better known by his pseudonym, Mark Twain, was an American writer, lecturer, and humorist. His works include *The Adventures of Tom Sawyer, Life on the Mississippi*, and *The Adventures of Huckleberry Finn*. (Painted by Robert Keith, age 17.)

18. Horace Mann (1796–1859) was an American educator and advocate of public education and educational reform. In 1853 he became the president of Antioch College in Ohio, an institution devoted to nonsectarianism, coeducation, and equal opportunity for African Americans. (Painted by Marilyn E. Kruty, age 16.)

19. William Shakespeare (1564–1616) is the most famous English poet and dramatist of all time. He wrote and acted in his plays, now performed worldwide, in a small repertory theater. Masterworks include *Romeo and Juliet, Hamlet, King Lear*, and *Macbeth*. (Painted by Vally Ringstmeyer, age 17.)

Historical Portraits: Charles Dickens *(image 9), Gustave Adolph Brand and Schurz High School students, 1937, Carl Schurz High School.*

20. Abraham Lincoln (1809–65) was the sixteenth president of the United States, from 1861 to 1865. His leadership in the fight to preserve the Union during the Civil War and his emancipation of the slaves are two of his most important accomplishments. His goals of democracy and self-government continue to guide U.S. politics. (Painted by Marilyn Prasse, age 16.)

John D. Shoop Academy of Math, Science and Technology Elementary School

ADDRESS
1460 West 112th Street
Chicago, Illinois 60643

NAMESAKE
John Daniel Shoop (dates unknown) served as a superintendent of the Chicago Public Schools.

ARCHITECT
John C. Christensen

TITLES

1. Abraham Lincoln Meeting Frederick Douglass

2. DuSable Trading with Indians at Fort Dearborn

ARTIST
William Edouard Scott

CREATED
Progressive Era

SIZE
2 murals: each H 6' x W 10'

MEDIUM
Oil on canvas adhered to wall

DATE
c. 1920s

DuSable Trading with Indians at Fort Dearborn, *William Edouard Scott, c. 1920s, John D. Shoop Academy of Math, Science and Technology Elementary School.*

LOCATION
First-floor hallway

CONDITION
In 1996 the murals were coated with grime and water stains. Areas of bulging canvas were present, and cracks were scattered throughout.

CONSERVATION
In 1996 Shoop Elementary School hired the Chicago Conservation Center to restore the murals. The murals were cleaned using conservation solvents, and areas of lifting canvas were reset into place using conservation adhesives. Areas of lifting paint and cracks were consolidated and returned to plane, and areas of loss were filled with gesso and retouched to match the original. A nonyellowing surface film was applied to protect the surface from air pollution and future damage.

MURAL DESCRIPTIONS
Here the well-known African American painter William Edouard Scott depicts two significant African American historical figures.

1. In the first mural, Scott shows the historic meeting between Abraham Lincoln and Frederick Douglass (1818–95) at Parker House on September 10, 1864. At the center the abolitionist and author Douglass extends his hand to greet the president as people from various classes and races look on.

2. In the second panel, Scott shows Jean Baptist DuSable at Fort Dearborn. DuSable, a fur tradesman who was the first non–Native American to settle in Chicago in 1779, is shown in his trademark buckskin clothing as he trades with a group of Native Americans. The coexistence of the

pioneer and Native American communities is indicated through the teepees shown near the fort and the covered wagon entering the scene from the right.

John M. Smyth Elementary School

ADDRESS
1059 West 13th Street
Chicago, Illinois 60608

NAMESAKE
John Smyth (1843–1909) was a religious libertarian and nonconformist minister called "the Se-Baptist" (self-baptized). Considered the founder of the organized Baptists of England, he influenced the Pilgrims who immigrated to North America in 1620.

ARCHITECT
Unknown

TITLES

1. Columbus Landing in America

2. Landing in Jamestown

3. French Explorers LaSalle and Marquette

4. George Washington and his Troops

5. The Expedition of George Rogers Clark

6. Abraham Lincoln in Front of the White House

ARTISTS
1. Dorothy Loeb
(signed lower right)

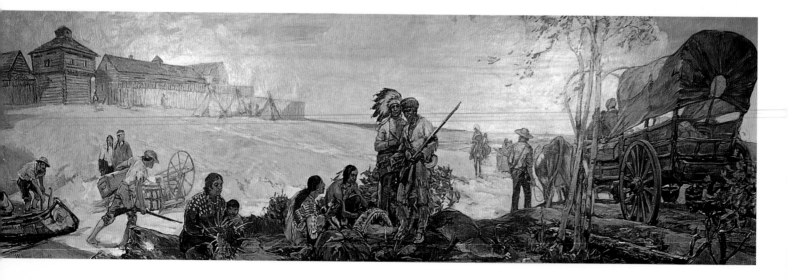

2. Gordon Stevenson
(signed lower left and "Restored by
the WPA/FAP 1936," lower right)

3. Beatrice Braidwood
(signed lower right)

4. Roy Smith Hambleton
(signed lower left)

5. Paul T. Sargent
(signed lower left, "Paul T.
Sargent 1910")

6. George Werveke
(signed lower left, "George
Werveke 1910")

CREATED
Progressive Era

SIZE
6 murals: each H 15' x W 7'

MEDIUM
Oil on canvas adhered to wall

DATE
1910

LOCATION
Auditorium

CONDITION
In 1997 the murals were coated with a
film of darkened oil and grime. Severe
buckling, lifting areas of paint, and
losses were present.

CONSERVATION
In 1998 and 1999 the Chicago Con-
servation Center restored the murals
as part of Phase II of the Mural
Preservation Project. The murals
were cleaned using conservation
solvents, lifting paint was reset using
a gelatin adhesive, areas of loss were
filled with gesso and retouched, and
a final nonyellowing surface film
was applied.

MURAL DESCRIPTIONS
1. In this image Loeb depicts the
arrival of Christopher Columbus in
the Americas. A red Spanish flag
waves in the upper left foreground
and draws the eye to the red-clad
explorer. The Spanish flotilla is seen
in the background, while the fore-
ground is dominated by the frenetic
activity of crewmen unloading cargo.

2. This panel depicts the landing
of British colonists in Jamestown in
the seventeenth century. Stevenson
depicts the colonists aboard a ship
in the foreground and a second
ship in the background. The comp-
osition mirrors the one depicting
Columbus's arrival.

3. In this panel Braidwood depicts the
arrival of René-Robert Cavelier, Sieur
de La Salle (1643–87), and Father
Marquette in the Chicago territory and
their meeting with Native Americans.
The bipartite composition shows
Europeans on the left and Native
Americans on the right. Lake Michigan
dominates the background.

4. In this image Hambleton shows
George Washington meeting his
troops in Alexandria, Virginia.
Washington is shown accompanied
by a woman and a young girl, while
troops walk in formation and a Union
Jack waves in the background.

5. This panel depicts the expedition
of George Rogers Clark and the early
settlers of the Midwest trudging
through a snow-covered landscape.
The varied costuming of the men
indicates the diversity among the
new arrivals.

6. In this painting, the artist depicts
Abraham Lincoln standing on a neo-
classical colonnaded porch overlook-
ing a procession of Union soldiers.
American flags wave and a band
accompanies the parade of troops.

Graeme Stewart Elementary School

ADDRESS
4525 North Kenmore Avenue
Chicago, Illinois 60640

NAMESAKE
Graeme Stewart (1835–1905) was a
powerful influence in Chicago civic
affairs and a member of the Board
of Education. He saved books of the
firm Stewart, Aldrich and Co. from
the Great Fire in 1871.

ARCHITECT
Dwight Perkins

TITLES
Unknown
(Historic Scenes)

1. Pioneer scene

2. Playing children

*3. Father Marquette
and Indians*

ARTIST
Unknown
(possibly Golding)

CREATED
Possibly WPA/FAP

SIZE
3 murals: each H 5' x W 6'

MEDIUM
Oil on canvas

DATE
1936

LOCATION
Auditorium

CONDITION
In 1999 the murals were coated with a
film of soot and grime, and yellowed
varnish had oxidized due to water
damage, appearing white and marred
in the upper portions of the murals.
Surface cracks were also present.

CONSERVATION
Restored by Parma Restoration
in 2000.

MURAL DESCRIPTIONS
1. The first mural is a typical represen-
tation of pioneer life and the westward
move. The cattle in the foreground,
the covered wagon, and the robust
family dominate the picture. Unlike
other images of pioneer life, here are
depicted several families in one
wagon and anecdotal detail such
as the young girl in the foreground
grasping a small bouquet of prairie
flowers. Other covered wagons are
visible in the distance, alluding to the
mass migration westward.

2. In the second mural, the artist
depicts nineteenth-century children
playing. Children crowd the composi-
tion and complement the staid red

George Washington and
his Troops, *Roy Smith
Hambleton, 1910, John M.
Smyth Elementary School.*

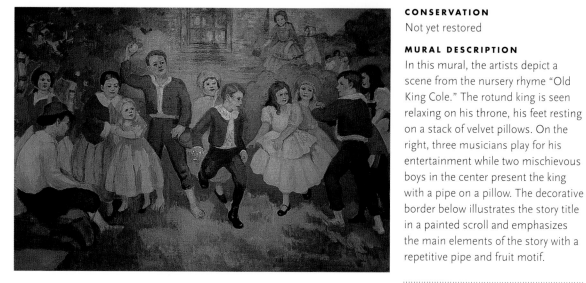

Playing children, *artist unknown, 1936, Graeme Stewart Elementary School.*

Puss in Boots *(detail), Dan Harper, Irene Mandogian, Jane Wilkinson, Tonie Karelas, John Kassure, Jean Mangold, Barbara Bisno, and Shirley Spinner, c. 1920s, Leander Stone Scholastic Elementary Academy.*

brick schoolhouse in the background. At the center, a young boy pulls his arm back to throw a ball while others run and frolic around him. On the left, a young boy in rolled-up pants and floppy hat rests on a rock.

3. The third mural of the series shows Father Jacques Marquette holding a Bible under one arm and a rosary in the other hand while preaching to Native Americans. To the left of Marquette is a trader, possibly DuSable. The surrounding figures include an array of Native Americans: a mother with a swaddled baby on her back, a chief in a feathered headdress, and scantily clad men and children.

Leander Stone Scholastic Elementary Academy

ADDRESS
6239 North Leavitt
Chicago, Illinois 60659

NAMESAKE
Leander Stone (1831–88) was a Chicago journalist who organized the Chicago Press Club.

ARCHITECT
John C. Christensen

TITLE
Old King Cole

ARTISTS
Lilian Anderson, Nancy Austin, Phyllis Henry, Betty Rae Heins, Jean Plambeck, Elayne Weiss, Ann Gartner, and Edgar Aberman
(signed)

CREATED
Progressive Era

SIZE
1 mural: H 3' x W 6'

MEDIUM
Oil on canvas

DATE
c. 1920s

LOCATION
Kindergarten room

CONDITION
In 1998 the mural was heavily coated with a film of grime, paint losses were scattered throughout the surface, and the canvas support was nailed to the wall.

CONSERVATION
Not yet restored

MURAL DESCRIPTION
In this mural, the artists depict a scene from the nursery rhyme "Old King Cole." The rotund king is seen relaxing on his throne, his feet resting on a stack of velvet pillows. On the right, three musicians play for his entertainment while two mischievous boys in the center present the king with a pipe on a pillow. The decorative border below illustrates the story title in a painted scroll and emphasizes the main elements of the story with a repetitive pipe and fruit motif.

TITLE
Puss in Boots

ARTISTS
Dan Harper, Irene Mandogian, Jane Wilkinson, Tonie Karelas, John Kassure, Jean Mangold, Barbara Bisno, and Shirley Spinner
(signed)

CREATED
Progressive Era

SIZE
1 mural: H 3' x W 7' 6"

MEDIUM
Oil on canvas

DATE
c. 1920s

LOCATION
Kindergarten room

CONDITION
In 1998 the mural was heavily coated with a film of grime, paint losses were scattered throughout the surface, and the canvas support was nailed to the wall.

CONSERVATION
Not yet restored

MURAL DESCRIPTION
The tale of "Puss in Boots" is the subject of the second mural at Stone Elementary School. The main character, Puss, is at the center of the composition, unveiling a bag of rabbits to the royal audience. The spectators are royal jesters, the king on his throne, a sentinel standing guard, and a princess with her suitor. The windmill and the vast landscape in the background locate the story in Holland.

In the decorative border below appear the story title in a painted scroll and the windmill as a repeated motif.

Roger C. Sullivan High School

ADDRESS
6631 North Bosworth
Chicago, Illinois 60626

NAMESAKE
Roger C. Sullivan (1861–1920) was an activist in party politics and a leader of the Democratic Party.

ARCHITECT
John C. Christensen

TITLE
Tree of Knowledge

ARTIST
Unknown

CREATED
WPA/FAP

SIZE
1 mural: H 20' x W 40'

MEDIUM
Oil on canvas steel curtain

DATE
1939

LOCATION
Auditorium stage fire curtain

CONDITION
In 1996 the fire curtain mural was lodged up in the holding position above the stage; a pole was holding it in place. It is not possible to determine whether the mural is salvageable until the fire curtain is lowered.

CONSERVATION
Not yet restored

MURAL DESCRIPTION
This mural is not visible. No photographs of this image exist.

Charles Sumner Mathematics and Science Community Academy Elementary School

ADDRESS
4320 West Fifth Avenue
Chicago, Illinois 60624

NAMESAKE
Charles Sumner (1811–74) was a Harvard graduate in 1830. He edited a law review, *The American Jurist,* and served as a reporter for the U.S. Circuit Court and became a leader of the anti-slavery forces in the Senate. He introduced the bill that eventually would become the Civil Rights Act of 1875.

ARCHITECT
Unknown

TITLE
Unknown
(Mount Vernon)

ARTIST
Unknown

SIZE
1 mural: H 7' 8" x W 12' 2"

MEDIUM
Oil on thin canvas adhered to wall

DATE
c. 1930s

LOCATION
Auditorium

CONDITION
In 1999 the mural was in critical condition due to severe flaking paint and a heavy film of grime. Flaking paint can occur when top layers are applied over wet layers of paint or when too much oil is mixed with the pigment during the painting process.

CONSERVATION
Not yet restored

MURAL DESCRIPTION
This scene depicts Mount Vernon, a colonial structure built in 1730 with additions in the 1770s, which was the home of George Washington. In the doorway on the right an affluent and well-dressed white couple peer out, and on the left side a young white girl plays in the garden. A caricatured African American woman attired in a stereotypical "mammy" outfit subtly indicates the inequities of antebellum Southern culture and the persistence of such stereotypes in America into the 1930s.

George B. Swift Specialty Elementary School

ADDRESS
5900 North Winthrop
Chicago, Illinois 60660

NAMESAKE
George Bell Swift (1845–1912) was the Republican mayor of Chicago in 1893 and 1895 to 1897.

ARCHITECT
Unknown

TITLES
1. *George Washington*
2. *Abraham Lincoln*

ARTIST
Harold Harrington Betts
(signed lower left, both murals, "H. H. Betts")

CREATED
Progressive Era

SIZE
2 murals: each H 8' 8" x W 5' 2"

Unknown (Mount Vernon), artist unknown, c. 1930s, Charles Sumner Mathematics and Science Community Academy Elementary School, before restoration.

Abraham Lincoln, *Harold Harrington Betts, c. 1920, George B. Swift Specialty Elementary School.*

MEDIUM
Oil on canvas on stretchers

DATE
c. 1920

LOCATION
Auditorium

CONDITION
In 1995 the murals were coated with yellowed varnish and grime, the canvases were rippled, and cracks were scattered throughout the surface.

CONSERVATION
In 1995 Swift School hired the Chicago Conservation Center to restore the murals. They were transported to the Center, where aged and discolored varnish layers were removed with conservation solvents. The weakened canvases were lined to Belgian linen

The Pied Piper, *Alson Skinner Clark, 1939, Mancel Talcott Elementary School.*

using a reversible conservation adhesive and then restretched onto new redwood spring-stretchers. Areas of loss were filled with gesso and retouched to match the original and a final nonyellowing varnish film was applied. The paintings were reinstalled in their original location.

MURAL DESCRIPTIONS
The two companion portraits of Abraham Lincoln and George Washington, typical of earlier traditional full-length portraits of statesmen and rulers, show the presidents in their offices surrounded by books and symbols of their high status. (See also Clinton School and Mount Vernon School.)

1. The portrait of George Washington echoes the well-known Gilbert Stuart portrait of the president and shows Washington standing and gesturing to an audience, in the pose of a classical Roman orator.

2. Abraham Lincoln is shown holding a book in his signature stance.

Mancel Talcott Elementary School

ADDRESS
1840 West Ohio
Chicago, Illinois 60622

NAMESAKE
Mancel Talcott (1817–78) was one of the founders of the First National Bank of Chicago. He was the director and president of the Union Stock Yards National Bank, president of the city Police Board, and a prominent civic leader.

ARCHITECT
Unknown

TITLE
The Pied Piper

ARTIST
Alson Skinner Clark
(signed lower left, "Alson S. Clark")

CREATED
WPA/FAP

SIZE
1 mural: H 3' x W 9'

MEDIUM
Oil on canvas

DATE
1939

LOCATION
Foyer, near main entrance

CONDITION
In 1996 the mural was coated with a layer of grime, which flattened the three-dimensional quality of the scene; scattered scratches were present.

CONSERVATION
In 2001 the mural was restored by Parma Restoration.[21]

MURAL DESCRIPTION
This mural depicts a contemporary incarnation of the Pied Piper, who, according to the rhyme "The Pied Piper of Hamelin" (Robert Browning), used his melodic flute to lure rats out of the town of Hamelin at the request of the mayor, leading them to drown in the nearby river. When the mayor refused to pay the promised reward, the Pied Piper proceeded to lure the town's children away, never to be seen again. Here the Pied Piper, dressed in red and gold with a yellow feathered cap, leads throngs of children, who are dressed in clothes typical of the late nineteenth and early twentieth century.

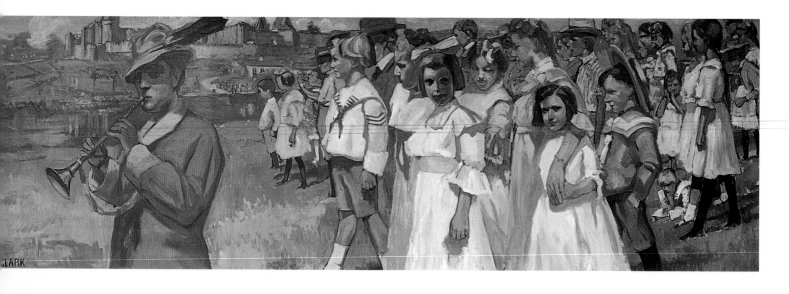

Edward Tilden Technical High School

(formerly Lake High School)

ADDRESS
4747 South Union Avenue
Chicago, Illinois 60620

NAMESAKE
Edward Tilden (dates unknown) was a member of the Board of Education and president of Libby, McNeil and Libby Bank.

ARCHITECT
Dwight Perkins

TITLE

Man the Builder; Man the Maker or Great Figures— Creative Figures

ARTISTS

James E. McBurney, John Courtright, and Jean Jacobs

CREATED
Progressive Era

SIZE
60 murals of various sizes: 6 long horizontal, 8 medium, 9 medium small, 37 small; ranging from H 2' 6" x W 8" to H 2' 6" x W 8'

MEDIUM
Oil on canvas adhered to wall

DATE
Dedicated March 24, 1931

LOCATION
Library

CONDITION
In 1995 the murals were coated with a heavy film of grime, cracks and losses were present, and several murals were separating from the wall.

CONSERVATION
In 1998 the Chicago Conservation Center restored the murals as part of Phase II of the Mural Preservation Project. Each mural was cleaned using conservation solvents, and areas of loose canvas were reattached using conservation adhesives. One mural was completely separated from the wall and transported to the Center, where it was stabilized and then returned to its original location. Areas of former loss were retouched and a final nonyellowing varnish film was applied.

MURAL DESCRIPTIONS
The school library houses sixty murals that include portraits and scenes from world history. The artist, James McBurney, created an inspirational and tranquil environment conducive to studying. McBurney was assisted by John Cortright, a mural painter, and Jean Jacobs, a Tilden student who later became an illustrator. Tilden students were used as models for the large murals in this series. This mural series is among the largest in the Chicago Public Schools. The mural cycle is devoted to scenes and writings about the nature of both manual and intellectual labor and their intersection with the arts. The panels of various sizes are all set in a quatrefoil format with gilded frames, lending a sense of uniformity and refinement to the pieces.

1. The first mural in the series is located above the library reference desk. The text reads: "Who shall the workman be? Everyone, everyone, everyone. Who shall the craftsman be? He who good work has done. Who shall the master be? He whose thought has won." These lines are bordered by decorative motifs that are repeated in other panels.

2. "Artistic work is efficient work." A carved bust of a woman and a painting flank a young man in an artist's smock.

3. Thomas Alva Edison is shown in a frontal portrait with a large light bulb above his head. Edison was an American inventor best known for inventing the first commercial electric light and power system.

4. "Ye cannot enter the labyrinth of the future without the torches your forefathers have lighted." A young man peers down at a large open book in the center of a library filled with books. On the left is a burnt candle and to the right is a globe and small replica of Rodin's sculpture *The Thinker*.

5. Covered

6. Covered

7. "As a structure appears when completed, so must it first have existed in the mind of the builder." This work depicts the journey from intellectual thought to practical application. The scene shows an architect at work at his drafting table while skyscrapers and other engineering achievements loom in the background as examples of his design.

8. "Ye cannot work an hour at anything without learning something." A worker in a cap and overalls drills steel girders.

9. "The vow to make our country a better place in which to live." The character traits of patriotism and heroism are shown. A young medieval knight kneels at the center of the composition. Behind him other kneeling knights holding shields and banners bow their heads. The group faces a lectern with a large open book on which they make their oath.

10. "Machinery is extended mentality." An engineer holds up blueprints, with a large industrial wheel behind him.

11. Sir Isaac Newton (1642–1727) is depicted from behind as a red apple plummets toward his head. The English mathematician and physicist was a primary figure in the seventeenth-century scientific revolution. His research in mechanics led the way for the development of law of universal gravitation, via his three laws of motion. His work in optics and white light and the phenomena of colors helped to form the backbone of modern physical optics. In mathematics he discovered infinitesimal calculus.

12. "Chemistry is the pilot of progress." A scientist in a laboratory is shown working with glass beakers and chemical liquids.

13. "The hero is the man who does his work—who carries the message to Garcia." A young scout is depicted in a forest clearing on a shoreline. This scene focuses on the noble inspirations and determination of youth. "A Message to Garcia" is the title of a moralistic essay by Elbert Hubbard, written in 1889. Perseverance was the prevailing moral of the essay, set during the Spanish American War.

14. "Work and wisdom are partners." A man in a vest thinking and working illustrates the marriage of mental and physical work.

15. Galileo Galilei (1564–1642) is represented not in a portrait but through well-known monuments in the towns where he lived and worked, such as the Duomo in Florence and the Leaning Tower of Pisa. The Italian astronomer, philosopher, and mathematician made significant accomplishments in astronomy and initiated advanced concepts of motion. His development of the telescope revolutionized the field of astronomy and led the way for the recognition of the work of Nicolaus Copernicus.

Man the Builder; Man the Maker *or* Great Figures— Creative Figures *(image 50), James E. McBurney, John Cortright, and Jean Jacobs, 1931, Edward Tilden Technical High School.*

16. Michelangelo di Lodovico Buonarroti Simoni (1475–1564) is depicted on his back painting the ceiling of the Sistine Chapel. Michelangelo was an Italian Renaissance painter, sculptor, architect, and poet. His frescoes on the ceiling of the Vatican's Sistine Chapel are among his most famous works. Some of his significant sculptures were *The Pieta, David,* and *Moses.* Michelangelo personified the phrase "renaissance man."

17. Abraham Lincoln (1809–65) is depicted in a frontal portrait and symbolized by an axe and sword

His work on the study of formal logic and the study of zoology are two of his most diverse and noted accomplishments.

22. Pericles (495–429 B.C.), the statesman responsible for making Athens the cultural and political center of Greece, is depicted in a frontal portrait. Above him is a Greek (Doric, Ionic, or Corinthian?) column, symbolizing the Acropolis, with a white dove flying overhead. He was also responsible for the construction of the Acropolis, which began in 447.

the Burbank potato. His experiments in plant breeding have had a great influence on the study of genetics.

26. Antoine van Leeuwenhoek (1632–1723) is depicted with a cap and a burning candle. The Dutch naturalist and microscopist was the first to research and observe protozoa and bacteria and provided the first complete descriptions of bacteria, protozoa, and spermatozoa.

27. George Washington (1732–99) appears in a portrait in the lower portion of the panel. The American flag and the Statue of Liberty are shown above the image of the man who commanded the colonial army during the American Revolution and was the first president of the United States.

28. Covered

29. Covered

30. Archimedes (287–212 B.C.), a mathematician and inventor, is depicted looking down at a hydraulic device he developed for raising water. Taught by the students of the Greco-Roman mathematician Euclid, he formulated the idea known as Archimedes' principle, which explains the relative density of different substances of the same volume. Archimedes is also known for his contributions to geometry, including the exact value of pi.

31. Francis Bacon (1561–1626) appears in Edwardian garb with a typical white ruffle collar. Sir Francis Bacon was a British lawyer, philosopher, and statesman who was the lord chancellor of England from 1618 to 1621. He became known as a great speaker in Parliament.

32. John La Farge (1835–1910), an American muralist, painter, and designer of stained glass, is shown in a frontal portrait. Above him is an example of his stained glass work. He painted murals for the Trinity Church in Boston. His best-known mural, *Ascension,* is located in the Church of the Ascension in New York City.

33. Louis Sullivan (1856–1924) is depicted in profile; below him is an architectural model. The famed architect built structures that were functional and modern, free of excessive decoration. His most famous buildings include the Auditorium Building in Chicago, the Wainwright Building in St. Louis, the Guaranty Building in

Man the Builder; Man the Maker or Great Figures—Creative Figures (image 8), James E. McBurney, John Courtright, and Jean Jacobs, 1931, Edward Tilden Technical High School.

YE CANNOT WORK AN HOVR AT ANYTHING WITHOVT LEARNING SOMETHING

bound by shackles above the portrait, a reference to his leadership in the Civil War, which ended slavery. Lincoln was the sixteenth president of the United States, from 1861 to 1865. His dedication to preserving the Union during the Civil War and abolishing slavery are two of his most important accomplishments.

18. Covered

19. Covered

20. Ramses the Great (1304–1237 B.C.) is depicted in a frontal portrait. Ramses was the third king of Egypt's nineteenth dynasty, notable for the elaborate structures and statues he had built all over Egypt.

21. Aristotle (384–322 B.C.) is depicted in a portrait with purple garb and scroll in hand. The Greek philosopher and scientist's writings became the foundation of Western philosophy.

23. Saint Thomas Aquinas (1225–74), an Italian Dominican theologian and medieval scholar, is shown reading a book. A founder of the official Catholic philosophy, he is most noted for his work related to Latin theology.

24. Francesco Petrarch (1304–74) is depicted wearing elaborate garb. Petrarch was an Italian scholar, humanist and poet, many of whose lyric works were written for his beloved, Laura. Petrarch traveled widely, studying in monastic libraries, examining classical manuscripts, and learning from his contemporaries.

25. Luther Burbank (1849–1926) appears in a frontal portrait surrounded by vegetables and a white daisy. Burbank was an American plant breeder and producer who created numerous fruit, flower, vegetable, grain, and grass varieties, including

Buffalo (now the Prudential Building), and the Schlesinger & Mayer department store in Chicago (now the Carson Pirie Scott & Co. building).

34. Charles Darwin (1809–82) peers out at the viewer while writing. The English naturalist is renowned for his revolutionary theories on evolution, described in his two written works, *On the Origin of Species by Means of Natural Selection* and *The Descent of Man, and Selection in Relation to Sex.*

35. Benjamin Franklin (1706–90) is depicted in profile; above his head appear a kite and lightning bolts. Benjamin Franklin was a famous American printer, author, publisher, inventor, diplomat, and scientist of the eighteenth century. He also played a strong role in politics, acting as a spokesman for the British colonies in debates on self-government. During the American Revolution, Franklin helped to write the Declaration of Independence and assisted in attaining the monetary and military aid of France. His various inventions still used in daily life include the stove and bifocal eyeglasses; he also helped to establish community institutions such as libraries, hospitals, firehouses, and insurance companies.

36. Henry James (1843–1916) is depicted in profile holding a book. The American novelist became the editor for the *Atlantic Monthly.* His most famous works were *Daisy Miller, Portrait of a Lady,* and *The Ambassadors.*

37. "Capacity never lacks opportunity." A man looks down as he carves a face with a tool.

38. "Originality is fresh eyesight." A scientist at a table conducts an experiment as a clock rests on the shelf behind him.

39. "Things printed can never be stopped, they have a soul and go on forever." A young man reads a text sheet that has come off a printing press.

40. Covered

41. Covered

42. "All things return to dust save beauty fashioned well." A young man is shown in a darkened room surrounded by beautiful objects of art.

43. Confucius (551–479 B.C.) is depicted in a frontal portrait holding a Chinese scroll. Confucius was

China's famous philosopher, teacher, and political theorist whose ideals to educate and elevate society incorporated a theory of self-cultivation and character development. He saw politics as a way to integrate his humanistic ideals into governmental structures. His mission spread as his number of students grew. His ideals are still revered today in a system of beliefs called Confucianism.

44. "When love and skill unite expect a masterpiece." Here the merging of artistic work and manual labor is shown. In this scene a young man puts together a stained glass composition on a table with an ornate background of stained glass.

Northeast pillar:

45. Johannes Gutenberg (1390–1468) is shown in a frontal portrait beneath a large crank of a printing press. The German inventor and craftsman developed a movable-type printing press, which revolutionized book-making and education and allowed the mass production of reading material. The first book printed with the movable type was the Bible.

46. Nicolaus Copernicus (1473–1543) is depicted looking down at a measuring instrument, beneath a sky and planets representing the solar system. Copernicus, a Polish astronomer, developed the theory that the sun was at the center of the solar system. He developed a model of the solar system and the planetary orbits around the sun, rather than accepting the theory established by the Greek astronomer Ptolemy that they orbited the earth. Copernicus's theory was not published until 1540 and a complete account of his research did not surface until the day of his death. It was not until Galileo made his discoveries that Copernicus's impact on astronomy was fully recognized.

47. James Watt (1736–1819) is depicted with his hand resting on his face as he ponders the designs floating above his head. The Scottish inventor and instrument designer's most important invention was the steam engine, which helped propel the Industrial Revolution.

48. Robert Fulton (1765–1815) appears in a frontal portrait beneath a depiction of his propulsion device. This American artist, inventor, and engineer developed the first commercially

successful steamboat design. He is also credited with designing canal waterways, a steam warship, and a submarine.

Southeast pillar:

49. Johann Sebastian Bach (1685–1750) is depicted in a frontal portrait, with a large musical note above his head.

Bach was a German composer of the Baroque period who has become one of the world's most famous composers of classical church and instrumental music. His most prominent works include the Brandenburg Concertos and the Mass in B Minor.

50. Huangdi (c. 2704 B.C.–unknown) appears in a frontal portrait wearing a Chinese cap, a circular symbol above him. Huangdi in Chinese means "Yellow Emperor." He was the third mythological emperor in China and is considered the patron saint of Taoism. According to legend, during his reign carts, boats, writing, the bow and arrow, coined money, and silk production were introduced.

51. Sir Henry Bessemer (1813–98) is

Man the Builder; Man the Maker or Great Figures—Creative Figures (image 56), James E. McBurney, John Courtright, and Jean Jacobs, 1931, Edward Tilden Technical High School.

depicted in a frontal portrait, above a vat of molten steel. This British engineer and inventor was the first individual to produce steel inexpensively. He also developed the Bessemer converter, a tilting container for pouring molten iron, which revolutionized steel manufacturing.

52. William Shakespeare (1564–1616) is depicted in the form of a sculptural bust. Shakespeare was an English actor, poet, and dramatist whose plays are the world's most widely read and performed stage works.

Southwest pillar:

53. Guglielmo Marconi (1874–1937) is shown in a frontal portrait, below two telegraph poles symbolizing his communications inventions. Marconi was an Italian inventor and physicist who won the Nobel Prize for Physics. He is known for inventing the radiotelegraph and for discovering the concept of long-distance radio, the premise for all modern radios using short-wave wireless communication.

54. William Harvey (1578–1657) appears in a frontal portrait; above his head is a scientific rendering of the human anatomy, complete with organs. Harvey was an English physician who discovered the function of the heart as a pump and the circulation of blood. Harvey became recognized for his patterns of research and experimental methods in biology.

55. Christopher Columbus (1451–1506) is depicted with a large ship sail over his head. Columbus, of Genoese decent, was a master navigator and mariner. Under the sponsorship of the Spanish Catholic monarchs Ferdinand and Isabella, he sailed across the Atlantic Ocean and is credited with discovering the New World in 1492. He made three more voyages to the New World between 1493 and 1504.

56. Louis Pasteur (1822–95) is shown holding a beaker. Pasteur was a French microbiologist and chemist who proved that certain microorganisms cause fermentation and then disease. He was the first to develop vaccines for rabies, cholera, and anthrax, and he originated the process called pasteurization (heating liquids to a specific temperature, destroying disease-producing bacteria).

Northwest pillar:

57. Henry Ford (1863–1947) is depicted in profile; above his head is the grill of his Model T automobile. Ford was an American industrialist and technological genius. He developed the Model T automobile and assembly-line methods, which changed the history of factory production.

58. Orville Wright (1871–1948) is shown in a frontal portrait, below a large propeller of an airplane. Orville and Wilbur, the Wright brothers, were American aviation pioneers and inventors who designed the first powered airplane in 1903. By 1905 they had perfected the design and flew the first plane.

59. Alexander Graham Bell (1847–1922) appears in a frontal portrait, with a telephone pole above his head. Bell was a Scottish-born American inventor and audiologist who is best known for his 1876 invention of the telephone.

60. Cyrus Hall McCormick (1809–84) is depicted in profile, a mechanical reaper shown above his head. McCormick was an American inventor and industrialist known for his development of the mechanical reaper. The principles used in his design were essential to the development of future grain-cutting machinery.

────────────────────────────

TITLE

Historical Scenes

ARTISTS

James Edwin McBurney and assistants

SIZE

7 murals: (2) H 11' x W 9'; (2) H 11' x W 9'; (2) H 7' x W 8'; (1) H 4' x W 5' 7"

MEDIUM

Oil on canvas

DATE

1935–44

LOCATION

School foyer

CONDITION

In 1995 the murals were coated with a film of grime and minor abrasions were apparent. Ghosting effects were present in the scenes as a result of the artist's changes to the compositions.

CONSERVATION

The murals were restored several years ago, but not as part of this preservation program.

MURAL DESCRIPTIONS

This mural series depicts two groups of historical architects and engineers, all midwesterners. The murals at the foot of the north staircase depict engineers; those at the foot of the south staircase, architects. McBurney's original plan was to feature men who were great teachers and planners. Four of those represented had classroom teaching experience: Mortimer Cooley, Eliel Saarinen, Louis Sullivan, and Arthur Talbot.

North stairwell:

1. This scene shows a man playing an organ in a churchlike setting. Apparitions of well-known artists, composers, and writers hover above the scene. The R. L. Stevenson quote inscribed beneath the image reads, "Bright is the ring of words when the right man rings them. Fair is the fall of songs when the singer sings them. Still they are controlled and said, on wings they are carried. . . After the singer is dead, after the maker is buried."

2. The second mural commemorates eight well-known engineers, arranged in a semicircle and superimposed on a depiction of the Hoover Dam. Below are written the names of each engineer. The signature in the lower right, "James McBurney Studios 1935," indicates that several hands may have contributed to this work. The engineers portrayed are John F. Wallace (dates unknown), the chief engineer for the building of the Panama Canal; Octave Chanute (1832–1910), an engineer and inventor who helped the Wright brothers develop their first airplane; Herbert C. Hoover (1874–1964), the thirty-first president of the United States and the force behind the construction of the Hoover Dam and the St. Lawrence Seaway; Arthur Newell Talbot (1857–1942), a chief engineer and teacher who became the principal authority on reinforced concrete design; Orville Wright, an engineer and inventor who, with his brother Wilbur, designed and piloted the first airplane; Mortimer E. Cooley (1855–1944), a teacher, administrator, and chief engineer for the U.S. Navy

during the Spanish-American War; Bion J. Arnold (1861–1942), an electrical engineer and inventor who acted as a consultant engineer for cities and railroads; and Onward Bates (dates unknown), a chief engineer, manufacturer, contractor, and structural engineer recognized for his steel bridges, such as the Eads Bridge near St. Louis.

2. In this mural a large commemorative stone obelisk inscribed "Wilbur Wright, Orville Wright" dominates the composition. Apart from the large structure and the two minuscule figures (thought to be the Wright brothers) at its base, the landscape is barren and desolate. Below the obelisk is a quote honoring the accomplishments of the Wright brothers that reads," In commemoration of the conquest of the air." The panel is signed in the lower right, "J. E. McBurney 44." At the bottom of the composition, to the right, is a quote by Herbert Hoover that reads, "There will always be frontiers to conquer as long as men think, plan, and dare." The unbalanced composition, the faint writing apparent beneath the quote, and the late date of this mural and the next mural suggest that they were repainted after the original mural cycle at Tilden was completed.

South stairwell:

4. A pendant to the third mural, this panel depicts the vast Chicago skyline submerged in luminescent clouds above a quote by Daniel Burnham, "Make no little plans. They have no power to stir men's blood. Make big plans. Aim high in hope and work." The panel is signed in the upper left, "J. E. McBurney 44."

5. The fifth mural features seven architects. This panel acts as a pendant to the second mural, which depicts eight engineers. The mural features a semicircle of well-known architects in the foreground, with a bustling urban cityscape in the background. Their names are inscribed in the band at the bottom of the panel. The drafting table and architectural plans, with the majestic buildings, bridges, and roads in the background, represent the tools and products of their labor. The panel is signed in the lower right, "J. E. McBurney Studios 1935." The architects portrayed are Irving K. Pond (1857–1939), an architect

and lecturer on art and architecture who specialized in community housing; Frank Lloyd Wright (1867–1959), an architect, writer, creative genius, and occasional lecturer whose Prairie Style designs became the foundation for modern twentieth-century residential design; Charles B. Atwood (1848–95), an architect best known as designer-in-chief for the 1893 World's Columbian Exposition in Chicago; Eliel M. Saarinen (1873–1950), an architect, artist, teacher, and designer known for his modern "cut-back" skyscrapers and church designs; Louis Sullivan (1856–1924), an architect, teacher, and writer whose dictum, "Form follows function," has become an important principle in modern architectural design; Daniel Hudson Burnham (1846–1912), an architect and city planner who helped guide the development of commercial architecture based on steel-frame construction in Chicago; and Raymond M. Hood (1881–1934), an architect noted for his skyscraper designs in New York City and Chicago, including Chicago's neo-Gothic Tribune Building.

6. The next panel portrays an artist with a palette, painting an image of a family. In the background is a depiction of an archetypal family group, a mother, father, son, and daughter, enjoying leisure time in a garden. Inscribed below is a quote by Kenyon Cox that reads, "Work thou for pleasure, paint or sing or carve the thing thou lovest though the body starve. Who works for glory misses oft the goal. Who works for money coins his very soul. Work then for the work's sake and it may be these things shall be added unto thee." This mural acts as a pendant to the first mural, of the organist; the two murals, placed opposite each other on the stairwells, suggest the enduring impact of the arts on culture and individuals.

7. The seventh mural commemorates Arnold Lurie (dates unknown), a former teacher at Tilden. The inscription reads, at top, "His influence never ends"; at bottom, "A teacher effects eternity." The canvas is presently framed and under glass, suggesting that it was moved or framed for protection because of its size. The mural is signed, "J. E. McBurney [illegible date]."

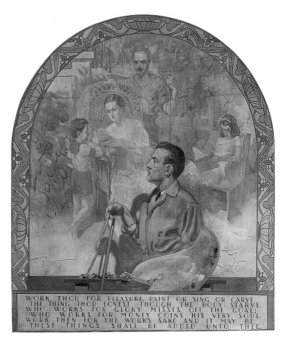

Historical Scenes (image 6), James Edwin McBurney and assistants, 1935–44, Edward Tilden Technical High School.

George W. Tilton Elementary School

ADDRESS
223 North Keeler Avenue
Chicago, Illinois 60624

NAMESAKE
George W. Tilton (1830–90) was superintendent of machinery for the Chicago and Northwestern Railroad during the 1870s and became prominent in community affairs. The school's designers spared no expense, spending $7.5 million; the building process took two years, 1904–06. The auditorium was designed as a miniature version of Carnegie Hall and includes an immense stained glass skylight, an oak stage, mahogany wall trim, and geometrically arranged glazed tiles.

ARCHITECT
Dwight Perkins

TITLES

1. Columbus 1910

2. Pilgrims 1911

3. William Penn 1911

ARTIST
Janet Laura Scott

CREATED
Progressive Era

SIZE
3 lunette murals: each
H 2' 9" x W 5' 1"

MEDIUM
Oil on canvas on new redwood spring stretchers

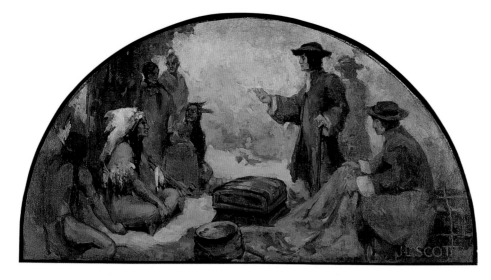

William Penn 1911, *Janet Laura Scott, 1910–11, George W. Tilton Elementary School.*

DATE
1910–11

LOCATION
Auditorium entrance

CONDITION
In 1995 we found the murals in a storage room, where an engineer had saved them. The murals were in severely poor condition. They had been painted over several times and then torn off the walls and placed in storage. Tears, holes, cracking paint, and chip losses were present.

CONSERVATION
In 1998 the Chicago Conservation Center restored the murals as part of Phase II of the Mural Preservation Project. The murals were transported to the Center and the overpaint was removed with a scalpel, uncovering the artist's signature, and the weakened canvases were relined to Belgian linen. Areas of loss were filled with gesso and retouched to match the original, and the arch-shaped murals were restretched onto custom-made stretchers. A final nonyellowing varnish film was applied and the murals were reinstalled in their original location above the auditorium doorways.

MURAL DESCRIPTIONS
These three lunettes represent important episodes in the settlement of the United States.

1. In the first mural, Christopher Columbus is depicted riding a white horse, accompanied by two other European explorers and led by two indigenous guides. Columbus's encounter with the natives of Haiti is likely what is represented in this scene.

2. The second mural depicts Pilgrims dressed in black and white in a winter coastal landscape, possibly a depic-

Landing of Christopher Columbus, *artist unknown, 1913, Lyman Trumbull Elementary School.*

tion of the landing of the *Mayflower,* which reached the shores of New England in December 1620.

3. In the third mural, Quaker leader William Penn meets with a Native American chief and tribesmen to create one of a series of treatises he made with the local Lenni Lenape tribe when he established a Quaker settlement in Pennsylvania. Penn offers his hand towards the Native Americans in peace. Another European negotiator offers a gift of European cloth as a peaceful gesture.

Lyman Trumbull Elementary School

ADDRESS
5200 North Ashland Avenue
Chicago, Illinois 60640

NAMESAKE
Lyman Trumbull (1813–96) was born in Connecticut, where he became a teacher, and then moved to Illinois, becoming active in state government. In 1841, he was elected the Secretary of State of Illinois, and he became a justice on the state supreme court in 1848. He later was elected as a Democrat to the state legislature in 1854. He became a Republican because

of his opposition to the expansion of slavery and was reelected to the Senate as a Republican in 1861 and 1867.

ARCHITECT
Dwight Perkins

TITLE
Landing of Christopher Columbus

ARTIST
Unknown

CREATED
Progressive Era

SIZE
3 lunette murals: each H 2' 2" x W 4' 8"

MEDIUM
Oil on canvas adhered to wall

DATE
"Class of 1913" appears on paneling of all three murals

LOCATION
Main entrance hallway

CONDITION
In 1999 the center mural was covered with a board and paper; it has not been determined whether this piece is salvageable. The two extant murals were coated with a heavy film of grime, which distorted the scenes, and severe cracks and buckling paint were visible.

CONSERVATION
Not yet restored

MURAL DESCRIPTIONS
The two visible lunette murals over the auditorium doors depict Columbus's voyage to and arrival in the New World. These innovative images are action-filled, cropped compositions.

1. In the left panel, upon the deck of a ship the crew, a nobleman, and Columbus busily complete their duties, while a few men on the right gape at land.

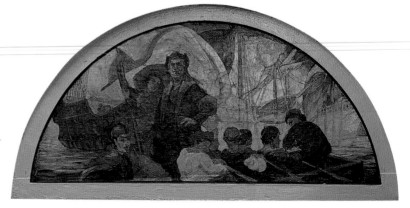

2. The central panel is covered.

3. In the right panel, the arrival of the Europeans is represented. Now safely on land, Columbus stands proudly with one hand on his hip as other men row ashore. The other ships in the flotilla appear in the background.

James Wadsworth Elementary School

(formerly Woodlawn School)

ADDRESS
6434 South University
Chicago, Illinois 60637)

NAMESAKE
James Wadsworth (dates unknown) was the realtor and donor of the site for the school after the 1883 Woodlawn School burned down in 1917. Wadsworth was one of the first settlers of the community, then called Woodlawn before being annexed by Chicago.

ARCHITECT
Unknown

TITLE
Allegories in a Pastoral Setting

ARTIST
John Harold Carlsen

CREATED
Progressive Era

SIZE
4 murals: (2) H 16' x W 6';
(2) H 4' x W 6' (triangle shaped)

MEDIUM
Oil on canvas adhered to wall

DATE
1919

LOCATION
Auditorium wall

CONDITION
In 1998 the murals were coated with a heavy film of grime. Water damage had caused cracking paint and drip stains, distorting the images.

CONSERVATION
Not yet restored

MURAL DESCRIPTIONS
The four Progressive Era murals are dedicated to the memory of Isabel J. Burke, an early principal of the Wadsworth School (1883–1910). The women portrayed in the two vertical panels probably represent Isabel J. Burke.

1. The first large vertical mural, on the left, depicts a woman dressed in a light blue dress with a white sash, holding a book. She stands in the center of an enclosed garden.

2. The second, a triangular mural, depicts a pastel landscape of treetops, an extension of the garden setting.

3. The third mural, a pendant to the second mural and similar in shape and size, depicts a landscape of trees and a cloudy blue sky.

4. The fourth mural, a pendant to the first mural and similar in shape and size, depicts a woman in a white dress with a light blue sash. She stands in the center of the composition, surrounded by a lush, green garden, holding a cornucopia overflowing with fruit and flowers.

Harold Washington Elementary School

(formerly Perry Elementary School)

ADDRESS
9130 South University
Chicago, Illinois 60619

NAMESAKE
The original building was named after Oliver Hazard Perry (1785–1819), who was an American naval officer who protected American commerce against West Indian pirates and won the battle of Lake Erie in 1813, making him a national hero. In 1992, the school was renamed in memory of Harold Lee Washington (1922–87), an African American politician, democratic representative, and mayor of Chicago from 1983 to 1987.

ARCHITECT
Unknown

TITLE
Unknown
(Seasons/Young Children at Play)

ARTIST
Unknown
(possibly Mary Chambers Hague)

CREATED
WPA/FAP

SIZE
4 murals: (2) H 10' x W 3';
(2) H 4' x W 6' (triangle shaped)

MEDIUM
Oil on canvas adhered to wall

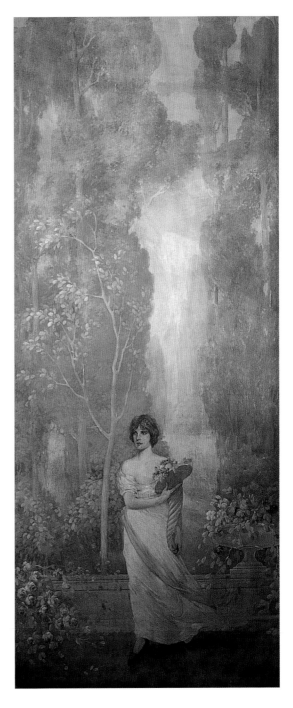

DATE
1940–41

LOCATION
Auditorium

CONDITION
In 1996 the unvarnished murals showed surface abrasions, scratches, and layers of grime, which distorted the original palette.

CONSERVATION
Not yet restored

MURAL DESCRIPTIONS
The four panels contrast the activities of children in a rural setting with those of children in an urban environment.

1. The first mural is a rural scene of children enjoying the pets and flowers in their community. In the foreground

Allegories in a Pastoral Setting (image 4), John Harold Carlsen, 1919, James Wadsworth Elementary School.

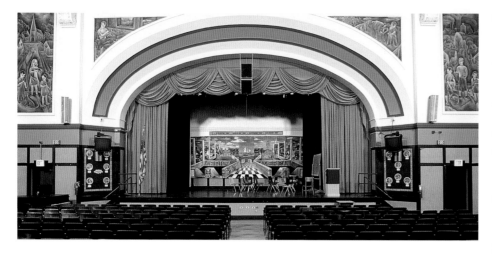

Unknown (Seasons/Young Children at Play), artist unknown, 1940–41, Harold Washington Elementary School.

a boy in overalls plays with a dog, a girl in a yellow dress holds a cat, and a younger girl in pink gathers flowers. In the background, a church steeple rises above a town.

2. The second mural, triangular in shape, depicts a boy at a workshop table building a model airplane.

3. The third mural, a pendant to the second and similar in size and shape, shows a farm scene with corn crops and a boy clad in overalls feeding a goat.

4. The fourth and last mural, a pendant to the first and similar in shape and size, portrays children in their city environment. In the foreground a young boy in red gathers leaves; an older boy holding a rake oversees the work; a young girl gathers blue flowers, trailed by a dog. In the background a housing community sits near the edge of an industrialized landscape with factory smokestacks.

William H. Wells Community Academy High School

ADDRESS
936 North Ashland
Chicago, Illinois 60622

NAMESAKE
William Harvey Wells (1812–85) was the second superintendent of the Chicago Public Schools and introduced graded curriculum and physical education. His *English Grammar* was published in 1846 and used as a textbook. In addition to the WPA/FAP murals by Simon, a December 1996 mural by Keith Haring hangs outside the auditorium.

Bishop McKendree at the Site of the College, Henry Simon, 1940–41, William H. Wells Community Academy High School.

ARCHITECT
John C. Christensen

TITLES
1. The Circuit Rider
2. Peter Akers's Prophecy
3. Bishop McKendree at the Site of the College

ARTIST
Henry Simon
(signed lower left, "Henry Simon, 1941")

CREATED
WPA/FAP

SIZE
3 murals: (2) H 3' 4" x W 5';
(1) H 5' x W 3' 4"

MEDIUM
Egg tempera on gesso coated panels

DATE
1940–41

LOCATION
Library

CONDITION
In 1996 the murals were covered with a heavy film of grime which masked the original color tones. Cracks and areas of buckling paint were present.

CONSERVATION
In 1998 the Chicago Conservation Center restored the murals as part of Phase II of the Mural Preservation Project. The murals were transported to the Center, where the darkened surface films were removed. Extensive cracks were retouched to match the original and a final non-yellowing varnish was applied. The paintings were then reinstalled in their original location.

MURAL DESCRIPTIONS
The three murals by Henry Simon were originally commissioned for McKendree College in Lebanon, Illinois. The murals were never delivered to McKendree College but were placed instead in the library of Wells High School. The murals depict three early supporters of McKendree College, which was founded in 1828. The monumental, expressive figures and muted earth colors are reminiscent of the work of Chicago muralists Edward Millman (see Lucy Flower High School), Mitchell Siporin, and Edgar Britton, colleagues of the artist. Liz Seaton wrote, "Like many American muralists-in-training, Simon was inspired by the example of Los Tres Grandes (Rivera, Orozco, and Siqueiros). But it was Chicago muralists Siporin, Britton, and Millman who most influenced his technique and approach to mural design. The Chicagoans helped Simon as he earned his own mural commissions. Millman, who had

worked with Rivera during visits to Mexico with Britton and Siporin in the late 1920s and early 1930s, taught Simon mural techniques, including Fresco."[22] Like many other Illinois Art Project murals, these murals were painted in the artist's studio and executed in egg tempera on gesso.

1. The first mural, *The Circuit Rider,* depicts Peter Cartwright (1785–1872), a McKendree circuit rider known for his strong opposition to slavery, preaching to a farmer holding a plow, a trapper leaning on a rifle, a gentleman in a top hat, and a woodsman holding a logging axe. The practice of circuit riding began in England as a way to spread Methodism; ministers and preachers would travel by horse from settlement to settlement preaching Methodist beliefs. Circuit riders began traveling between the American colonies in 1764, becoming a source of moral and religious support along the frontier.

2. The second mural, *Peter Akers's Prophecy,* depicts the college's first president (1790–1886) standing with arms open wide decrying the destruction of war, signified below by a broken drum and defeated men amid a wartorn landscape. In 1856 Akers gave a sermon predicting the Civil War.

3. The third mural, *Bishop McKendree at the Site of the College,* depicts the college's namesake, Bishop William McKendree (1757–1835), a pioneer circuit rider and the first American-born bishop for the Methodist Church. He stands, wearing a cloak with a book in his hand, on what is thought to be the original site of the college, surrounded by four men and his horse. Behind the group are a river and farm with grazing livestock.

Daniel Wentworth Elementary School

ADDRESS
6950 South Sangamon
Chicago, Illinois 60621

NAMESAKE
Daniel Sanborn Wentworth (1824–82) was the principal of numerous schools in Chicago and an organizer of teacher education.

ARCHITECT
Unknown

TITLE
American Youth

ARTIST
Florian A. Durzynski

CREATED
WPA/FAP

SIZE
3 murals: (2) H 7' 10" x W 8' 3";
(1) H 5' 9" x W 10'

MEDIUM
Oil on canvas adhered to wall

DATE
1937

LOCATION
First-floor corridor (originally in the fourth-floor library)

CONDITION
In 1995 the severely damaged murals were located in the fourth-floor library, now used as a storage room, with chairs, books, and tables blocking the murals. The murals were heavily coated with discolored varnish and grime, and the surfaces showed stains, scratches, and holes distorting the images and signatures.

CONSERVATION
In 1999 the Chicago Conservation Center restored the murals as part of Phase II of the Mural Preservation Project. The murals were separated from the walls and transported to the Center, where aged and discolored varnish layers were removed with conservation solvents. The weakened canvases were lined to Belgian linen using a reversible conservation adhesive and then restretched onto new redwood spring-stretchers. Areas of loss were filled with gesso and retouched and a final nonyellowing varnish film was applied. The paintings were then reinstalled in a first-floor hallway.

MURAL DESCRIPTIONS
The three murals are typical of Durzynski's style in their portrayal of muscular figures in a rolling landscape rendered in clear, vivid colors and strong, curving lines. These panels stress distinct groups in American society.

1. The first mural, possibly representing *The Adventures of Huckleberry Finn,* is located next to the staircase at the school entrance. The figures in the first mural are from a low social class; they wear tattered clothes and worn shoes from which their toes peek out. On the left, a bearded man carries a tattered tapestry bag while a well-dressed man wearing a black hat and necktie stands behind him holding a box. To the right, a woman in country garb stands with arms akimbo at the top of the composition. A young African American boy, possibly representing

American Youth *(image 3),*
Florian A. Durzynski,
1937, Daniel Wentworth
Elementary School.

the character Jim, is in the center of the composition fishing, with Huck Finn next to the river below. Tom Sawyer is possibly the character with the hat in the lower right. Durzynski sets his figures among undulating green fields filled with flowers and trees.

2. In the second mural, young, affluent white American boys and girls play in a landscape. In the lower left, one girl holds a drawing and another holds a doll, both admiring the drawing. Next to them is a boy lying on

TITLES

Medieval Scenes

1. King Arthur Meeteth Ye Lady Gweneviere

2. Arthur Draweth Forth Ye Sword From Ye Anvil

ARTIST

Norman P. Hall

(signed lower right, "Norman P. Hall 1904," and lower left, "Restored by WPA/FAP 1936")

Project. The aged and discolored varnish layers were removed with conservation solvents, revealing the signature and date. The weakened canvases were lined to Belgian linen using a reversible conservation adhesive and restretched onto new redwood spring-stretchers. Areas of loss were filled with gesso and retouched and a final nonyellowing varnish film was applied. The paintings were then rehung in a first-floor hallway.

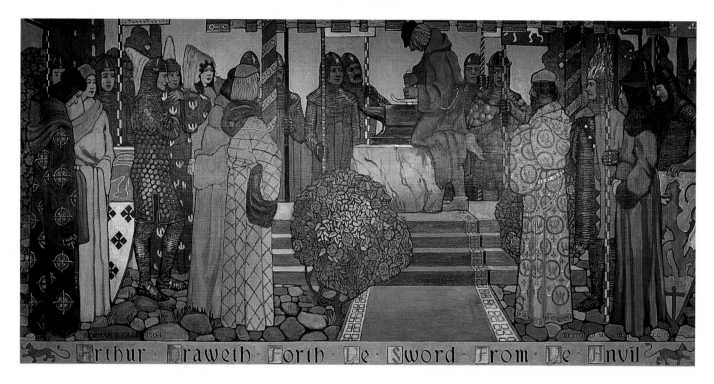

Medieval Scenes: King Arthur Draweth Forth Ye Sword From Ye Anvil, *Norman P. Hall, 1904, Daniel Wentworth Elementary School.*

the ground playing with a model train. Standing behind him are muscular young boys playing with toys. In the center of the composition two boys play with a skyscraper model. Due to the original design of the mural, which was centered over a doorway, a cutout exists in the composition where the doorway extended into the mural. To the right in the foreground a girl sits on the ground reading, while three girls stand behind her in a circle and look at a small notebook.

3. In the third mural, possibly representing the characters of *Little Women,* an affluent white woman knits, possibly Marmie, while her injured father relaxes under a wooden structure with a book in hand and blanket over his legs. The three women in country dress gather at the center of the composition. A young male and female, possibly Jo and her eventual husband, to the far right, look toward an elderly couple in admiration.

CREATED
Progressive Era

SIZE
2 murals: each H 6' x W 12'

MEDIUM
Oil on canvas

DATE
1904

LOCATION
First-floor corridor (originally in the fourth-floor library)

CONDITION
In 1995 the murals were heavily coated with discolored varnish and grime, and the surfaces had suffered from years of deterioration, soot, and heat damage from radiators placed in front of the murals.

CONSERVATION
In 2000 the Chicago Conservation Center restored the murals as part of Phase III of the Mural Preservation

MURAL DESCRIPTIONS
These two murals by Norman Hall are the oldest murals in the Chicago Public Schools collection. In the two panels, Hall depicts scenes from the Arthurian legends, based on Celtic myths, possibly based on facts in the life of King Arthur around the sixth century A.D., a war leader defending post-Roman Britain from the invading Saxons.

1. The first mural is entitled "King Arthur Meeteth Ye Lady Gweneviere," which appears in Old English text along the bottom border of the mural. Arthur is shown in red with a golden crown, kneeling before the flaxen-haired Gweneviere. The Knights of the Round Table assembled in the background witness the meeting. Hall's rendition is elegantly and theatrically conceived.

2. In the second mural, Hall shows a key moment in young Arthur's life.

At the center of the crowded composition, a red-clad Arthur, wearing an apprentice's cap, draws his magical sword, Excalibur, out of an anvil, proving his predestined right to rule. Arthur is shown surrounded by knights wearing helmets and carrying shields emblazoned with heraldry, all of whom look toward the dais anxiously awaiting the outcome of this test. The bottom border bears Old English text that reads, "Arthur Draweth Forth Ye Sword From Ye Anvil."

::

TITLE

Historical Scenes

ARTIST

James Edwin McBurney

(signed on several panels,
"J. E. McBurney '26" and
"J. E. McBurney '28")

CREATED

Progressive Era

SIZE

29 murals of various sizes:
H 1' x W 10' to H 16' x W 10'

MEDIUM

Oil on canvas

DATE

1926–28

LOCATION

26 in auditorium; 3 in auditorium foyer

CONDITION

In 1997 the murals showed severe water damage from a leaking roof, which had caused considerable flaking paint on the murals. Canvases had drip stains, tears, lifting paint, and overall grime, and some smaller panels were falling off the wall. One mural was missing.

CONSERVATION

In 2000 the Chicago Conservation Center restored the murals as part of Phase III of the Mural Preservation Project. Areas of lifting canvas were reset into place using conservation adhesive. Discolored layers of grime and water staining were removed using conservation solvents. Areas of lifting paint and cracks were consolidated and returned to plane. Areas of loss were filled with gesso, a non-yellowing surface film was applied, and retouching was carried out using reversible conservation pigments.

MURAL DESCRIPTIONS

The cycle of twenty-six panels is composed of five main subjects:

the westward move of pioneers into Native American territory, the life of Daniel S. Wentworth, the exploration of major waterways in the United States, the life of Abraham Lincoln, and Native American daily life. Several of the murals are text panels that describe the scene above them.

Native Americans and pioneers series:

1. To the left of the stage is a vertical pioneer scene. In the foreground two settlers cut down trees in a wooded area, next to two oxen. In the background is a log cabin in a dense wooded landscape. The mural is signed in the lower right, "J. E. McBurney '26."

2. The second mural, directly below the first, is a text panel that reads, "Fearless and independent, hardy, adventurous and cautious were the freedom-loving men and women who built their homes in that ever-shifting border land between Indian hunting grounds and the frontier villages. By their energy and courage, they redeemed a wilderness and made of it a garden. May we, as their children, honor their memory and be grateful for this land of opportunity which they have left for us."

3. The third mural, directly over the stage, is a long, narrow image depicting the westward move of nineteenth-century pioneers in covered wagons into Native American territory. The scene includes Native Americans, explorers, frontiersmen, and settlers. The central scene includes a group of eight frontiersmen on foot and two on horseback, proceeding along a path, representing the westward move. To the far left are Native Americans at a river's edge and another figure resembling Father Marquette standing with a cross as he faces the Native Americans on the other side. On the far right, another pioneer family group with their covered wagon moves toward another river.

4. The fourth mural, to the right of the stage, depicts a transaction between Native Americans and a trader. A seated Native American chief is shown surrounded by four tribesmen who are shown standing and holding textiles and furs, while the trader holds a large red silk textile. On the ground are knives and beads the trader has also brought. The mural is signed in the lower right, "J. E. McBurney '26."

5. The fifth mural is a text panel that reads, "By canoe and by pack—over river, lake, and portage, came keen and courageous traders with broad cloths, shimmering silks, brightly colored beads, awls, knives, and copper kettles to exchange for beaver, fox, and lesser furs. Back over the long trail to an eastern port, then on to far away Europe the skins were sent to be made into coat and muff for lord and lady of high degree."

Daniel S. Wentworth series:

6. Along the north wall, the sixth mural depicts a farm scene with a wooden house on the left and a large barn on the right. The text below reads, "The Parsonsfield, the birth-place of D. S. Wentworth, for whom the school was named."

7. The seventh mural is a scene depicting children and teachers in front of a colonial school building. The text below reads, "Cook County Normal School, established 1869, D. S. Wentworth elected first principal."

8. The eighth mural is a small vertical portrait of Daniel S. Wentworth holding a book. Across the top of the portrait reads, "D. S. Wentworth," and below, "1824–1882"

Waterway series:

9. Along the front of the balcony is a series of murals depicting the exploration of U.S. waterways. This winter scene depicts the first permanent settlement of the Pilgrims, as indicated by the text at the top of the panel, "Plymouth 1620." To the left of the composition is a ship at sea, symbolizing the landing of the *Mayflower*. To the right are a snow-covered settlement of wooden buildings surrounded by trees, and a group of Native Americans looking toward the settlement from near the edge of the woods.

10. The tenth mural reads, "Hudson River 1609." In this scene the river runs down the center of the composition, with flat land on one bank and cliffs on the other. A sailing ship appears in the center of the river, named after Henry Hudson, the English explorer who traveled the Hudson in 1609.

11. The third waterway scene is "Chicago 1681." In 1681 LaSalle made a famous journey down the frozen Chicago River and stopped at Portage in Lyons, eventually making his way to the Mississippi River.

In this scene, three explorers are canoeing down the Chicago River. To the left are trees and to the right is a large river expanse.

12. The fourth waterway scene is "Denver 1858." In this mural the meeting of the native Indians and settlers at the Colorado River is depicted. To the left a man on horseback is followed by a covered wagon. Coming from the opposite direction is a Native American chief on horseback, with several Native Americans standing behind him.

13. The last waterway scene is "San Francisco 1775." This scene depicts the *San Carlos*, the first Spanish ship to enter the Golden Gate, anchored in the San Francisco Bay. To the left is the Pacific coastline. On the cliffside, two Native Americans peer at the large ship with three sails. To the right are the headlands surrounding San Francisco Bay.

Abraham Lincoln series:

14. McBurney begins the visual biography of Lincoln with the president's early childhood and ends with his delivery of the Gettysburg Address in 1864. The series covers the auditorium's south wall. The first Lincoln mural is at the back of the balcony centered over a doorway. The scene

Historical Scenes *(image 1)*, James Edwin McBurney, 1926–28, Daniel Wentworth Elementary School.

depicts Lincoln's father leading the family as they move from Kentucky to Indiana. Lincoln's father carries a rifle while a girl, a boy (the young Lincoln), and a dog walk by his side. Following on horseback is Lincoln's mother leading another horse as they proceed through the woods. Below, the text reads, "Lincoln's father moves his family from Kentucky to Indiana."

15. This scene depicts young Lincoln in a boat watching a slave auction in New Orleans, a large cloudy sky above. This mural is signed in the lower left, "J. E. McBurney '26."

16. The text mural below reads, " 'If ever I get the chance to hit that, I shall hit it hard.' Spoken by Lincoln in New Orleans when he first saw a slave being sold at auction."

17. This panel depicts Lincoln as a circuit rider, dressed in a heavy coat and top hat, riding a white horse across a stream in a snow-covered scene. Signed lower right, "J. E. McBurney 1926."

18. The text mural directly below the preceding mural reads, " 'Lincoln, the circuit rider, on his lonely rides from town to town brooded over the perplexing questions that were stirring his countrymen to strife. Courageous and alone, in the silence and solitude of the prairies, his great spirit rose above party hatreds to the high principles of justice and human brotherhood; and when at last came the time for him to speak, men knew that his voice was truly the voice of the people.' James E. McDade."

19. This scene depicts Lincoln as an orator. He stands behind a podium covered with an American flag, reading the Gettysburg Address, considered a masterpiece of prose, to a crowd of men including Union and Confederate soldiers standing below. The mural is signed in the lower left section, "J. E. McBurney."

20. The text mural directly below the preceding mural reads, " 'It is rather for us to be here dedicated to the great task remaining before us, that from these honored dead we take increased devotion to that cause for which they gave the last full measure of devotion that we highly resolve that these dead shall not have died in vain; that this nation, under god, shall have a new birth of freedom, and that government of the people by the

people—and for the people—shall not perish from the earth.' Abraham Lincoln." Below, in small lettering, "A part of the address delivered at the dedication of the National Cemetery at Gettysburg November 19, 1863."

American Indian series:

21. A series of small panels appear along the east wall of the upper balcony depicting everyday activities of Native Americans. One of the murals is missing; the remaining five are signed in the lower right, "McBurney Studios '26." The first is a mural of a kneeling male Native American, painting on stretched and dried animal skin, with a small red textile hanging in the background.

22. Missing

23. The third mural in this series depicts a Native American hiding in the brush with a pack of arrows on his back and a bow in one hand. He kneels in a hunting position ready to attack his prey.

24. The next mural depicts a female Native American making a canoe; she works on the bottom seam. A tree trunk appears in the background.

25. The next in this series is an illustration of a male Native American making arrows with a teepee directly behind him. Grazing horses appear in the background.

26. The final mural in this series depicts a female Native American grinding corn. Next to her is a baby, with animal skins drying on wooden structures in the background.

Foyer lunettes:

27. Above each of the east wall doors leading into the auditorium is a lunette mural with a small dedication text panel below. Across the top arch of the left lunette is written the statement, "The windows of truth are opened to the mind of observation." In the scene a woman in a yellow dress sits near the seaside, reading. The mural is signed in the lower right, "J. E. McBurney '28." Directly underneath the lunette is a small rectangular text panel, "In gratitude for the long and fruitful service of Mrs. Edward Hecht as president of the Wentworth School Parent-Teacher Association and in appreciation of her unselfish devotion to the school and to their children, this picture is placed here by members of the association."

28. Across the top arch of the second lunette appear the words, "The noble & the wise become our familiar friends in reading." In the scene a boy and girl stand before a large open book on a desk. Directly underneath the lunette is a small rectangular text panel, "The mural paintings in this auditorium are the gift of the Wentworth School Parent-Teacher Association, the Wentworth School Fathers' Club, and the children and teachers of the school. The achievement of the plan is due to the vision and untiring devotion of the principal, James E. McDade 1927–1928."

29. Across the top arch of the third lunette is written, "Self-knowledge & self-control are the fruits of thinking." In this scene a young man sits at the seashore, with cliffs and rocks in the background. His head is resting on his hand while he peers at the sea in thought. The mural is signed in the lower right, "J. E. McBurney '28." Directly below is a small rectangular text panel, "In appreciation of the years of faithful service of Mr. John P. Jutzi as president of the Wentworth School Fathers' Club, and his diligence and zeal in promoting the welfare of the children and the school, this picture is placed here by members of the club."

West Pullman Elementary School

ADDRESS
11941 South Parnell
Chicago, Illinois 60628

NAMESAKE
George M. Pullman (1831–97) is best known for his sleeper cars for the Chicago and Alton Railroad. Pullman also established the free manual training school at Pullman Elementary School. The school's neighborhood was created by Pullman for his workers. Many of the buildings Pullman erected still exist in their original form.

ARCHITECT
Unknown

TITLE
Americanization of Immigrants
ARTIST
Ralph (or Ralf) Christian Henricksen

CREATED
WPA/FAP

SIZE
2 murals: each H 12' x W 8'

MEDIUM
Oil on canvas, framed

DATE
1940

LOCATION
Auditorium

CONDITION
In 1995 the unvarnished murals were coated with grime and several canvas ripples were present.

CONSERVATION
Not yet restored

MURAL DESCRIPTIONS
The two large panels depict immigrant families and their activities in a rural setting during the turn of the twentieth century, and an urban modern setting.

1. In the first panel, depicting the Americanization of immigrants, the central familial group consists of traditionally dressed parents and a little girl in a blue dress, who are flanked by a housewright constructing a building and a woman working in a garden. In the background stands a quaint suburban home.

2. The second panel mirrors the compositional structure of the first panel, but with a contemporary urban setting. Again a familial group is placed in the center, flanked by a young girl arranging flowers in a flower box and a man working in a steel mill. The contemporary dress of the figures and the urban buildings locate this image in a city. Bulky, large-scale figures and bright primary colors are typical of the artist's work.

TITLE
American Educational System

ARTIST
Ralph (or Ralf) Christian Henricksen

CREATED
WPA/FAP

SIZE
1 mural: H 5' 2" x W 10' 3"

MEDIUM
Oil on canvas

DATE
1941

LOCATION
First-floor hallway

CONDITION
In 1995 the framed mural was coated with grime and several ripples were present.

CONSERVATION
Not yet restored

MURAL DESCRIPTION
This horizontal mural depicts the study of art, geography, theater, literature, sports, and music activities. On the left, Henricksen depicts a boy painting and a girl learning geography by studying a globe. To the right, two students watch a play in the school auditorium. Henricksen cleverly includes a fragment of his auditorium murals in this vignette. Along the bottom of this section a young girl inspects a globe. The central section depicts children in the school library. In the top center of the composition is a boy in a library looking at various examples of literature, while below a young girl reads a book, *The American Girl*. In the far right section, extracurricular activities are portrayed. A boy dressed in a school uniform plays baseball and a young girl sings and listens to the radio.

Americanization of Immigrants (image 2), Ralph Christian Henricksen, 1940, West Pullman Elementary School.

Missing or Destroyed Murals in 30 Chicago Public Schools

Clara W. Barton Elementary School
7650 South Wolcott
Chicago, Illinois 60620
Architect: John Christensen

Title: Unknown
Artist: Irene Bianucci
Program: WPA/FAP
Size: 3 mural panels
Medium: Oil on canvas adhered to wall
Date: 1940
Status: Missing
Location: Auditorium

William H. Byford Elementary School
5600 West Iowa
Chicago, Illinois 60651
Architect: Unknown

Title: *Children on the Beach*
Artist: Unknown
Program: WPA/FAP
Size: 8' x 6'
Medium: Oil on canvas
Date: 1938
Status: Unknown
Location: Kindergarten

Grover Cleveland Elementary School
3121 West Byron Street
Chicago, Illinois 60618
Architect: Dwight Perkins

Title: Unknown
Artist: Unknown
Program: WPA/FAP
Size: Unknown
Medium: Oil on canvas
Date: Unknown
Status: Unknown
Location: Unknown

Richard Crane Technical High School
2245 Jackson Boulevard
Chicago, Illinois 60612
Architect: John C. Christensen

Title: *Boilermakers, Pipefitters, Architects*
Artist: Rudolph Weisenborn
Program: WPA/FAP
Size: 3 murals: each 5' x 8'
Medium: Oil on canvas
Date: 1937
Status: Destroyed
Location: Unknown

James R. Doolittle Elementary School
535 East 35th Street
Chicago, Illinois 60616

Architect: John Christensen (1925), Skidmore Owings and Merrill (1962)

Title: *Recreation*
Artist: Stuart Purser
Program: WPA/FAP
Size: 9' x 3' 6"
Medium: Oil on canvas
Date: 1940
Status: Destroyed
Location: Unknown

Englewood High School
6201 South Stewart Avenue
Chicago, Illinois 60621
Architect: Normand Patton (1898), Arthur Hussander (1917), Lowenberg & Lowenberg (1979)

Title: *School Activity*
Artist: Francis Coan
Program: WPA/FAP
Size: 6' x 25'
Medium: Oil on canvas
Date: 1937
Status: Destroyed
Location: Main stairway (Building torn down in 1979)

Samuel Gompers Elementary School
12302 South State
Chicago, Illinois 60628
Architect: John Christensen

Title: *Indian Crafts*
Artist: Unknown
Program: WPA/FAP
Size: 6 murals: (1) 14' x 2' 6"; (2) 13' x 2' 6"; (3) 2' x 5'
Medium: Oil on canvas
Date: 1938
Status: Destroyed
Location: Unknown

Stephen K. Hayt Elementary School
1518 West Granville
Chicago, Illinois 60660
Architect: Dwight Perkins

Title: *Circus*
Artist: Unknown
Program: WPA/FAP
Size: 3 murals: (1) 11' x 6' 3-1/2"; (2) each 2' x 6' 3-1/2"
Medium: Oil on canvas
Date: 1937
Status: Unknown
Location: Auditorium

Title: *Landscape*
Artist: J. Richrel

Program: WPA/FAP
Size: 3' x 3'
Medium: Oil on canvas
Date: 1937
Status: Unknown
Location: Corridor bridge, second floor

Theodore Herzl Jr. Elementary School
3711 West Douglas Boulevard
Chicago, Illinois 60623
Architect: Arthur Hussander

Title: Unknown
Artist: Emmanuel Jacobson
Program: WPA/FAP
Size: Unknown
Medium: Unknown
Date: 1940–41
Status: Destroyed
Location: Unknown

Emil G. Hirsch High School
7740 South Ingleside
Chicago, Illinois 60619
Architect: John C. Christensen

Title: *Circus*
Artist: Andrene Kauffman
Program: WPA/FAP
Size: 9' x 22'
Medium: Oil on canvas
Date: 1936
Status: painted over
Location: Cafeteria

Title: *Rodeo*
Artist: Andrene Kauffman
Program: WPA/FAP
Size: 23' 3" x 9'
Medium: Oil on canvas
Date: 1938
Status: painted over
Location: Cafeteria

Title: *Stock Show and Amusement Park*
Artist: Andrene Kauffman
Program: WPA/FAP
Size: 2 murals: each 9' x 12'
Medium: Oil on canvas
Date: 1940
Status: painted over
Location: Cafeteria

Vernon Johns Community Academy
(Formerly Hermann Raster Elementary School)
6936 South Hermitage, Chicago, Illinois 60636
Architect: Dwight Perkins

Title: Unknown
Artist: SAIC students
Program: Pre-WPA
Size: Unknown
Medium: Unknown
Date: 1902
Status: Unknown
Location: Unknown

Kelvyn Park High School
4343 West Wrightwood
Chicago, Illinois 60639
Architect: Arthur Hussander

Title: *Applications of Study*
Artist: Emmanuel Jacobson
Program: Unknown
Size: Unknown
Medium: Oil on canvas
Date: Unknown
Status: Unknown
Location: Unknown

Charles Kozminski Community Academy
936 East 54th Street
Chicago, Illinois 60615
Architect: Unknown

Title: *Episodes from Literature*
Artist: James Jules
Program: WPA/FAP
Size: 3' 6" x 2' 4"
Medium: Oil on canvas
Date: 10/4/1937
Status: Missing
Location: Previously located in the library

Lake View High School
936 East 54th Street
Chicago, Illinois 60615
Architect: Unknown

Title: *Evolution of Art of Printing*
Artist: Elizabeth Gibson
Program: WPA/FAP
Size: 3' 6" x 2' 4"
Medium: Oil on canvas
Date: 1917–18
Status: Unknown
Location: Library (15 panels), (The Art Institute of Chicago Circulars and Yearbooks)

Victor F. Lawson Elementary School
(building demolished: murals relocated)
1256 South Homan
Chicago, Illinois 60623
Architect: Unknown

Title: *History of Ships*
Artist: Possibly Gustaf Dalstrom
Program: WPA/FAP
Size: 2 murals: (1) 4' 8" x 21' 3"; (1) 4' 7" x 7' 3"
Medium: Oil on canvas
Date: 1936
Status: Relocated in private offices in the Rookery Building 209 S. LaSalle Street Chicago.
Location: Third floor

Title: *History of Transportation*
Artist: Possibly Gustaf Dalstrom
Program: WPA/FAP
Size: 2 murals: (1) 3' 5" x 11' 8"; (1) 3' 5" x 10' 4"
Medium: Oil on canvas
Date: 1937
Status: Relocated in Brinks, Hofer, Gilson, and Lions in the NBC Building Suite 3600, 455 N. Cityfront Plaza Drive
Location: Second floor

Abraham Lincoln Elementary School
615 West Kemper Place
Chicago, Illinois 60614
Architect: Unknown

Title: Unknown
Artist: Unknown
Program: WPA/FAP
Size: Unknown
Medium: Oil on canvas
Date: Destroyed
Status: Unknown
Location: Unknown

Hugh Manley High School
2935 West Polk Street
Chicago, Illinois 60612
Architect: John C. Christensen

Title: *Rural Scenes*
Artist: Unknown
Program: WPA/FAP
Size: 2 murals: each 4' 7" x 19' 10"
Medium: Oil on canvas
Date: 9/14/37
Status: missing
Location: Main lobby

John Marshall High School
3250 West Adams
Chicago, Illinois 60624
Architect: Paul Gerhardt

Title: Unknown
Artist: William Krep
Program: WPA/FAP
Size: Unknown
Medium: Unknown
Date: 1940–41
Status: Destroyed
Location: Unknown

Horatio N. May Community Academy Elementary School

512 South Lavergne
Chicago, Illinois 60644
Architect: Dwight Perkins

Title: *Children at Play*
Artist: Roberta Elvis
Program: WPA/FAP
Size: 6 murals:
(2) 14' x 4'; (4) 1' 6"x 1' 6" or
1 mural: 26' x 4' 6"
Medium: Oil on canvas
Date: 5/9/39
Status: Destroyed
Location: Main corridor

Cyrus H. McCormick Elementary School

2712 South Sawyer
Chicago, Illinois 60623
Architect: Robert Williamson

Title: Various decorative works
Artist: Unknown
Program: WPA/FAP
Size: 4 murals: each 3' x 20'
Medium: Oil on wall
Date: 1940
Status: Unknown
Location: Kindergarten

William McKinley

(now Besk Practice
High School)
2040 W. Adams Street
Chicago, Illinois 60609
Architect: W.B. Mundie, later
addition by Dwight Perkins

Title: *Painting, Music,
Architecture, Sculpture,
and Science*
Artist: Otto E. Hake/
John Warner Norton
Program: Pre-WPA
Size: 5 lunettes: each 25' x 25'
Medium: Oil on canvas
Date: 1905
Status: Unknown
Location: Auditorium

Parental Elementary School

(building demolished)
3600 West Foster
Chicago, Illinois 60625
Architect: W.B. Mundie, later
addition by Dwight Perkins

Title: *Boy's Activities*
Artist: Otto E. Hake
Program: WPA/FAP
Size: 5 lunettes: each 5' x 25'

Medium: Oil on canvas
Date: 1940
Status: Destroyed
Location: Cafeteria

Park Manor Elementary School

7049 South Rhodes
Chicago, Illinois 60637
Architect: Unknown

Title: *Decorated Panels*
Artist: Unknown
Program: WPA/FAP
Size: 6 murals: each 4' x 6'
Medium: Casein
Date: 1940
Status: Unknown
Location: Unknown

Francis W. Parker Community Academy

6800 South Stewart
Chicago, Illinois 60621
Architect: Paul Gerhardt

Title: *The Children's World*
Artist: Unknown
Program: WPA/FAP
Size: 2 murals: each 4' x 15'
Medium: Oil on canvas
Date: Unknown
Status: Destroyed
Location: Previously on the
first-floor staircases

Betsy Ross Elementary School

6059 South Wabash
Chicago, Illinois 60637
Architect: Unknown

Title: Unknown
Artist: William Edouard Scott
Program: Pre-WPA
Size: Unknown
Medium: Unknown
Date: Unknown
Status: Destroyed
Location: Unknown

Maria Saucedo Academy

(formerly Carter Harrison
High School)
2850 West 24th Boulevard,
Chicago, Illinois 60623
Architect: Arthur Hussander

Title: *Life and Times of
Carter Harrison Sr.*
Artist: Lucile Ward
Program: WPA/FAP
Size: 4 murals: each 6' x 10'
Medium: Oil on canvas
Date: 1938
Status: Destroyed
Location: Lunchroom

Title: *The Steel Mill*
Artist: Merlin Pollock
Program: WPA/FAP
Size: Unknown
Medium: Oil on canvas
Date: c. 1939/40
Status: Destroyed
Location: Auditorium stage

Jesse Spalding Elementary School

(Special School for
disabled children)
1628 West Washington,
Chicago, Illinois 60612
Architect: Arthur Hussander

Title: Unknown
Artist: Frank Perri, Michael
Ursuleseu, William Jacobs,
Scapicchi, and John Stenvall
Program: Unknown
Size: Unknown
Medium: Unknown
Date: Unknown
Status: Destroyed
Location: Corridors

Charles P. Steinmetz High School

3030 North Mobile
Chicago, Illinois 60634
Architect: Paul Gerhardt

Title: *Life of Steinmetz*
Artist: Unknown
Program: WPA/FAP
Size: 18' x 30'
Medium: Oil on steel curtain
Date: 1939
Status: Destroyed
Location: Auditorium, stage
fire curtain

Edward Tilden Technical High School

4747 South Union
Chicago, Illinois 60620
Architect: Dwight Perkins

Title: *Steel Mill*
Artist: Merlin Pollock
Program: WPA/FAP
Size: 10' x 26'
Medium: Fresco
Date: 1937
Status: Destroyed
Location: Study room #206

Title: *Sylvan Dell*
Artist: Unknown
Program: WPA/FAP
Size: 23' x 49' 6"
Medium: Stage backdrop, oil
Date: 1937
Status: Destroyed
Location: Auditorium

Thomas J. Waters Elementary School

4540 North Campbell
Chicago, Illinois 60625
Architect: Arthur Hussander

Title: *Alice in Wonderland*
Artist: Malcolm E. Hackett
Program: WPA/FAP
Size: 5' 8" x 1' 8"
Medium: Oil on canvas
Date: 1936
Status: Destroyed
Location: Auditorium

Size: Unknown
Medium: Limestone sculptures done in the façade of the building
Date: 1939
Status: Extant

Petersburg Post Office
220 S. Seventh Street
Petersburg, Illinois 62675

Title: *Lincoln at New Salem, Illinois*
Artist: John Winters
Program: Section
Size: 6' 9" x 14' 10"
Medium: Oil on canvas
Date: 1938
Status: Extant

Pittsfield Post Office
129 S. Madison
Pittsfield, Illinois 62363

Title: *River Boat & Bridge*
Artist: William Schwartz
Program: Section
Size: 5' x 11' 6"
Medium: Oil on canvas
Date: 1938
Status: Extant

Plano Post Office
102 N. Center
Plano, Illinois 60545

Title: *Harvest*
Artist: Peterpaul Ott
Program: Section
Size: Unknown
Medium: Wood relief
Date: 1941
Status: Extant

Rock Falls Post Office
212 Second Avenue
Rock Falls, Illinois 60171

Title: *Farming by Hand and Manufacture of Farm Implements*
Artist: Curt Drewes
Program: Section
Size: Unknown
Medium: Plaster reliefs
Date: 1939
Status: Extant

Rushville Post Office
101 E. Washington
Rushville, Illinois 62681

Title: *Hart Fellows: Builder of Rushville*
Artist: Rainey Bennett
Program: Section
Size: 4' x 12'
Medium: Oil on canvas
Date: 1940
Status: Extant

Salem Post Office
217 W. Main Street
Salem, Illinois 62881

Title: *Lincoln as Postmaster in New Salem*
Artist: Vladimir Rousseff
Program: Section
Size: 4' 6" x 12'
Medium: Oil on canvas
Date: 1938
Status: Extant

Sandwich Post Office
22 N. Eddy Street
Sandwich, Illinois 60548

Title: *Family*
Artist: Marshall Fredericks
Program: Section
Size: Unknown
Medium: Sculpture—terra cotta relief
Date: 1941
Status: Extant

Shelbyville Post Office
200 S. Morgan Street
Shelbyville, Illinois 62565

Title: *Shelby County Fair 1900*
Artist: Lucia Wiley
Program: Section
Size: 4' 6" x 14'
Medium: Fresco
Date: 1941
Status: Extant

Staunton Post Office
113 S. Edwardville Street
Staunton, Illinois 62088

Title: *Going to Work*
Artist: Ralf Henricksen
Program: Section
Size: 4' x 10'
Medium: Oil on canvas
Date: 1941
Status: Extant

Tuscola Post Office
120 E. Sale Street
Tuscola, Illinois 61953

Title: *The Old Days*
Artist: Edwin B. Johnson
Program: Section
Size: Unknown
Medium: Oil on canvas
Date: 1941
Status: Extant

Uptown Post Office
4850 North Broadway
Chicago, Illinois 60640

Title: *Portrait of Carl Sandburg, Portrait of Louis Sullivan*
Artist: Henry Varnum Poor
Program: Section
Size: 2 murals: each 10' 6" x 7' 6"
Medium: Mosaic
Date: 1943
Status: Extant

Vandalia Post Office
304 S. Fourth Street
Vandalia, Illinois 62471

Title: *Old State Capitol Building*
Artist: Aaron Bohrod
Program: Section
Size: 4' x 10' 4"
Medium: Oil on canvas
Date: 1936
Status: Extant

Virden Post Office
211 N. Springfield
Virden, Illinois 62690

Title: *Illinois Pastoral*
Artist: James Daugherty
Program: Section
Size: 5' x 12'
Medium: Tempera and oil
Date: 1939
Status: Extant

White Hall Post Office
116 S. Jacksonville Street
White Hall, Illinois 62092

Title: *Potter and Burro*
Artist: Felix Schlag
Program: Section
Size: Unknown
Medium: Sculpture, plaster relief
Date: 1939
Status: Extant

Wilmette Post Office
1241 Central Avenue
Wilmette, Illinois 60097

Title: *In the Soil is Our Wealth*
Artist: Raymond Breinin
Program: Section
Size: 13' 8" x 5' 2"
Medium: Oil on canvas
Date: 1938
Status: Extant

Wood River Post Office
161 Ferguson Street
Wood River, Illinois 62095

Title: *Stagecoach & Mail*
Artist: Archibald Motley, Jr.
Program: Section
Size: 4' 3" x 3'
Medium: Oil on canvas
Date: 1937
Status: Extant

Libraries

Blackstone Library
4904 South Lake Park Ave.
Chicago, Illinois 60615

Title: *Literature, Science, Labor, and Art*
Artist: Oliver Dennett Grover
Program: Unknown
Size: Unknown
Medium: Unknown
Date: 1904
Status: Unknown
Location: Unknown

Chicago Public Library, Austin Branch
5615 Race St.
Chicago, Illinois 60644

Title: *Animals at Play and Cultural Steps to American Progress*
Artist: Francis Coan
Program: WPA/FAP
Size: 4 murals: (1) 8' 9": x 37'; (1) 9' 11" x 37'; (1) 8' 9" x 50'; (1) 9' 11" x 50'
Medium: Oil on canvas
Date: 1938
Status: Unknown

George Cleveland Hall Branch Library
4801 S. Michigan Ave.
Chicago, Illinois 60615

Title: *Fight for Freedom*
Artist: Charles White
Program: WPA/FAP
Size: Unknown
Medium: Unknown
Date: Unknown
Status: Unknown
Location: Unknown

Lake Forest Public Library
360 East Deerpath
Lake Forest, Illinois 60045

Title: *Poets and Writers of Antiquity*
Artist: Nicolai Remisoff
Program: Not WPA
Size: 12 murals: (8) 7' x 18'; (4) 7' x 8'
Medium: Oil on canvas
Date: 1932
Status: Extant
Location: Lobby

Legler Library
115 South Pulaski Road
Chicago, Illinois 60624

Title: *Father Marquette's Winter in Chicago*
Artist: Richard Fayerweather Babcock
Program: Pre-WPA
Size: 11' x 18'
Medium: Oil on canvas
Date: 1934
Status: Extant
Location: Study room

Other WPA Commissioned Murals

Chicago City Hall
121 N. Lasalle St.
Chicago, Illinois 60602

Title: *The Blessings of Water*
Artist: Edward Millman
Program: WPA/FAP
Size: 10' x 27'

Medium: Fresco
Date: 1937
Status: Extant
Location: Service center

Chicago State University
6800 South Stewart
Chicago, Illinois 60621

Title: Unknown
Artist: Mildred Waltrip & Arthur Lidov
Program: WPA/FAP
Size: 2 unknown
Medium: Oil on canvas
Date: 1940
Status: Unknown
Location: Now in the collection of the Museum of Contemporary Art

Cook County Hospital
1835 West Harrison Street
Chicago, Illinois 60612

(Over 50 murals originally existed in this hospital, all are now missing, a few are listed below.)

Title: *Zoo, Fort Dearborn, Museums, Stockyards and Industry*
Artist: Edwin Boyd Johnson
Program: WPA/FAP
Size: 4 murals: (2) 6' x 24'; (2) 6' x 26'
Medium: Oil on canvas
Date: 1940
Status: Missing
Location: Second-floor balcony

Title: *Orange Harvesting and Banana Harvesting*
Artist: Henry Simon
Program: WPA/FAP
Size: 2 murals: each 4' x 14'
Medium: Tempera on glass
Date: 1940
Status: Missing
Location: Reception room/recreation room

Field Museum
1400 South Lake Shore Drive
Chicago, Illinois 60605

Title: *The Story of Food Plants*
Artist: Julius Moessel
Program: WPA/FAP
Size: 18 murals: each 7' x 9'
Medium: Oil on canvas
Date: 1938–40
Status: Extant
Location: Second Floor

Northeastern Illinois University Center for Inner City Studies
700 Oakwood Blvd.
Chicago. Illinois 60653
(Formerly Abraham Lincoln Center)

Title: *Development of man*
Artist: Morris Topchevsky

Program: WPA/FAP
Size: 6 murals: each 4' x 5'
Medium: Casein on panel
(glass murals)
Date: 1940
Status: Extant
Location: Unknown

Oak Park Historical Society

217 Home Avenue
Oak Park, Illinois 60302

Title: Treasure Island
Artist: Frances Badger
Program: Unknown
Size: Unknown
Medium: Unknown
Date: 1936
Status: Unknown
Location: Unknown

Old Town School of Folk Music

(Formerly Hild Library)
4544 North Lincoln Avenue
Chicago, Illinois 60625

Title: The Children's World
Artist: Francis F. Coan
Program: Unknown
Size: 2 murals: each 9' x 34'
Medium: Oil on canvas
Date: 1937
Status: Extant
Location: First Floor

Southern Illinois University

Carbondale, Illinois
62901-6801

Title: Typical Products of
Southern Illinois
Artist: Karl Kelpe
Program: WPA/FAP
Size: 3 murals: 8' x 8' 10"
overall
Medium: Oil on canvas
Date: 1937
Status: Storage
Location: Library

Title: Lincoln Douglas Debate
Artist: Karle Kelpe
Program: WPA/FAP
Size: 8' x 8' 2"
Medium: Oil on canvas
Date: 1937
Status: Unknown
Location: Faner Hall

University of Illinois at Chicago Medical Centers

833 South Wood Street
Chicago, Illinois 60612

Title: The Story of
Natural Drugs
Artist: Thomas
Jefferson League
Program: WPA/FAP
Size: 5 murals: (2) 7' 6" x 5' 6";
(3) 7' 6" x 2'

Medium: Oil on canvas
Date: 1937
Status: Extant
Location: College of
Pharmacy, room 32, 36

University of Illinois at Chicago Department of Emergency Medicine

1740 West Taylor
Chicago, Illinois 60612

Title: The History of Anatomy
Artist: Rainey Bennett and
Ralph Graham
Program: WPA/FAP
Size: 10 panels: each 8" x 10"
Medium: Stained glass
Date: 1938
Status: Extant
Location: Room 618

University of Illinois at Chicago College of Medicine West

1819 West Polk Street
Chicago, Illinois 60612

Title: Great Men of Medicine
Artist: Edwin Boyd Johnson
Program: WPA/FAP
Size: 9 panels: each
2' 6" x 1' 6"
Medium: Fresco
Date: 1938
Status: Extant
Location: Room 119, formerly
medical library

Title: Map of the University of
Illinois at Urbana-Champaign
Artist: Rainey Bennett and
Ralph Graham
Program: WPA/FAP
Size: 8' x 12'
Medium: Oil on canvas
Date: 1938–39
Status: Extant
Location: Vestibule outside
room 106

Title: Women & Children
Among Ruins
Artist: Edgar Britton
Program: WPA/FAP
Size: 2' 11" x 3' 11"
Medium: Fresco
Date: 1938
Status: Unknown
Location: Basement

Wilbur Wright College

4300 North Narragansett,
Chicago, Illinois 60634

Title: Unknown
Artist: Merlin Pollock
Program: WPA/FAP
Size: Unknown
Medium: Unknown
Date: 1940–41
Status: Destroyed
Location: Unknown

Exhibition of American Artists, seven times between 1921–37; The Ten, Chicago, c. 1920–40; the Art Institute of Chicago, International Watercolor Exhibition, 1929–35; Increase Robinson's (Illinois State Director for the WPA/FAP) Gallery, Chicago, one-man exhibitions, c. 1933–35; Woman Aid Club, Chicago, one-man exhibition, c. 1933–35; Chicago No-Jury Society of Artists, c. 1930s

MURALS
Frank I. Bennett Elementary School, Chicago; Hugh Manley High School, Chicago; Harper Elementary School, Wilmette, Illinois; Green Bay Road Elementary School, Highland Park, Illinois; De Kalb Public Library, De Kalb, Illinois; post office, Gillspie, Illinois; Chestnut Street Post Office, Chicago, 1938; post office, Herrin, Illinois; Laurel School, Wilmette, Illinois; State Hospital, Manteno, Illinois. Murals from the demolished Lawson High School are now privately owned.

OTHER
Position: supervisor for the mural division and administrator for the Illinois Federal Art Project; president of Chicago No-Jury Society of Artists, 1926–29. Work in the collection of the Museum of Modern Art

REFERENCES
Mavigliano 1990; Bulliet 1991; Falk 1999; Sparks 1971; Gray 2001; Jacobson, 1932; Park 1949

Florian A. Durzynski

(1902–69) Durzynski created more murals in schools (seven) than any other WPA/FAP artist.

EDUCATION
National Academy of Art in Cracow, 1926–28. Arrived in Chicago, 1928.

EXHIBITIONS
Lewis Hotel, 1929; Polish Activists Exhibit, Chicago, 1931; Knickerbocker Hotel, Chicago; WPA/FAP Building, exhibition, May 1940, Chicago.

MURALS
Newton Bateman Elementary School, Chicago; Frederic Chopin Elementary School, Chicago; Laughlin Falconer Elementary School, Chicago; John Harvard Elementary School, Chicago; Julia Ward Howe Elementary School, Chicago; McKay Elementary School, Chicago; Daniel Wentworth Elementary

School, Chicago; Greenman Elementary School, Aurora, Illinois

OTHER
Known as one of the most prolific WPA/FAP muralists in Chicago, he was also a recognized portrait painter

REFERENCES
Mavigliano 1990; Gray 2001

Roberta Elvis

(dates unknown)

EDUCATION
School of the Art Institute of Chicago

MURALS
Newton Bateman Elementary School, Chicago; Hiram H. Belding Elementary School, Chicago; Joseph E. Gary Elementary School, Chicago; Horatio N. May Elementary School, Chicago (murals destroyed)

OTHER
Member: Mural and Index of American Design departments for the Illinois Federal Art Project

REFERENCES
Mavigliano 1990; Gray 2001; School of the Art Institute of Chicago alumni records

Helen Finch

(dates unknown)

MURALS
Wolfgang A. Mozart Elementary School, Chicago

EDUCATION
School of the Art Institute of Chicago

REFERENCES
Gray 2001

Elizabeth Merrill Ford

(c. 1903–77), b. Chicago; d. Los Angeles

EDUCATION
School of the Art Institute of Chicago; DePaul University, Chicago

EXHIBITIONS
The Art Institute of Chicago, c. 1924

MURALS
Fort Dearborn Elementary School, Chicago; Vanderpoel Art Association, Chicago; Mount Vernon School, Chicago; Vanderpoel School, Chicago (painting); Washington School, Chicago (destroyed); Lincoln School (destroyed), Chicago; Eskrine College, Chicago; Mission San Antonio, Monterey County, California

OTHER
Position: Artist for the Chicago Park District. Member: South Side Art Association

REFERENCES
Falk 1999

Charles S. Freeman

(dates unknown)

MURALS
Wolfgang A. Mozart Elementary School, Chicago

OTHER
Worked for the Illinois Art Project mural division

REFERENCES
Mavigliano 1990; Gray 2001

Harry Lawrence Gage

(1887–1982), b. Battle Creek, Michigan; d. unknown

EDUCATION
School of the Art Institute of Chicago, Chicago; Tucson Watercolor Guild, Tucson, Arizona

EXHIBITIONS
The Art Institute of Chicago, 1909; New Jersey State Exhibition, 1939; American Artists Professional League (location and date unknown); Rockport Art Association, Rockport, Illinois; North Shore Art Association, Gloucester, Massachusetts (date unknown); Concord Art Association, Concord, Massachusetts (date unknown); Ogunquit Art Association (location and date unknown); American Institute of Graphic Arts (location and date unknown), 1942; Industrial Association (location and date unknown), 1959

MURALS
Fredrich C. Jahn Elementary School, Chicago

OTHER
Preferred media: watercolors. Lectures: modern book design. Positions: cofounder and chairman, Annisquam Art Gallery, Massachusetts, 1954; secretary, Bartlett-Orr Press (location unknown), 1919–31; consultant/vice-president, Mergenthaler Linotype Company, New Jersey (city and date unknown); editor graphic arts, *Encyclopedia Americana* (date unknown). Author: *Applied Design for Printers,* United Typothetae Am. (date unknown); coauthor: *A Composition Manual,* Printing Industry. Am. (date unknown)

REFERENCES
Falk 1999; Gray 2001

Miklos Gaspar

(1885–1946), b. Kaba, Hungary;
d. Chicago

EDUCATION
Art Academy of Budapest, Hungary;
Industrial Art School, Budapest, under
Korosfoi Kriesh Aladar and Ujvary
Ignacz; Venice, Italy; Florence, Italy;
the Art Institute of Chicago, mural
painting, 1922

EXHIBITIONS
National Salon and Exhibition,
Budapest, Hungary, 1920; the
Art Institute of Chicago, Annual
Exhibition of Chicago and Vicinity
Artists, 1923–26; the Art Institute of
Chicago, International Watercolor
Exhibition, 1922, 1925–28; Illinois
Academy of Fine Arts Annual
Exhibition, Chicago, 1926, 1928;
Century of Progress Exposition,
Chicago, 1933

MURALS
Albert G. Lane Technical High School,
Chicago (thirteen of the forty States
murals); Knights of Columbus
Building, Springfield, Illinois; Medinah
Athletic Club (now the Intercontinental
Hotel), Chicago; Union League Club,
Chicago; Fisher Building, Detroit,
Michigan (ceiling); Terre Haute House,
Terre Haute, Indiana; Oak Terrace
Elementary School, Highwood, Illinois

OTHER
Came to the U.S. in 1921 and
primarily resided in Chicago.
Member: Hungarian Art Institute,
and Illinois Art Project easel division.
Position: painter for the Hungarian
Government; was sent to the Imperial
and Royal Press Headquarters and
painted in Russia, Italy, Serbia,
Romania and Bulgaria. Came to
the United States in 1921; painted
religious murals for buildings and
churches in Chicago and surround-
ing cities, 1938–46

REFERENCES
Anna Gaspar (daughter) 2001;
Mavigliano 1990; Sparks 1971;
Gray 2001

Elizabeth F. Gibson

(dates unknown)

EDUCATION
School of the Art Institute of Chicago

MURALS
Wolfgang A. Mozart Elementary
School, Chicago; Joseph E. Gary
Elementary School, Chicago

OTHER
Position: worked for Illinois Art Project
mural division

REFERENCES
Mavigliano 1990; Gray 2001

Albert F. Giddings

(1883–unknown), b. Brenham, Texas;
d. unknown

EDUCATION
The Art Institute of Chicago;
F. W. Freer

MURALS
Wendell Phillips High School, Chicago

OTHER
Member Chicago Art Students
League; League of American Artists

REFERENCES
Falk 1999

Robert Wadsworth Grafton

(1876–1936), b. Chicago; d. Michigan
City, Indiana

EDUCATION
The Art Institute of Chicago;
Académie Julian, Paris; Holland;
England

EXHIBITIONS
The Art Institute of Chicago, 1907,
1911, 1916, 1918; Paris Salon
(date unknown); New Orleans
Art Association, 1914, 1916–17;
Indiana Art Association, Fort Wayne,
Indiana, 1908; Thurber Gallery,
Chicago, 1917–18; Richmond Art
Association, Richmond, Indiana,
1910, 1919; Delgado Museum, New
Orleans; Brooks Memorial Museum,
Memphis, Tennessee

MURALS
Jean de Lafayette Specialty Elementary
School; St. Charles Hotel, New
Orleans; Rumely Hotel, La Porte,
Indiana; Fowler Hotel, Lafayette,
Indiana; Anthony Hotel, Ft. Wayne,
Indiana; First National Bank,
Ft. Wayne, Indiana

OTHER
Genre, portrait, landscape and mural
painter. Opened a studio in Chicago.
Member: Palette and Chisel Club,
Chicago; Chicago Gallery Association;
Chicago Artist's Guild; officer of
various art societies. Was one of the
first teachers to organize an art class
in the French Quarter

REFERENCES
Newton 1993; Delehanty 1996;
Opitz 1982; Falk 1999

Marion Mahony Griffin

(1871–1962), b. Chicago; d. Chicago

EDUCATION
Massachusetts Institute of
Technology, School of Architecture

MURALS
George B. Armstrong School, Chicago

OTHER
Was the second woman to receive
a degree from the MIT School of
Architecture. Positions: apprentice
to architect Dwight D. Perkins; award-
winning senior member of studio of
Frank Lloyd Wright. Married co-worker
Walter Burley Griffin in 1911; moved
to Australia in 1914 and developed
an innovative plan for the city of
Canberra with her husband. Returned
to Chicago in 1930. Her work has
been featured in major retrospective
exhibits in Chicago, and two books
have been written about her life and
career.[3] Author: *Magic in America* (un-
published manuscript held by the New
York Historical Society)

REFERENCES
Watson 1998; Trumbull 1998; Griffin
n.d.; Kruty 1997; Munchick 1974

Mary Chambers Hauge

(dates unknown)

EDUCATION
School of the Art Institute of Chicago

MURALS
Harold Washington Elementary
School, Chicago; Arthur Dixon
Elementary School, Chicago

OTHER
Member: Illinois Art Project easel
division, Chicago

REFERENCES
School of the Art Institute of Chicago
alumni records; Mavigliano 1990

Norman Phillip Hall

(1885–1967), b. Chicago; d. unknown

EDUCATION
The Art Institute of Chicago,
under John H. Vanderpoel, John
Johansen, Walter Marshall Clute,
and Richardson

MURALS

Daniel Wentworth Elementary School, Chicago

OTHER

Member: Art Students League, Chicago; Artists Guild, Chicago

REFERENCES

Falk 1999; Gray 2001

...

Roy Smith Hambleton

(1887–1977), b. Michigan; d. Kalamazoo, Michigan

EDUCATION

School of the Art Institute of Chicago; member of the 1909–10 life class of the Art Institute of Chicago, with Beatrice Braidwood, George Brandt, Margaret Hittle, Dorothy Loeb, Datus E. Myers, William E. Scott, and Gordon Stevenson[4]

EXHIBITIONS

The Art Institute of Chicago, 1913

MURALS

John M. Smyth Elementary School, Chicago; Sherman Park Fieldhouse, Chicago

OTHER

Member: Art Students League, Chicago

REFERENCES

Dryer 2000; Gray 2001; School of the Art Institute of Chicago alumni records

...

Ralph (or Ralf) Christian Henricksen

(1907–75), b. Chicago; d. unknown

EDUCATION

School of the Art Institute of Chicago; Instituto Allende, Mexico; under Boris Anisfeld

EXHIBITIONS

The Art Institute of Chicago, Annual Exhibition for American Art, 1932, 1935; the Art Institute of Chicago, Annual Exhibition for Chicago and Vicinity Artists, 1934–45; the Art Institute of Chicago, International Watercolor Exhibition, 1942; Museum of Modern Art, New Horizons Exhibition, New York, New York, 1936; Philips Gallery, Federal Art Project Exhibition (unknown); Contemporary Art Exhibition, Los Angeles, 1956; Flint Art Institute, Flint, Michigan, 1958; Detroit Artists Market, Michigan,

1968; Central Michigan University, Mount Pleasant, Michigan, 1970

MURALS

Horace Mann Elementary School, Chicago; Cecil A. Partee Academic Preparatory High School (formerly Amelia D. Hookway Transitional High School), Chicago; West Pullman Elementary School, Chicago; Gorton Elementary School, Lake Forest, Illinois; Park District Administration Building, Scott Field, Illinois; post office, Staunton, Illinois; post office, Monroe, Michigan

OTHER

Position: worked for the Treasury Section of Fine Arts and the Illinois Art Project mural and easel divisions. Was an educator, watercolorist, painter, and muralist

REFERENCES

Sparks 1971; Mavigliano 1990; Gray 2001; Falk 1999

...

Margaret A. Hittle

(1886–1984), b. Victor, Iowa; d. unknown

EDUCATION

Art Students League, New York; School of the Art Institute of Chicago; member of the 1909–10 life class of the Art Institute of Chicago, with Beatrice Braidwood, George Brandt, Roy Smith Hambleton, Dorothy Loeb, Datus E. Myers, William E. Scott, and Gordon Stevenson[5]

EXHIBITIONS

Pan-Pacific Exposition, San Francisco, California, 1915; the Art Institute of Chicago, 1910, 1912, 1913, 1914, 1917[6]

MURALS

Albert G. Lane Technical High School, Chicago; Bennett Museum; Garrett Biblical Institute, Evanston, Illinois

OTHER

Specialized in murals and friezes for public buildings; also worked as an illustrator and engraver in Chicago. Member: Chicago Society of Artists

REFERENCES

Gray 2001; Falk 1999

...

Gayle Porter Hoskins

(1887–1962), b. Brazil, Indiana; d. Wilmington, Delaware

EDUCATION

The Art Institute of Chicago, under John H. Vanderpoel, 1904; under Howard Pyle, 1907

EXHIBITIONS

Wilmington Society of Art, 1916–58; Swope Gallery of Art, Terre Haute, Indiana (date unknown); Indiana Art Association (city and date unknown); Marshall Field's, Chicago (date unknown); Wanamakers, Wilmington (date unknown)

MURALS

Wendell Phillips High School, Chicago; Custer Battlefield National Monument, Wilmington; Eleutherian-Hagley Mills Foundation Museum, Wilmington; Delaware Chamber of Commerce

OTHER

Painter, illustrator, and designer; specialized in historical military and Western subjects. Received an award from the Wilmington Society of Fine Arts

REFERENCES

Falk 1999

...

Camille Andrene Kauffman

(1905–93), b. Chicago; d. unknown

EDUCATION

The Art Institute of Chicago; Illinois Academy of Fine Arts, Chicago; Illinois Institute of Technology, Chicago; University of Chicago; under George Oberteuffer and Leon Kroll; Andre Lhote, Paris; Rockford College, Rockford, Illinois

EXHIBITIONS

The Art Institute of Chicago, Annual Exhibition of American Artists, 1927, 1928; the Art Institute of Chicago, Annual Exhibition of Chicago and Vicinity Artists, 1926–38; the Art Institute of Chicago, International Watercolor Exhibition, 1930, 1934, 1935; Increase Robinson's Gallery, Chicago, 1933; Bernard Gallery, Chicago, c. 1960s; Third Unitarian Church, Chicago, 1967; Vanderpoel Gallery, Chicago, 1970

MURALS

Luther Burbank Elementary School, Chicago; Emil G. Hirsch High School, Chicago (destroyed); Washington and Lincoln Schools, Evanston, Illinois; Lowell School, Oak Park, Illinois; various playgrounds, Chicago; Cook Country Hospital, Chicago (destroyed)

OTHER

Professor of painting and drawing at the School of the Art Institute from 1927 to 1967. Worked for the Illinois Art Project mural and easel divisions

REFERENCES

Mavigliano 1990; Sparks 1971; Falk 1999; Gray 2001; Park 1949

Thomas Jefferson League

(1892–unknown), b. Galveston, Texas; d. unknown

EDUCATION

School of the Art Institute of Chicago

MURALS

Clissold Elementary School, Chicago; Cook Elementary School, Chicago; Lane Technical High School, Chicago; University of Illinois Medical Center, Chicago

OTHER

Art teacher at Lane Technical High School

REFERENCES

Mavigliano 1990; Gray 2001

Arthur Herschel Lidov

(1917–90), b. Patterson, New Jersey; d. Poughquag, New York

EDUCATION

University of Chicago; School of the Art Institute of Chicago, under Emil Armin

EXHIBITIONS

The Art Institute of Chicago, 1933, 1939–44; University of Chicago, 1933; the Art Institute of Chicago, Federal Art Project Exhibition, 1938; Hyde Park Gallery, Chicago; Milwaukee Art Institute, Wisconsin, 1945; American Institute of Graphic Artists, New York, New York, 1956

MURALS

Walter S. Christopher Elementary School, Chicago; Chicago State University

OTHER

Position: illustrator for *Fortune* magazine

REFERENCES

Gray 2001; Mavigliano 1990; Falk 1999

Axel Linus

(1885–1980), b. Orebro, Sweden; d. Palm Springs, California

EDUCATION

Royal Academy of Arts, Stockholm, 1905–10; Academie Colarossi, Academie Moderne, Paris, 1911–12

EXHIBITIONS

The Art Institute of Chicago, 1922; Scandinavian Artists of the West, Los Angeles, 1939

MURALS

Albert G. Lane Technical High School, Chicago

OTHER

Immigrated to Chicago in 1920; specialized in portraits and murals. Member: Desert Art Center, California

REFERENCES

Dryer 2000, Falk 1999

Dorothy Loeb

(1887–1971), b. Starnberg, Bavaria; d. unknown

EDUCATION

Paris, under Fernand Leger, Louis Marcoussis, and Henri Martins; Munich, under Heinrich Knorr; School of the Art Institute, Provincetown, Massachusetts, under Charles Hawthorne; under Wood Stevens; the Art Institute of Chicago, under Birge Harrison. Member of the 1909–10 life class of the Art Institute of Chicago, with Beatrice Braidwood, George Brandt, Roy Smith Hambleton, Margaret Hittle, Datus E. Myers, William E. Scott, and Gordon Stevenson[7]

EXHIBITIONS

The Art Institute of Chicago, Annual Exhibition of Chicago Artists, 1912–17; Wadsworth Athenaeum, Hartford, Connecticut, 1938; Worcester Museum, Worcester, Massachusetts, 1938; Institute of Contemporary Art, Boston, Massachusetts, 1939; Milwaukee Art Institute, Wisconsin; Wisconsin Artists Traveling Exhibition (date unknown)

MURALS

Lane Technical High School, Chicago; John M. Smyth Elementary School, Chicago; Hall of Social Science, Century of Progress Exposition, Chicago, 1933

REFERENCES

The Art Institute of Chicago Alumni records; Gray 2001; Falk 1999

W. F. Madden

(dates unknown)

EDUCATION

School of the Art Institute of Chicago

MURALS

William D. Gray School, Chicago

REFERENCES

School of the Art Institute of Chicago alumni records

James Edward McBurney

(1868–1955), b. Lore City, Ohio; d. Chicago

EDUCATION

Pratt Institute of Art, Brooklyn, New York, under John Henry Twachtman, Arthur W. Dow, Charles H. Davis, Howard Pyle; Académie Colarossi and Academy Castelucho, Paris

EXHIBITIONS

Pan-Pacific Exposition, San Francisco, 1915; Chicago Gallery Association

MURALS

Parkside Elementary School, Chicago; Wentworth Elementary School, Chicago; Tilden Technical High School, Chicago; Scott School, Chicago (destroyed); Palmer Park Field House, Chicago; Woodlawn National Bank, Chicago; University of Michigan, Ann Arbor; 1933 Century of Progress Exposition, Chicago; Federal Bank and Trust Company, Dubuque, Iowa; State Agricultural Expo Building, Los Angeles, California; Pasco Bank, Cheney, Washington; Southern California Counties' Commission, San Diego, California

OTHER

Position: art director for the Chicago Park District. Member: South Side Art Association, Chicago; Cliff Dwellers, Chicago; Society of Fine Art, Chicago

REFERENCES

Falk 1999; Sparks 1971; Dawdy 1974; Mavigliano 1990; Gray 2001

Edgar Miller

(1899–1993), b. Idaho Falls, Idaho; d. unknown

EDUCATION

The Art Institute of Chicago (at age 17); apprentice to Alfonso Ianelli, Chicago (four years)

EXHIBITIONS

The Art Institute of Chicago, Applied Art Exhibition, 1919, 1923, 1924; the Art Institute of Chicago, International Watercolor Exhibition, 1934; Century of Progress Exposition, Chicago, 1933; the Art Institute of Chicago, Annual Exhibition of American Artists, 1936, 1938; the Art Institute of Chicago, Annual Exhibition of Chicago and Vicinity Artists, 1939, 1943; University of Illinois, Chicago, 1941

MURALS/COMMISSIONS

Kelvyn Park High School, Chicago (stained glass panels); Brookfield

Zoo, Field Building, Chicago; Chicago Tavern Club, Chicago; Standard Club, Chicago; Cliff Dwellers Club, Chicago; LaSalle Hotel, Chicago; chapel, Loyola University, Chicago; Recreation Center, Neenah, Wisconsin; State Capitol, North Dakota (sculptures); Jane Addams Housing Project, Chicago (sculptures); North State Building, Chicago (wood carving/ stained glass)

OTHER

Embellished Chicago residences with mosaics, tiles, wood carvings, reliefs and stained glass. Position: worked for the WPA/FAP sculpture division

REFERENCES

National Archives RG 69; Park 1949; Mavigliano 1990; Gray 2001

Edward Millman

(1907–64), b. Chicago;
d. Woodstock, New York

EDUCATION

The Art Institute of Chicago, under Leon Kroll, John Warner Norton; Mexico City, under Diego Rivera

EXHIBITIONS

Mexico City (location unknown), one-man exhibition, 1934; Chicago Artists Group Gallery, 1936–39; the Art Institute of Chicago, Annual Exhibition of Chicago and Vicinity Artists, 1936–43; the Art Institute of Chicago, Federal Art Project Exhibition, 1938; Philips Gallery, Federal Art Program Exhibition (location and date unknown); New York World's Fair, 1939; Golden Gate Exposition, San Francisco, California, 1939; the Art Institute of Chicago, one-man exhibition, 1942; Downtown Gallery, New York, one-man exhibition, 1942; Associated American Artists, New York, one-man exhibition, 1948; University of Kansas, 1949; Louisiana State University, one-man exhibition (date unknown); Clearwater Florida Art Center, one-man exhibition, 1950; Indiana University, one-man exhibition, 1951; Arkansas University, one-man exhibition, 1953; the Allan Gallery, New York, 1954; White Art Museum, Cornell University, Ithaca, New York, one-man exhibition; Layton School of Art, Milwaukee, Wisconsin, 1955; Albright Museum, Buffalo, New York, one-man exhibitions; The Nordess Gallery (location unknown), one-man exhibition, 1959; Brooklyn Museum, New York

(date unknown); Corcoran Gallery, Washington, D.C. (date unknown); Museum of Modern Art (MOMA) and the Whitney Museum of American Art, New York (dates unknown)

MURALS

Lucy Flower Career Academy High School; Chicago Bureau of Water, City Hall, Chicago; 1933 Century of Progress Exposition, Chicago; post office, Moline, Illinois; post office, Decatur, Illinois; St. Louis Post Office, St. Louis, Missouri; New York World's Fair, 1939–40; Oak Park High School, Oak Park, Illinois

OTHER

Millman was a navy combat artist during World War II from 1944–45; his work is represented in several museum collections; author: *A Compilation of Technical Procedures and Materials for Fresco Painting.* Member: Chicago Society of Artists; American Artists Congress; Chicago Artists Union; National Society of Mural Painters. Positions: worked for Illinois Art Project as state director of the mural division; member of art staff of *Chicago Evening American* and *The Chicagoan*

REFERENCES

Falk 1999; Hills 1983; Contreras 1983; Marling 1977; O'Connor 1973; Gray 2001; Sparks 1971; Mavigliano 1990; Park 1949

Datus Ensign Myers

(1879–1960), b. Jefferson, Oregon;
d. Shasta Springs, California

EDUCATION

Chouinard School of Art, Los Angeles; the Art Institute of Chicago, member of the 1909–10 life class of the Art Institute of Chicago, with Beatrice Braidwood, George Brandt, Roy Smith Hambleton, Margaret Hittle, Dorothy Loeb, Gordon Stevenson, and William E. Scott[8]

EXHIBITIONS

The Art Institute of Chicago, Annual Exhibition of Chicago Artists, 1909–14; the Art Institute of Chicago, Watercolor, Pastel and Miniature Exhibition, 1909, 1910, 1913; Chicago No-Jury Society of Artists, 1922

MURALS

Carl Von Linné Elementary School, Chicago; post office, Winnsboro, Louisiana, 1939

OTHER

Worked and lived in Santa Fe in 1923; had an interest in Indian painting and played a significant role in coordinating Indian artists under the Public Works of Art Project; drew from Indian ceremonies for his subjects

REFERENCES

Sparks 1971; Dawdy 1974; Flynn 1995; Gray 2001

John Warner Norton

(1876–1934), b. Lockport, Illinois;
d. Charleston, South Carolina

EDUCATION

Harvard University, Cambridge; School of the Art Institute of Chicago

EXHIBITIONS

The Art Institute of Chicago, Annual Exhibition of American Artists, 1904–26; the Art Institute of Chicago, Annual Exhibition of Chicago Artists, 1905–26; the Art Institute of Chicago, International Watercolor Exhibition, 1922, 1923, 1926; Architecture League, Chicago, 1931; the Art Institute of Chicago, one-man exhibitions, 1924, 1934; Century of Progress Exposition, Chicago, 1933; the Art Institute of Chicago, Half-Century of American Art (date unknown)

MURALS

Helen C. Peirce Elementary School, Chicago; 1933 Century of Progress Exposition, Chicago, Hall of Science (later moved to the Museum of Science and Industry); Cliff Dwellers Club, Chicago; Tavern Club, Chicago; Adler Planetarium (mosaic entrance), Chicago; Fuller and Hamilton Park Fieldhouses, Chicago; Chicago Board of Trade Building, Chicago; Normal College, Chicago; Daily News Building, Chicago (his most notable mural, currently in storage); 333 North Michigan Building, Chicago; Loyola University Library, Chicago; bank, Aurora, Illinois; Logan Archaeological Museum, Beliot, Wisconsin; Court House, Birmingham, Alabama; St. Paul City Hall and Court House, Minnesota

OTHER

Influenced by Beaux Arts and then Modernist styles, Norton created interior designs for Frank Lloyd Wright's Midway Gardens (which were never realized), taught murals painting and other mediums at the School of the Art Institute of Chicago

from 1910 to 1929, lived at the Tree Studios in Chicago and worked with Chicago artist Tom Lea, and was a member of the Chicago Society of Art

REFERENCES

Falk 1999; Sparks 1971; Bulliet 1991; Prince 1990; Zimmer-Murray 1993; Norton 1935; Dawdy 1974; Rosales 1996; Gray 2001

Gregory Orloff

(1890–unknown), b. Kiev, Russia; d. unknown

EDUCATION

Kiev Academy of Art, Russia, under Korenev; National Academy of Design, New York; School of the Art Institute of Chicago, under Ivan Olinsky and Karl Beur

EXHIBITIONS

The Art Institute of Chicago, Annual Exhibition of Chicago and Vicinity Artists, 1925–35; the Art Institute of Chicago, Annual Exhibition of American Artists, 1930; Pennsylvania Academy of Fine Arts Annual Exhibition, Philadelphia, Pennsylvania, 1929

MURALS

Lake View High School, Chicago; John Mills Elementary School, Chicago

OTHER

Worked for Illinois Art Project mural division and for the Illinois State Museum, Springfield, Illinois, and was a member of the South Side Association, Chicago, and the Chicago Society of Art, Chicago

REFERENCES

Sparks 1971; Mavigliano 1990; Jacobson 1933

Peterpaul Ott

(1895–unknown), b. Pilsen, Czechoslovakia; d. unknown

EDUCATION

Royal Academy, Dresden, Germany; Emerson University, Los Angeles, California; Cooper Union Art School, New York, under Alexander Archipenko; and under Karl Albiker in Chicago

EXHIBITIONS

Dresden Academy of Art, Germany, 1919–21; Pennsylvania Academy of Fine Art Annual Exhibition, Philadelphia, Pennsylvania, 1931–32, 1935; The Art Institute of Chicago, 1931–40; Metropolitan Museum,

Artists for Victory, 1942; Laguna Beach Art Association, Laguna Beach, California, 1941–46

MURALS

Albert G. Lane Technical High School, Chicago; Kedzie-Grace Post Office, Chicago; post office, Plano, Illinois; Greater New York Savings Bank, Brooklyn, New York; St. George Playhouse, Brooklyn, New York; Regiment Hall, Pilsen, Czechoslovakia; post office, Oak Park, Illinois

OTHER

Worked for the Illinois Art Project sculpture and administrative divisions, Northwestern University, the Evanston Academy of Fine Arts, and ran the Ott Studio in Evanston, Illinois

REFERENCES

Sparks 1971; Mavigliano 1990; Falk 1999

Karl Peter Andreas Ouren

(1882–1943), b. Fredrikshald, Norway; d. unknown

EDUCATION

Copenhagen; School of the Art Institute of Chicago; Palette and Chisel Club, Chicago, under H. Larvin

EXHIBITIONS

Palette and Chisel Club, 1919; Chicago Gallery Association, 1929–30; Norwegian National League, Norway (date unknown); Springfield, Illinois (date unknown)

MURALS

Lake View High School, Chicago

OTHER

Member: Northwest Art League, Chicago; Society for Sanity in Art, Chicago; Chicago Gallery Association, Chicago

REFERENCES

Sparks 1971; Falk 1999; Opitz 1986

Louise Carolyn Pain

(1908–unknown), b. Chicago; d. unknown

EDUCATION

Under Emil Zettler

EXHIBITIONS

The Art Institute of Chicago, Annual Exhibition of Chicago and Vicinity Artists, 1933, 1934, 1936; the Art Institute of Chicago, Federal Art Project Exhibition, 1938; Illinois Art Project Gallery, 1940

MURALS

Luke O'Toole Elementary School, Chicago; Oakton School, Evanston, Illinois (sundial)

OTHER

Worked for the Illinois Art Project sculpture division and taught at Southern Illinois University from 1941–45

REFERENCES

Sparks 1971; Mavigliano 1990; Falk 1999

Frank Charles Peyraud

(1858–1948), b. Bulle, Switzerland; d. Chicago

EDUCATION

College of Fribourg, Switzerland, under Bonnet; Ecole des Beaux-Arts, Paris; the Art Institute of Chicago, 1881

EXHIBITIONS

The Art Institute of Chicago, Annual Exhibition of American Artists, fourteen times between 1899–1926; the Art Institute of Chicago, Watercolor, Pastel and Miniature Exhibition, 1909; the Art Institute of Chicago, one-man exhibition, 1909, 1915; St. Louis Museum, Missouri, 1913; Pan-Pacific Exposition, San Francisco, California, 1915; Minneapolis Institute of Art, Minnesota, 1926; San Francisco, California, 1926; Chicago Galleries Association, one-man exhibition, 1929

MURALS

George B. Armstrong School, Chicago; Peoria Public Library, Peoria, Illinois (with Hardesty G. Maratta); assisted H.H. Gross in Chicago on a panorama of the Chicago Fire 1893–94

OTHER

Taught at the City Art League, Peoria, Illinois, and was a member of the Chicago Painters and Sculptors Association and the Chicago Watercolor Club

REFERENCES

Sparks 1971; Bulliet 1991; Falk 1999; Carr 1993

Lauros Monroe Phoenix

(1885–unknown), b. New Rochelle, New York; d. unknown

EDUCATION

School of the Art Institute of Chicago; under John H. Vanderpoel, Thomas Wood Stevens, Louis W. Wilson, J.F. Carlson; Woodstock Summer School

MURALS

Wendell Phillips High School, Chicago; Lowry Doctors' Building, St. Paul, Minnesota; Donaldson Building, Minneapolis, Minnesota; Elks Club, Minneapolis; St. Paul Hotel, St. Paul, Minnesota (paintings)

OTHER

Professor at New York University; director, Phoenix School of Design, New York City

REFERENCES

Opitz 1986; Falk 1999

Hubert C. Ropp

(1894–unknown) b. Illinois; d. unknown

EDUCATION

Art Institute of Chicago; Vienna; Paris

EXHIBITIONS

The Art Institute of Chicago, Annual Exhibition of Chicago and Vicinity Artists, twelve times between 1927–45; the Art Institute of Chicago, Annual Exhibition of American Artists, 1932; the Art Institute of Chicago, International Watercolor Exhibition, 1939; Golden Gate Exposition, San Francisco, California, 1939; Carnegie Institute; Boyer Gallery, Philadelphia; National Gallery, Toronto

MURALS

Parkside Elementary School, Chicago

OTHER

Member of the Chicago Art Club; Chicago Society of Art; director, Hubert Ropp School of Art; instructor/dean, National Academy of Art, Chicago; instructor/dean, School of the Art Institute of Chicago

REFERENCES

Sparks 1971; Falk 1999

Paul Turner Sargent

(1880–1946), b. and d. Hutton Township, Coles County, Illinois

EDUCATION

Coles County, under John M. Harlow; Eastern Illinois State Normal School, under Anna Piper and Otis Caldwell; the Art Institute of Chicago, under Charles Francis Browne, John H. Vanderpoel, Henry Wood Stevens

EXHIBITIONS

The Art Institute of Chicago, Annual Exhibition of Chicago Artists, 1912–17; Art Association of Charleston, Illinois, 1913; Henry Ford Museum, Dearborn, Michigan, one-man exhibition;

Eastern Illinois State Teachers College, Charleston, Illinois, one-man exhibition (date unknown); Hoosier Salon, Wesleyan University, Bloomington, Illinois (date unknown); Illinois State Museum (date unknown); University of Illinois, Chicago (date unknown); Lievers Art Gallery, Indianapolis, Indiana, one-man exhibition (date unknown); Sheldon Swope Gallery, Terre Haute, Indiana, one-man exhibition (date unknown); Los Angeles Central Library, California, 1940

MURALS

John M. Smyth Elementary School, Chicago; Crippled Children's Home, Chicago; Sherman Park Fieldhouse, Chicago

OTHER

Professor at Eastern Illinois University, Charleston, Illinois, 1938–42

REFERENCES

Sparks 1971; Falk 1999; Newton 1993; Dawdy 1974; Opitz 1982; Gray 2001

Philip Ayer Sawyer

(1863–1949), b. Chicago; d. Clearwater, Florida

EDUCATION

The Art Institute of Chicago, under John H. Vanderpoel; Purdue University, West Lafayette, Indiana; Yale University, New Haven, Connecticut; Ecole des Beaux-Arts, Paris, under Léon Bonnât

EXHIBITONS

The Art Institute of Chicago, 1926; Society of Independent Artists, New York, 1934

MURALS

Joseph E. Gary Elementary School, Chicago; New York Public Library, New York

OTHER

Taught at the Clearwater Academy in Florida, 1947; member of the Salon d'Automne, Paris and the Artists Union, New York

REFERENCES

Falk 1999; Gray 2001; Dawdy 1974; Opitz 1982

Janet Laura Scott

(dates unknown), b. unknown; d. Chicago or Boothbay, Maine

EDUCATION

School of the Art Institute of Chicago

MURALS

George W. Tilton Elementary School, Chicago

EXHIBITIONS

The Art Institute of Chicago, 1926

REFERENCES

Dryer 2000; School of the Art Institute of Chicago alumni records; Falk 1999

William Edouard Scott

(1884–1964), b. Indianapolis, Indiana; d. Chicago

EDUCATION

School of the Art Institute of Chicago, under John H. Vanderpoel, 1904–08; Académie Julian and Académie Colarossi, Paris, under Henry Ossawa Tanner

EXHIBITIONS

Autumn Salon, Paris, 1912; Royal Academy, London, 1913; the Art Institute of Chicago, Annual Exhibition of American Artists, 1915–27; the Art Institute of Chicago, African Sculpture, Modern Paintings and Sculpture, 1927; Chicago Art League, 1928; Harmon Foundation, New York, 1928, 1931, 1933; Port-au-Prince, Haiti, one-man exhibition, 1931; Art Institute of Chicago, 1932; Smithsonian Institution, Washington, D.C., 1933; New Jersey State Museum, Trenton, New Jersey, 1935; Findlay Galleries, Chicago, 1935; Cincinnati Museum (year unknown); San Diego Museum (date unknown) ; Los Angeles Museum (date unknown); Johannesburg, Africa (location and date unknown); Harmon College Traveling Art Exhibit, 1934–35; Texas Centennial, 1936; American Negro Exposition, Chicago, 1940; South Side Community Art Gallery, Chicago, 1941, 1945; Howard University, 1945; James A. Porter Gallery, 1970

MURALS

Albert G. Lane Technical High School, Chicago; John D. Shoop Elementary School, Chicago; Zenos Colman Elementary School, Chicago; Daniel Hale Williams Elementary School, Chicago (painting); Felsenthal School, Chicago (destroyed); Betsy Ross Junior High School, Chicago (destroyed); Gillespie School, Chicago (painting); DuSable High School, Chicago (painting); Sexton School, Chicago (painting); Tuley Park, Davis Square, and Stanford Park Fieldhouses in Chicago; Wabash YMCA (recently restored), Chicago;

Cook County Juvenile Court, Chicago; Tuberculosis Sanitarium, Chicago; First Presbyterian Church, Chicago; Pilgrim Baptist Church, Chicago; Bethesda Baptist Church, Chicago; Metropolitan Community Center, Chicago; Chicago Defender Building; 1933 Century of Progress Exposition, Chicago; New York Public Library, New York; YMCA branches, New York City, Indianapolis; City Hospital, Indianapolis; Fisk University, Nashville, Tennessee; courthouse, Ft. Wayne, Indiana; courthouse, Lafayette, Indiana

OTHER

His artistic focuses were Haitian art, realism, African American themes, portraiture, and rural genre scenes. Worked for the Illinois Art Project mural and easel divisions and was a member of the Chicago Art League. Commissioned to paint murals in government buildings, banks, hospitals, churches, and schools throughout the Midwest

REFERENCES

School of the Art Institute of Chicago alumni records; Sparks 1971; Locke 1940; Taylor 1996; Mavigliano 1990; Lewis 1978; Gray 2001; Falk 1999; Cederholm 1973

Henry Simon

(1901–95), b. Plock, Poland; d. Chicago

EDUCATION

The Art Institute of Chicago, under Charles Schroeder, J. Allen St. John, Carl Hoeckner, and Park Phipps

EXHIBITIONS

Weyhe Gallery, New York, one-man exhibition (date unknown); Metropolitan Museum of Art, New York, Artists for Victory Exhibition, 1942; the Art Institute of Chicago, 1940, 1944–45, one-man exhibition, 1973; College of Lake County Community Art Gallery, Grayslake, Illinois, one-man exhibition, 1987; Mary and Leigh Block Gallery, Northwestern University, Evanston, Illinois, retrospective exhibition, 1997 (organized by Liz Seaton)

MURALS

William H. Wells High School, Chicago; Cook County Hospital, Chicago (destroyed); post office, Fairborn, Ohio; post office, DeQueen, Arkansas, 1942

OTHER

Political cartoonist, *Midwest Daily Record;* worked for eight years with A. Raymond Katz designing posters for theater events in Chicago; worked as a sign maker; worked for the Illinois Art Project easel and graphics divisions; art director for the Hull House, 1944–45

REFERENCES

Seaton 1997; Mavigliano 1990; Gray 2001; Falk 1999

Mitchell Siporin

(1910–76), b. New York, New York; d. unknown

EDUCATION

The Art Institute of Chicago; under Todros Geller; American Academy, Rome

EXHIBITIONS

Phillips Gallery, Federal Art Project Exhibition (date unknown); Chicago Artists Group Gallery, 1935–39; Museum of Modern Art, New York, New Horizons Exhibition, 1936; the Art Institute of Chicago, Federal Art Project Exhibition, 1938; the Art Institute of Chicago, Annual Exhibition of Chicago and Vicinity Artists, 1939; New York World's Fair, 1939; the Art Institute of Chicago, International Watercolor Exhibition, 1940; the Art Institute of Chicago, Annual Exhibition of American Artists, 1941; the Art Institute of Chicago, Room of Chicago Art, one-man exhibition, 1942; Portland Art Museum, Oregon, 1942; Toronto Art Gallery, 1942; St. Louis Museum, Missouri, 1943; the Art Institute of Chicago, Army at War Exhibition, 1944; Carnegie Institute, 1944–49

MURALS

Albert G. Lane Technical High School, Chicago; Bloom Township High School, Chicago, 1938; post office, Decatur, Illinois; post office, St. Louis, Missouri (with Edward Millman), 1939–41; Berlin Chapel, Brandeis University

OTHER

Painter, muralist, teacher, and designer. Fellow at the American Academy, Rome; worked for the Illinois Art Project easel and mural divisions and the Treasury Section of Fine Arts; illustrated for *Esquire* and *New Masses* magazines; served in the U.S. Army 1942–45. Member: Brandeis University Creative Arts Award Commission

REFERENCES

Noah Hoffman; Sparks 1971; O'Connor 1973; Mavigliano 1990; Falk 1999; Baigell 1986; Hills 1983; Contreras 1983; Gray 2001

George Melville Smith

(1879–unknown), b. Chicago; d. unknown

EDUCATION

The Art Institute of Chicago; Paris, under Andre L'hote.

EXHIBITIONS

The Art Institute of Chicago, Annual Exhibition of American Artists, 1922; the Art Institute of Chicago, Annual Exhibition of Chicago and Vicinity Artists, 1922–32; the Art Institute of Chicago, Federal Art Project Exhibition, 1938; 48 States Competition, 1939; Chicago Society of Artists (date unknown)

MURALS

Franz Peter Schubert Elementary School, Chicago; 1933 Century of Progress, Chicago, General Exhibits Building; post office, Elmhurst, Illinois; post office, Park Ridge, Illinois; post office, Crown Point, Indiana

OTHER

Worked for the Illinois Art Project mural and administrative divisions

REFERENCES

Sparks 1971; Mavigliano 1990; Gray 2001

Ethel Spears

(1903–74), b. Chicago; d. unknown

EDUCATION

The School of the Art Institute of Chicago, under Herman Hosse, John Norton; Art Students League, Woodstock, New York, under Alexander Archipenko

EXHIBITIONS

Weyhe Gallery, one-man exhibition (date unknown); the Art Institute of Chicago, Annual Exhibition of Chicago and Vicinity Artists, 1926–38; Increase Robinson's Gallery, Chicago, 1933–34; Philips Gallery, Federal Art Project Exhibition (location and date unknown); the Art Institute of Chicago, Federal Art Project Exhibition, 1938; the Art Institute of Chicago, Room of Chicago Art Exhibition, 1944

MURALS

Charles Kozminski Community Academy, Chicago; Louis Nettelhorst Elementary School, Chicago; Carl Von Linné Elementary School, Chicago;

Chicago Crippled Children's Ward, Illinois Research Hospital, Chicago; Oakton School, Evanston, Illinois; post office, Hartford, Wisconsin; Lewis Carroll Community House, Oak Park, Illinois; James Barrie Community House, Oak Park, Illinois; Hans Christian Andersen Playground, Oak Park, Illinois; Lowell Elementary School, Oak Park, Illinois

OTHER

Worked for the Illinois Art Project mural, sculpture, and easel divisions

REFERENCES

Sparks 1971; Gray 2001; Park 1949; Bulliet 1991; Mavigliano 1990; Prince 1990

Grace Spongberg

(1906–92), b. Chicago; d. unknown

EDUCATION

The Art Institute of Chicago, under Albert Krehbiel and Louis Rittman; School of the Art Institute of Chicago summer school, Saugatuck, Michigan

EXHIBITIONS

Swedish-American Exhibition, Chicago, 1936; Pennsylvania Academy of Fine Arts (date unknown); the Art Institute of Chicago (date unknown); Cincinnati Art Museum (date unknown); Chicago Society of Artists (date unknown)

MURALS

Frank I. Bennett Elementary School, Chicago; Roswell B. Mason Elementary School, Chicago; William Byford Elementary School, Chicago (destroyed)

OTHER

Photographer, printmaker, and painter in various mediums. Member: Illinois Art Project easel and photography departments; Chicago Society of Artists. Work is in the permanent collection of the Museum at Vexio, Sweden

REFERENCES

Mavigliano 1990; Falk 1999; Gray 2001

Frank Stahr

(dates unknown)

MURALS

Lincoln Park High School, Chicago

OTHER

Teacher, Robert Waller School, Chicago

Gordon Stevenson

(1892–1984), b. Chicago; d. unknown

EDUCATION

School of the Art Institute of Chicago; Madrid, Spain, under Joaquín Sorolla y Bastida

EXHIBITIONS

Olympic Exhibition, Berlin, 1936; National Academy of Design, New York; Kilgore Galleries, New York, Exhibition of Portraits, 1921

MURALS

Albert G. Lane Technical High School, Chicago; John Smyth Elementary School, Chicago; private office, Rookery Building, Chicago

OTHER

Stevenson eventually settled in New York City, specializing in portraiture. Member: American Watercolor Society; American Veterans Society. Work is in the collection of the Brooklyn Museum. *Time* magazine's 1923 cover featured Stevenson's portrait of David Lloyd George. Worked for the Brooklyn Museum, New York; Rutgers Unversity, New Brunswick, New Jersey; Harvard University, Cambridge, Massachusetts

REFERENCES

School of the Art Institute of Chicago alumni records; Falk 1999; Opitz 1982; Gray 2001

John Edwin Walley

(1910–74), b. Sheridan, Wyoming; d. unknown

EDUCATION

Chicago Academy of Fine Arts; Hubert Ropp School of Art, Chicago; under Rudolph Weisenborn, Vaughn Shoemaker, Cary Orr, and C. Jension

EXHIBITIONS

Chicago No-Jury Society of Artists (date unknown); Museum of Modern Art, New York, New Horizons Exhibition, 1936; the Art Institute of Chicago, Federal Art Project Exhibition, 1938; the Art Institute of Chicago, Annual Exhibition of Chicago and Vicinity Artists, 1939; New York World's Fair, 1939; Carnegie Institute (date unknown); Corcoran Gallery, Washington, D.C. (date unknown); Minneapolis Institute of Art (date

unknown); Nelson Gallery, Kansas City, Missouri (date unknown); St. Louis Museum, Missouri (date unknown)

MURALS

Albert G. Lane Technical High School, Chicago; Tilden Technical High School, Chicago; public library, Cody, Wyoming; Art Building, University of Wyoming

OTHER

Teacher, lecturer, designer, painter, and draftsman. Positions: worked as newspaper cartoonist; designed theater sets and displays; worked for the Illinois Art Project easel, mural, design, and administration divisions; director of the Illinois Art Project design workshop; assistant state director for the Illinois Art Project. Member: Wyoming Artist Society. Author: *New Bauhaus in Chicago: 1938–42*

REFERENCES

The Art Institute of Chicago catalogs; Federal Art Project mural list; National Archives RG 69; Park 1949; Sparks 1971; Mavigliano 1990; Gray 2001

Lucile Ward (Robinson)

(1906–), b. Hermann, Missouri

EDUCATION

Lindenwood College, St. Charles, Missouri; the Art Institute of Chicago

MURALS

Donald C. Morrill Math and Science Specialty Elementary School, Chicago; Louis Pasteur Elementary School, Chicago; Maria Saucedo Community Academy (formerly Carter Harrison High School), Chicago; Sidney Sawyer Elementary School, Chicago; Cook County Children's Hospital, Chicago (destroyed)

OTHER

Worked freelance jobs in fine art, commercial art, graphic design, and illustration; worked for the Illinois Art Project mural and easel divisions; senior designer for window and interior display departments of Marshall Field's department store; received a major mural assignment for Walgreens in connection with the opening of a store in Salt Lake City, Utah

REFERENCES

Lucile Ward (Robinson); Mavigliano 1990; Gray 2001

Dudley Craft Watson

(1885–1972), b. Lake Geneva,
Wisconsin; d. Highland Park, Illinois

EDUCATION

The Art Institute of Chicago; Madrid,
Spain, under Joaquín Sorolla y Bastida;
Paris; London, under Sir Alfred East

MURALS

Wendell Phillips High School, Chicago

EXHIBITIONS

The Art Institute of Chicago,
International Watercolor Exhibition,
six times between 1909–25

OTHER

Teacher, art director, and lecturer
throughtout the Wisconsin and
Illinois region. Position: art editor,
Milwaukee Journal (date unknown).
Author: *Nineteenth-Century Painting*
(date and publisher unknown);
Twentieth-Century Painting (date
and publisher unknown)

REFERENCES

Thwaites, 1946; Sparks 1971; Bulliet
1991; Mavigliano 1990; Falk 1999;
Opitz 1982

Rudolph Weisenborn

(1881–1974), b. Chicago; d. unknown

EDUCATION

Students School of Art, Denver,
Colorado, under Henry Reed,
Jean Mannheim

EXHIBITIONS

Molten and Rickettes Gallery,
Chicago, one-man exhibition, 1913;
Marshall Field's Galleries, Chicago,
one-man exhibition, 1915, 1923;
Palette and Chisel Club, Chicago,
1917; the Art Institute of Chicago,
Annual Exhibition of Chicago and
Vicinity Artists, ten times between
1917–43; Salon des Refusees, 1919;
Chicago No-Jury Society of Artists,
1920; the Art Institute of Chicago,
Annual Exhibition of American Artists,
1923, 1928, 1929, 1933; Century of
Progress Exposition, Chicago; the
Art Institute of Chicago, Federal Art
Project Exhibition, 1938; the Art
Institute of Chicago, Room of Chicago
Art Exhibition, 1943; Mortimer
Levitt Gallery, New York, one-man
exhibition, 1948

MURALS

Louis Nettelhorst Elementary School,
Chicago; Richard Crane Technical
High School, Chicago (destroyed);
Opera House, Telluride, Colorado
(curtain); 1933 Century of Progress
Exposition, General Exhibits Building,
Chicago; Great Northern Theater,
Chicago; Tennessee Valley Authority
(diorama), Tennessee; Goodman
Theater, Chicago (stage sets)

OTHER

Known as Chicago's Picasso, pioneer-
ing avant-garde and modern move-
ments in Chicago. Taught at the Hull
House, Chicago; Chicago Academy of
Fine Arts; privately at studio, 1934–64;
Austin, Oak Park, and River Forest
Art League. Worked for the Illinois
Art Project easel division. Member:
founder, president, Chicago No-Jury
Society of Artists; president, Midwest
region of Artists' Equity; American
Abstract Artists

REFERENCES

Prince 1990; Sparks 1971; Bulliet 1991;
Falk 1999; Thwaites 1946; Rudolph
Weisenborn 1965

Hans Werner

(dates unknown)

MURALS

Dewitt Clinton Elementary School,
Chicago

EXHIBITIONS

The Art Institute of Chicago, 1938

REFERENCES

Falk 1999

George Werveke

(dates unknown)

EDUCATION

School of the Art Institute of Chicago

MURALS

John M. Smyth Elementary School,
Chicago

REFERENCES

School of the Art Institute of Chicago
alumni records; Gray 2001

Glossary

Art Conservation Terms

Alcohol-based solvent: Solvent containing an OH radical

Aqueous: Water-based

Binocular magnification: Magnification produced by a microscope with two eyepieces

Calcimine: White or tinted wash for walls

Conservation (art): Preservation, repair, and/or stabilization of artworks

Conservation pigments: Chemically stable pigments used for in-painting and other treatments in art conservation

Gelatin adhesive: Flexible and warm bonding substance typically used for mold making in art conservation

In-painting: The process of adding pigment to areas of loss in a work of art, in order to match tone and hue to the original composition

Lead abatement: Removal measures designed to permanently eliminate lead-based paint or lead-based paint hazards from sites

Lead-white paint: A toxic white paint with the chemical formula of carbonate of lead $2PbCO_3 - Pb(OH)_2$

Lightfast: Colors or materials designed to undergo minimal or no change when exposed to light

Lining process: Supporting the original canvas by backing it with a secondary canvas

Nonaqueous adhesive: An adhesive substance that is not water soluble

Nonyellowing varnish: Clear-drying liquid sprayed or painted on the surface of an artwork as a protective layer; formulated not to yellow or darken with time

Organic solvents: Solvents with formulas of carbon, hydrogen, and oxygen

Palette knife: Utensil with a thin, flexible blade

Poultice paste: A soft, moist substance used for cleaning and for other conservation treatments

Ren-weld adhesive: A reversible epoxy-based adhesive

Retouching: Process of adding new details or touches to artwork for correction or improvement

Reversible: Removable without risk of damage to the artwork (as with a conservation or treatment process)

Spatula: Small implement with a broad, flat, flexible blade; used to mix, spread, or lift material

Titanium dioxide: A white pigment with the chemical formula TiO_2

Vacuum-table procedure at 1" mercury: Table that has the ability to heat up and offer slight vacuum pressure

Wallpaper paste adhesive: A water-based adhesive

Art History and Other Terms

Abstract (art): Artistic content consisting of line and/or form without pictorial representation

Abstract geometric: An abstract composition based on non-representational geometric shapes

Allegory or allegorical: A story, play, or image that offers symbolic meaning within its literal interpretations

American Scene: Artworks from about 1920 to 1942 that render scenes of everyday American life

Art Deco: A period of eclectic design identified between the two world wars that originated from a 1925 design exposition in Paris (Exposition Internationale des Arts Decoratifs Industrials et Modernes), characterized by geometric forms, vibrant colors, and simple technologically based designs

Attribute: Distinctive feature

Avant-garde: Art that breaks with accepted conventions

Baroque: Ornately decorated art typical of the 1600s and early 1700s

Cartoon: Full-scale line drawing used to plan a mural

Classical: Containing characteristics of Greek or Roman culture

Classical Music: A period of music from 1750 to 1820, centered in Vienna with clean, uncluttered sounds that focused on technique, tone, and perfection of composition. Haydn, Mozart, and Beethoven created music of this era in new forms called symphonies, sonatas, and string quartets

Classify: To categorize

Commission: An agreement between artist and patron for the artist to create a particular work of art

Composition: The arrangement of elements in a work of art

Contrapposto: In a painting or sculpture, the position of a human figure twisted in an asymmetrical posture as if weight is balanced mainly on one leg

Cubism: An art movement from 1907 to 1914 that introduced multiple views of objects, expressing natural forms as their geometric equivalent

Engraving: Printmaking technique in which images are incised or engraved onto a metal plate and then inked; the excess ink is wiped off, leaving ink only in the engraved lines. The image is then transferred to paper using a press

Etching: Printmaking technique in which the artist creates an image on a metal plate using acid and special tools; the plate is inked and run through an etching press, which transfers the image to paper

Fauvism: An art movement characterized by the use of vivid, non-naturalistic colors

Fresco: The art of painting on fresh, moist plaster using pigments dissolved in water

Frieze: Decorative horizontal band along the upper part of a wall

Gesso: A mixture of an inert whiting and an adhesive, used as a primer or ground for paint

Gothic style: Style of art and architecture used in medieval Europe

Hue: A particular gradation of color; a shade or tint

Impressionism: An art movement of the late 1800s characterized by the use of paint and brushwork to capture observed conditions of light, texture, and color

Landmark status: Official designation of a building or site's historical significance, marking it for preservation by law

Lithograph: Printing process that involves etching an image onto a lithography stone, which is then inked and the image transferred to paper using a press or by hand rolling

Lunette: A semicircular opening in a wall or door

Magic realist: One who creates meticulously realistic paintings of imaginary scenes and fantastic images

Modernist style: The deliberate departure from traditional art and the use of innovative forms of expression; used in many styles in the arts and literature of the twentieth century

Narrative (art): Artwork that represents parts of a story

Naturalistic (art): Artwork containing the characteristics of nature

Panel: A hard surface to which paint is applied

Phoenicians: Natives of Phoenicia, an ancient country at the eastern end of the Mediterranean Sea

Pigments: Natural or synthetic materials ground into powders, which give paints their color

Prairie School of architecture: An architectural movement that started in Chicago with architects Louis Sullivan and Frank Lloyd Wright

Primer: A prepared layer of whiting used as a stable ground on panel or canvas before the application of paint

Precisionism: Art style depicting scenes of industry or objects in a precise, geometrically rendered manner

Quatrefoil: An ornamental form that has four foils, resembling a four-petaled flower or four-leaf clover

Regionalism: Tendency or style in art or writing that is descriptive or characteristic of a particular region

Renaissance: Movement in Europe between the 1300s and 1600s marked by renewed interest in classical Greek and Roman art and architecture

Rendering: An artist's visual interpretation of an object, figure, or structure

Romantic Music: Following the Classical period, because of the socio-political revolutions, romantic music added emotional depth to the classical form. Musicians of this era were more interested in the feeling expressed by their music rather than technique. Beethoven, Chopin, Mendelssohn, and Liszt were Romantic composers

Roundel: A circular work of art

Secco: A technique of painting onto a wall of dry plaster, which is moistened before paint is applied

Sketch: A loose or undetailed drawing or painting, often made as a preliminary study

Social realism: A style of art characterized by representational scenes depicting realities of the human condition, especially subjects pertaining to social movements such as labor rights

Surrealism: An art movement using principles of psycho-analysis and metaphysics; style of art depicting dream-like or imaginary imagery

Tone: A color or shade of color

Value: The relative lightness or darkness of a color

Verso: The reverse side, or back; opposite of recto

Victorian era: Period of the reign of England's Queen Victoria (1837–1901)

Vignette: A portion of an artwork depicting an isolated scene or figure

Wainscoting: Wall paneling or facing, usually covering the lower part of an interior wall

Program Descriptions and Acronyms

Current Programs

CPS Chicago Public Schools

GSA General Services Administration

SHPO State Historic Preservation Offices

NNDPA National New Deal Preservation Association

NDN New Deal Network

PBC Public Building Commission of Chicago

LPCI Landmarks Preservation Council of Illinois

NARA National Archives and Records Administration

Progressive Era and New Deal Programs

Agricultural Adjustment Administration (AAA)

A former U.S. government agency established in the Department of Agriculture under the Agricultural Adjustment Act of 1933 as part of the New Deal program; its purpose was to help farmers by reducing production of staple crops, thus raising farm prices and encouraging more diversified farming.

Civil Works Administration (CWA)

An agency created under the New Deal to provide immediate relief to unemployed workers by providing jobs. The CWA gave a grant to the Treasury Department in 1933 creating the Public Works of Art Project. This was the first art project sponsored by the federal government. The CWA was terminated in 1934.

Civilian Conservation Corps (CCC)

The Emergency Conservation Work Act created the CCC in 1933 as an employment measure, authorized to provide work in reforestation, road construction, prevention of soil erosion, park projects, and flood control.

Emergency Work (later Relief) Bureau (EWB, ERB)

Farm Security Administration (FSA)

Created in the Department of Agriculture in 1937, the FSA was a New Deal program designed to assist farmers during the years of the Dust Bowl and the Great Depression.

National Labor Relations Board (NLRB)

An independent federal agency created by Congress in 1935 to administer the National Labor Relations Act, the primary law governing relations between unions and employers in the private sector. The statute guarantees the right of employees to organize and to bargain collectively with their employers or to refrain from such activity.

National Recovery Administration (NRA)

A U.S. government agency established by President Franklin D. Roosevelt to stimulate business recovery through fair-practice codes during the Great Depression. The NRA was an essential element in the National Industrial Recovery Act (June 1933), which authorized the president to institute industry-wide codes intended to eliminate unfair trade practices, reduce unemployment, establish minimum wages and maximum hours, and guarantee the right of labor to bargain collectively.

National Resources Planning Board (NRPB)

National Youth Administration (NYA)

The NYA first started as a program to obtain part-time work for unemployed youths. As unemployment decreased and war approached, the goal changed to training youths for war work until in early 1942, when all NYA activities not concerning the war were dropped. The administration ended in 1943.

Progressive Era (PE)

Liberal political and social movement from the 1880s to 1933, a period of business expansion and progressive reform in the United States. The progressives worked to improve society; they battled corruption in government and big business and fought for equal rights of women, laborers, and minorities, which paved the way to future civil rights movements.

Public Works Administration (PWA)

A federal agency established by the New Deal administration of President Franklin D. Roosevelt to promote employment and increase public purchasing power. It administered the construction of many public buildings, bridges, dams, and highways. The PWA was phased out in 1939.

Public Works of Art Project (PWAP) 1933–34

The first of the U.S. federal art programs conceived as part of the New Deal during the Great Depression of the 1930s, to create government patronage and give meaningful work to unemployed artists with funds from the Civil Works Administration. The PWAP emphasized "American scene" subject matter and initiated about 700 mural projects, 7,000 easel paintings and watercolors, 750 sculptures, more than 2,500 works of graphic arts, and other numerous works designed to embellish nonfederal public buildings and parks.

Resettlement Administration (RA)

Established in 1935, the Resettlement Administration was probably the first federal government agency to promote folk music as a cohesive force in new farming communities. The agency made field recordings for use in government projects to train recreational leaders for rural settlements in eastern and midwestern states. The RA team recorded Lithuanian, Finnish, Serbian, Gaelic, Swedish, and American Indian music as well as some Appalachian and Ozark songs and dance tunes. The Farm Security Administration replaced the RA in 1937.

Rural Electrification Administration (REA)

President Roosevelt created the REA in 1935 as a national effort to bring electricity and telecommunications to rural areas.

Temporary Emergency Relief Administration (TERA)

Established in 1933, the TERA was a temporary agency providing various social welfare programs.

Tennessee Valley Authority (TVA)

Established in 1933, the TVA is known for its dam building and ongoing electrical generations; during the Depression the TVA also developed fertilizers, taught area farmers how to increase crop yields, and engaged in reforestation and fire suppression.

Treasury Relief Art Project (TRAP), 1935–39

The smallest of the federal visual arts projects created under the New Deal to help Depression-stricken American artists in the 1930s, the TRAP was designed to embellish existing federal buildings that lacked construction appropriation to finance artworks. The project was operated under the procedures of the U.S. Department of the Treasury Section and funded by the Works Progress Administration, producing 89 murals, 65 sculptures, and about 10,000 easel paintings between 1935 and 1939.

Treasury Section of Painting and Sculpture (SECTION), 1935–43

The Treasury Section of Painting and Sculpture (SECTION) was the most important of the U.S. Department of the Treasury's three visual arts programs conceived during the Great Depression. Established in 1934, it was designed to embellish new federal buildings with murals and sculpture, funded by one percent of each construction appropriation. It sponsored more than 1,100 murals and 300 sculptures, executed in the Justice, Postal Service, Interior, and Social Security buildings in Washington, D.C., and in post offices and courthouses throughout the country. The main objective was to obtain art and not, like the WPA/FPA, to provide work relief for needy artists. It did not commission abstract or politically controversial art. The program ended in 1943 with the other remaining cultural projects.

Works Progress Administration Programs

Federal Art Project (WPA/FAP) 1935–43

The FAP began as part of "Federal One" of the Works Progress Administration to establish employment in the arts. Fifty percent of the WPA/FAP workers were directly engaged in creating works of art, while ten to twenty-five percent worked in art education; the rest worked in art research. By 1938, 42,000 easel paintings and 1,100 murals in public buildings were commissioned. Large numbers of sculptures, silk-screen prints, posters, and other graphic works were also made. The WPA/FAP frequently worked in cooperation with the Federal Writers' Project to design covers and illustrations for its publications.

Federal Music Project (WPA/FMP) 1935–43

Also a part of Federal One, the FMP was organized into educational and performing units; its purpose was to employ or retrain unemployed musicians. Teachers were hired to direct choruses, bands, and orchestras, conduct classes in both vocal and instrumental music, and direct amateur community productions and group sings.

Federal Theater Project (WPA/FTP) 1935–39

A component of Federal One, the FTP was originally designed to offer "free, adult, uncensored theater" and bring new life to the dying theaters of large cities. It also aimed to integrate theater into the smaller cities of America through the development of independent, community, and experimental groups.

Federal Writer's Project (WPA/FWP) 1935–43

Also part of Federal One, the FWP was designed to put writers to work, also employing lawyers, teachers, librarians, ministers, and other white-collar workers who were on relief. The main goal of the project was to compile tour guides to the 48 states and the territories of Alaska and Puerto Rico. Articles, pamphlets, books, and monographs were also published on American life, including history, folklore, nature studies, children's educational materials, and the first ethnic studies to reach the public.

Index of American Design (WPA/IAD)

One of the major activities of the Federal Art Project, the Index helped popularize American folk art by documenting the country's past with drawings and photographs recording American handcrafts, folk art, traditional furniture, and other arts.

Works Progress Administration, later renamed Works Projects Administration (WPA), 1935–43

The WPA, a group of agencies established by the federal government in the 1930s during Franklin D. Roosevelt's administration, provided jobs for the unemployed to work on public projects during the Depression; all of the WPA programs were dismantled in 1943 due to WWII.

Notes

INTRODUCTION

1. Mitchell Siporin, "Mural Art and the Midwestern Myth," in Francis V. O'Connor's *Art for the Millions: Essays from the 1930s by Artists and Administrators of the WPA Federal Art Project* (Boston: New York Graphic Society, 1975), pp. 64–67.

2. Carl Fleischhauer and Beverly W. Brannan, *Documenting America: 1935–1943* (Berkeley, California: University of California Press, 1988), p. 18.

3. From a letter of May 9, 1933, from George Biddle to President Franklin Roosevelt, quoted in Francis V. O'Connor's "A History of the New Deal Art Projects: 1933 to 1943" in *Art for the People: New Deal Murals on Long Island* (Hempstead, Long Island, New York: The Emily Lowe Gallery, Hofstra University, 1978), p. 11. For more on George Biddle, refer to Biddle's autobiography, *George Biddle, An American Artist's Story* (Boston: Little Brown, 1939).

4. Van Wyck Brooks, *America's Coming of Age* (New York: B. W. Huelsch, 1915 and later editions). See also discussions in Alfred Howorth Jones, "Search for a Usable American Past in the New Deal Era," *American Quarterly* 23 (December 1971), pp. 710–724.

5. O'Connor, *Art for the Millions*, p. 21.

6. Audrey McMahon, "The Trend of the Government in Art," *Parnassus* (January, 1936).

CHAPTER 1
The Mural Research Project: Discoveries of a Forgotten Public Art Collection

1. Barbara Bernstein, "Federal Art: Not Gone, Just Forgotten," *Chicago Tribune Magazine,* December 2, 1973, pp. 80–96; and George Mavigliano and Richard A. Lawson, *The Federal Art Project in Illinois: 1935–1943* (Carbondale and Edwardsville: Southern Illinois University Press, 1990).

2. Ibid.; Victor Sorell, *Guide to Chicago Murals: Yesterday and Today* (Chicago: Chicago Council on Fine Arts, 1979).

3. The Board of Education was asked to define the Capital Improvement Plan. Chris Bushell, director of school services, from Tim Martin's office, chief of operations for the Chicago Public Schools, responded with the following definition in February 2001. "The current Chicago Public Schools Capital Improvement Program began in 1995 when Mayor Daley appointed the Reform Board of Trustees. The program's goals are to renovate existing schools and build new classrooms to address overcrowding. Since 1995, the program has renovated over 350 schools and added 900 classrooms at a cost of $2.4 billion. The current CIP will continue through 2005 and has identified an additional $2.5 billion of future work."

4. Fritzi Weisenborn, "School Loses Murals So WPA Loses Temper," *Chicago Sunday Times* (November 4, 1941).

5. Maureen O'Donnell, "Murals Hide Behind School Walls," *Chicago Sun-Times* (April 15, 1991).

6. The Field Foundation: Chicago Philanthropy, 116 W. Illinois, 5E, Chicago, IL 60610, phone: (312) 321–1370, fax: (312) 321–1373. The mission of the Field Foundation is to increase the understanding and awareness of the contributions of nonprofits and philanthropic organizations in the northern Illinois, northern Indiana region.

7. The Bay Foundation: 7 West 94th Street, 1st Floor, New York, NY 10025, phone: (212) 663–1115. Contact: Robert W. Ashton, executive director. Types of support: General/operating support; program development; seed money; scholarship funds; research; matching funds.

8. Robert Eskridge, Women's Board endowed executive director of Museum Education, the Art Institute of Chicago, has provided continued support for the book, preservation projects, and educational efforts from their inception.

9. Jean Follett, board member, Landmarks Preservation Council of Illinois, has shown continued interest in our preservation projects related to the CPS mural collection.

CHAPTER 2
The Genesis of the Mural Preservation Project

1. Our first meeting with Ben Reyes, then chief of operations for the Chicago Public Schools, was on April 23, 1996. Barry Bauman and I presented all the research compiled to date with accompanying slides. We discussed the various schools' murals; he was aware of many of them, including Lucy Flower High School. He recognized their correlation to the Mexican mural movement.

2. The Phase I proposal included seven mural locations housing 46 murals. It was proposed that the seven mural locations be restored over a two-year period for $300,000. The proposal had three primary sections: (1) a list of seven schools in order of conservation with fees; (2) murals, artists, significance, and conservation budget; (3) condition and conservation proposal section.

3. See Gary Wisby, "Restored Mural Unveiled," *Chicago Sun-Times,* May 19, 1997, p. 1.

4. Refer to the Mural Preservation Project press list at www.chicagoconservation.com.

5. For more information on *Chicago: The City in Art* visit the website at www.artic.edu/aic/students/mural_project/ or call (312) 443–3719.

6. The 30-minute program on the Mural Preservation Project was titled "Buried Treasures," on *Artbeat Chicago,* WTTW Channel 11, June 11, 1997. For more information refer to www.wttw.com/wttw_web_pages/productions/artbeat/art_intro2.html

7. The GSA provides other federal agencies the work space, products, services, technology, and policy they need to acomplish their missions. For more information refer to www.gsa.gov/ 1800 F Street NW, Washington, D.C., 20405, phone: (202) 501–0705.

8. Francis V. O'Connor, *Federal Support for the Visual Arts: The New Deal and Now* (Greenwich, Connecticut: New York Graphic Society, 1969, 1971), p. 206.

9. See Scarlett D. Gross, *Legal Title to Art Work Produced Under the Works Progress Administration* (General Services Administration, Washington, D.C., 1996), p. 4.

CHAPTER 3
The Mural Preservation Project: A Mixture of Art, History, and Science

1. Statement by Geneva Ransfer, principal of Smyth Elementary School, in a letter to Barry Bauman, Chicago Conservation Center, November 10, 1998.

2. Statement by Arlene Hersh, principal, Armstrong Elementary School of International Studies, in a letter to Barry Bauman, Chicago Conservation Center, June 8, 1998.

3. Quote by Auburny Lizana, student, Peirce Elementary School, from the Mural Preservation Project Video, 2000 (produced by Orbis Production Co., Chicago, funded by the Public Building Commision of Chicago).

4. Quote by Anna Waywood, art teacher at Sawyer Elementary School, from the Mural Preservation Project Video, 2000 (produced by Orbis Production Co., Chicago, funded by the Public Building Commision of Chicago).

5. Quote by Gery Chico, former president, Chicago Board of Education, from the Mural Preservation Project Video, 2000 (produced by Orbis Production Co., Chicago, funded by the Public Building Commision of Chicago).

6. Fr. G. H. Lucanus, *Complete Guide to the Preservation, Cleaning, and Restoration of Paintings* (Halberstadt, 1842).

7. Helmut Ruhemann, *The Cleaning of Paintings: Problems and Potentialities* (New York and Washington: Frederisk A. Praeger, 1968), p. 387.

8. Horsin Déon, *The Conservation and Restoration of Pictures* (Paris, 1851).

9. G. Secco-Suardo, *The Restorer of Paintings* (Milan, 1866).

10. Ulisse Forni, *Manual for the Painter-Restorer* (Florence, 1866).

11. Theodor Forni, *Knowledge of Painting* (Leipzig, 1920).

12. George L. Stout, *The Care of Pictures* (New York, 1948).

13. Helmut Ruhemann, *The Cleaning of Paintings* (New York: Frederick A. Praeger, 1968).

14. Charles Lock Eastlake, *Materials for a History of Oil Painting* (London, 1847).

15. Mary P. Merrifield, *Original Treatises Dating from 12th to the 18th Centuries on the Art of Painting* (London, 1849).

16. J. F. L. Mérimée, *Oil Painting* (Paris, 1830). Translated into English by W. B. Sarsfield Taylor as *The Art of Painting in Oil* (London, 1830). The quote is from the preface of the English version.

17. Statement by Janice Rosales, principal, Peirce Elementary School of International Studies, in a letter to Barry Bauman, Chicago Conservation Center, February 20, 1998.

18. Statement by Nancy Russell, art teacher, Linné Elementary School, in a letter to Barry Bauman, Chicago Conservation Center, February 1998.

19. Statement by Mary Ridley, art teacher, Nettelhorst Elementary School, in a letter to Barry Bauman, Chicago Conservation Center, February 10, 1997.

20. Bylaws, American Institute for Conservation of Historic and Artistic Works, Washington, D.C. http://aic.stanford.edu/geninfo/

21. The student intern was Jennifer Rickter (July 1998, *Chicago Educator* article). The student who won first prize for the WPA 2000 Competition was Wai Yin Luk. Both were students from Lane Technical High School.

CHAPTER 4
The Tradition of Murals in the United States: 1750 to 1933

1. Holger Cahill, *New Horizons in American Art* (The Museum of Modern Art and Arno Press, 1936, 1969), p. 31.

2. Edward B. Allen, *Early American Wall Paintings, 1710–1850* (New Haven, CT.: Yale University Press; London: Humphrey Milford, 1926).

3. Forbes Watson and Edward Bruce, *Art in Federal Buildings: An Illustrated Record of the Treasury Department's New Programs in Painting and Sculpture* (Washington, D.C.: Art in Federal Buildings Inc., 1936), pp. 11–13.

4. Jean Lipman, *Rufus Porter Rediscovered: Artist, Inventor, Journalist, 1792–1884* (Yonkers, NY: The Hudson River Museum, 1980).

5. There is some evidence that true fresco was employed earlier. See Francis V. O'Connor's "A History of True Fresco in the United States: 1825 to 1945" in *Fresco: A Contemporary Perspective* (exhibition catalog) (Staten Island, NY: Snug Harbor Cultural Center, 1995), pp. 3–10.

6. Forbes Watson and Edward Bruce, *Art in Federal Buildings: An Illustrated Record of the Treasury Department's New Programs in Painting and Sculpture* (Washington, D.C.: Art in Federal Buildings Inc., 1936), pp. 17–19.

7. Ibid.; Anthony W. Lee, *Painting on the Left* (Berkeley and Los Angeles: University of California Press, 1999), p. 9.

8. Geoffrey Norman, "The Development of American Mural Painting," in O'Connor's *Art for the Millions: from the 1930s by Artists and Administrators of the WPA Federal Art Project* (Boston: New York Graphic Society, 1975), p. 50.

9. Ibid., pp. 50–55.

10. Sue Ann Prince, *The Old Guard and the Avant-Garde* (Chicago and London: The University of Chicago Press, 1990).

11. Anthony W. Lee, *Painting on the Left* (Berkeley and Los Angeles: University of California Press, 1999), pp. 40–41.

12. Ibid., p. 60.

13. For more on Benton, see Robert Henry Adams's *Thomas Hart Benton* (exhibition catalog) (Kansas City: Harry N. Abrams, 1989); and Matthew Baigell, *Thomas Hart Benton* (New York: Harry N. Abrams, 1973).

14. Horst De la Croix and Richard G. Tansey, *Gardner's Art Through the Ages* (7th edition) (New York: Harcourt Brace Jovanovich, 1980), p. 833.

15. Desmond Rochfort, *Mexican Muralists: Orozco, Rivera, Siqueiros* (San Francisco: Chronicle Books, 1993), p. 39; the text of the manifesto is published in English in *David A. Siqueiros, Art and Revolution* by David Siqueiros (London: Lawrence and Wishart, 1975), pp. 24–25.

16. Raquel Tibol, *Arte y Politica: Diego Rivera* (Mexico City: Editorial Grijalbo, 1979), p. 27; see also Laurance P. Hurlburt, *The Mexican Muralists in the United States: Their Work and Influence* (Albuquerque: University of New Mexico Press, 1989).

CHAPTER 5
Mural Themes from the Progressive Era to the WPA Federal Art Project: 1904 to 1933 and After

1. For background information on the Progressive Era, see J. M. Blum, *The National Experience: A History of the United States* (New York: Harcourt Brace Jovanovich, 1977), chapters 20 to 26; Sean Dennis Cashman, *America Ascendant: From Theodore Roosevelt to FDR in the Century of American Power, 1901–1945* (New York: New York University Press, 1998); and Arthur M. Schlesinger, Jr., *The Age of Roosevelt: The Crisis of the Old Order—1919 to 1933* (Boston: Houghton Mifflin, 1957).

2. Most of the information that follows is taken from this author's ongoing research for a history of the mural in America.

3. See Janet C. Marstine, *Themes of Labor and Industry in American Mural Painting, 1893–1914: The Gospel of Work* (unpublished doctoral dissertation, University of Pittsburgh, 1989); and Marianne Doezema, *American Realism and the Industrial Age* (exhibition catalogue) (The Cleveland Museum of Art, Indiana University press, 1980).

4. For more on Abbey, see Edward V. Lucas, *Edwin Austin Abbey* (2 volumes) (New York: Charles Scribner's Sons, 1921).

5. The main source has been Thomas Folk, "Everett Shinn: The Trenton Mural," *Arts* (volume 56, No. 2, October 1981), pp. 136–38. Milton Brown comments that these murals were "among the first instances of the use of such a contemporary subject painted in a realistic manner and as such they should have been a milestone in American art," in *American Painting*

from the Armory Show to the Depression (Princeton, NJ: Princeton University Press, 1955), p. 25. True enough, but the point begs another: why did subsequent literature on American art ignore such clearly recorded precedents, and give the impression that social realism—indeed mural painting itself—somehow began in the 1930s?

6. Quoted in Folk, p. 136. The article was titled "Everett Shinn's Painting of Labor in the New City Hall at Trenton, N.J.," p. 384.

7. Iconographic identifications and interpretations are taken from "A Description of John W. Alexander's Mural Decorations Entitled 'The Crowning of Labor,'" by Mrs. J. W. [Elizabeth] Alexander, in the files of the Carnegie Institute. This brief flyer seems to predate Alexander's death in 1915, since it speaks of the murals as ongoing. I have also relied on Emily R. Alter, "The John W. Alexander Murals," The Carnegie Magazine (volume VII, No. 4, September 1933), pp. 102–110. The Carnegie Museum of Art has more recently taken to titling its murals "The Apotheosis of Pittsburgh."

8. See Richard Murray, ed., Art for Architecture: Washington, D.C., 1895–1925 (exhibition catalog) (Washington, D.C.: National Collection of Fine Arts, Smithsonian Institution, 1975).

9. For Saÿen, see Adelyn D. Breekskin, H. Lyman Saÿen (exhibition catalogue) (Washington, D.C., National Collection of Fine Arts, Smithsonian Institution, 1970).

10. For more on Oakley, see Patricia Likos, "Violet Oakley (1874–1961)," Bulletin (Philadelphia Museum of Art) (volume 75, No. 325, June 1979), pp. 1–32.

11. Edward J. Renehan, Jr., John Burroughs: An American Naturalist (Black Dome Press, 1998); Stephen Fox, John Muir and His Legacy: The American Conservation Movement (Boston: Little, Brown & Co., 1981).

12. The following is based on materials in the files of the Fair preserved in the Special Collections Department of the Library of the University of Illinois at Chicago.

13. In general, the WPA/FAP murals mentioned here can be found illustrated in the author's The New Deal Art Projects: An Anthology of Memoirs (Washington, D.C.: Smithsonian Institution Press, 1972) and Francis V. O'Connor's Art for the Millions. The Section murals mentioned are illustrated by Marlene Park and Gerald Markowitz in Democratic Vistas: Post Office Murals & Public Art in the New Deal (Philadelphia: Temple University Press, 1984).

14. See Lowe Art Gallery, Syracuse University, The Mural Art of Ben Shahn (exhibition catalog) 1977, "Register of Murals" No. 3; and Michael Rosenfeld Gallery, New York, The WPA Era: Urban Views and Visions (exhibition catalog) 1992, mural study and detail (the former illustrated in color).

CHAPTER 6
Progressive Era Murals in the Chicago Public Schools: 1904 to 1933

1. Louise Dunn Yochim, Role and Impact: The Chicago Society of Artists (Chicago: Chicago Society of Artists, 1979).

2. For the Boston Public Library, see Sally Promey, Painting Religion In Public: John Singer Sargent's Triumph of Religion At the Boston Public Library (Princeton, N.J.: Princeton University Press, 1999). For the Library of Congress, see Richard Murray, "Painted Words: Murals in the Library of Congress," in John Y. Cole and Henry Hope Reed, eds., The Library of Congress: The Art and Architecture of the Jefferson Building (New York and London: W.W. Norton, in association with the Library of Congress), pp. 196–224.

3. Winifred Buck, "Pictures in Public Schools," Municipal Affairs 6 (March–December 1907), pp. 189–197.

4. Author unknown, "Pictures for Public Schools," Art and Progress 1 (March 1910), p. 136.

5. Chicago Public Library, Special Collections Division, A Breath of Fresh Air: Chicago's Neighborhood Parks of the Progressive Reform Era, 1900–1925 (Chicago: The Library, 1989).

6. Winifred Buck, "Pictures in Public Schools," Municipal Affairs 6 (March–December 1907), pp. 189–197. See also Ross Turner, "Art for the School Room," Art and Progress 1 (July 1910), pp. 257–260.

7. Gregory F. Gilmartin, Shaping the City: New York and the Municipal Art Society (New York: Clarkson Potter/Publishers, 1995).

8. William H. Gerdts. "The Golden Age of Indiana Landscape Painting," in Indiana Influence (Fort Wayne: Fort Wayne Museum of Art, 1984).

9. Emma Roberts, "Some Minneapolis Rooms," School Arts Magazine (February 12, 1913), pp. 374–77. Photographs of contemporary American murals were popular adjuncts to schoolroom decorations.

10. The mural was originally painted for the Washington Park building, but was moved to Davis Park. My thanks to Bart Ryckbosch, archivist and curator of Special Collections, Chicago Park District, in a letter of June 28, 1991.

11. "Contributors to Pension Fund Start Petition to Sue City for Interest," Chicago Star Herald (September 15, 1907).

12. Thomas Wood Stevens, "Mural Decorations by Art Students," School Arts Magazine 12 (January 1913), pp. 299–307.

13. "Demand for the Product of Students Shows Usefulness of Specialized Lines of Training," Chicago Post (September 7, 1907); "Mural Paintings at the Art Institute," Chicago Post (June 6, 1908).

14. "Arts Club of the Public Schools," Chicago Journal (September 22, 1910).

15. On Norton and his murals, see Richard Murray, "John Norton, Mural Painter," in Illinois State Museum, Lockport Gallery, John Warner Norton (Springfield: Illinois State Museum, 1993).

16. "Chicago is Mural Painting Center," Boston Ploughman (July 9, 1909).

17. Stevens, "Mural Decorations by Art Students," p. 302.

18. A description of these murals and photographs of them are in "Student Works at the Art Institute," Chicago Record Herald (June 20, 1910).

19. William E. Taylor, A Shared Heritage: Art By Four African Americans (Indianapolis: Indianapolis Museum of Art, with Indiana University Press, 1996).

20. See Margaret Breuning, "Tendencies in Mural Painting," International Studio 82 (October–December 1925), pp. 173–81.

21. John Warner Norton quote from "Business Turns to Art." unidentified newspaper clipping, John Warner Norton Papers, Archives of American Art, Smithsonian Institution, reel 3257, frame 231.

22. Marguerite Williams, "New Art in Mural Designs," Chicago Daily News (July 8, 1929), p. 5.

CHAPTER 7
The Great Depression, the New Deal, and the WPA/FAP Federal Art Project

1. Marlene Park and Gerald E. Markowitz, New Deal for Art: The Government Art Projects of the 1930s with examples from New York City and State (New York: The Gallery Association of New York State, Inc., 1977), pp. 1–2; and Bustard, A New Deal for the Arts (National Archives and Records Administration and the Washington University Press, Washington, D.C., 1997), pp. 1–3.

2. Howard E. Wooden, American Art of the Great Depression: Two Sides of the Coin (Witchita, Kan.: Wichita Art Museum, 1985), p. 9.

3. Bustard, A New Deal for the Arts, p. 3.

4. Wooden, American Art of the Great Depression: Two Sides of the Coin, pp. 9–10.

5. See the bibliography for more reading on FDR's New Deal.

6. *Franklin Delano Roosevelt* (National Archives and Records Administration, Washington, D.C., 1994), pp. 5–6.

7. Wooden, *American Art of the Great Depression: Two Sides of the Coin*, p. 10.

8. William F. McDonald, *Federal Relief Administration and the Arts* (Columbus, Ohio: Ohio State University Press, 1969), p. 25.

9. *Franklin Delano Roosevelt* (National Archives and Records Administration, Washington, D.C., 1994), p. 6.

10. Richard D. McKinzie, *The New Deal for Artists* (Princeton: Princeton University Press, 1975), p. 10.

11. Forward to *National Exhibition of Art by the Public Works Art Project* (Washington, D.C.: The Corcoran Gallery of Art, 1934), p. 2.

12. Bustard, *A New Deal for the Arts*, p. 6.

13. Wooden, *American Art of the Great Depression: Two Sides of the Coin*, p. 15.

14. John Reed Clubs were a part of the International Union of Writers and Artists. John Reed (1887–1920), author of *Ten Days That Shook the World*, was a left-wing journalist who reported on the Russian Revolution.

15. O'Connor, *Art for the Millions*, pp. 27–28.

16. Bustard, *A New Deal for the Arts*, p. 6.

17. Wooden, *American Art of the Great Depression: Two Sides of the Coin*, p. 18.

18. O'Connor, *Federal Support for the Visual Arts*, p. 26.

19. O'Connor, *Federal Support for the Visual Arts*, p. 27. Also, Wendy Jeffers, "Holger Cahill and American Art," *Archives of American Art Journal* (volume 31, No. 4, Fall 1992), pp. 2–11.

20. Holger Cahill, *Federal Art Project Manual* (College Park, Maryland: National Archives, Civilian Reference Branch, Records Group 69, October 1935), p. 1.

21. Ibid.

22. Ibid.

23. Holger Cahill, *Record of Program Operation and Accomplishment*, Division & Service Projects, Work Projects Aministration, Federal Works Agency, Washington, D.C., 1943, p. 27.

24. Ibid., p. 23–25; Cahill, *Federal Art Project Manual*, p. 2.

25. Cahill, *Federal Art Project Manual*, pp. 2–3; Cahill, *Record of Program Operation*, pp. 23–25, 27, 33.

26. O'Connor, *Federal Support for the Visual Arts*, p. 28.

27. O'Connor, *Federal Support for the Visual Arts*, p. 27; Cahill, *Record of Program Operation*, p. 10.

28. O'Connor, *Federal Support for the Visual Arts*, p. 27; Cahill, *Record of Program Operation*, pp. 17, 18, 21.

29. Ibid.

30. Frances T. Bourne and Betty Herscher, *Preliminary Checklist of the Central Correspondence Files of the Work Projects Administration and its Predecessors, 1933–1944.* (College Park, Maryland: National Archives, Civilian Reference Branch, Record Group 69, March 1946), pp. 64–65.

31. *Final Report on the WPA Program 1935–43* (Washington, D.C.: Government Printing Office, n.d.), p. 65.

32. Bustard, *A New Deal for the Arts*, p. 8.

33. Ibid., p. 9.

34. Ibid., pp. 8–9.

35. For more information on the FTP, see Jane De Hart Mathews, *The Federal Theater, 1935–1939: Plays, Relief, and Politics* (Princeton: Princeton University Press, 1967); Paul Sporn, *Against Itself: The Federal Theater and Writers' Projects in the Midwest* (Detroit: Wayne State University Press, 1995); and John O'Connor and Lorraine Brown, eds., *Free, Adult, Uncensored: The Living History of the Federal Theater Project* (Washington, D.C.: New Republic Books, 1978).

36. O'Connor, *Art for the Millions*, p. 29.

Thomas Thurston Sidebar

1. Marlene Park and Gerald E. Markowitz, *New Deal for Art: The Government Art Projects of the 1930s with Examples from New York City And State* (New York: The Gallery Association of New York State, Inc., 1977), p. 2.

2. Ibid.

3. Suzanne La Follette, "The Artist and the Depression," *The Nation* 137 (September 6, 1933), p.265.

4. Francis V. O'Connor, *Federal Support for the Visual Arts: The New Deal and Now* (Greenwich, Conn.: New York Graphic Society, 1969/1971), p. 19.

5. Ibid., pp. 18–19.

6. Harry Hopkins, press conference, February 23, 1934 (National Archives and Records Administration, RG 69/737, Box 4).

7. O'Connor, *Federal Support for the Visual Arts*, p. 19.

Anna Eleanor Roosevelt Sidebar

1. Anna Eleanor Roosevelt wrote this text in a letter to Heather Becker (January 4, 2000) for this publication. She is the director of education and community relations for Boeing Company in Chicago.

CHAPTER 8
The Illinois Art Project of the Federal Art Project: 1935 to 1943

1. William F. McDonald, *Federal Relief Administration and the Arts* (Columbus, Ohio: Ohio State University Press, 1969), p. 407.

2. See J. Z. Jacobson, *Art of Today: Chicago 1933* (Chicago: L. M. Stein, 1932); and Sue Ann Prince, *The Old Guard and the Avant-Garde* (Chicago and London: The University of Chicago Press, 1990).

3. See Paul Kruty, "Declarations of Independents: Chicago's Alternative Art Groups of the 1920s" in Prince, *The Old Guard and the Avant-Garde*, p. 80.

4. Robert Evans, Maureen McKenna, and Terry Suhre, *After the Great Crash: New Deal Art in Illinois* (The Illinois State Museum Society, 1983), p. 9.

5. Ruth Ann Stewart, *New York/Chicago: WPA and the Black Artist* (New York: Studio Museum in Harlem, 1978).

6. See Robert Jay Wolff, "Chicago and the Artists' Union," in O'Connor, *Art for the Millions*, p. 242.

7. George Mavigliano and Richard A. Lawson, *The Federal Art Project in Illinois: 1935–1943* (Carbondale and Edwardsville: Southern Illinois University Press, 1990), p. 204.

8. Victor Sorrell, *Guide to Chicago Murals: Yesterday and Today* (Chicago: Chicago Council on Fine Arts, 1979), p. 8.

9. Mavigliano and Lawson, *The Federal Art Project in Illinois*, p. 214.

10. Mavigliano, "The Federal Art Project: Holger Cahill's Program of Action," in *Art Education* 37 (May 3, 1984), pp. 26–30.

11. Mavigliano and Lawson, *The Federal Art Project in Illinois*, pp. 14–45.

12. From a letter by Holger Cahill to Mitchell Siporin, May 11, 1942. (Washington, D.C.: Archives of American Art, Mitchell Siporin file, microfilm reel 2011).

13. Lazslo Moholy-Nagy and his New Bauhaus School were indirectly involved with design program activities thanks to Walley's efforts. See Mavigliano, "The Chicago Design Workshop:

1939–1943," in *The Journal of Decorative and Propaganda Arts* 6 (Fall 1987), pp. 34–47; and Sibyl Moholy-Nagy, "The Chicago Years," in Richard Kostelanetz. *Moholy-Nagy* (New York: Praeger Publishers, 1970).

14. Mavigliano and Lawson, *The Federal Art Project in Illinois*, pp. 214–215.

15. William F. McDonald, *Federal Relief Administration and the Arts* (Columbus, Ohio: Ohio State University Press, 1969), pp. 474–479.

16. Mavigliano and Lawson, *The Federal Art Project in Illinois*, pp. 62–81.

17. The Midwest New Deal Preservation Association is a chapter of the National New Deal Preservation Association (NNDPA). For more information, see www.newdeallegacy.org/links.html.

18. Mavigliano donated his oral histories to the Smithsonian Institute, Archives of American Art, Washington, D.C., For more information, see http://artarchives.si.edu.

19. The Center for New Deal Studies is located at Roosevelt University in Chicago. For more information, see www.roosevelt.edu/newdeal/.

20. Mavigliano and Lawson, *The Federal Art Project in Illinois*, pp. 111, 203.

Liz Seaton Sidebar

1. Holger Cahill, "The WPA Art Program—A Summary, Revised as of January 30, 1942," 2, Holger Cahill Papers, Archives of American Art, MF 1105: 249–253.

2. See the Holger Cahill print allocation cards, Holger Cahill Papers, Archives of American Art, MF 1106: 655–1513.

3. These prints can be searched on the Block Museum's Web site: www.blockmuseum.northwestern.edu.

CHAPTER 9
Styles and Themes of the Chicago Mural School

1. William F. McDonald, *Federal Relief Administration and the Arts* (Columbus, Ohio: Ohio State University Press, 1969), p. 430.

2. McDonald, *Federal Relief Administration and the Arts*, p. 428; Belisario R. Contreras, *Tradition and Innovation in New Deal Art* (London and Toronto: Associated University Presses, 1983), p. 184; (brochure) *Murals for the Community, May 24–June 15* (College Park, Maryland: National Archives, CRB RG 69/WPA/FAP, 1937), p. 21; and Holger Cahill letter to Maxson Holloway (December 21, 1935, National Archives, CRB RG 69/WPA/FAP).

3. Verified by signatures on the remaining murals; National Personnel Records Center; Mavigliano and Lawson, *The Federal Art Project in Illinois*, p. 110; and Robert Evans, Maureen McKenna, and Terry Suhre, *After the Great Crash: New Deal Art in Illinois* (The Illinois State Museum Society, 1983), p. 12.

4. There were originally 233 mural locations in Illinois (according to Mavigliano and Lawson). Approximately 150 exist today based on our research over the past seven years.

5. Mathew Baigell, *The American Scene* (New York/Washington: Praeger Publishers, 1974), p. 18.

6. Baigell, *The American Scene*, p. 188. He footnotes this statement with "Some of the ideas suggested here are based on two brilliant essays written by social historian Warren Susman."

7. McDonald, *Federal Relief Administration and the Arts*, p. 429.

8. Robert Henry Adams, *Chicago: The Modernist Vision* (Robert Henry Adams Fine Art catalog, 1990).

9. Belisario R. Contreras, *Tradition and Innovation in New Deal Art.* (London and Toronto: Associated University Presses, Inc., 1983), p. 184.

10. On-location notes describing the murals; and Clark Sommer Smith, "Nine Years of Federally Sponsored Art in Chicago, 1933–1942" (Ph.D. diss., University of Chicago, 1965), p. 35.

11. Mavigliano and Lawson, *The Federal Art Project in Illinois,* p. 17.

12. Baigell, *The American Scene,* p. 58–61.

13. Baigell, *The American Scene,* p. 55.

14. Cahill, *New Horizons in American Art,* p. 33.

15. Marlene Park and Gerald Markowitz. eds., *New Deal for Art* (New York: The Gallery Association of New York State, 1977), p. 156.

16. Sorell, *Guide to Chicago Murals: Yesterday and Today,* p. 7.

17. I would like to thank Heather Becker for sharing her research notes on Chicago's Public School murals with me.

18. Scholarship begun in the late 1960s on the New Deal mural projects included recording of oral histories with artists and administrators, recovery of key archival documents, and interpretive studies written by Francis V. O'Connor, Richard McKinzie, Marlene Park and Gerald Markowitz, Greta Berman, Helen Harrison, Karal Ann Marling, and Belisario R. Contreras (see bibliography). The exemplary work of these historians is the bedrock of the field.

19. It is instructive to consider Chicago Public School murals in relation to those painted in Mexico during the 1920s. A useful reference is Carlos Merida, *Frescoes in Primary Schools by Various Artists, Mexico* (Mexico City: Frances Toor Studios, 1937). A revised version was published in 1943. Thanks to Jay Oles, Wellesley College, for sharing this source. For an extensive discussion of Pablo O'Higgins murals for a Mexican elementary school, see Jay Oles, "Walls to Paint On: American Muralists in Mexico, 1933–36" (Ph.D. diss., Yale University, 1995), chapter 3.

20. Belisario R. Contreras, *The New Deal Treasury Department Art Programs and the American Artist: 1933–1944* (American University, 1967), p. 41. Art instruction, and exposure to professional artists, were not part of school curricula even in urban, cosmopolitan cities.

21. Park and Markowitz, *New Deal for Art,* p. 35.

22. Erica Beckh-Rubinstein, "The Tax Payers' Murals" (Ph.D. diss., Harvard University, 1944), p. 167.

23. Jonathan Harris, *Federal Art and National Culture: The Politics of Identity in New Deal America* (Cambridge: Cambridge University Press, 1995).

24. Art historian Marlene Park introduced the issue of gender representation in her writings; historian Barbara Melosh has produced the most thorough study to date. Melosh establishes how New Deal murals upheld traditional images of women as housewife, mother, helper, and loving companion but not part of the economic system.

25. In the late 1950s, the school began to focus on educating boys to become scientists and engineers.

26. See James Michael Newell, "The Evolution of Western Civilization," in O'Connor, *Art for the Millions,* pp. 60–63. Newell painted "The Evolution of Western Civilization" for Evander Childs High School, Bronx, New York.

27. Park and Markowitz, *Democratic Vistas: Post Offices and Public Art in the New Deal* (Philadelphia: Temple University Press, 1984), p. 93.

28. A forthcoming book by Andrew Hemingway discusses Millman and Siporin, giving attention to these important artists and their murals in Decatur, Chicago, and St. Louis.

29. John R. Gilles, ed., *Commemorations: The Politics of National Identity* (Princeton: Princeton University Press, 1994), p. 10.

30. Jeanette Francis from a December 2000 questionnaire created by Diana L. Linden with the input of art educators Carolyn Halpin-Healy and Dorothea Basile. The author thanks the students in Mr. Massel and Ms. Shepard's classes for their responses.

31. Karal Ann Marling, *Wall-to-Wall America: A Cultural History of Post-Office Murals in the Great Depression* (Minneapolis: University of Minnesota Press, 1982), p. 256.

32. O'Connor, *Art for the Millions* (Boston: New York Graphic Society, 1975), pp. 23–24. A cogent discussion of resistance to pure abstraction during the 1930s.

33. Conclusions drawn from surveys completed by students at Lucy Flower High School, as well as the author's prior experience as a member of the Brooklyn Museum's education staff (1987–97), and discussions with teachers and museum and art educators.

34. Baigell, *The American Scene*, p. 38.

35. R. L. Duffus, *The American Renaissance* (NewYork: Alfred Knopf, 1928), pp. 317–318.

36. Baigell, *The American Scene*, p. 188.

Lucille Ward Robinson Sidebar

1. Mavigliano, George J., and Richard A. Lawson, *The Federal Art Project in Illinois 1935–1943* (Carbondale and Edwardsville, Ill.: Southern Illinois University, 1990), p. 80.

2. Rainey Bennett, quoted in Barbara Bernstein, "Federal Art: Not Gone, Just Forgotten," *Chicago Tribune Magazine* (December 2, 1973), p. 95.

CHAPTER 10
The WPA/FAP's Impact on Arts Education

1. William F. McDonald. *Federal Relief Administration and the Arts* (Columbus, Ohio: Ohio State University Press, 1969), p. 467–468.

2. Ibid.

3. Quote by Kevin McCarthy from the Mural Preservation Project video funded by the Public Building Commission of Chicago, 2000 (produced by Orbis Production Co.).

4. Quote by Gery Chico from the Mural Preservation Project video funded by the Public Building Commission of Chicago, 2000 (produced by Orrbis Production Co.).

5. Quote by Anna Waywood from the Mural Preservation Project video, 2000.

6. Statement by Jonathan Butler, a Nettelhorst student, in a letter to Gery Chico, December 15, 1999.

7. Giovann Raymond, student of Nettelhorst Elementary School, letter to Gery Chico, former president, Chicago Board of Education, provided to this publication by the school art teacher, Mary Ridley.

8. Quote by Robert Eskridge of the Art Institute of Chicago from the Mural Preservation Project video, 2000.

9. Quote by Mary Ridley from the Mural Preservation Project video, 2000.

10. Quote by Katherine Kampf from the Mural Preservation Project video, 2000.

11. Ibid.

12. Peter Cretia, student of Nettelhorst Elementary School, letter to Gery Chico, former president, Chicago Board of Education, provided to this publication by the school art teacher, Mary Ridley.

13. Quote by Robert Henry Adams from the Mural Preservation Project video, 2000.

14. Dorothy Shipps, "Corporate Influences on Chicago School Reform" in Clarence N. Stone, *Changing Urban Education* (Lawrence, Kan.: University Press of Kansas, 1998), p. 177; United States Conference of Mayors, "Best Practices in City Governments," vol. 3, "Focus on the Mayor's Role in Education" (Washington, D.C: U.S. Conference of Mayors, 1996).

15. Dorothy Shipps, "Corporate Influences on Chicago School Reform" in Clarence N. Stone, *Changing Urban Education* (Lawrence, Kan.: University Press of Kansas, 1998), p. 182.

16. Department of Cultural Affairs: www.ci.chi.il.us/CulturalAffairs/. Location: 78 East Washington Street, Chicago, Illinois 60602.

17. The Chicago Architecture Foundation mission statement is "The Chicago Architecture Foundation is dedicated to advancing public interest and education in architecture and design. CAF pursues this mission through a comprehensive program of tours, exhibitions, lectures, and special events, all designed to enhance the public's awareness and appreciation of Chicago's outstanding architectural legacy." www.architecture.org/. Location: 224 S. Michigan, Chicago, Illinois 60604.

18. Museums in the Parks, a project of a consortium of nine of Chicago's major museums, began the first full year of its Museums and Public Schools program at the Museum of Science and Industry, September 28, 2000. The MAPS program, a collaboration with the Chicago Public Schools, aims to make museum resources an integral part of public elementary school education.

19. The Landmarks Preservation Council of Illinois is a not-for-profit membership organization dedicated to promoting historic preservation in Illinois communities. Location: 53 W. Jackson, Suite 752, Chicago, Illinois 60604: phone: (312) 922-1742, fax: (312) 922-8112.

20. For more information about the Chicago Park District, call (312) 742-PLAY or (312) 747-2001, or e-mail play@chicagoparkdistrict.com.

MURAL REFERENCE GUIDE

1. Barbara Bernstein, "Federal Art: Not Gone, Just Forgotten," *Chicago Tribune Magazine* (December 2, 1973), p. 81.

2. Fritzi Weisenborn, "School Loses Murals So WPA Loses Temper," *Sunday Times* (November 4, 1941), p. unknown.

3. Belisario R. Contreras, *The Art Student: Tradition and Innovation in New Deal Art* (London and Toronto: Associated University Presses, Inc., 1983), pp.185–86.

4. The Haymarket Riot was a violent confrontation on May 4, 1886, between police and labor protestors. On May 3, one person was killed and several others were injured during a labor strike at the McCormick Harvesting Machine Company in Chicago. A protestors' meeting was held on May 4 in Haymarket Square. This event became violent when police attempted to disperse the crowd. A dynamite bomb was thrown, killing seven policemen and injuring sixty others. Hysteria ensued.

5. *The Art Student* (Chicago: Art Institute of Chicago, October 1915). (This student-run monthly sold for 15 cents.)

6. Ibid.

7. Author unknown, "General Motors Displays 40 Industrial Murals at World's Fair," *The Art Digest* (July 1, 1933), p. unknown.

8. Henry Baldwin, "Tale of WPA Art and Offer Made to Library Told," *Daily News* (Evanston, Ill., October 25, 1938), p. unknown.

9. Barbara Bernstein, "Federal Art: Not Gone, Just Forgotten," *Chicago Tribune Magazine* (December 2, 1973), p. 81.

10. *Epochs in the History of Man, Frescoes by Edgar Britton in the Lane Technical High School* (Chicago: Federal Art Project, Works Progress Administration), p. 5. The works of art described in this brochure and the brochure itself were produced through a cooperating sponsorship between the Federal Art Project of Illinois, a unit of the Works Progress Administration, and the Lane Technical High School student body.

11. Belisario R. Contreras, *Tradition and Innovation in New Deal Art* (London and Toronto: Associated University Presses, Inc., 1983), p. 189.

12. *Epochs in the History of Man*, p. 6.

13. Ibid., p. 12.

14. Author unknown, "Art Students Making Murals for Library," *Lane Tech Daily* (Chicago, May 6, 1942), p. unknown.

15. Ibid.

16. Susan Weininger, "Modernism in Chicago Art," *The Old Guard and the Avant-Garde,* ed. Sue Ann Prince (Chicago and London: The University of Chicago Press, 1990), pp. 67–69.

17. Ibid., p. 70.

18. Richard Murray confirmed the date; it was previously thought to be 1925–27.

19. Author unknown,"Old Murals' True Colors Shine Again," *Chicago Tribune* (March 19, 2000), p. 4.

20. Gustave Brand quote provided by Schurz High School.

21. The Board of Education felt it was important to allow other conservators in Chicago the opportunity to work on this project. While the Chicago Conservation Center continued work on Phase III, Parma Restoration began restoration of other school locations such as Talcott. For more information on Parma Restoration, see www.parmarestoration.com.

22. Liz Seaton, *Henry Simon: 1901–1985* (Evanston, Ill.: Mary and Leigh Block Gallery, Northwestern University, 1997), p. 2.

ARTISTS' BIOGRAPHIES

1. The Art Institute of Chicago, *The Art Institute of Chicago Circular of Instruction of School of Drawing, Modeling, Decorative Designing, Normal Instruction, Illustration, and Architecture with a Catalogue of Students for 1909–1910* (Chicago: Ryerson Library, 1909); and Peter Hastings Falk, *The Annual Exhibition Record of the Art Institute of Chicago 1888–1950* (Madison, Conn.: Sound View Press, 1990).

2. Ibid.

3. See Jeff Turnbull and Peter Y. Navaretti, eds., *The Griffins in Australia and India: The Complete Works and Projects of Walter Burley Griffin and Marion Mahony Griffin* (Victoria, Australia: Miegunyah Press, 1998); and Anne Watson, *Beyond Architecture: Marion Mahony and Walter Burley Griffin: America, Australia, India* Museum of Applied Arts and Sciences: Powerhouse Press, 1999).

4. Peter Hastings Falk, *The Annual Exhibition Record of the Art Institute of Chicago 1888–1950.*

5. Ibid.

6. Ibid.; and the Art Institute of Chicago, *A Catalogue of Students for 1909–1910: The Art Institute of Chicago Circular of Instruction of School of Drawing, Modeling, Decorative Designing, Normal Instruction, Illustration, and Architecture.* Chicago, 1909–1910.

7. The Art Institute of Chicago, *The Art Institute of Chicago Circular of Instruction of School of Drawing, Modeling, Decorative Designing, Normal Instruction, Illustration, and Architecture with a Catalogue of Students for 1909–1910* (Chicago: Ryerson Library, 1909).

8. Ibid.

Bibliography

Adams, Robert Henry. *Chicago: The Modernist Vision.* Chicago: Robert Henry Adams Gallery catalogue, 1990.

American Stuff: An Anthology of Prose and Verse by Members of the Federal Writer's Project. New York: Viking Press, 1937.

The Art Institute of Chicago. *A Catalogue of Students for 1909–1910: The Art Institute of Chicago Circular of Instruction of School of Drawing, Modeling, Decorative Designing, Normal Instruction, Illustration, and Architecture.* Chicago, 1909–10.

The Art Institute of Chicago. *The Art Student.* Chicago: Art Institute of Chicago, October 1915.

The Art Institute of Chicago. *The Art Institute of Chicago Bulletin* 25–32, 1931–38.

The Art Institute of Chicago. *Chicago: The City in Art, A Curriculum Guide for Teachers.* Chicago: The Art Institute of Chicago, 1997.

The Art Institute of Chicago. *The Plan of Chicago: 1909–1979.* Exhibition Catalogue, The Art Institute of Chicago, 1979.

The Art Institute of Chicago. *Chicago: The City in Art 1998–1999, A Curriculum Guide for Teachers.* Chicago: The Art Institute of Chicago, 2000.

Baigell, Matthew, and Julia Williams. *Artists Against War and Fascism: Papers of the First American Artist's Congress.* New Brunswick, New Jersey: Rutgers University Press, 1986.

Baigell, Matthew. *The American Scene: American Painting of 1930s.* New York: Praeger Publishers, Inc., 1974.

Berman, Greta. *The Lost Years: Mural Painting in New York City Under the Works Progress Administration's Federal Art Project, 1935–43.* New York: Garland Publishers, 1978.

Bernstein, Barbara. "Federal Art: Not Gone, Just Forgotten." *Chicago Tribune Magazine* (December 2, 1973): 80, 122.

Bloxom, Marguerite D. *Pickaxe and Pencil: References for the Study of the WPA.* Washington, D. C.: Library of Congress, 1982.

Brown, Josephine Chapin. *Public Relief 1929–1939.* New York: Henry Holt and Company, 1940.

Brown, Milton. *American Painting: From the Armory Show to the Depression.* Princeton, N.J.: Princeton University Press, 1955.

Bulliet, C. J. *Artists of Chicago Past and Present: A Series of Articles Written for the Chicago Daily News, Numbers 1–106, February 23, 1935–September 30, 1939.* Chicago: Ryerson and Burnham Libraries, 1991.

Bustard, Bruce I. *A New Deal for the Arts.* Washington, D.C.: National Archives and Records Administration in association with the University of Washington Press. Seattle, 1997.

———. *Picturing the Century.* Washington, D.C.: National Archives and Records Administration in association with the University of Washington Press. Seattle. 1999.

Cahill, Holger. *Introduction to New Horizons in American Art.* The Museum of Modern Art. New York: Arno Press, 1936, 1969.

———. *Record of Program Operation and Accomplishment Art Program.* Division of Service Projects, Works Project Administration, Federal Works Agency. Washington, D.C.: Works Progress Administration, 1943.

Carl Schurz High School. "Dedication of the Gustave Brand Art Collection to Carl Schurz High School." Chicago, 1944.

Cederholm, Theresa Dickason, ed. *Afro-American Artists: A Bio-Bibliographical Directory.* Boston: Boston Public Library, 1973.

Chicago Public Library. Chicago Artists' Archive. Special Collections.

Contreras, Belisario R. *Tradition and Innovation in New Deal Art.* Lewisburg: Bucknell University Press; London: Association University Presses, 1983.

Contributions by Carl W. Condit and Hugh Dalziel Duncan. Chicago: University of Chicago Press, 1980.

Cummings, Paul. *Dictionary of Contemporary Artists.* 4th ed. New York: St. Martin's Press, 1982.

Dawdy, Doris Ostrander. *Artists of the American West: A Biographical Dictionary.* Chicago: Sage Books, 1974.

De la Croix, Horst, and Richard G. Tansey. *Gardner's Art Through the Ages.* 7th ed. New York: Harcourt Brace Jovanovich, 1980.

Delehanty, Randolph. *Art in the American South: Works from the Ogden Collection.* Baton Rouge: Louisiana State University Press, 1996.

Doezema, Marrianne. *American Realism and the Industrial Age.* Cleveland: Cleveland Museum of Art; distributed by Indiana University Press, Bloomington, 1980.

Doody, Flora. *Albert G. Lane Technical High School Collection.* Exhibition catalog. Chicago: Universal Press, 1999.

Dover, Cedric. *American Negro Art.* Greenwich, Conn.: New York Graphic Society, 1960.

Evans, Robert, Maureen McKenna, and Terry Suhre. *After the Great Crash: New Deal Art in Illinois.* Exhibition catalog. Springfield, Ill.: The Illinois State Museum Society, 1983.

Falk, Peter Hastings. *The Annual Exhibition Record of the Art Institute of Chicago 1888–1950.* Madison, Conn.: Sound View Press, 1990.

———. *Who Was Who in American Art, Compiled from the Original Thirty-four Volume of American Art Annual.* Madison, Conn.: Sound View Press, 1985.

———. *Who Was Who in American Art 1564–1975: 400 Years of Artists in America.* Madison, Conn.: Sound View Press, 1999.

Fielding, Mantle, au., Opitz, Glenn B., ed. *Mantle Fielding's Dictionary of American Painters, Sculptors and Engravers* (revised from 1974 edition, author Mantle Fielding, compiled by James F. Carr, 1965). Poughkeepsie, N.Y.: Apollo, 1983.

Findlay, James A., and Margaret Bing. *The WPA: An Exhibition of Works Progress Administration Literature and Art from the Collections of the Bienes Center for the Literary Arts.* Fort Lauderdale, Fla.: Bienes Center for the Literary Arts, the Dianne and Michael Bienes Special Collections and Rare Book Library, Broward County Library, 1998.

Fleischhauer, Carl, and Beverly W. Brannan. *Documenting America 1935–1943.* Berkeley: University of California Press in association with the Library of Congress, c. 1998.

Flynn, Kathryn A. *Treasures on the New Mexico Trails: Discover New Deal Art and Architecture.* Santa Fe, N.M.: Sunshine Press, 1995.

Forrey, Roy. *Chicago's Famous Buildings: A Photographic Guide to the City's Architectural Landmarks and Other Notable Buildings.*

Freedman, Kerry, and Fernando Hernandez. *Curriculum, Culture, and Art Education: Comparative Perspectives.* New York: State University of New York, 1998.

Galbraith, John Kenneth. *The Great Crash 1929.* 7th ed. Boston and New York: Houghton Mifflin Company, 1997.

Gerdts, William. *American Impressionism.* Seattle: Henry Art Gallery, 1984.

Gray, Mary Lackritz. *A Guide to Chicago Murals.* Chicago: University of Chicago Press, 2001.

Griffin, Marion Mahony. *Magic in America.* Unpublished manuscript in the possession of the New York Historical Society (microfilm).

Gude, Olivia, and Jeff Huebner. *Urban Art Chicago: A Guide to Community Murals, Mosaics, and Sculptures.* Chicago: Ivan R. Dee, 2000.

Harris, Jonathan. *Federal Art and National Culture: The Politics of Identity in New Deal America.* Cambridge: Cambridge University Press, 1995.

Hefner, Loretta L. *The WPA/FAP Historical Records Survey: A Guide to the Unpublished Inventories, Indexes, and Transcripts.* Chicago: The Society of American Archivists, 1998.

Helm, MacKinley. *Mexican Painters: Rivera, Orozco, Siqueiros and Other Artists of the Social Realist School.* New York: Dover Publications, Inc., 1941.

Helms, Cynthia Newman. *Diego Rivera: A Retrospective.* New York and London: W. W. Norton and Co., and the Founders Society Detroit Institute of Arts, 1986.

Hilberry, Jane. *The Erotic Art of Edgar Britton: Documents of Colorado Art.* Denver: Ocean View Press, 2001.

Hills, Patricia. *Social Concern and Urban Realism: American Painting of the 1930s.* Boston: Boston University Art Gallery, 1983.

Jacobson, J. Z. *Art of Today: Chicago 1933.* Chicago: L. M. Stein, 1932.

Janson, H. W. *History of Art: A Survey of the Major Visual Arts from the Dawn of History to the Present Day.* 11th ed. New York: Harry N. Abrams, Inc., 1974.

Kruty, Paul Samuel. *Two American Architects in India: Walter B. Griffin and Marion M. Griffin, 1935–1937.* Urbana-Champaign, Ill.: University of Illinois Press, 1997.

La Follette, Suzanne. *Art in America.* New York: Harper and Brothers, 1929.

Lea, Tom, and Thomas E. Tallmadge. *John W. Norton: American Painter, 1876–1934.* Chicago: Lakeside Press, 1935.

Lee, Anthony W. *Painting on the Left.* Los Angeles and Berkeley, Calif.: University of California Press, 1999.

Lewis, Samella. *African American Art and Artists.* Berkeley, Calif.: University of California Press, 1990.

Library of Congress. www.loc.gov/catalog

Locke, Alain. *The Negro in Art: A Pictorial Record of the Negro Artist and of the Negro Theme in Art.* Washington, D.C.: Associates in Negro Folk Education, 1940.

Mann, Maybelle. *Art in Florida: 1564–1945.* Sarasota, Fla.: Pineapple Press, 1999.

Marnham, Patrick. *Dreaming with His Eyes Wide Open: A Life of Diego Rivera.* New York: Alfred A. Knopf, Inc., 1998.

Marling, Karal Ann. *Wall-to-Wall America: A Cultural History of Post-Office Murals in the Great Depression.* Minneapolis: University of Minnesota Press, 1982.

Marqusee, Janet. *Painting America: Mural Art in the New Deal Era.* Exhibition catalog. New York: Midtown Galleries, 1998.

Mavigliano, George J., and Richard A. Lawson. *The Federal Art Project in Illinois 1935–1943.* Carbondale and Edwardsville, Ill.: Southern Illinois University, 1990.

Mavigliano, George J. "The Federal Art Project: Holger Cahill's Program of Action." *Art Education* (May 1984).

McDonald, William F. *Federal Relief Administration and the Arts.* Columbus, Ohio: Ohio State University Press, 1969.

McKinzie, Richard D. *The New Deal for Artists.* Princeton, N.J.: Princeton University Press, 1973.

Melosh, Barbara. *Engendering Culture: Manhood and Womanhood in New Deal Public Art and Theater.* Washington, D.C., and London: Smithsonian Institution Press, 1991.

Metropolitan Museum of Art. *Artists for Victory.* Exhibition catalog. New York: Metropolitan Museum of Art, 1942.

Miller, John, ed. *Chicago Stories: Tales of the City.* San Francisco: Chronicle Books, 1993.

Mullen, Bill, and Sherry Linkon. *Radical Revisions: Rereading 1930s Culture.* Urbana and Chicago: University of Illinois Press, 1996.

Munchick, Donna Ruff. "The Work of Marion Mahony Griffin, 1894–1913." Master's thesis, Florida State University, 1974.

National Archives and Records Administration. RG 69. Records of the Work Projects Administration, Washington, D.C.

National Archives and Records Administration. *Franklin Delano Roosevelt: Presidential Perspectives from the National Archives.* Washington, D.C.: National Archives Trust Fund Board, 1994.

Newton, Judith, and Carol Weiss. *A Grand Tradition: The Art and Artists of the Hoosier Salon, 1925–1990.* Indianapolis, Ind.: Hoosier Salon Patrons Association, 1993.

Nixon, Richard M., and Robert L. Kunzig. *The Heritage of American Art.* Washington, D.C.: National Archives, 1971.

O'Connor, Francis V. *Art for the Millions.* Boston: New York Graphic Society Ltd., 1975.

———. *Federal Art Patronage 1933–1943.* College Park, Md.: University of Maryland Art Gallery, 1966.

———. *Federal Support for the Visual Arts: The New Deal and Now.* Greenwich, Conn.: New York Graphic Society, 1969.

———. *The New Deal Art Projects: An Anthology of Memoirs.* Washington, D.C.: Smithsonian Institution Press, 1972.

———. "New Deal Art Projects in New York." *American Art Journal* (volume 1, No. 2, Fall 1969): pp. 58–79.

O'Toole, Judith Hansen. *Mitchell Siporin: The Early Years 1930–1950.* New York: Babcock Galleries, 1990.

Palette and Chisel Academy of Fine Arts. *Palette & Chisel Academy of Fine Arts records, 1896–1974.* Chicago: Ryerson & Burnham Libraries, date unknown (microfilm).

Park, Esther Aileen. *Mural Painters in America: A Biographical Index.* This remained a mimeographed manuscript, it was never published. Pittsburg, Kans.: Kansas State Teachers' College, 1949.

Park, Marlene, and Gerald E. Markowitz. *Democratic Vistas: Post Offices and Public Art in the New Deal.* Philadelphia: Temple University Press, 1984.

————. New Deal for Art: The Government Art Projects of the 1930s with Examples from New York City and State. New York: The Gallery Association of New York State, Inc., 1977.

Pells, Richard H. Radical Visions and American Dreams: Culture and Social Thought in the Depression Years. Urbana and Chicago: University of Illinois Press, 1998.

Petteys, Chris. Dictionary of Women Artists: An International Dictionary of Women Artists Born Before 1900. Boston: G. K. Hall, 1985.

Plenderleith, H. J., and A. E. A. Werner. The Conservation of Antiquities and Works of Art. 2d ed. London: Oxford University Press, 1971.

Prince, Sue Ann. The Old Guard and the Avant-Garde. Chicago and London: University of Chicago Press, 1990.

Rochfort, Desmond. Mexican Muralists: Orozco, Rivera, Siqueiros. San Francisco: Chronicle Books, 1993.

Rosales, Janice Marienthal. "A History of the Helen C. Peirce School Trust." Ph.D. diss., Loyola University, 1996.

Rosestone Art Gallery (author unknown). Rudolph Weisenborn: A Retrospective. (publisher unknown) November 10–December 1, 1965.

Rubenstein, Erica Beckh. "The Tax Payers' Murals." Ph.D. diss., Cambridge, Massachusetts: Harvard University, 1944.

Ruhemann, Helmut. The Cleaning of Paintings: Problems and Potentialities. New York and Washington, D.C.: Frederick A. Praeger, 1968.

Ryerson and Burnham Library. www.artic.edu/aic/libaries, Art Institute of Chicago. Ryerson Archives, Pamphlet p-20932. (This scrapbook is not in any order or indexed.)

Seaton, Liz. Henry Simon: 1901–1985. Exhibition catalog. Evanston, Ill.: Mary and Leigh Block Gallery, Northwestern University, 1997.

Smith, Clark Sommer. "Nine Years of Federally Sponsored Art 1933–1942." Ph.D. diss., University of Chicago, 1965.

Sokel, David M. Rainey Bennett: Senior Artist's Retrospective. Exhibition catalog. Chicago: University of Illinois, 1979.

Sorell, Victor A. Guide to Chicago Murals: Yesterday and Today. Chicago: The Chicago Council on Fine Arts, 1979.

Sparks, Esther. A Bibliographical Dictionary of Painters and Sculptors in Illinois: 1808–1945. Ph.D. diss., Northwestern University, 1971.

Stern, Jean. Alson S. Clark. Los Angeles: Peterson Publishing Company, 1999.

Stewart, Ruth Ann. New York/Chicago: WPA/FAP and the Black Artist. Exhibition catalog. New York: Studio Museum in Harlem, 1978.

Stone, Clarence N. Changing Urban Education. Lawrence, Kans.: University of Kansas Press, 1998.

Taylor, Joshua C. America as Art. Washington, D.C.: National Collection of Fine Arts, 1976.

Taylor, William E., and Harriet G. Warkel. A Shared Heritage: Art by Four African Americans. Indianapolis, Ind.: Indianapolis Museum of Art, 1996.

Terkel, Studs. Hard Times: An Oral History of the Great Depression. New York: The New Press, 2000.

Thwaites, John. Weisenborn and the American Vision. 1946.

Turnbull, Jeff, and Peter Y. Navaretti, eds. The Griffins in Australia and India: The Complete Works of Walter Burley Griffin and Marion Mahony Griffin. Victoria, Australia: Miegunyah Press, 1998.

Union League Club catalog, Chicago, 1907.

U.S. Works Projects Administration. A List of Prints by WPA/FAP Artists in the Department of Prints and Drawings, Art Institute of Chicago/Federal Works Agency, Works Projects Administration, WPA/FAP Art Program, 1943.

Vinci, John. Inventory and Evaluation of the Historic Parks in the City of Chicago. Chicago: Chicago Park District, unpublished papers, 1982.

Watkins, T. H. The Hungry Years: A Narrative History of the Great Depression in America. New York: Henry Holt and Company, 1999.

Watson, Anne, ed. Beyond Architecture: Marion Mahony and Walter Burley Griffin: America, Australia, India. Museum of Applied Arts and Sciences, 1998.

Watson, Forbes, and Edward Bruce. Art in Federal Buildings: An Illustrated Record of the Treasury Department's New Programs in Painting and Sculpture. Washington, D.C.: Art in Federal Buildings Inc., 1936.

Weber, Alicia. WPA/FAP Artwork in Non-Federal Repositories. 2d ed. Washington, D.C.: United States General Services Administration, 1999.

Wooden, Howard E. American Art of the Great Depression: Two Sides of the Coin. Wichita, Kans.: Wichita Art Museum, 1985.

Yochim, Louise Dunn. Role and Impact: The Chicago Society for Artists. Chicago: The Chicago Society for Artists, 1979.

Zimmer, Jim L., Richard N. Murray, and Cheryl Hahn. John Warner Norton. Exhibition catalog. Springfield, Ill.: The Illinois State Museum, 1993.

Photo Credits

The American Federation of Arts. From the book *The Heritage of American Art*. New York, 1975: 76

Courtesy the Architect of the U.S. Capital: 48t

Courtesy The Art Institute of Chicago: 87, 88

Courtesy The Art Institute of Chicago. Photograph by Jim Prinz. Cover design by Sally Bernard. Product photo by the Chicago Conservation Center: 22tr

Trustees of the Boston Public Library: 49t

Courtesy Margaret Bourke-White/TimePix, New York: 72b

Brooklyn Museum of Art Archives Photograph Collection. Photograph by Robert C. Lautman, Commissioned by the Brooklyn Museum of Art for The American Renaissance (October 13, December 30, 1979), catalog cover: 49b

Collection, AXA Financial, Inc. through its subsidiary The Equitable Life Assurance Society of the U.S. From *America Today*, 1930: 50t

Courtesy The Carnegie Museum of Art, Pittsburgh; Commissioned from the artist in 1905: 55b

Courtesy the Chicago Conservation Center: 18t, 18b, 19t, 19b, 21t, 22tl, 22c, 22b, 23t, 33, 34bl, 34bm, 35t, 35c, 35b, 36t, 38t, 38b, 39t, 39c, 75t, 96c

Courtesy the Chicago Conservation Center. Photograph by Peter J. Schulz: ii, iv, 1, 2, 6, 7t, 8, 10, 11t, 12t, 14–16, 18b, 20t, 20b, 21b, 23b, 25, 26, 29–32, 34t, 34br, 36b, 37t, 37b, 39b, 40t, 40b, 41–46, 52, 54b, 55t, 56–58, 59t, 59b, 60, 62t, 62b, 63, 64t, 64b, 65t, 65c, 65b, 67t, 68–70, 75b, 77b, 79, 80, 82, 85, 89, 90, 91b, 93, 94, 97, 98t, 98b, 99b, 100, 101, 104, 106t, 106b, 108, 110, 111, 112l, 113t, 113b, 114, 118, 119t, 119b, 120t, 120b, 121t, 121b, 122, 123–26, 127t, 127b, 128, 130t, 130b, 131, 133, 134t, 134b, 135, 136t, 136b, 137, 138t, 138b, 139–43, 144t, 144b, 145t, 145b, 147, 148tl, 148tr, 148cl, 148cr, 148bl, 184br, 150t, 150b, 151, 152, 153l, 153r, 154, 155, 156t, 156b, 157, 158t, 158b, 159, 160t, 160b, 161t, 161c, 161b, 162, 163, 165, 166t, 166b, 167–70, 171t, 171b, 172tl, 172tr, 172cl, 172cr, 172bl, 172br, 173, 174t, 174b, 175–83, 184t, 184b, 185, 186t, 186b, 187–89, 191, 192t, 192b, 193, 194t, 194b, 195, 196, 198, 199

Courtesy, Archives, the Church of the Ascension, New York: 48b

Courtesy Library of Congress, 504200: 67b

Letter courtesy Peter Cretia, Nettelhorst Student: 109

Gift of Edsel B. Ford. Photograph ©1932 The Detroit Institute of Arts: 51t

Photograph courtesy Noah Hoffman: 112r

Courtesy Peter A. Juley & Son Collection/Smithsonian American Art Museum: 4

Gift of John Stewart Kennedy, 1897. Photograph ©1992 The Metropolitan Museum of Art: 51b

Courtesy Patrick J. McDonald, Curator, The Millman Collection, Olympia, WA: 24

Courtesy Pennsylvania Capitol Preservation Committee: 54t

Courtesy Ben Reyes of Chicago: 28

Photograph courtesy Lucile Ward Robinson: 102, 103t–b

Courtesy Ryerson and Burnham Libraries, The Art Institute of Chicago: 7b, 66, 77t

Courtesy, Ryerson and Burnham Libraries, The Art Institute of Chicago. Works Progress Administration Federal Art Projects photographs: 81, 95t, 96t, 96b, 98c, 99t, 105t

Collection of the City and County of San Francisco. Courtesy the San Francisco Arts Commission: 50b

Courtesy Special Collections and Preservation Division, Chicago Public Library: 78, 84, 86l, 86r, 91t, 95b, 105b

Illustrations by Jim Swanson: 11b, 12b

Gift of Paul S. Taylor. ©2001 Copyright the Dorothea Lange Collection, Oakland Museum of California, City of Oakland. All rights reserved: 72t

Courtesy U.S. Department of Agriculture. Photo by: Dorothea Lange: 73

Acknowledgments

It has taken over six years (1994–2002) to compile this manuscript, and throughout those years many people have offered their insight and support. I would like to thank:

The Art Institute of Chicago

Jane Clarke, associate director of communications, museum education, the Art Institute of Chicago.

Robert Eskridge, Women's Board endowed executive director, Department of Museum Education for the Art Institute of Chicago, for his overwhelming support for this book and his development of *Chicago: The City in Art*, an educational program for class curriculum based on the Mural Preservation Project.

Sylvia Rhor, former Program Coordinator for *Chicago: The City in Art*, who is working on a dissertation about the CPS murals, for her generous contributions to the catalog section of the book, and for her essay.

Liz Seaton, Web site coordinator for the Department of Museum Education at the Art Institute of Chicago, who offered an essay in addition to editing this book.

Andrew Walker, assistant curator, American Painting and Sculpture for the Art Institute of Chicago, who led me to Diana Linden.

The Chicago Conservation Center

Lorabel Araos, Lane Technical High School student intern.

Barry Bauman, for funding and allowing me to pursue the research and preservation of the Chicago Public School mural collection, and for his endless support of my endeavors in this regard.

Shannon Eiker, former assistant to the vice president of the Chicago Conservation Center.

Margaret Nowosielska, Ph.D., head mural conservator for the Chicago Conservation Center.

Paulette Olson, administrative assistant of the Chicago Conservation Center.

Peter Rybchenkov, student intern from Parker School, Chicago.

Summer Street, current director of marketing for the Chicago Conservation Center, was instrumental in the final stages of writing and editing.

Nahn Tseng, former research assistant for the Chicago Conservation Center.

Marek Wiacek, former assistant mural conservator for the Chicago Conservation Center.

Angela Yon, current director of administration of the Chicago Conservation Center.

The Chicago Public Schools

Armando Almendarez, chief officer, Office of Language, Cultural and Early Childhood Education, the Board of Education.

Rene Arceo, visual arts coordinator, Office of Language, Cultural and Early Childhood Education, the Board of Education.

The Board of Education for the Chicago Public Schools, for project support.

Chris Bushell, director of school services for the Chicago Public Schools, for his support to the various projects.

Diane Chandler, director of cultural arts, Chicago Public Schools, for her efforts as an essayist.

Arne Duncan, current chief operating executive of the Chicago Public Schools.

Tim Martin, chief of operations, Chicago Public Schools, for generous support to the projects.

Michael Scott, current president of the Board of Education.

Brandi Turco, senior assistant to the Board for generous support to the projects.

City Officials

Mayor Richard M. Daley and his staff have offered support letters for our research and preservation efforts throughout the years. I thank him for his welcoming letter at the beginning of this book.

Michael Lash, curator of public art for the Department of Cultural Affairs for project support.

Lois Weisberg, commissioner, Department of Cultural Affairs, for letter and project support.

Essayists

The late Robert Henry Adams, a Chicago art dealer specializing in works from 1900 to 1940.

William Creech, archivist at the National Archives and Records Administration.

Peter Cretia, former student, Nettelhorst Elementary School.

Flora Doody, former teacher at Lane Technical High School, for her insight to start the Lane Tech projects, and her essay.

Maria Gibbs, former student, Lane Technical High School.

Noah Hoffman, nephew of Mitchell Siporin.

Diana L. Linden, a historian who has written many papers on WPA/FAP artists.

Richard Murray, senior curator of the Smithsonian Institution.

Francis V. O'Connor, independent historian of American Art.

Ed Paschke, one of Chicago's premier artists, for his great help with our documentary, and his essay contribution.

Lucile Ward Robinson, WPA/FAP muralist, and her daughter, Mary Robinson Kalista, and son, John Robinson.

Anna Roosevelt, granddaughter of FDR and director of education and community relations for Boeing Company in Chicago.

The late Harry Sternberg, WPA/FAP printmaker and muralist.

Studs Terkel, who was generous with his advice and essay for this project.

Thomas Thurston, project director for the New Deal Network, who offered an essay and has posted many aspects of the projects on their Web site.

Alicia Webber, chief of fine arts, General Services Administration.

Susan Weininger, professor, Roosevelt University.

Dorothy Williams, principal, Lucy Flower High School, for her insight to preserve the Flower mural, and her essay.

Funding and Project Initiation

The Field Foundation and the Bay Foundation, for the first support funds for the Lucy Flower High School preservation project.

Ben Reyes, who has offered support for this project since its inception. Ben's vision allowed the book and the Mural Preservation Project to flourish under his direction for several years.

Dorothy Williams, for her insightful reasons to unveil the controversial whitewashed mural at Lucy Flower High School.

Other Individuals and Foundation Support

The Archives of American Art.

Rolf Achilles, art historian, for project support.

Jean Follett, board member, Landmarks Preservation Council of Illinois, for support throughout the project.

Kathy Flynn, executive director of the National New Deal Preservation Association.

Margaret Gross, Visual and Performing Arts Division, Art Information, Harold Washington Library Center.

Sandra Guthman, president and CEO of the Polk Brothers Foundation.

Connie Kieffer, former teacher at Highland Park High School and executive director of the Midwest Chapter of the National New Deal Preservation Association, for research assistance and copyediting.

Marilew Kogan, a Chicagoan who helped me get in touch with Studs Terkel.

Bill Latoza of Bauer Latoza Architects offered the names of most of the architects, which were otherwise difficult to find. His research on CPS architecture will be forthcoming in a book.

Samuel Larcombe, New Deal historian, who offered an essay on the Index of American Design, which unfortunately could not be included.

David Manilow, fundamental in making the Chicago Mural Preservation Project documentary and offered additional support throughout the research.

Jennifer Masengarb, education programs specialist, Chicago Architecture Foundation.

Patrick J. McDonald, curator for the Millman Collection.

Ellen O'Brien, reference librarian in the Municipal Reference Collection, Harold Washington Library Center, Chicago Public Library.

The Richard H. Driehaus Foundation, which funded part of the mural preservation efforts at Clissold Elementary School in 1997.

Edward Ripp, Chicago bookseller, for supplying all reference books for research.

Charlie Ritchie, assistant curator, Department of Modern Prints, National Gallery of Art, Washington, D.C.

Mary Emma Thompson, New Deal historian of Illinois Post Offices, who assisted with the list of post offices in this book.

David Williams, reference librarian in the Social Sciences and History Division of the Harold Washington Library Center, Chicago Public Library.

The Public Building Commission

Eileen Carey, executive director of the Public Building Commission, for support throughout the projects.

Gery Chico, former President of the Board of Education, has offered continued support for our efforts while on the Board of the Public Building Commission and while president of the Board of Education.

Monica Lasky, former director of development for the Public Building Commission.

Raquel Loll, former chief of staff for the Public Building Commission.

Publishing and Editing

Tony Gardner, who generously supported this project as my publishing agent.

Connie Kieffer, arts educator, who offered generous and comprehensive editing for this book.

Dr. Howard Kotler, who offered support and advice throughout the publishing process.

Francis V. O'Connor, who offered generous and extensive support.

Alan Rapp, editor, Chronicle Books, who supported this project throughout the publishing process.

Edward Ripp, Chicago bookseller, who offered generous support with copyediting.

Liz Seaton, art historian, who offered generous and comprehensive editing for this book.

Peter J. Schulz, Chicago photographer who was hired as the sole photographer for this publication.

Fronia Simpson, freelance art history editor.

Research and Awareness

Barbara Bernstein, whose research offered a strong foundation of information on the subject.

Mary Gray, a Chicago art historian, who worked with me researching murals for over four years; recently finishing her book, *A Guide to Chicago Murals*.

George Mavigliano and Richard Lawson, authors of *The Federal Art Project in Illinois: 1935–1943*.

Clark Sommer Smith and Victor Sorell, who wrote dissertations on the subject.

John Vinci, a Chicago architect who directed me to Mary Gray.

Mural Index by Subject

Index